**Norbert Lynton**

# Ben Nicholson

Phaidon Press Ltd
140 Kensington Church Street
London W8 4BN

First published 1993
© 1993 Phaidon Press Limited

ISBN 0 7148 2813 0

Printed in Hong Kong

A CIP catalogue record for this book
is available from the British Library

Half-title page illustration:
*1945 (bus tickets)*.
Oil, collage and pencil on board,
29.2 × 12 cm
Private collection

Frontispiece:
BN in his studio, *c*.1933.
Photo Humphrey Spender

The publishers have made every effort to
ensure that the dimensions given in captions
are accurate. However, it has not always
been possible to verify independently the
information given in earlier publications or by
suppliers of photographs. Sometimes it has
not been certain whether measurements
refer to the image or to the mount.
This would explain the apparently anomalous
measurements appearing in some captions.
For prints, the dimensions given refer to the
size of the image.

Acknowledgements
The publishers wish to thank all the
museums, galleries and private owners who
have kindly co-operated in the preparation
of this book, and have provided photographs
or given permission for works in their
possession to be photographed.
© Sir Alan Bowness: 122, 263; Ivor Braka;
Browse & Darby; Christie's; Crane Kalman
Gallery; Gimpel Fils; Bernard Jacobson
Gallery; Marlborough Fine Art; National
Portrait Gallery, London: frontispiece, 440;
New Art Centre; Sotheby's; Tate Gallery
Archive: 6, 67, 157, 219 & 230
(© Studio St Ives), 231 (© Kay Gimpel),
279 (© Studio St Ives), 428, 429
(© Sir Alan Bowness), 430; Marian
Thompson: 426; Victoria & Albert Museum:
215, 216, 338, 341, 343; Felicitas Vogler;
Waddington Galleries Ltd.

# Contents

My prime qualification for writing about Ben Nicholson is my long-established and ever-growing admiration for his work. I also knew the man himself but cannot claim intimacy. I did not meet him during my first visits to St Ives in the 1950s though I then got to know many of the important artists working there. I wrote about him occasionally during my regular work as a part-time critic in the 1960s, and visited him in Switzerland in 1965. From then on we corresponded, occasionally at first, quite frequently in his last years back in England. He was essentially a private man, on his guard against anyone and anything that might interfere with his work and dismissive of the rhetoric of art critics and of art-historical research. Inevitably I was pleased that he seemed to think well of me who have long combined art history and art criticism.

It was perhaps at his suggestion, certainly with his agreement, that I was asked to provide introductory texts for some of his exhibition catalogues, for the Galerie Beyeler in Basel in 1968, for Marlborough Fine Art in London in 1971, and for Waddington Galleries in London in 1976 and 1980. Another Marlborough exhibition, a Mondrian and Nicholson two-man show, was planned in 1970 and I wrote a piece for it, but it never happened. In 1979-80 Nicholson was in discussions with publishers and with his dealer, Leslie Waddington. He wanted another book published in succession to the 1969 volume which included a lively essay by John Russell; he wanted me to write on this occasion and at whatever length I wanted. He liked my ideas, he said, and the way I wrote. This too never happened. There has, until now, been no full-length study of the life and work of one of the best and most interesting modern painters. In 1992 I was invited to put together a Nicholson exhibition to tour Japan and to provide a catalogue for it. The Japanese organizers were Art Life Ltd of Tokyo, whom I thank for the friendly efficiency with which they carried through their part of the operation as well as for the opportunity their commission gave me to spend some concentrated time on looking at, thinking about and then writing about a selection of his work. From this came the idea that I should also write a book, in effect the first monograph on the artist if the several publications combining plates with an introductory text alone do not qualify for that term.

Anyone studying Ben Nicholson starts from what has been published on him already. I am happy to acknowledge here the special importance of Jeremy Lewison's scholarly work in various forms, ranging from the Circle exhibition catalogue he wrote in 1982, to his short Nicholson book published by Ediciones Polígrafa of Barcelona and in the United Kingdom by Phaidon Press in 1991 and the catalogue he did for his Nicholson show in Martigny, Switzerland, in 1992. A major part of the Tate Gallery's Nicholson archives was closed while I was working on this book, but I was more than compensated for that handicap by having the help of Nicholson's family and friends. I will list them here briefly but my gratitude to them is great: Jake and Shirley Nicholson, Sir Alan and Lady Bowness, Andrew and Rosemary Nicholson, Jovan Nicholson, Felicitas Vogler, Angela Verren Taunt, Margaret Gardiner, Sir Leslie Martin and Sir Geoffrey Jellicoe. Their interest and encouragement have been of the greatest importance. I have also had help of significant sorts from others. I benefited from Judith Collins's special interest in Winifred Nicholson. Giles de la Mare answered very promptly my queries about the publication history of Circle. Andrea Rose, of the British Council's Visual Arts Department, drew my attention to a very fine 1920s Nicholson I had not known of. Amanda Renshaw of Christie's has been a source of knowledge and provided invaluable advice. Many others have smiled on this work, not least the owners of the

# Preface

1
BN working on
a relief, 1963.
Photo Felicitas Vogler

Nicholsons illustrated here. I hope all these good people will take some satisfaction in the outcome.

The proposal that I should write this book came from Phaidon Press in the person of Richard Schlagman, a great Nicholson enthusiast. I have had the good fortune to have as editor Bernard Dod who knew when to push and when to hearten and believes in sensible English. Philippa Thomson has been a patient and resourceful picture researcher. I have given priority to Nicholson's work, but of course I am intensely interested in him as a man. The Tate archives are now accessible, but there are archival holdings elsewhere on which a full account of his life would have to draw.

Two technical matters. I refer to the mature Ben Nicholson as 'BN' throughout. John Russell used this form in his 1969 essay. BN and I soon used Christian names after our first, more formal encounters. But for me to have written about 'Ben' here would have implied an intimacy I did not have with him though I often feel it when I am looking at his work. In any case, 'BN' saves space and is unambiguous in a book that has to mention several Nicholsons. The other matter is that of titling his work. He himself changed titles and also his manner of titling, but in the 1950s he began to use a formula in which the date appears as the main title and an identifying subtitle follows in parentheses. I use it throughout. This is not merely for the sake of looking orderly but because I have found, in making and using lists and in working with captions in books and catalogue entries, that a multiplicity of systems is an obstacle and makes for confusion. One wants something reliable and unobtrusive. In discussing a work, having used its full title, I feel free to refer to it by the subtitle alone to avoid cluttering up the text.

Many of the pages that follow are devoted to examining examples of BN's work in all media. Selecting them must have been conditioned by many factors. Access was the most important: almost all of those I discuss I have seen at first hand, often discovering things in them that photography obscured. Many other works are illustrated without being discussed. Sheer preference must have been another factor, but not merely as a matter of taste. My enthusiasm for the chosen examples varies in intensity but I find them all interesting. Attention shows them to be more complex than they seem at first, so that my conclusions about what they mean often differs from what has been said about BN's work in particular and in general from a greater distance. Examined with care and over a wide range, BN's work reveals his creative genius more convincingly than any less detailed study can convey. At a time when much writing about art deals with theoretical approaches but leaves the works themselves aside, these remain my primary and final concern. I hope that the step-by-step process involved will not come between the reader and the works and obscure altogether my delight in them. I have enjoyed giving them the attention this method called for, and they have rewarded me by deepening my pleasure in them and the deep sense of gratitude I feel to the artist.

Benjamin Lauder Nicholson was born into an art world remarkable for its diversity and shallowness. Pre-Raphaelitism lived on, but mostly without its first fervour and often now fused with elements of Symbolism brought in from the Continent. William Morris died in 1896, having laboured in words and deeds to reintegrate painting with honest craft traditions and with folkish themes. His aim in this, as in his political activities, was revolutionary. His immediate achievement, he himself admitted, was merely to 'serve the swinish luxury of the rich'. Success in and visible leadership of the British art world belonged to others. Lord Leighton (made a baronet in 1896, the year he too died) and Sir Lawrence Alma-Tadema were leading figures in the Royal Academy by virtue of diligent research, brilliant performance and coy subject-matter. Leighton had become a painter in Frankfurt, Rome and Paris. Alma-Tadema, a Dutchman, had been trained in Belgium and did not come to Britain until he was well into his career.

It does not follow that the Royal Academy was hungry for foreign innovations. Many of the more searching British painters were attracted to foreign examples and methods of a firmly pre-Impressionist sort, setting up artists' colonies in rural settings in the manner of the Barbizon School and its more recent offspring in France and Belgium, and painting rustic scenes in a poetic style that managed to combine a convincing degree of natural observation with artful devices guaranteed to turn nature into warm and harmonious compositions. The best and friendliest of them might find a place in the Royal Academy and its Summer Shows, but their spirits were as far away from the grandiose and often sentimental subjects of academic painting as their chosen workplaces were from Piccadilly. James McNeil Whistler, that wholly international creature whose art mediated deftly between Velázquez, Manet and *Japonisme* and who naturally

existed only in capital cities, was the Royal Academy's proud enemy as well as the victim of Ruskin's impatience with any tendency to abstract or generalize. Whistler's particular representation of Paris in London both encouraged young artists to do some of their studying there – though many preferred Holland or Belgium – and limited their responsiveness to what Paris had to offer.

Benjamin's father, William Nicholson (1872-1949), was an indirect disciple of Whistler as well as, in time, a leading figure in Edwardian upper-class art though never a member of the Royal Academy. A poor pupil at school, interested only in drawing, he had failed also as a student in the school of drawing and painting which Sir Hubert Herkomer had opened at Bushey, Hertfordshire, in 1883. Herkomer dismissed him for 'bad attendance and bad work', in fact for producing a sketch of a model that he judged 'a piece of Whistlerian impudence' both for the pose Nicholson had required of her and for the manner of his drawing. A period during 1889 at the Académie Julian in Paris did less for him than the Paris environment and especially such offerings as the Exposition Universelle. He certainly returned to England aware of Manet and of developments in the graphic arts of Paris, especially poster design. Yet Herkomer's school had contributed something. One day a fellow student, a girl of Scottish origin, did something even more astonishing than draw in a Whistlerian manner: having encountered a flock of geese near the school, she drove them before her into the life class. William and Mabel Pryde, one year older than he, became friends and married in the spring of 1893. A former pub at Denham, 'The Eight Bells', was their first home, and there Benjamin, their first child, was born on 10 April 1894. Asked why he had named his first child Benjamin, William replied he hadn't been able to think of any other name; in fact one of his grandfathers had been a Benjamin.'

Chapter 1

# Benjamin and the Nicholsons

There was no precedent for doing art in the Nicholson family. On Mabel's side it was strong. Robert Scott Lauder and his younger brother, James Eckford Lauder, were her uncles and well-known painters. Her older brother, James Pryde, was a painter and an intermittent actor. Six years older than William, he had studied painting at the Royal Academy Schools in Edinburgh and under Bouguereau in Paris where he also frequented the Académie Julian when William was there. James visited the Nicholsons soon after they married, and that visit turned into something like a second marriage for William, a professional one. We do not know who proposed, but William must have felt that in marrying Mabel and working with James he was taking root in the world of artists. The brothers-in-law became known as the Beggarstaff Brothers, creators of a new line in posters signed 'J & W Beggarstaff'. Their idiom was firmly avant-garde. It combines the flat colours of Art Nouveau graphic art and the formal elisions of Toulouse-Lautrec and Bonnard's posters with a John Bullish muscularity that echoes chapbook traditions. The designs were made by means of *papiers collés*, cut and arranged for maximum economy and effect – but it is unclear which of the 'Brothers' contributed what. Pryde, who was at home in the world of the theatre, brought in some of the commissions, notably those for posters for Edward Gordon Craig's *Hamlet* in the summer of 1894 and for Henry Irving's *Don Quixote* in 1895. The latter was paid for, then not used as a poster; but reproduced in magazines it became widely influential.

William was the more industrious of the two, and probably the one who managed the business side of their work. As the head of a multiplying family he had to be. Antony was born in 1897, Nancy in 1899, Christopher in 1904. The Nicholsons moved house several times. They lived in William's mother's maiden home, Chaucer's House at Woodstock near Oxford, opposite the gates of Blenheim Palace, from 1897 to 1903, then in Hampstead, at 1 Pilgrim's Lane, until they moved to Mecklenburgh Square in Bloomsbury in 1906. William had meanwhile become famous for his woodcuts. These were his personal works, designed, cut, printed and usually also handcoloured by himself, and then mass-produced by publishers for an appreciative public by means of lithography. Particularly successful was one of the ageing Queen Victoria, published in 1907 as a lithograph in *The New Review* but available in its original and always, being handcoloured, unique form to those who sent two guineas. The demand for more was met with further woodcut portraits, amusing as well as sympathetic, of such public figures as Sarah Bernhardt, Whistler, Bismarck and Kipling. To make studies for the last of these William visited Rottingdean on the coast of Sussex in 1897; two years later he bought the Old Vicarage there and that was the family's second home until 1914. More moves followed in the war years, including William's departure to India to paint the Viceroy in 1915-16. Both the Nicholson parents appear to have had a taste for moving about; their son-in-law Robert Graves was to write that William 'loves houses more than people'. William had a studio in London, in Apple Tree Yard, into which he could disappear.

Mabel died in July 1918. She had not been in full health for some time, from child-bearing and wifely tasks that left little time for art, perhaps also on account of William's attractiveness to other women. None of her pre-motherhood paintings remain; the few that are known, mainly of her children and home, are marked by an austere sense of design that may well have impressed itself on her son. Benjamin got the news of her death in California, where he had been told to go because he suffered badly from asthma. He had inherited his father's physical neatness and grace,

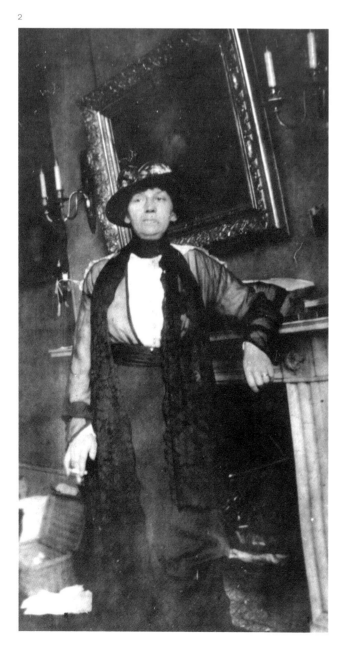

adding an amazingly capacious forehead, but lacked the confident charm that made William a great social success, with artists and theatre people, with the ladies particularly, and with the well-off and the well-born who came to him for their confident and charming portraits. Benjamin had gone to California in 1917. He had embarked on a cargo ship to New York, making money out of members of the crew foolish enough to play cards with him, and then on to Pasadena by train. Mabel had agonized over his going, fearing she might never see him again. He was uneasy, perhaps feeling sent away and probably some guilt at not fighting for his country. At the news of Mabel's death he returned at once. That October, only (as it turned out) days before the signing of the Armistice, the family learned that Tony, serving in the Royal Field Artillery in northern France, had died of gunshot wounds.

In 1919 William Nicholson married Edith Stuart-Wortley. Edie was a close friend of Mabel's and a painter too, sixteen years younger than William, the widow of Major Stuart-Wortley, long pronounced 'missing' in France, and mother of two. But before that she had been Benjamin's fiancée, though six years older. They had thought of marrying once the likelihood of the husband's death was confirmed at the end of the war. It seems that William snatched her out of that relationship and promise, but Edie must have had her part in this and we may well wonder what the marriage would have done to BN. What is known of her work does not suggest that he and she would have been allies in art. At the time, the *volte-face* and the double rejection must have been at the very least a severe blow: he threw away the ring in disgust and for some time kept away from his father and step-mother. He knew that his father did not entirely love him, preferring the more relaxed second son, Tony. Moreover, William and Benjamin were already rivals – in art. There have

**3**
BN's father,
William Nicholson

Benjamin and the Nicholsons

been many instances of father–son relationships easing the younger man's entry into a profession or craft, and in many cases we can sense an element of productive competition between them. In this case the competition may have been more edgy, Benjamin early on deciding that he could not adopt his father's styles. Also, he must have been aware of his father's philandering and of the pain it gave his mother. In the mid-twenties, married himself, BN did visit William and Edie in the Manor House at Sutton Veny in Wiltshire, their chief home from 1923 on. This was and is a beautiful, rambling place, developed from a large medieval hall; William had painted its interior a cold pink. Ten years later he abandoned the marriage. In 1934 he met Marguerite Steen in Spain and she remained his companion until his death in 1949.

William had developed into a very fine painter of still lifes and landscapes and a successful painter of portraits, some lively, many of them exercises in adroit flattery. They earned him a knighthood in 1936 but it was the other, more personal work that earned the praise of artists and of commentators such as Kenneth Clark, director of the National Gallery. William had twice refused nomination to be an Associate of the Royal Academy; the knighthood he accepted very readily in 1936. The only artists' association he joined was the Society of Twelve, which organized exhibitions, of graphic work only, from 1904 to 1912 and included among its better-known members Charles Conder, Augustus John, Charles Shannon, Charles Ricketts, William Rothenstein, George Clausen and that great man of the theatre, in part William's pupil for art, Edward Gordon Craig. Craig and Rothenstein were the same age as William; John was six years younger; most of the others were substantially older. There was nothing overtly progressive about the group as a whole. William did not have anything to do with the New English Art Club, earlier Whistler's domain and associated with French Impressionism, nor with the Camden Town Group formed by Sickert, Spencer Gore and others in 1907 as a second Impressionist vanguard but tending more to unglamorous interiors than to sun-kissed meadows. One feels that the essentially clubbable William Nicholson wanted nothing but his artist and theatrical friends (of whom Craig continued to be one) and the smart society from which he drew his sitters and commissions.

Benjamin's formal education appears to have been intermittent, presumably because of his asthma. For a while he was at a preparatory boarding school, Tittenhanger School in Seaford, Sussex, then at Heddon Court in Hampstead, and finally at Gresham's School at Holt in Norfolk. Gresham's was a progressive public school. It appears that Benjamin was there for at most a year and that his remembered achievement was in sport rather than study. His skill at cricket was such that he was put into the First XI at once, and thus able to wear the scarlet blazer that went with that honour. But he was the newest, smallest boy in the school, and the rest of the team were 'great sixth-form giants'. One wonders whether this precocity did much for his health; at any rate, he left the school because he was unwell.[2] There is no reference to tutors or to parental teaching, yet no one who knew BN will have thought him anything less than well educated.

At the early age of sixteen, BN went to the Slade School of Fine Art, a part of University College in the University of London. He stayed there for a little more than one academic year during 1910-11. He emphasized later that he had spent most of his Slade time playing billiards at the Gower Hotel nearby, and it is normal to speculate on the aesthetics of the balls moving with precision across the green baize in relation to BN's at once athletic and fastidious mature style. But he

Benjamin and the Nicholsons

**William Nicholson**
*Vase and Books on
a Red Table*, c.1920.
Oil on paper,
39 × 31 cm
Private collection

4

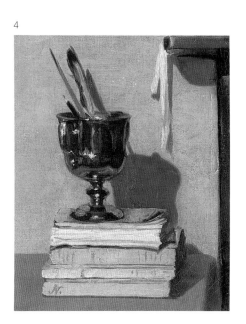

made friendships at the Slade that were to be of continuing value to him, notably that of Paul Nash, five years older than himself. And he did some drawing from plaster casts. Then he spent time at Tours in France during 1911-12 and in Milan, during 1912-13, in both cases to learn the language of the country. He wrote much later that 'I was in the painting world and trying to get out'.[3] Was the parental example too much for him? Geoffrey Grigson, who later knew him very well, states that BN distrusted his father's charm and felt that BN spoke in guarded terms even when he was praising William's paintings. He adds: 'Ben's mother did not make things easier when she remarked to Ben in a motherly way that he would never be as good a painter as his father. Ben replied that he painted as well as his father already, if not better'.[4] We know that he did draw and paint though there is almost nothing left to show what. He also wrote, and thought of writing as a possible *métier*. But on 4 November 1920 BN, 'Painter Artist' and son of William Nicholson, 'Painter Artist', married Rosa Winifred Roberts, no rank or profession, daughter of Charles Henry Roberts, 'Politetion' [sic].[5] Soon after, the young man decided he would henceforward be Ben.

It seems Benjamin had a happy childhood. He was intelligent as well as adroit and earned his father's approval with his quickness and skills. William was known for his physical grace and his deftness, including his unmatched performance at bilboquet (which we call cup-and-ball). Benjamin, good at all sorts of games, was known to be 'the Child Champion of Diabolo'.[6] William was a relentless punster. Benjamin too liked puns and other games with words, subtle or diabolical; when he came to write he used words with an economy that showed his regard for them and gave them extra force. But one senses in all this that, from the first, he had to prove himself in his father's eyes: he had to compete and he had to win where winning was possible. As he moved

Benjamin and the Nicholsons

into his teens tensions developed between him and his father. He developed asthma too, and perhaps this may be seen as a symptom of that, though it may also relate to his mother's always reliable, increasingly clinging care and need of him as her relationship with William deteriorated. Marguerite Steen reports, on the strength of what William told her much later, that it was Benjamin's brother Tony, the second-born, who was 'most completely William's son', being lovable, gay and reckless when Benjamin was becoming too earnest to be fun, too in-turned and burdened by the seriousness of life. Winning presumably became more necessary, and winning the approbation of his father's friends. The Nicholson home was often full of visitors, theatre people and artists mostly, including Craig who was both. They would eat and drink and smoke and sink into endless discussions of the state of the arts. None of the Nicholsons could bother with art theory, but William readily joined in art gossip and art politics whereas Mabel was irritated by them. Everyone writing about BN has to quote what he said about her in this connection, that 'after a lot of art talk from

5

our visitors she always said that it made her want to go downstairs and scrub the kitchen table'.[7]

Benjamin loved and admired his mother and thought her the most intelligent person in the family. His relationship to his father was a two-edged one of admiration and disapproval on both sides.[8] Benjamin was driven by a desire to impress and feared he could not; he knew William's excellence in many departments and had to do better. Mabel's death so quickly followed by that of Tony, the preferred child who did not have asthma and therefore went to be killed, must have shaken him to his roots. It meant for him, to an unusual degree, the end of family life and family feeling. But he did not break away from his father and siblings entirely. We know that he visited Sutton Veny, that he kept in affectionate touch with Nancy who became a textile designer and printer, and that he was very close to Kit who became one of England's pioneer modernist architects, at least until Kit's marriage to the interior designer Elsie Myers, known as E.Q., in December 1931.

Once his father was dead, BN was to go out of his way to praise his sensibility and, selectively, his art. William was to him 'a painter, not an "intellectual"' (a distinction BN adhered to and sometimes used against art historians and critics). His mother's symbolic appeal to scrubbing the kitchen table stayed always in his mind, 'But of course I owe a lot to my father – especially to his poetic idea and his still-life theme.' BN got that theme from William, and 'not only from what he did as a painter but from the very beautiful striped and spotted jugs and mugs and goblets, and octagonal and hexagonal glass objects which he collected. Having those things throughout the house was an unforgettable early experience for me. These words are taken from what BN said in 1963. In 1967 he wrote a piece about his father in response to the introduction his son-in-law Alan Bowness

had written for the catalogue of a William Nicholson exhibition at Marlborough Fine Art – instructive but too measured for BN's taste. His answer was to emphasize the liveliness of a home life that featured his uncle, 'Pryde, a large, affectionate and humorous man … my father smaller and very lively and elegant', and his mother 'with her usual sphinx-like look' as 'the rock on which my whole existence has been based'. The article is a collection of amusing anecdotes, but ends with an emphasis on the '*poetic spirit*' to be found in William's landscapes and 'the simplest of his still lifes': 'In my view it is some of the smallest paintings … which contain this true poetic spirit.' They made BN think of Constable, 'whose small sketches of landscape are some of the nicest things produced in English painting.' He was ashamed of his father's 'portraits and character studies', seeing in them aspects of an easy, self-regarding charm and sociability that he himself could not bear or emulate.[9]

Writing to John Summerson in 1948, when Summerson was preparing his introductory essay for the BN volume in the Penguin Modern Painters series, BN said that 'in my home life set-up my mother played a vital part in my development. I admire my father's paintings – his still lifes and landscapes – v. much & I think he is a v. real painter – it is I suppose a kind of poetic-painting? but it is very accomplished and sophisticated and with only that as a starting point I think the next move via my work might easily have been something over-ripe & the end of something whereas I always *hope* it is the beginning of something.' Winifred Nicholson, who got to know her father-in-law well in the 1920s, thought of William's art as 'typically English': 'His eye would detect and appreciate the finest gradation of light and shade, his brush could handle the finest nuance with consummate skill … his mastery of black, and black to grey, created masterpieces.' She was distanced by the gloom of

his studio, filled though it was with attractive objects of all sorts. His concern, she concluded, was always with surfaces, with 'the outsides of the people he painted, as he painted the outsides of his jugs and goblets'.[10] Later, BN took scissors and paste and a copy of the William Nicholson volume in the Penguin Modern Painters series, and edited it, removing most of the portraits.

In 1916 William painted *The Hundred Jugs*, a relatively large canvas now in the Walker Art Gallery in Liverpool. It shows a great crowd of objects, many of them known from his more concentrated still lifes. We are told it was done in answer to a challenge from Benjamin. Since what BN admired most in his father's work was its discrimination and simplicity one wonders what that challenge could have meant. In a letter of 1979 BN linked the story to his own, and supposedly first, painting of a single jug: 'The landscape of 100 jugs was result of my *one* jug bec. when my father saw it – "why not 100 jugs!" and I said "it's your idea why don't you do it?"'[11] It sounds like an invitation to disaster. One or two objects – a bowl, mushrooms on a plate, a few flowers, a gold jug, pears – seen close to and carefully lit, had always produced the best results. What made them special was William's fine sense of tone, learnt from Whistler and Velázquez, the exactness with which he allocated degrees of presence to these objects and to their usually quite modest setting. William had the real painter's ability to fuse observed data with the pleasures of brush and paint; interest and pleasure in the objects he painted is finely balanced against the representation as an aesthetic object made of quite other stuffs. Painterly painting like this is a kind of pun in itself. *The Hundred Jugs* is an extravaganza outside William's normal range as a painter though within it as an elaborate joke. It suggests some musical director's quick idea for a finale, 'over-ripe & the end of something'.

Marriage to Winifred Roberts was a milestone and a great beginning. It signalled BN's decision that art would be his life, and it marked the start of a relationship that profoundly affected his work and thought. It also initiated a period of intense work – often done in a spirit of eager optimism but backed by severe self-criticism, with much reworked or destroyed at the time and later. The many pleasures he shared with Winifred, a woman gifted in the business of enjoying, brought out his energies and underlying optimism. After he left her, BN referred to her rarely in his public statements, though the relationship continued in terms of friendship and mutual encouragement. But then the first of BN's published writings date from the early 1930s when he was with Barbara Hepworth, and the occasions were impersonal.' Any assessment of his artistic relationship with Winifred must be based on the work of both painters and on the texts, mainly recollections and letters, collected together in *Unknown Colour* by their second son, Andrew.

In his introduction to this book Sir Norman Reid states that BN was 'the single greatest influence on [Winifred's] life as a painter' and quotes her words to him: 'I was painting "faerie" pictures when I met Ben, but soon he changed all that.'[2] By 'faerie' she meant romantic literary pictures in the Pre-Raphaelite mode. She had studied painting in the Byam Shaw School of Art in London, and Byam Shaw was one of the last fulsome Pre-Raphaelites. He produced elaborate History paintings on subjects from such authors as Rossetti and he illustrated Browning's poems, a book of nursery rhymes and various historical texts. Her grandfather, George Howard, Earl of Carlisle, was a painter and friend of the Pre-Raphaelites and of the leading poets of his day, as well as for many years chairman of the Trustees of the National Gallery. He encouraged the young Winifred Roberts to study art and perhaps influenced her choice of art school. It seems her

parents had wanted her to go to Girton, founded by her grandmother. In fact her education to that point had been wholly informal, with a succession of governesses teaching her languages and little else, while art was always her favourite occupation. She stood in awe of Byam Shaw, as did all his students, and he noted her strength as a fatal flaw: 'You are seeing too many colours, Roberts.' In 1919 her father was sent to India on a government commission, and she went with him. The watercolours she brought back show a relaxed use of colours in conjunction with fluent drawing, and it seems the visit also gave life to spiritual affections within her. She had a strong sense of human and divine love, associating it with light, particularly with epiphanic experiences of celestial light. One of these occurred when she first met BN, in her aunt's house in London, and she knew she would marry him.

A few months later this expectation was fulfilled, and the young couple immediately set off on a rapid tour of Italian cities. They lingered over the Italian primitives, ignored the glories of High Renaissance art, and fell in love with the old towns and landscapes. They ended their trip near Lugano, at Castagnola, where the light was brilliant and BN could breathe easily. 'Each day was a miracle of sunlight, each evening a wonder of stars.' Winifred's father bought the Villa Capriccio there, on the slopes of Monte Bré and looking on to Lake Lugano, and let it to them. They spent every winter there until 1924. They painted the villa white inside. A small room, with an unappealing view and a curtain to cut out even that, became BN's studio. They painted outdoors and in, and went for long walks, drawing and looking. Further trips, involving transport, took them in all directions, 'But mostly we walked in the uplands – and it was there that his first picture emerged … It was "Cortevallo" – a pathway, a house, a mountain, a young sapling – a masterpiece.'

Chapter 2

# The 1920s: Castagnola, Banks Head and London

**6**

*1911 (striped jug).*
Oil on canvas,
51 × 71 cm
Formerly collection of
Sir William Nicholson
(destroyed)

Summers were spent in London, where they had a *pied-à-terre* and a studio, and in Cumberland where they stayed with Winifred's parents until they bought their own place, Banks Head, in 1923; they started using it in 1924. Going to and coming from the Ticino they would stop off in Paris. 'Its creative energy was not to be believed,' Winifred wrote. That last winter (1923-4) 'our painting came to flowering point', she wrote later. Her masterpiece (I use the word for once in its original sense, as the work with which journeymen demonstrated their fitness to be a master) was *Mugetti*. It is a picture of a pot of lilies of the valley (strictly, *mughetti*), given her by BN, still in its tissue paper wrapping and seen against the blue of the lake, mountain and sky – 'and the tissue paper wrapper held the secret of the universe'. (It also looks astonishingly like some of Barbara Hepworth's bronze sculptures of more than thirty years later.) Winifred dated it '1921' but she implies it was painted around 1923; BN ascribed his *Cortivallo* to 1921 also but it too must have been painted or finished in 1922-3.[3]

The paintings BN had done up to then, in so far as we know them, were substantially different. The earliest, reproduced twice in 1948, in Penguin Modern Painters and in the first volume of the Lund Humphries monograph, but apparently destroyed since, is known as *1911 (striped jug)* [plate 6] but was probably painted or reworked some years after that date. Ultra-neat and specific, it takes its theme from his father's still-life pursuit and seems to comment on it. Its cool precision is the opposite of William's deft display of skills; the almost spaceless setting of the object in profile against a plain background is the opposite of his adroit lighting and telling angles of sight. It is a primitivist's answer to a whole tradition of fine and ingratiating work in oils, looking back far beyond that tradition to the sort of innocence, an apparently unprejudiced picturing of aspects

6

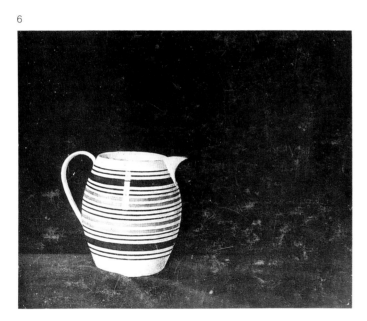

**7**
*1917 (portrait of Edie).*
Oil on canvas,
47 × 35.6 cm
Sheffield City
Art Galleries

**8**
*1919 (blue bowl
in shadow).*
Oil on canvas,
48.2 × 64.7 cm
Private collection

**9**
*1921-2 (still life – Villa
Capriccio, Castagnola).*
Oil on canvas,
62 × 75 cm
Private collection

**10**
*1922 (bread).*
Oil on canvas,
68.5 × 75.6 cm
Private collection

The 1920s

of reality, found among the pre-Renaissance Italians.[4] The next is *1917 (portrait of Edie)* [plate 7], another neat profile set against a dark background like many an early Italian portrait, but with angles, curves and curving shapes brought out through selective simplifications, with tone and cool–warm contrasts clarifying each form. Mabel's rather austere style of painting seems echoed here. Winifred recalled that the day after she first met Ben he showed her, in Nancy Nicholson's house, a portrait he was painting of Nancy's husband, the poet Robert Graves: 'a small black portrait … blocked in to hard shapes as the Cubists'. That suggests a heightened, perhaps more masculine, formalizing of the shapes of the head first tested in *Edie*, and perhaps the influence of Vorticism's insistence on tough, uningratiating forms.[5]

A very different note is struck in *the red necklace*, dated broadly to the years 1916-19. It shows a plain jug on a table in front of a curtain and, hanging just in front of that, a fringed shawl and a long necklace, all done in a smooth manner that explains BN's later reference to some of his early paintings as 'slick and "Vermeer"'. *1919 (blue bowl in shadow)* [plate 8] is an elegant study of an orange picture frame and a blue bowl on a shelf. The shelf is set just below eye level, so that we see the bowl in almost exact profile and have no view of its interior. The frame leans against the wall, a parallelogram on the picture surface. Its orange colour is reflected by the bowl and echoed in a cockerel of much the same colour on its side. There is little to distract the eye from these two objects and the dialogue between them, except that the only direct light falls so as to cut across the lower part of the frame and part of the bowl, making an interesting lit shape. There is much of William's cunning in this composition, yet it is more economical than any of his pictures, and in this way closer to Whistler

than William was willing to come. Vermeer's name might still be relevant here, but not the word 'slick'.

Those were presumably painted in London and before Winifred, the following in Castagnola after their marriage. *1921-2 (still life – Villa Capriccio, Castagnola)* and *1922 (bread)* fuse elements of Bonnard, Matisse and the pre-Cubist Picasso [plates 9 and 10]. Both emphasize space in their compositions by means of table tops seen in free-hand perspective. In the former the far corner of the table is repeated in the corner of the room, and the striped tablecloth runs our eye into this space and to the simple still-life group, a spoon on a plate. The latter has many more objects on the table – bowls, a saucepan of milk, loaves of bread and so on, several of them on a curved white or pale area that may be a cloth or a board – and thus BN entered into that concern with the relationships between objects, formal, spatial and psychological, which Cézanne had made so poignantly his own and which was to remain central to BN's art.

Compared with these, three paintings of a house in Castagnola treat their subject with childlike directness. BN took a photograph of the house, and comparing it and the pictures we see how he selected aspects of the subject, altering the proportions of the house and omitting many of its features, as well as greatly simplifying near and far elements of its setting. One, *c.1921 (pink house in the snow)* [plate 11], announces its main focus of interest, the play of the colours of the house against the white snow on the ground, on its roof and on a distant mountain. Another, *1922 (Casaguba)* [plate 13], may be an autumn scene and is full of rich, mostly earthy colours, with the landscape background rising behind the flattened house. Unearthy are the two pale blue lines on the house, one on its near corner, the other horizontal and marking the floor level between its two storeys. They represent quoins and a string course but here serve as

10

9

The 1920s

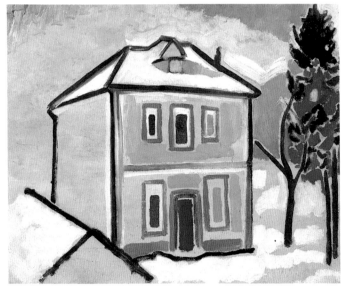

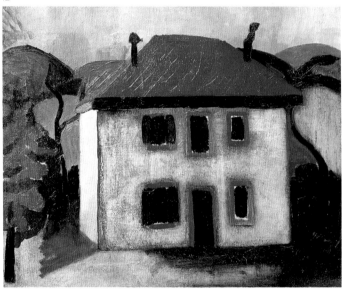

13

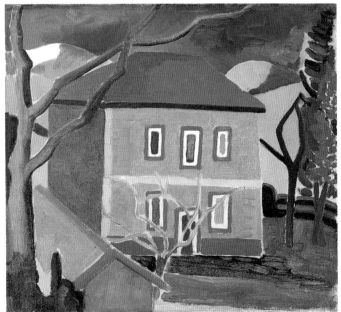

refreshing colour accents.[6] It would be difficult to imagine a painting more unlike William Nicholson's fine, sometimes exquisite, tonal studies of houses and parts of towns.

Where did the impulse to colour come from? Tonal subtleties, delight in lean forms and in manual dexterity – these were BN's parental inheritance, moderated by BN mainly in terms of Italian primitivism. But by 1922-3 he had discovered a delight in colour for its own sake – for its pictorial energy as well as for its inherent joyousness – that he may have owed to Winifred [plate 14]. It is already in her paintings of 1921-3 in combination with a direct, unsubtle, half-clumsy but very effective use of the brush – far from Pre-Raphaelitism and from Vermeer or William – that BN also adopts. It emerges in BN most clearly with *Casaguba*. Later he said, 'From Winifred I learned so much about colour, and from Barbara a great deal about form.'[7]

That is not to say that Winifred alone opened BN's eyes to colour and a new sort of painterly painting. He cannot have been unaware of Roger Fry's two Post-Impressionist exhibitions, shown in London in 1910 and 1912, passionately argued over among artists and ridiculed by the press. (He was in Italy when the second of these shows was on but he would certainly have known of it.) Gauguin's work was particularly prominent in the first, Matisse was included in the second, as well as contemporary British painters. If that and the Bloomsbury versions of Post-Impressionism did not at that stage touch him, Paris would later have shown him that one of Modernism's projects was the use of heightened colour for the sake of poetic expression and its liberation from the task of describing the visible world in naturalistic terms. Gauguin, Van Gogh, the Nabis, Fauvism – all emphasized colour as an expressive force; Van Gogh, Cézanne and Matisse demonstrated the use of colours that were simplified, concentrated, at times amplified versions of

nature's hues, as a means of pictorial construction as well as symbols. (Three Gauguin reproductions hung in the dining room at Castagnola.) The same individuals and movements proposed new ways of using the brush. Art Nouveau, including the Beggarstaff posters and William Nicholson's woodcuts, displayed various ways of concentrating colours and giving them decorative as well as structural roles. The Slade gave no encouragement to exploring colour. The green plane of the billiard table, with white and red balls darting over it, probably contributed more. The sight of pre- and early Renaissance painting, in London, Paris and above all Italy, excited Ben's and also Winifred's sense of light colours and clear forms.[8] And then there were those repeated visits to Paris and clearer awareness of the work of, especially, Cézanne and Matisse, and – we do not know on which visit – their joyous response to a particular Picasso, recalled by BN in 1948 (and mentioned later by Winifred): 'It was what seemed to me then completely abstract and in the centre there was an absolutely miraculous *green* – v. deep, v. potent and absolutely real – in fact, none of the actual events in one's life have been more real than that, and it still remains a standard by which I judge any reality in my own work.'[9] Colour as a pictorial fact, free of external reference.

Seeing this, BN wrote, was 'the real revelation'. Revelations require preparedness. This may have been supplied by Italian painting, by talking about colour with Winifred and seeing her at work, even by insight into her Pre-Raphaelite schooling, as well as by memories of Post-Impressionism and some awareness of the Bloomsbury painters' occasional use of poetic colouring. Summerson mentions a BN scrap book of 1922 that 'summarizes his loyalties at the time: Giotto, Uccello, Cézanne, the Douanier, Matisse, Derain, Braque, Picasso'.[10] Sharing thoughts about colour with Winifred would have meant speaking also of light,

**11**
*c.1921 (pink house in the snow).*
Oil on canvas,
46 × 56 cm
Private collection

**12**
*c.1921 (house, Castagnola).*
Oil on canvas,
46.3 × 55.3 cm
Private collection

**13**
*1922 (Casaguba).*
Oil on canvas,
69 × 75.5 cm
Private collection

**14**
**Winifred Nicholson**
*Window-sill, Lugano*, 1923.
Oil on board,
28.6 × 50.8 cm
Tate Gallery, London

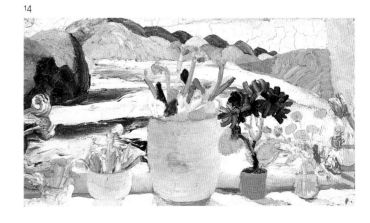
14

The 1920s

**15**

*1922 (coast of Spain).*
Oil on board,
40.5 × 46 cm
Private collection

in her case about miraculous sights, joyous manifestations of the divine spirit. She was 'exploring new thinking – in India I had read the Vedas and Buddhist writers, and Laotze'[11] and building up a transcendental view of the world that already informed her pictures and was to guide her life with, soon, support from Christian Science. BN responded sympathetically. I doubt he read those Oriental texts, just as later he did not even attempt to read a Mondrian booklet on Neo-Plasticism, and he never formally became a Christian Scientist. Yet he sensed the reality of spiritual energies and continued to do so after his marriage to Winifred ended.[12]

Paintings done away from Castagnola before the turning point of BN's masterpiece include *1922 (coast of Spain)* [plate 15], a simplified landscape represented in terms of successive horizontal aspects and done with a loose, soft, dabbing brush that may have been borrowed from Winifred; *c.1922 (lake shore)* [plate 17] which may have been the painting exhibited as *Nudes, coast of Spain* in 1926 and shows two nude women, one standing, one seated, placed classically against a sea background; *c.1922 (Balearic Isles)* [plate 16], a half-figure of a naked woman, somewhat idealized in classical terms but hinting also at Picasso's solid figures of that time, most obviously in her powerful left arm, though that influence, here and in the preceding picture, could have come to BN through his friendship with the sculptor Frank Dobson; *c.1923-4 (Bertha; no.2)*, a simplified head-and-shoulders portrait of a woman, more volumetric than the preceding half-figure but still done in unemphatic fresco-like tints; and what may have been his first Cumberland landscape, *c.1922-3 (Coal Fell)*, also brushed in gently and full of space and weather but including areas of a sudden sharp green.[13]

*1921-3 (Cortivallo, Lugano)* [plate 18] has qualities that point to Cézanne's influence but also further into the past as

15

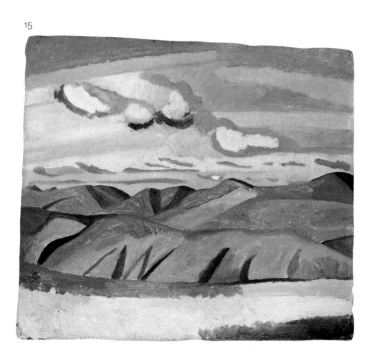

**16**

*c.1922 (Balearic Isles)*.
Oil and pencil on
canvas, 59.6 × 54.6 cm
Kettle's Yard, University
of Cambridge

**17**

*c.1922 (lake shore)*.
Oil and pencil on
canvas, 36.8 × 44.5 cm
Private collection

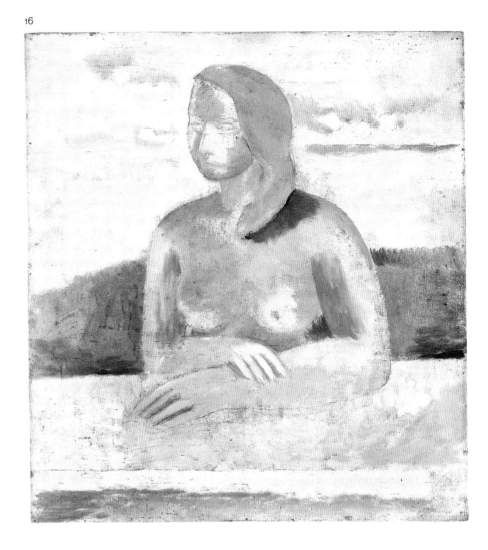

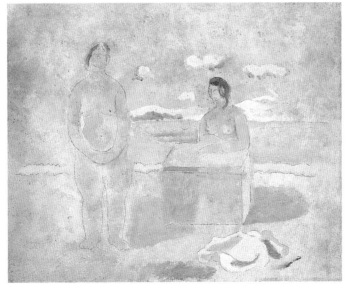

The 1920s

well as into the future. Most Cézanne-like is its intentional incompleteness (BN sent it to an exhibition at the Patterson Gallery, London, in late 1923). It is his first painting in which pencil marks exist not merely to guide the brush but to play roles in the finished work. The role of paint here is relatively minor. Some parts of the canvas show only the primer. Soft bands of paint serve to suggest the distant mountains and trees. Some shapes and pencil accents in the immediate foreground are left undefined, but a little way in, at the start of a band which represents a road snaking into the picture, we see a pair of trees, inscribed into the paint. These speak vividly of space, making us aware of the off-white expanse as a receding landscape even though we can also read it as quite flat. The composition pivots on these two trees. Charles Harrison makes the point that it is balanced spatially on the gap between the first two houses, one red, the other a firmer white: 'The clear spatial white of one house behind the sharp physical red of the other carves out a space which deepens and intensifies the whole painting.' That red is the one strong colour note in the picture, and it reminds one of BN's delight at that 'real' green in the Picasso. The other colours function as tints and have their echoes in the picture, as in a Cézanne, without asserting themselves. Pale blues, a variety of pale greys and mushroomy cool/warm hues, a fuzzy band of creamy yellow horizontal in the left half of the middle distance and, everywhere else, a range of whites, from the pronounced white of that central house and the relatively clear white of the curved shape dominating the foreground to the scrubbed warm white of much of the landscape and the bluish white of the sky. The general effect, of a calm sprightliness and of airy space combined with flatness, reminds one of certain early Renaissance fresco and panel paintings that rely on off-white as key signature and seem full of air while leaving the surface plane undisturbed,

especially those of Piero della Francesca, seen in London and in Italy. The neat forms of BN's houses will recur in his Cumberland and Cornish landscapes of the later 1920s but we shall not find a comparable emptiness, or silence, until he embarks on his white reliefs in 1934.[14]

*Cortivallo, Lugano* serves perfectly as masterpiece: it shows the artist's arrival at a point where lasting influences are fused in a way that reveals also his priorities. Those influences include that of William, whose best landscapes are marked by acute control of tone and are done with the same deft touch as his best still lifes; they can also exhibit enchanting colours, not bright but luminous in their interaction. Would William have approved of his son's masterpiece? One guesses he would have admired Ben's economy and surface design but jibbed at the anonymous brushwork with those dabs and dashes for the mountain sides and the impersonal filling in of the roofs. But he would have noted his son's sensitive control of the picture as a space and as a flat structure, and there are times when one wonders whether William's landscapes did not benefit from BN's example.

BN did not feel that his journeyman period was at an end. He went on experimenting in several directions. Less widely now, in that his essential taste had formed and could be relied on: he knew what he would not want to do. Yet he still destroyed much of his work, and in later years was liable to ask for some of his 1920s paintings back, sometimes exchanging more valuable works for them, in order to destroy them. The 1969 retrospective exhibition at the Tate Gallery, organized in close consultation with him, excluded all paintings prior to 1921 and opened with the two paintings of the house he had photographed, discussed above, ascribed to *c*.1921, and *Cortivallo, Lugano*, there dated 1921. Yet the exhibition, totalling 127 exhibits, included 27 works of the

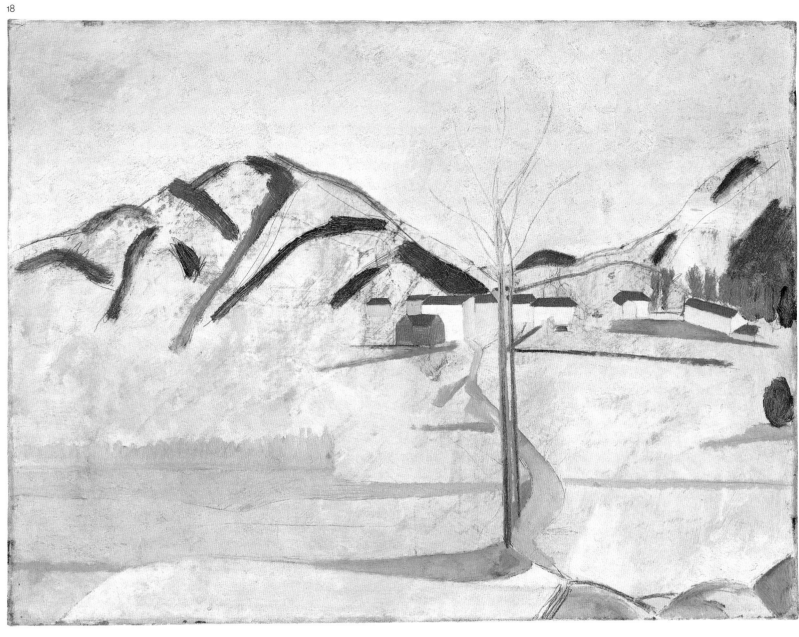

The 1920s

**19**
*1924 (first abstract
painting – Chelsea).*
Oil on canvas,
55.4 × 61.2 cm
Tate Gallery, London

**20**
*1924 (trout).*
Oil on canvas,
56 × 58.5 cm
Private collection

**21**
*1923 (Dymchurch).*
Oil on canvas,
29 × 38.5 cm
Private collection

1920s. BN was willing to stand by these selected works as representing him and his career.

In England the Nicholsons divided their time between London and Cumberland. Castagnola meant relative solitude for the couple though there were occasional visits from family and friends; Paris meant exciting art sightings and encounters; England meant more contact with artist friends as well as family. Banks Head was their main home from 1924. Beautifully situated on the line of Hadrian's Wall and partly built of its stones, it made a well-nigh perfect place for the Nicholsons to live and work in; they took evident pleasure in the ever-changing light of Cumberland, in the local landscape and also in particular subjects, such as other farmhouses and their settings. In 1923 BN visited Paul Nash and his wife at Dymchurch on the coast of Kent (in 1924 the Nashes visited Banks Head – it was Margaret Nash, otherwise 'Bunty', who first spoke to Winifred of Christian Science; in 1925 Ivon Hitchens was a visitor and Christopher Wood in 1928). There BN painted *1923 (Dymchurch)* [plate 21]. Nash had painted the waterfront and its sea wall in dramatic perspective with sharp forms but with mostly flat and unemphatic colours that scarcely hint at his fear-filled sense of the sea devouring the land. BN's *Dymchurch* is small and gentle, simplified in both design and colour. It is insistently horizontal, with quite unspecific forms and marks going across the foreground so that the eye steps over them to the horizontals of the sea, the horizon and then the sky. The one nearly vertical element in all this, a softly indicated breakwater, cannot disturb this horizontality and is not used to create space or recession. What space there is – the picture gives us an option of reading it as primarily flat or sensing its three-dimensionality – comes from finely judged relationships of scale and tone, here and there affected by the rough ground under it all. This is the barest and least

inflected of BN's early compositions and a conscious reconstruction of the natural scene.

In that sense, it is also the most abstract. The sea motif remains dominant, yet the painting as a whole is markedly less specific, less insistent on offering visual data related to the motif than is many a subsequent BN picture. In fact, the lower half of *Dymchurch* would not by itself suggest a seashore. In 1924 BN produced some paintings he referred to as 'abstract'. Three remain that fit the term. In discussing these paintings reference is usually made to the Cubism of Braque, for whom BN developed a particular affection, and Picasso, whose 'absolutely real', apparently abstract patch of green had been such a revelation, and to Synthetic Cubism in general. Lewison rightly adds Arp's *papiers déchirés* as another source. That seems essential since two of these three paintings, though executed in oils, have the character of *papiers collés*, as though they had been assembled from a range of small and larger pieces of paper; most of the edges in them look torn (*déchiré*) rather than cut. The result is an effect of flatness combined with insistent suggestions of space because of the apparent overlapping of pieces of paper, that is to say planes of colour. In both instances there is a general sense of vertical and horizontal controls.

*1924 (first abstract painting – Chelsea)* [plate 19] looks at first glance like ten or so pieces of paper assembled on a brown surface, with many of the pieces overlapping and some of them built up to make a salient compositional area in the upper centre. There is no hint of representation. The fact that it is all done in oil paint (with pencilled guide lines) forces one to attend to variations in the density of the colour areas and to variations also in the character of their edges, some of which suggest the paintbrush rather than torn paper. The vertical–horizontal co-ordinates also turn out to be unreliable though there is still a general sense of controlling

21

axes. The colours are non-referential. In fact, they are a surprising congruence of unlikely partners, with, for example, a firm red overlapping the large bluish pink area which abuts an odd shape in salmon pink. There are also juxtapositions that suggest tone: for example, in the way that the grey-blue shape, right of centre, darkens when it appears to lie not over the off-white area but over the bluish pink. The relatively firm white form at bottom left, almost a rectangle and with neat edges, offers some support or even impulse to the rest of the composition. Its partner painting is *1924 (trout)* [plate 20]. This too hints at collage rather than paint and suggests an, on the whole, neater arrangement of roughly rectangular elements. The striped rectangle top left is a reference to the striped jug of the '1911' painting.

The dating of these paintings has been questioned and it is not impossible that, whenever BN originally did them, he may have altered them subsequently. It is likely that they were the works he sent to the London Group that year. Founded in 1914, anti-academic and unconventional in the tendencies it represented at first, in the 1920s this association and its annual exhibitions were dominated by the benign Post-Impressionism of the Bloomsbury painters, notably Duncan Grant and Vanessa Bell, members since 1919. Ivon Hitchens persuaded BN to join in 1924, but the paintings he exhibited were attacked by the press and may have worried fellow members of the Group. Their avant-garde models, in many cases, were Cézanne and Fauvism; BN's abstracts seemed to stem from Cubism and from growths out of Cubism in some indefinable way. *1924 (trout)* was acquired by its present owner from the artist in 1929, and there is no reason to think that either painting was altered after the mid-1920s. The owner recalled that he had a particular liking for it 'because of its being purely abstract', but that BN 'denied it was abstract and insisted that the

stripes in the top left corner represented his father's striped jug'.[15] Thus the title becomes a distraction, perhaps an intentional one, and there are many other diversions in the painting itself. Its relative neatness delays our recognition that it harbours contradictions, as when changes of colour are used to suggest shadows, most obviously in the case of the shadow cast on to the stripes by the off-white shape apparently floating in front of them. Harrison considered the picture 'unresolved', because of this 'appearance of a cast shadow' and the composition's 'slightly top-heavy appearance'.[16] Both paintings have this sense of being top-heavy, or at least being fuller of incident in the upper half, and in *trout* this is very pronounced. But this effect is countered by others, such as the sense of areas of different whites advancing towards us in the lower half. If we consider both compositions as abstracted still lifes on a table this relationship of upper to lower becomes understandable. Much of BN's work, we shall see, has its area of interest and action in the upper half, as though to distinguish his art from the pull of material gravity that art learned to embody in the Renaissance.

In their flat organization – leaving aside the spatial reading set up by apparent overlaps – these two paintings are akin to *Dymchurch*. The third 'abstract' painting adopts something of the diagonal structuring found in *still life – Villa Capriccio, Castagnola* and *bread*. It is *1924 (first abstract painting – Andrew)* [plate 23]. BN mentioned this painting in a letter to Summerson as one he exhibited in April 1924 in the London Group show: 'it had some fancy naturalistic title like "Andrew", the basis of it was a flat form [BN here drew in outline an approximation to the L-shape in the centre of the painting] which seemed to me to be a kind of head form.' The reference cannot, at that date, have been to BN's and Winifred's second son, and may have been to young Andrew

**22**

*1925 (still life).*
Oil on canvas,
38 × 46 cm
Private collection

**23**

*1924 (first abstract
painting – Andrew).*
Oil and sand on
canvas, 63.5 × 76 cm
Private collection

22

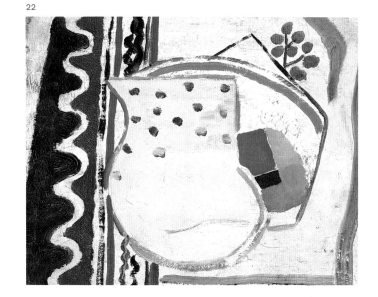

23

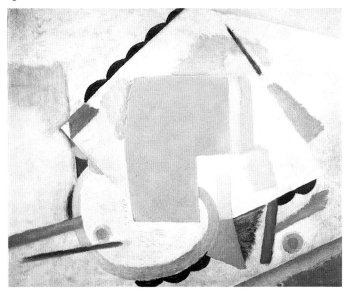

The 1920s

Warwick whose home was at the farm closest to Banks Head and whose sister, Janet, helped in the Nicholson household. The form, in yellow, seems to float in front of a composition of, for BN, an unusually loose sort. Again we may interpret it as referring to objects seen on a table and seen from above, but the objects lie higgledy-piggledy and include a variety of shapes, including a near circle and two little disks in red haloed with blue. There is more than a hint here of Kandinsky's influence, rather than Cubism's, with that almost complete diamond form behind the 'head form' in the centre, those little red spots and blue haloes, the cut-off corners top and bottom right, the soft use of brush and medium in most of the picture, and perhaps also the broad use of greyish off-white.

As well as a tendency to alter his titles over the years, BN veered this way and that in his use of the word 'abstract'. In 1929 he wanted the owner of *trout* to know what the stripes referred to. In or after 1944 he crossed out 'Trout' in Paul Nash's copy of the catalogue of BN's Leeds exhibition and substituted 'completely *abstract* ptg.', underlining the adjective twice. The hesitation BN felt in using that word in the 1920s had gone by the 1940s; between the two periods come not only his own adventure into the apparently non-referential white reliefs and related paintings, but his partnership with Barbara Hepworth and his membership of the Paris-based international association of abstract artists, Abstraction–Création, as well as London's emergence as a busy centre for abstract painting and sculpture in the 1930s. The reaction of the London critics to BN's early abstract work was largely negative, with even BN's friends having difficulties with images lacking in self-evident emotional or ideas content.[17] This in spite of Herbert Read's well-timed attempt to defend 'Abstract Art' against both Worringer's association of abstraction with a turning away from nature in

a spirit of fear, which Read's master T. E. Hulme had given currency to in English, and the notion that it was an extreme form of individualism of no social significance. The chapter 'Social Significance of Abstract Art', in Read's *Art Now*, first published in 1933, asserts this significance without quite managing to say what it might be. Where BN was concerned, it may well be that the spiritual ideas developing in his mind in the 1920s, and never entirely rejected, made him reluctant to draw a hard line between the referential and the wholly abstract, the assuredly earthly and the potentially cosmic.

Between these experimental abstract or near-abstract paintings and the non-figurative reliefs of the 1930s come years of activity pointing in the opposite direction. BN's work of the later 1920s displays his intimate regard for still-life objects and for the landscape of Cumberland and Cornwall – both shared with Winifred. His work was still essentially tentative in its diversity. In 1924, for example,[18] he painted a group of still lifes in a naïve style that owes nothing to Cubism and Modernist abstraction, nor even to the example of Cézanne except in so far as that showed how fertile the exploration of the simplest still-life composition could be. Matisse had learned that lesson, turning from elaborate domestic scenes with well-laden tables and attendant maidservants to concentrated, more or less flat and greatly simplified still lifes done between 1899 and 1906, before and during his Fauve period. These were often in striking, only partly naturalistic colours, and BN was increasingly aware of Matisse. Rousseau's painstaking delineation of forms, echoing that of the early Italians, may also have encouraged him to go for a few objects, lined up for our inspection. BN's primary motive may still have been the negative one of eradicating Edwardian luxuriousness. His art would not only be better than his father's, but would represent another generation, another world, a world of fresh and open air, of

24

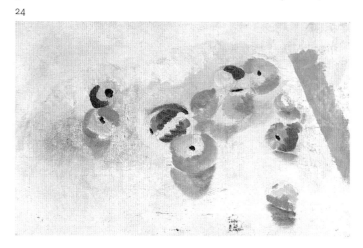

**24**
*c.1926 (apples).*
Oil and pencil on canvas, 43.9 × 67.5 cm
Kettle's Yard, University of Cambridge

**25**

*1924 (goblet and
two pears).*
Oil and pencil on
board, 37 × 44.5 cm
Kettle's Yard,
University of
Cambridge

**26**

*1926 (still life with
fruit – version 2).*
Oil on canvas,
55.2 cm × 61 cm
The British Council

light and of shining colours, of a directness and simplicity of
heart that would counter the histrionics of the past and heal
a weary world. That was Winifred's way too. She wrote later:
'To us to say that a thing was Modern was to say that it was
"good", sweeping away Victorian, Edwardian, Old Theology,
Old Tory views. In the New World there would be … clarity,
white walls, simplicity – complete and satisfying.'[19]

c.1926 (apples) [plate 24] is certainly Cézannesque in its
presentation of apples and other fruit as discrete but related
objects and also as touches of paint which assert their
presence without describing the objects completely and with
only the minimum of modelling. Yet BN's colour here is
almost wholly tonal; indeed he is more concerned to create a
sense of light coming on to the still life from behind, and thus
towards us, than to create light by means of colour alone as
was Cézanne's mature practice. This and the more or less
traditional viewpoint lead one to question the dates ascribed
to this work and to propose one two or three years earlier,
say 1923-4.[20] The 1924 still lifes seem more coherent. A good
example is *1924 (goblet and two pears)* [plate 25]. Delicate
pencil outlines remain visible because they were not followed
closely by the brush which was used to fill in the main colour
areas – artlessly, it would seem, but also in such a way that
varying densities of paint, rather than tone, produce a sense
of modelling. The colours are high in tone except for that
of the goblet, and even here there is a slightness and a
partial transparency that associate its grey with light rather
than darkness. The mouth of the goblet, though drawn in,
is obscured by a local haze of white. Only the left edge of
the goblet and the stalks of the pears are done with anything
approaching a firm touch. Much the same gentleness
and transparency characterize the other still lifes of 1924.
In a letter to Summerson BN spoke of wanting 'at some
point in the Lugano period … to paint *simply a cup & saucer*

25

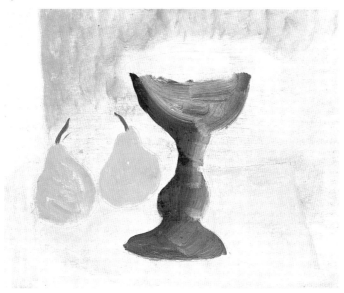

26

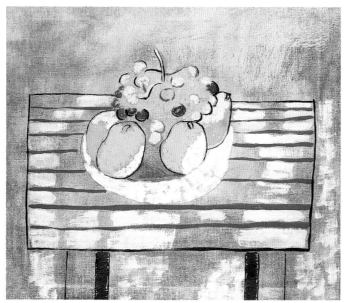

The 1920s

(i.e. a white cup and saucer)', and added: 'also about then I did a series of goblets … and I remember saying to Laura Riding [the American poet, for many years Graves's partner after his marriage to Nancy ended] that I painted a goblet because it was the object with the simplest form and that after many years work one could perhaps take the next step – a mug – the addition of a handle being a big event'.[21]

There are landscapes painted with much the same delicacy and an even greater reluctance to strike a firm colour chord, such as 1925 (Banks Head, looking east) [plate 27]. In spite of the buildings indicated on the left – outbuildings later developed by BN as a picture store and studio but then used mainly for table-tennis – there is little feeling of spatial recession in the picture. The colours are few and recall Cézanne in the use of polarities, one pole warm yellow, the other cool grey. But Cézanne's hues are stronger. Again BN is going for luminosity by absorbing as little light as possible and letting the whole surface glow. Everything is soft, with much the same touches suggesting trees in the distance and fencing in the foreground. Blotches of paint substitute for delineation; there are no sharp forms and even the pencil marks, mostly in the middle distance, are gentle and indistinct. The painting presents an evanescent vision, with the landscape fading noticeably towards the edges of the canvas. The same blotchy use of paint and much the same use of colour and tone are found in 1925-6 (snowscape) [plate 28], but here the landscape does not fade so markedly towards the edges.

There is nothing here of the potent reality he had admired in Picasso's patch of green. These paintings suggest a lyrical purveying of sensations of light and space, Impressionist only in the vaguest way and belonging rather to the long history of naturalistic oil sketches of nature and showing an attachment to the English watercolour tradition. Other paintings of about the same time counter this tendency with much firmer outlines and detailing and with a more assertively Modernist idiom related to Cubism. 1925 (still life with jug, mugs, cup and goblet) [plate 31] presents its objects flatly, on a table top which recedes if we focus on its white lower edge but rises steeply, almost flatly, if we focus on the objects. They are drawn quite firmly and filled in, with details of their ornamentation carefully recorded and shapes as well as visual textures entertaining our eyes. The general disposition is not unlike that of 1924 (first abstract painting – Chelsea). A more specific connection is suggested by 1926 (still life with fruit – version 2) [plate 26].[22] BN's admiration for Braque was already established; in the 1930s they were to become close friends. The 1926 still life is indebted to Braque's pictures of the early 1920s, in several of which the structural and disruptive methods of Analytical Cubism and the more decorative flattening mode of Synthetic Cubism are modified to produce paintings in which descriptive line and colour coexist with the shallowest of spaces and a wholly traditional centring of the composition. The horizontal stripes of BN's table both suggest recession and deny it, while the bowl of fruit is seen in a generalized perspective moderated by the flattening outlines and the blotchy painting, especially the dabs of white. There is no modelling, though the emphatic vertical bands of black below the table top ask to be read as the shadowed sides of the table legs, lit in contrary directions.

A more or less exact date can be given to 1927 (Winifred and Jake) [plate 29], a portrait of BN's wife and the child she had longed for and had almost lost. Some time after their marriage, Winifred was told by a gynaecologist that she would never be able to have a child: operations she had undergone in girlhood had settled that. The fact, she wrote, 'gave us time to work out our profession as painters and to

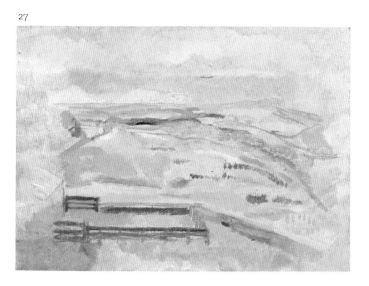

27

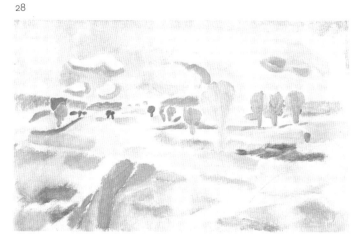

28

study the dawnings of Christian Science'. Then, in 1927, she discovered she was pregnant; she was delighted and the gynaecologist said it was 'nice to see a miracle'. All went well until, six or more months later, she was helping to hang a show of work by herself, BN, Christopher Wood and William Staite Murray (a potter) at the Beaux Arts Gallery in London, stepped back to consider the look of a wall and fell through an open trap door on to the concrete floor below. She woke up in hospital. BN was there, reading, she recalled, the 23rd Psalm ('Yea, though I walk through the valley of the shadow of death, I will fear no evil'). He told her later that he had telephoned a Christian Science practitioner, that is, someone trained in healing. Her back was broken. There was doubt whether she would ever walk again; that she would lose her baby looked certain. She healed with amazing ease and speed, was sent home after five days, and two months later had her first child, Jake, 'a strong and sturdy boy'. In the painting he looks four to six months old, and it should probably be dated 1928.

Lewison points out that BN 'appears to have executed paintings and drawings with figures on occasions of change in his family life'. He made several sketches of mother and baby about this time. The square canvas perhaps enhances the sense of a Madonna and Child icon; iconic too is the emphasis on the eyes. Generally, soft painting is here balanced against crisp detail, and soft tints against colour accents, in a way that is characteristic of BN's work in the late 1920s. Relatively firm pencil lines suggest that BN planned to show mother and child against a window. Other, gentler lines indicate the major forms of Winifred's face and Jake's head and body, while substantial portions of the canvas are left bare. This is the last of BN's more or less naturalistic portraits, and it could hardly offer a greater contrast to William's. When he returns to the subject five

**27**
*1925 (Banks Head,*
*looking east).*
Oil on canvas,
54 × 74 cm
Private collection

**28**
*1925-6 (snowscape).*
Oil on canvas,
49.5 × 78.4 cm
Kettle's Yard,
University of
Cambridge

**29**
*1927 (Winifred*
*and Jake).*
Oil on canvas,
68 × 69 cm
Private collection

29

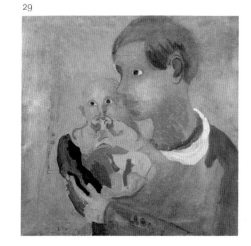

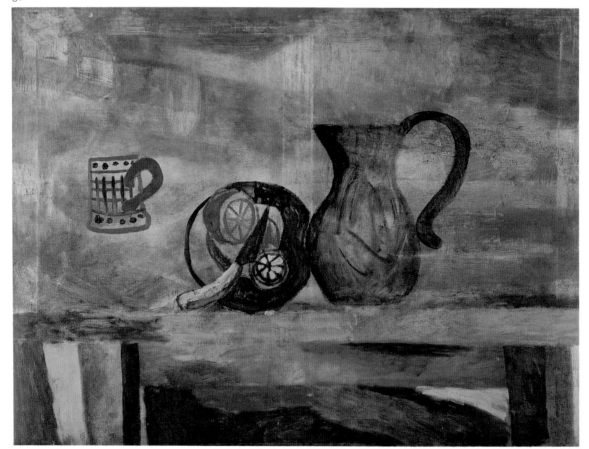

**30**
*1927, May (still life
with knife and lemon).*
Oil on canvas,
91.5 × 122 cm
Kettle's Yard,
University of
Cambridge

**31**
*1925 (still life with jug,
mugs, cup and goblet).*
Oil and pencil on
canvas, 60 × 60 cm
Private collection

The 1920s

/>

The 1920s

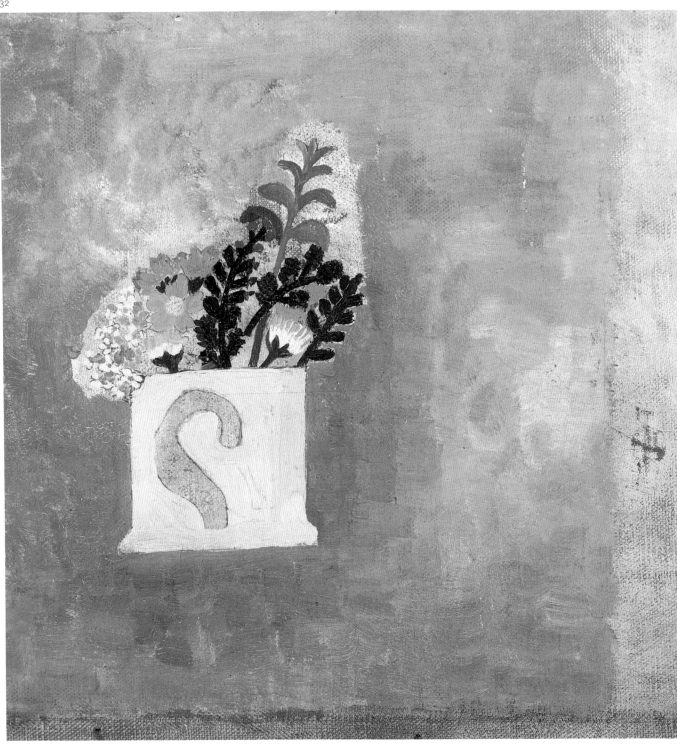

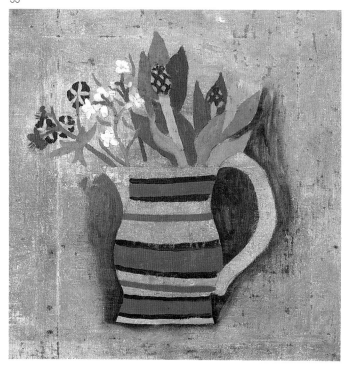

**32**
*1927 (flowers)*.
Oil and pencil on
canvas, 38 × 36.8 cm
Private collection

**33**
*1928 (striped jug
and flowers)*.
Oil on canvas,
38 × 37 cm
Private collection

years later it is by very different means. Much later, BN wrote to Winifred in rather negative terms about this painting, looking at a photograph of it: it is not '*complete*', he wrote, and it 'has some sentimentality, which I don't like at all'. She replied that she found it neither sentimental nor like her or Jake, but she was interested in 'the theme of 2 heads or shall we say 2 circles'.[23]

About the same time BN painted one of his flower pieces – a subject dear to Winifred but rare in his *oeuvre*. *1927 (flowers)* [plate 32] is a piece of adroitly managed primitivism. The white mug hovers before a soft grey background. Its handle is outlined and shown flat against the mug. Out of it rises a handful of wild flowers, possibly presented in this guise to the new mother. They are painted without much apparent skill or calculation and enchant the eye with their simplicity. At some later date BN restretched the almost square canvas, making it squarer as well as larger in the process, and revealing a vertical margin of off-white on the right and at the bottom a horizontal margin of coarse brown canvas, including the holes through which nails had been

driven. Both now contribute to the picture's visual strength by enhancing its luminosity. Another flower piece, of much the same size and shape but with a sizeable jug and larger flowers, followed soon after. *1928 (striped jug and flowers)* [plate 33] is a darker, more sonorous picture but has the same air of naïvety. Jake Nicholson has pointed out that in BN's pictures of flowers 'the jug is always more important than the flowers'.[24] The jug and the mug were familiar companions; the flowers were transient visitors, but there is no doubting BN's pleasure in them.

This more radical primitivism was encouraged by a new friendship. Winifred and BN met Christopher Wood (1901-30) in July 1926 and took to him at once. BN was then chairman of the Seven and Five Society. This London association of artists was founded in 1919. Ivon Hitchens had joined it in 1920 and brought BN into it in 1924, Winifred in 1925. Becoming chairman in 1926, BN was eager to make the Society more avant-garde, and Wood was one of the first new members proposed by the Nicholsons.[25] He visited them at Banks Head in March 1928. That August to October the

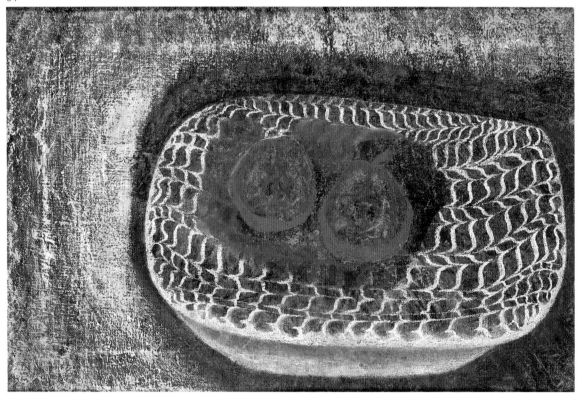

**34**
*1929 (pomegranate).*
Oil and gesso on
canvas, 40.5 × 60.5 cm
Private collection

**35**
*1929 (still life
with green jug).*
Oil and pencil on
board, 45.7 × 54.5 cm
Private collection

three of them were in Cornwall painting landscapes, often side by side. BN had recently got to know Marcus Brumwell, the creator and head of the Stuart Advertising Agency. The Nicholsons at this time had a home in Dulwich, and BN met Brumwell through the local tennis club. Marcus and Irene Brumwell invited them to stay in Feock; Wood came down as well but stayed separately. He too was seeking a form of simplicity. He had gone to Paris at the age of twenty, and had rapidly become something of a pet in that glittering world on account of his combination of talent and charm. He had early concluded that Modernism involved a return to innocence. In 1922 he wrote to his mother:

Dearest Mother, do you know that all the great modern painters who we may not quite understand through their pictures, are not trying to see things and paint them through the eyes and experience of a man of forty or fifty or whatever they may be, but rather through the eyes of the smallest child who sees nothing but those things which would strike him as being the most important. To the childish drawing they add the beauty and refinement of their own experience. This is the explanation of modern painting.[26]

Thus he had taken a view of what art should do that was close to the Nicholsons', but without their base in a belief that the world could be renewed by means of spiritualization and clarification and that art could contribute to this evolution.

Wood's base was in the contemporary work of Paris which he knew better than any British artist of the day, being close to the Diaghilev–Cocteau–Picasso circle and thoroughly informed of all the new art that was being seen and talked about, from Post-Impressionism to Fauvism and Cubism and to the primitive classicism that was Picasso's chief mode in the early 1920s. Aware of the sophisticated methods and multiple sources of French painting, he opted for a relatively direct recording of his subjects, often landscapes, with or without figures and landscape-related activities. For this he depended on memory more than on immediate transcription, and on humour as well as a keen eye for effectively mastered and popularized forms.

The interaction of these three spirited artists was complex and is not easily analysed, owing partly to the insecure dating

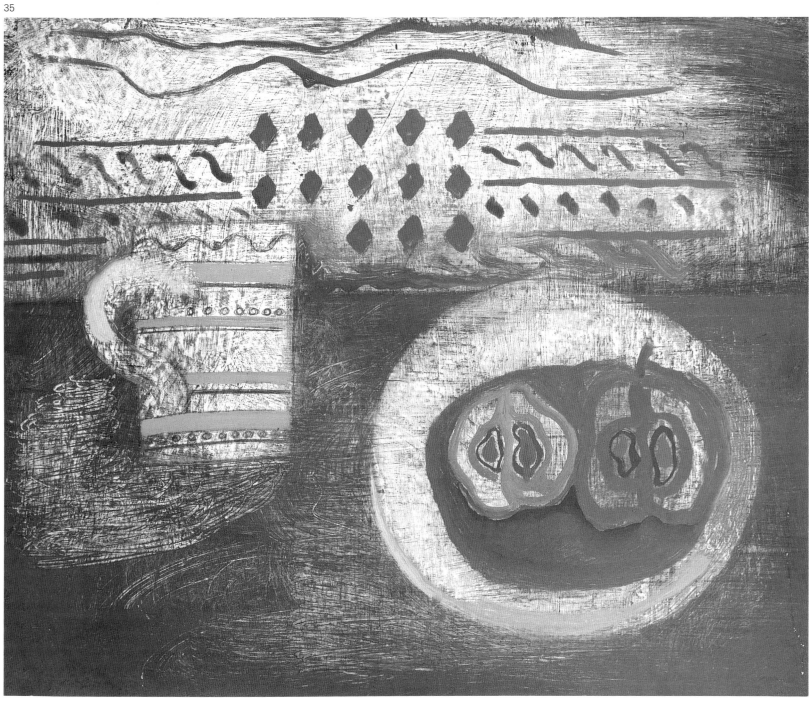

The 1920s

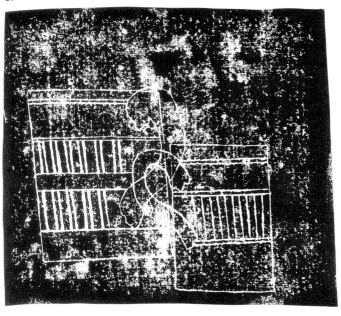

**36**
*c.1928 (mug and jug).*
Pencil on paper,
34.2 × 42 cm
Private collection

**37**
*c.1928 (two mugs).*
Linocut, 17 × 19 cm
Kettle's Yard,
University of
Cambridge

of many of their works. The following may be a fair summary of the contribution of each of them. Winifred Nicholson was secure in her pictorial idiom in which bright colours and an unguarded, spontaneous use of the brush made for light and life. Her landscapes are summary but rich with space suggested more by the forms of land and sky than by perspective or the diminishing scale of things. 'Kit' Wood brought up-to-date information about art in Paris and its many styles and methods. During the earlier years of the friendship, his landscapes were more traditionally descriptive and thinly painted, and rooted in tonal relationships rather than relationships of colour. After 1928 they tend to be less detailed and more inventive in the selection and simplification processes they depended on. Here BN's influence was important – Wood used to say to Winifred about his own latest work that BN would probably tell him he should have left more out – and it was quite dramatically reinforced by the example of Alfred Wallis. They discovered the truly primitive paintings of this ex-seafarer and ex-ship's chandler in 1928 when they glimpsed them through a St Ives

doorway. They admired them and encouraged Wallis, who was seventy-three and had only recently taken up painting, 'for company', after the death of his wife. They bought work from him, as did their friends, and helped him with gifts of paint. BN's painting of landscapes developed from the gently lyrical style of about 1925 to an almost childlike language in which disparate usages come together to give results that seem at once humorous and romantic. Wallis's example gave encouragement but came too late to have pointed the way. The only aspect of Wallis's painting that influenced BN significantly was his use of odd-shaped supports, found pieces of wood and cardboard and bits he cut or tore from cardboard boxes. BN enjoyed their spontaneous look and the way Wallis's compositions and colours responded to them, as well as their unambiguous presence as made objects, as opposed to illusionistic scenes inviting us to suspend our disbelief [plate 61]. For Wallis, his paintings were factual accounts of their subjects, informed by his experience of sea, ships and Cornwall and taken from his intense recall of places and events.

The 1920s

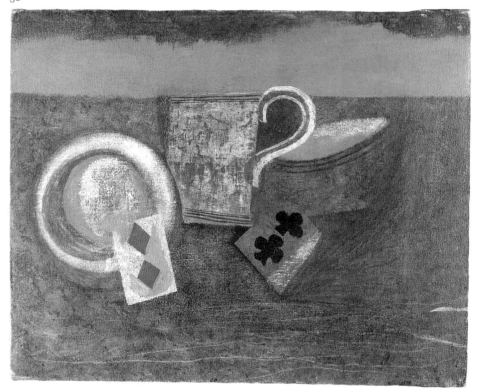

*1930 (still life – jug
and playing cards).*
Oil on canvas,
61.5 × 76.7 cm
Private collection

**39**

*1930 (still life with jug).*
Oil and pencil on
board, 34.8 × 43.4 cm
Private collection

BN's use of a rough-edged, scruffy piece of board for *1930 (still life with jug)* [plate 39] is certainly in emulation of Wallis's *ad hoc* response to found supports. Later BN was to make frequent use of non-rectangular formats, mostly creating his own by trimming pieces of paper and by cutting copper sheet into odd shapes before preparing etchings on them. But here he uses the board as he found it. It is an aged thing; it has lived and suffered. BN enhances that aspect of it by giving an antique effect to the paint he puts on it. And then he seems to use it as a tablet, apparently laying on it a smaller sheet of paper on which he shows the still-life group. This is both hard and soft; sharp lines and firm red go with a grainy surface and soft tonal effects, so that the objects appear both quite flat and unusually three-dimensional according to what we attend to. A dark form behind them, a sort of shadow, lifts them towards us and at the same time implies space behind them. BN leaves it incomplete, following an instinct which has nothing to do with representational logic and everything with pictorial value. There is a shadow too along the top edge of this inner area,

put in in pencil only. The outer area suggests, on the right, that the board is or was patterned with red diamonds; we see them clearly on the right, like part of a playing card, and pencil lines suggest that the diamonds continued, or will one day continue, behind the illusionary sheet of paper. On the left another kind of pattern rules, its stripes echoing the stripes on the mug. There is no way we can reconcile the two patterns. The whole work is at once quite simple and a rich visual and mental experience, with just a few colours and tones – black, Indian red and a range of off-whites and creams, and some grey rubbed into them here and there – adding up to a sumptuous image.

There is a heraldic quality about this still life which we find also in other BN still lifes of around 1930. In this one the picture is presented as though collaged on to a board. What suggestions of three-dimensionality and of space there are, are symbolic rather than illusionistic. Flatness prevails. Some still lifes of 1929 seem to make approaches to this non-naturalistic mode. The objects distributed over the table top in *1929 (still life with jugs and mugs)* [plate 40] exist in a

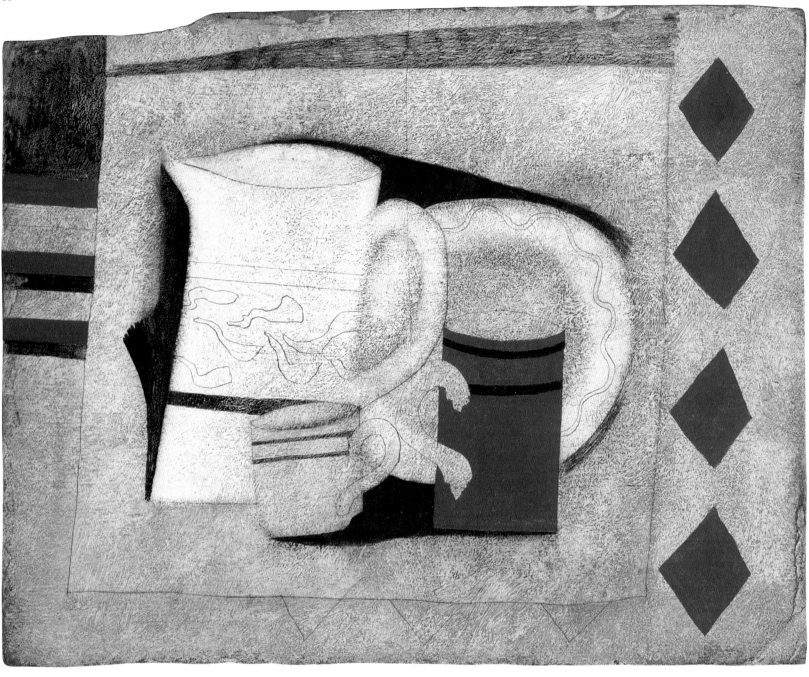

The 1920s

**40**

*1929 (still life with
jugs and mugs).*
Oil and pencil on
canvas, 38 × 56 cm
Private collection

spatial limbo that gives them no support and thus denies
their physical reality. A two-tone shadow looms behind the
larger jug but that too is left unexplained while the jug on the
right has its own halo of shadow. The individual objects
emerge out of the gentle tonality of the picture thanks to
their colour and patterns and thanks to the way they overlap
or touch; there is nothing else in the picture for them to
relate to. In the larger contemporary painting *1929 (still life –
jug and playing cards)* [plate 41] the named objects and
others are distributed rather gingerly over the table top that
faces us as a vertical surface. There is a hint of shadow
along its right edge and down the right table leg. Above the
table a stream of brown brushstrokes flows towards the
upper left edge of the picture, a little like one of Cézanne's
skirting boards, shaped and placed to minimize whatever
space an interior with a table and still life might suggest. The
painting is almost monochrome – more so even than *1928
(Pill Creek)* [plate 45] – and it is painted thinly, transparently.
Even the playing cards are treated as ghostly emanations.

 In *1930 (still life with jug and mugs)* [plate 42] the heraldic

mode has become dominant. The whole picture may be
thought to be the table top in this case. This works for the
plate and mug shown in the lower half but it does not explain
the shadow that falls to the left of the mug and on to the
plate. There is mystery too in the way the plate may be said
to be lying on the table while the mug next to it appears to
be standing in front of the table's vertical plane. At any rate,
they share a background, whatever we read it as. The other
two objects above, jug and mug, have their own grounds. The
mug is a bouncy little thing and it is seen against a partly red
background on a white patch; the jug, much less assertive, is
pale grey on a pale grey ground. That we see it at all is due
more to its pencil outlining and shadowing than to the very
slight changes of tone and colour we can observe in it. The
four objects are distributed over the surface almost equally,
making it a four-part display more than a unified composition.
Yet BN characteristically does not quite leave it at that. The
pale but handsome mug bottom right is made to overlap the
pale grey patch containing the jug top left. This gives a sense
of both contact and separation at that point, and we are told

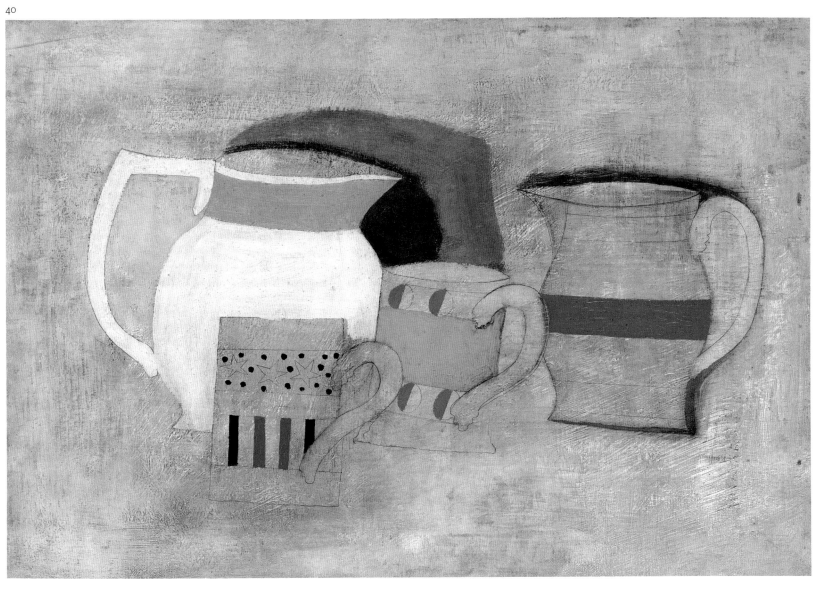

The 1920s

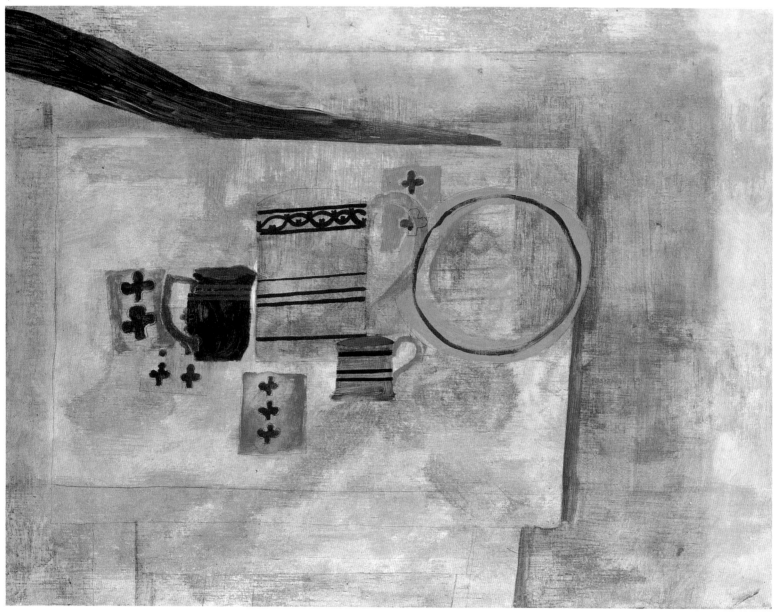

The 1920s

**41**

*1929 (still life – jug and playing cards).*
Oil and pencil on
canvas, 68.5 × 87 cm
Ivor Braka Ltd

**42**

*1930 (still life with jug and mugs).*
Oil and pencil on
board, 37.8 × 44.5 cm
Private collection

**43**
*c.1931 (fireworks).*
Oil and pencil on
board, 24 × 33 cm
Private collection

**44**
*1929 (fireworks).*
Oil and pencil on
board, 30 × 46 cm
Pier Arts Centre,
Stromness, Orkney

The 1920s

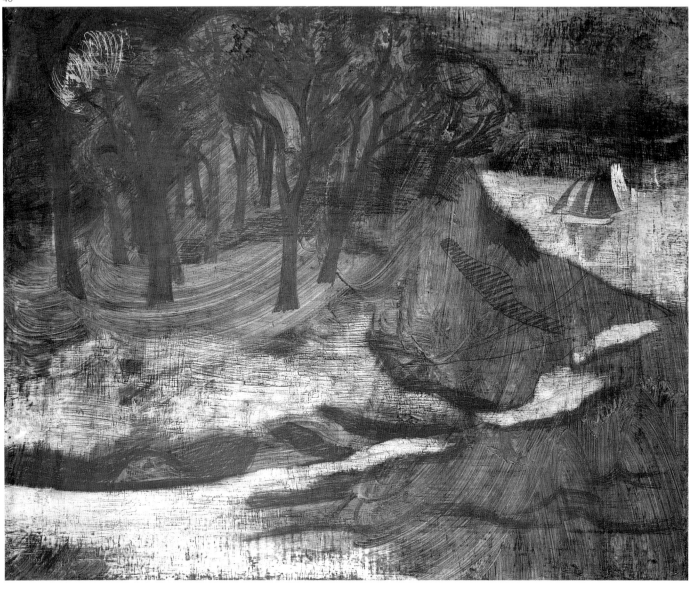

The 1920s

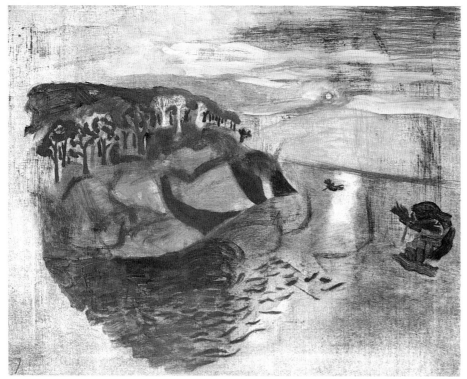

**45**
*1928 (Pill Creek).*
Oil and pencil on
canvas, 48.2 × 60.9 cm
Private collection

**46**
*1928 (Pill Creek,
moonlight).*
Oil, pencil and gesso
on canvas,
49.5 × 61 cm
Private collection

that the mug is a little way in front of that patch. Both patches could be seen as on a wall behind as well as above the lower objects, yet all these readings are short-lived and cancelled out by others. We are left with an impression of delicacy combined with humour, and in some doubt how to cope with the problem of the four distinct modes in which BN has pictured those four familiar and ordinary objects.

The BN landscapes ascribed to 1928 show a wide stylistic range that could suggest a longer period of development but of course need not do so. It would be helpful if artistic developments always occurred in one direction and at a steady pace. In tracing a development, as here, we are always in danger of imposing neatness where the possibilities open to the artist were many, and thus of burdening him or her with a straiter mind and spirit than may have been the case. Where we can rely on firm dates we accept and perhaps welcome a painter's adventurousness, and there will certainly be occasion later to draw attention to BN's ability to break off a stylistic sequence in order to start a new one, or to make excursions into another mode in – as

it would seem to us – the middle of a definite phase. Yet discussing these works in any detail requires some sense of chronology and sequence.

*1928 (Pill Creek)* [plate 45] is an unusually dark and romantic work. The subject is Feock, on the south coast of Cornwall, where the Nicholsons stayed from August into October. *1928 (Pill Creek, moonlight)* [plate 46], similar in many ways and the same size, is actually lighter in tone but may be unfinished: BN may have intended to make more of the light–dark contrast moonlight would imply. So *1928 (Pill Creek)* may also be a night scene. The colours here are mainly brown against off-white, with hints of blue-grey for an exceptionally small area of sky. They are put in over a gesso ground. This gives a texture to the whole surface, over which sweeps of the brush lay down a brown tint except where the off-white priming is to show, and there are places where BN has scratched through his painted surface to reveal the white gesso below, most noticeably in the foliage area top left and to silhouette the grey sail against white, upper right. Also very striking in this painting is the prominent use of pencil.

The main forms were outlined in pencil and these lines are left visible in places. But pencil has also been used to add darkness in several places; a patch of bold shading, in the brown slope some way below the boat, suggests that BN was considering painting in a dark form there. The trees are put in almost entirely with the pencil. BN had used pencil marks prominently in *Cortivallo, Lugano* [plate 18]. Here the pencil contributes even more powerfully to the final appearance of the picture.

This raises the question of finish, already signalled in work such as *Cortivallo, Lugano*. I have suggested that *Pill Creek, moonlight* may have been left unfinished yet allowed to escape destruction. Parts of the picture are so unresolved as to make one doubt they were meant to stay that way. BN was liable to rework pictures after he had thought them finished, sometimes long after the event, even after exhibition and purchase. Unfinished work by him is very rare. We should generally assume that artists leave a work the way they want it to be, though of course they can change their minds. This principle is particularly important in BN's

case since he sought freedom and never ceased trying new methods in support of new ideas. Consistency is not to be expected from him, especially not in this early, often experimental phase.

*1928 (Porthmeor Beach, St Ives)* [plate 47], though another Cornish subject done about the same time, is thoroughly different from the two *Pill Creek* paintings. Now the colours and tones are pale, and the composition is centreless, its few accented forms being distributed around the central area. These are: a sailing ship, a little rocky island with a lighthouse and an adjacent headland in the top half; a horse or donkey and an archway in the bottom half. That archway, or rather its reveal, picked out as a strong shadow in a picture which has only a generalized sense of misty daylight and no other shadows, makes a powerful shape. It suggests italic lettering or some other calligraphic process, starting as a broad stroke and curving to end in a fine point. The placing of a few neat forms among more generalized ones is a BN habit belonging to those years. That calligraphic form will be echoed in later works, including the

The 1920s

**48**
*1928 (Cumberland
landscape).*
Pencil on paper,
34.× 42.5 cm
Private collection

**49**
*1928 (foothills,
Cumberland).*
Oil on canvas,
55.9 × 68.6 cm
Tate Gallery, London

very last. *Porthmeor Beach, St Ives* recalls BN's Cumberland landscapes of around 1925 in its gentle tonality, and seems to press even further into a realm of visions and dreams rather than remain in the world of description.

But that summer was to find BN attempting yet other styles in his pursuit of landscape. *1928 (foothills, Cumberland)* [plate 49] has something of *Pill Creek*'s concentration on brown and off-white with a little blue-grey. Its trees are more primitive than *Pill Creek*'s: a trunk for each one, and a few spreading branches in heavy, unvariegated brushstrokes that ignore any tendency of the branches to develop in three dimensions, not two. The foreground is empty, as in some of Winifred's landscapes, so that our eye moves at once into the middle distance where areas of off-white yield some brightness and the trees offer us something to examine, and then to the horizon where glimpses of brightness come forward from under a brown sky. Its relatively dark tonality may show the influence of Wood, and perhaps this landscape was painted when he was staying at Banks Head; its broad treatment of landscape forms and space may owe something

to Winifred. Jake Nicholson made the general point to me that Christopher Wood's landscapes imply an artist looking downwards, towards and into the earth, so that they strike one as solid, while BN's are generally the work of an artist looking up and along, into space and along the horizon and up into the sky.[27] Even in this relatively sombre work the horizon is a generous sweep across the picture and brings a vivid sense of light beyond and above.

*1928 (Walton Wood cottage, no. 1)* [plate 50] seems much more self-evidently a work by BN. He knew the house well since his sister Nancy was staying there after separating from Robert Graves. The painting has trees right and left on the model of *foothills, Cumberland*, but also softer, rounder trees in the middle and a reclining horse guarding a rectangular sanctum, a walled garden perhaps, on the edge of which stands a silver-grey house. In reality the cottage stands enclosed in a wood and is without views; BN has cleared the surroundings to let air, light and space surround his version of it. Partly because of this, and partly because of the invented horse, whose red colour is picked up by a red

The 1920s

**50**
*1928 (Walton Wood cottage, no.1).*
Oil on canvas,
56 × 61 cm
Scottish National
Gallery of Modern Art,
Edinburgh

**51**
*1929 (Holmhead, Cumberland).*
Oil and pencil on
canvas, 50.8 × 76.2 cm
Private collection

touch near the right edge of the picture (a flower?), and because of that geometrical enclosure, almost a table top, this painting exhibits particularly well BN's ability to play with the sweetness as well as the singularity of the visible world, in reality and in his adjusted presentation of it. There is no sky to speak of here, nor any hint of rising hills to occupy its place: the pale green of the enclosure plays the sky's role in this instance, being the most luminous part of the picture. Beyond the house there is a general sense of space and light echoing the off-white of the ground closer to us and of the house itself.

BN's ambivalent ways with landscape appear to have continued into 1930; then anything we can with certainty call landscape disappears from his output for some time. *1929 (Holmhead, Cumberland)* [plate 51] has much of the charm and luminosity of *Walton Wood cottage, no. 1*, and here too the sky is neither obscured nor made anything of above the nearby roofs and the distant hills. In this landscape a horse and BN's profile trees perform a dance against a mostly off-white and pale grey background that reveals itself as a line

of two- and one-storey farm buildings. As against this, *1929 (Kingwater Valley, Cumberland)* [plate 52] exhibits the summary command of the shapes of landscape and the space they exist in that we associate with Winifred, and the suave interrelated tones that are probably Wood's, but the grey and white buildings dotted about here, shining and crisp in that soft and softly lit context, illustrate again BN's love of sharp accents in a tender setting. Here too he may be indebted to Winifred. At any rate, her painting *The Swaites*, dated 1923, makes similar use of the shapes and painted brightness of buildings amid nature's forms and tones. It should be said also that this contrast is characteristic of Cumberland. On the other hand, BN's landscapes are generally more structured than Winifred's, without any loss of lyricism.

*Birch Craig summer* [plate 55] is undated but clearly belongs to the end of the 1920s – perhaps between *1928 (landscape with haystacks)* and *1930 (Birch Craig winter)*. The way the low, straggly farm buildings are drawn and painted recalls *Kingwater Valley*. Its trees and other details

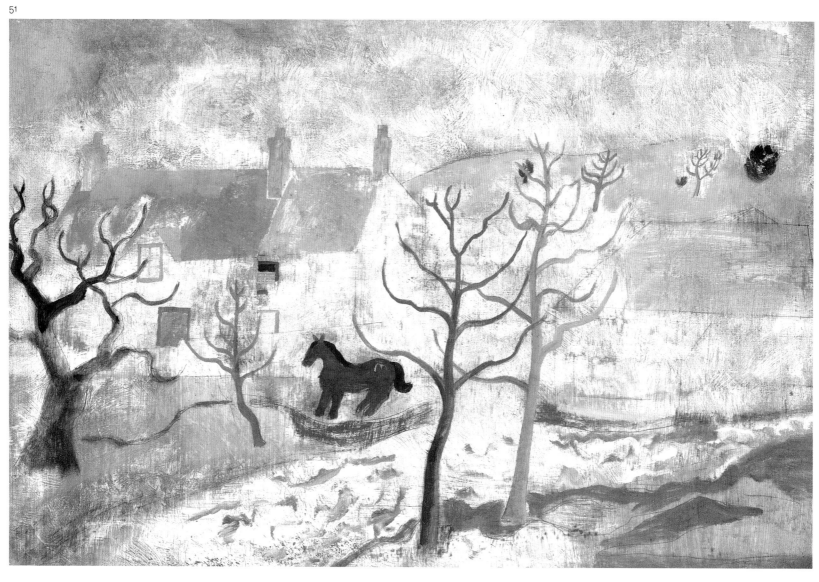

The 1920s

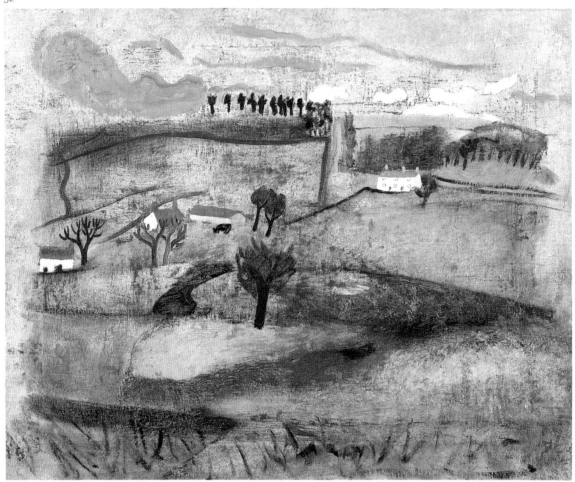

**52**
*1929 (Kingwater Valley,
Cumberland).*
Oil on canvas,
56.5 × 68.5 cm
Private collection

**53**
*1928 (landscape
with haystacks).*
Oil and pencil on
canvas,
51.5 × 57 cm
Private collection

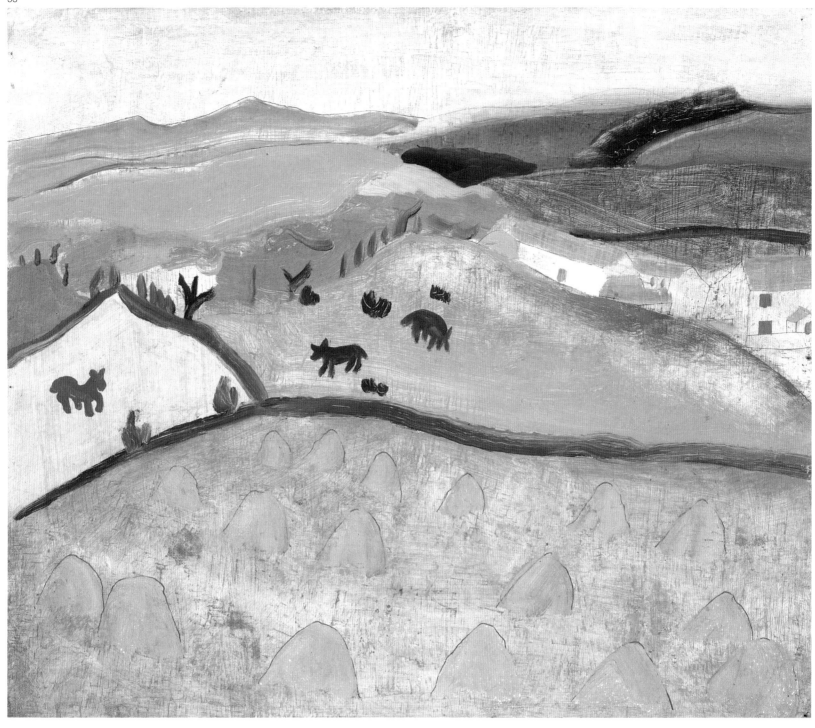

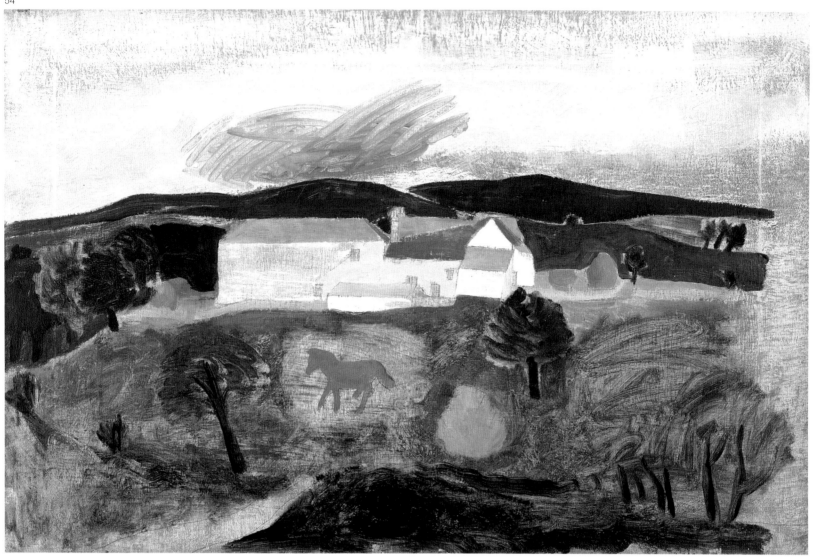

The 1920s

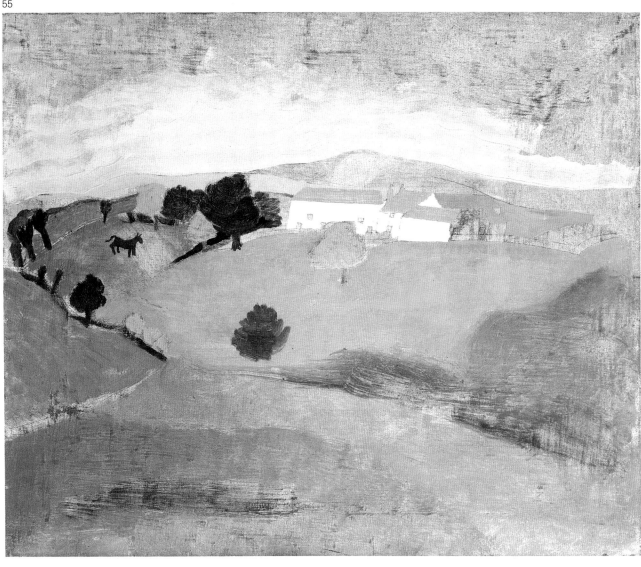

**54**
*1930 (Birch
Craig winter)*.
Oil on canvas,
61 × 92 cm
Private collection

**55**
*c.1930 (Birch
Craig summer)*.
Oil on canvas,
51 × 61 cm
Private collection

are close to those of *1930 (Villandry)*, discussed below. An unusual feature is the way BN deals with the frontier where land meets sky. In various parts of *Birch Craig summer* we get glimpses of the pencil lines with which BN noted the limits of his colour areas: he has used a thin white to confirm and in places to override the skyline. Further up the picture the sky area is hardly touched, the canvas and the underpainting being enough to hold the surface there and relate it to the lower part of the picture. In comparison, *1928 (landscape with haystacks)* [plate 53] is more painstaking and a little less spirited for all the fun he has with the haystacks in the foreground and the horses beyond. There is only one patch of white in this picture, on just one of the farm buildings, and even this tapers off into grey, but this is compensated for by BN's exceptionally emphatic use of blue-grey (his roof colour in the other landscapes of this time) to state the line of hills in the distance. With them in place, he leaves the sky again to the underpainting.

    *1930 (Birch Craig winter)* [plate 54] is different in many ways. Perhaps the much freer use of paint and the dramatic

contrasts between light and dark areas in it were suggested by winter weather. It is one of BN's largest landscapes of the period and – in a sequence of essentially lyrical pictures – one of the most dramatic. Among the stormy brushstrokes of the sky, the dark brown hills and the loose painting of the foreground, the cluster of grey and white buildings calmly occupies the centre of the composition like a still life. It has the lightest tones in the picture, more gently imitated in a sky of near-white and wispy brown, as well as the brightest colours. The white and off-white of the walls is accompanied by various greys in the slate roofs and then by an unexplained flood of mid- to light blue that washes around the farmyard like a picture-book ocean. Closer to us are softly indicated trees and a central horse, a clean silhouette enhanced, almost to saintly status, by a nimbus of pale, translucent ochre – actually nothing more special than the priming given to the canvas, yet effective as an unexplained patch of soft luminosity. Pencil marks lend precision in several places. They are more prominent in *1930 (Villandry)* [plate 57]. This could be another Cumberland landscape –

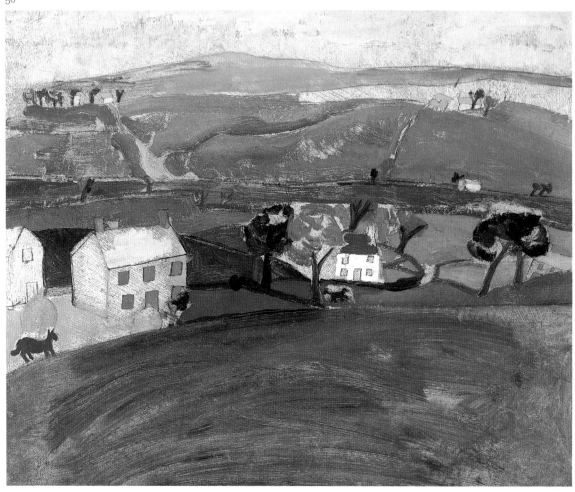

**56**
*1928 (Cumberland).*
Oil and pencil on
board, 45.6 × 54.5 cm
Setagaya Art Museum,
Tokyo

**57**
*1930 (Villandry).*
Oil and pencil on
board, 33 × 45.7 cm
Private collection

a cluster of farm buildings, a few trees and a horse – yet the name refers us to a village ten miles or so from Tours in France and famous for its early Renaissance château. Perhaps it represents a mingling of Cumberland and Indre-et-Loire. Was it done in part from long-ago memory or from drawings done when staying in Tours in 1911-12, or did he visit the area that year? He was certainly in Paris in 1930, sharing with Wood an exhibition at the Galerie Georges Bernheim, at his friend's suggestion. Perhaps he took Wood a little way south to revisit a place he had fond recollections of. But there is little in the picture to warn us that we are far from home. The chief pointer is the absence of the slate we see on his Cumberland houses. Here the roofs appear to be tiled. At any rate there are hints of brown, and these reveal how firmly BN has scrubbed or even scraped the surface of his painting, reducing contrast as much as adding textural interest. That done, he clearly stressed the presence of some areas of paint: the horse most evidently, and the rectangles of pale blue and of red that vivify the buildings, the yellow path leading to them and the khaki field to its right. The deep

turquoise that silhouettes the buildings and separates them from the distant hills and the sky was also reinstated over the rubbed texture; perhaps it represents the river Cher. Whites and off-whites in the sky echo the colours of the buildings, so that the upper half of the painting would be predominantly pale but for the turquoise stream; the lower half is mainly warm colours but for some dark bluish touches in the foreground, less luminous echoes of the turquoise.

There are very substantial differences between some of these landscapes though they appear to have been done in a period of only three years. There are wide differences too between the still lifes of these same years, especially if we include in this category an exceptionally fine combination of still life with an outdoor scene beyond a window – a subject dear to Winifred and to be endlessly important to BN, which here makes its first decisive appearance. The landscapes accept the tradition of pictorial space as receding behind the picture surface, though of course BN manipulated that space by means of colour and tone and his disposition of visual accents. The still lifes, on the other hand, continue his

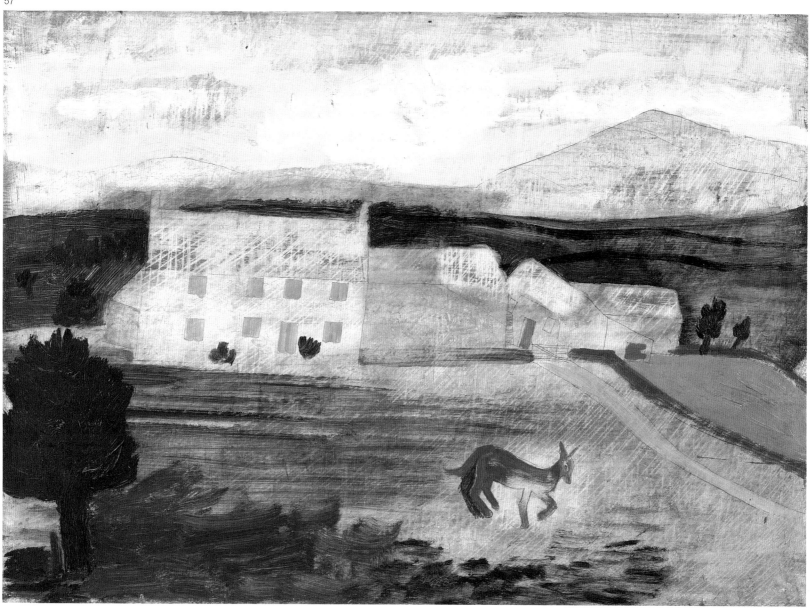

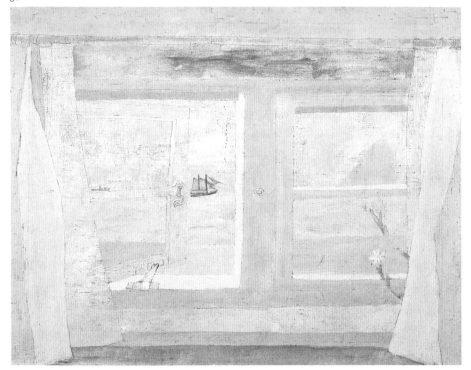

*1930 (Porthmeor window – looking out to sea).*
Oil and pencil on canvas, 64 × 87.5 cm
Private collection

**59**
*c.1928 (breakfast table, Banks Head – Villa Capriccio).*
Pencil on paper, 34.2 × 42.8 cm
British Museum, London

exploration of the more or less flat picture and also, at times, exploit the Cubist invention of appearing to place forms on the picture plane and to build up towards us from it. And while landscape painting almost inevitably refers us to the light and life of nature, so that each picture embodies impressions of a living scene, however much simplified, still lifes can have their own pictorial light and permanence and admit to being much more obviously arranged or constructed by the artist. The two genres can thus be seen as complementary, and this adds to the significance of paintings in which the two are combined.

There is another combination to be thought about. It has its precedents in the history of art: a view from a window that includes the window itself. Traditionally easel paintings have been regarded as views through a window, with the frame acting as the window; we look through it on to a scene located in a picture space made convincing by means of devices which include perspective and the adjustment of colour, tone and definition called aerial perspective. There is also a long tradition of views out of windows as part of

religious and secular paintings. In late medieval art they will have had symbolical meaning. In Romanticism symbolism was again invoked, with openings on to a second space being understood to symbolize glimpses of a world beyond our own. Matisse, among the moderns, made important use of it, probably without implying symbolical values. Delaunay had based a long sequence of *Fenêtres* on a view from his window and a postcard showing the Eiffel Tower in the distance, and some kind of symbolism was certainly involved in his Cubist visions of the Tower, a 'New World' image, from a conventional domestic setting. Boccioni had similarly represented figures on balconies and by windows with a view on to streets charged with new energies.

BN painted a number of window pictures during the years *c.*1928-31 and we may wonder whether the combination they employ, an enclosed foreground looking on to an open, expansive land- or seascape, attracted him unconsciously. There is a fine drawing, previously in the collection of one of his first great patrons, Helen Sutherland – *c.1928 (breakfast table, Banks Head – Villa Capriccio)* [plate 59] – whose main

59

**60**

*1929 (Feock).*
Oil and pencil on
canvas, 52.4 × 64.4cm
Private collection

**61**
**Alfred Wallis**
*St Ives with Godrevy
Lighthouse, c.1935.*
Oil and pencil on card,
17.1 × 95.1 cm
Private collection

subject is the table and its friendly burden of crockery and flowers. It is placed diagonally so that our eyes run easily over it and out through the open window to a tree and hills and clouds beyond. These are presented very sketchily and feel all the more visionary for it. The double reference in the subtitle is perhaps explained by the glimpse he gives us of water between the tree and the hills.

*1929 (Feock)* [plate 60] may have been developed from a drawing made a year earlier during the Nicholsons' visit: BN's detailed, unhesitating drawing in of the overhanging roof and the open window with its stays and handles suggests a direct source. Compositionally the painting could hardly be simpler. Wall, window and eaves frame the view so that it is centred on the canvas. A small dark mark beside the buoy (some inches above the boat with black sails) is in the exact centre of the canvas, and it is more than a little surprising to find, in this apparently primitive picture, that the top and bottom lines of the right half of the casement run exactly to it in accord with the rules of Renaissance perspective. This not only underlines our sense of spatial recession; it also ties the

framing foreground to that space. In other respects the image is quite flat. There is no perspective in the rafters which could have been used to point into the space, and the exterior view is brought very close. The boats come forward because of their sharp forms on a broadly represented sea, and Wallis may well have influenced BN's account of them, especially in the tilting of the two more distant ones. Also, they and the sea are painted a little more solidly than most of the rest. Much of the painting is rubbed back to the underpainting to give a transparent and grainy effect. The main exception is the spotted curtain on the left, a white apparition that greatly refreshes what would otherwise have been an almost monochrome picture. Some emanation of whiteness has also obscured the top of the fencing which, were it more noticeable. would come between us and the sea; it continues on to the sea and appears in the distance as two white clouds, the most solid touches of paint in this delicate work.

*1931 (St Ives Bay, sea with boats)* [plate 63] is another treatment of much the same subject but revealing in the

**62**
**Christopher Wood**
*Le Phare*, 1929.
Oil on canvas,
54 × 79 cm
Kettle's Yard,
University of
Cambridge

**63**
*1931 (St Ives Bay,*
*sea with boats).*
Oil and pencil on
canvas, 40.9 × 56 cm
Manchester City
Art Galleries

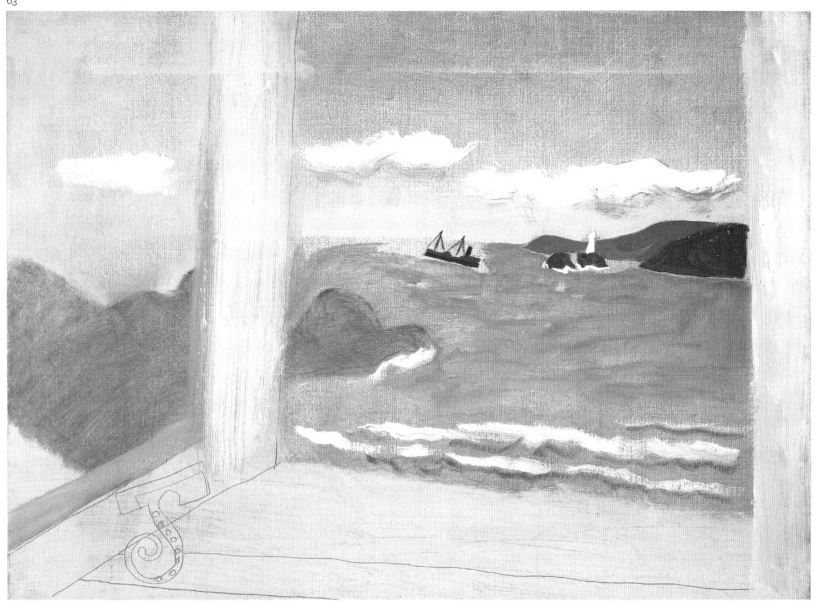

The 1920s

differences it shows. The composition is diagonal. This is
prepared in the pencil lines, still visible in many parts, and
enhanced by the way the pale grey-over-blue of the window-
sill is continued into the picture as far as the bottom corner
of the open casement. The further edge of the window frame
is brushed in so as to leave the shape of the timber vague.
This undermines its exact location in the picture space, and
on the right a curtain or wall provides another soft element.
The picture's focus is on the sea, especially the boat and
Godrevy lighthouse, not on the domestic situation, though
BN draws our attention to it with his characteristically
amused and amusing drawing of the cast-iron window-stay,
extravagantly curled and perforated. The stay is left
transparent whereas in the *Feock* painting the stays are
given their own colour as well as drawn detailing.
Here the blue of sea and sky and the white of clouds,
lighthouse and breaking waves, recalled far away,
dominate our experience of the picture.

    *1930 (Christmas night)* [plate 64] has some of the
characteristics of both. It was painted at Sutton Veny manor
house, the home of William and Edith Nicholson. BN's
combination here of an interior dominated by a still life with
a view through a window is modified by his choice of a
night scene. The view is ghostly and spaceless, an almost
flat darkness in which he has literally inscribed — in lines
scratched through the dark blue paint to reveal the light
underpainting beneath it — the forms of church, tree and an
animal (donkey, dog, wolf?). What space and reality there is
belongs to the interior, to the round table on which we see
a toilet set with BN's initials, a bowl, a comb and a dressing
table mirror in which is reflected a view of another internal
space, the landing glimpsed through a door behind us. Thus
the picture refers to space behind the picture plane and in
front of it. It may not be wholly fanciful to associate this
switching in space with switching in time. Christmas induces
in adults thoughts of times past. BN cannot ever have been
entirely at ease with his father's second marriage, and it may
be that Sutton Veny, though a very pleasant house in a
beautiful environment, produced melancholy reflections in
the younger father. He was there without Winifred. Kate had

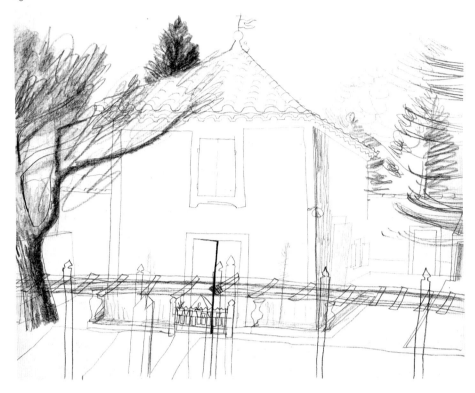

**65**
*c.1932-3 (Café Robinson, St Rémy).*
Pencil on paper,
30.5 × 38 cm
Bernard Jacobson Gallery

**66**
*1929 (Hôtel du Pavillon).*
Pencil on paper,
18 × 14 cm
Private collection

been born in 1929. In 1931 a second son, Andrew, would arrive. But where, in terms of his career as well as his artistic development, was BN in 1930, in the climacteric middle years of his life? *Christmas night* looks forward and back. It is a charming work, at first sight a comforting image of domestic warmth, and it seems relaxed in the way the artist's handwriting, most obvious in the pencil lines, neither obeys the calls of accuracy nor commands the brush as it brings colour to the loosely indicated forms. Its several blues are met by variations on a muted orangey yellow; white is countered by black. The toilet set says 'BN BN BN'; he is alone. On the landing, behind him and us, a flower painting. In front, the warm darkness and church and tree revealed in it and that ambiguous animal, sharp-eyed though quiet. The bowl on the table contains nothing but pencilled darkness. The comb bares its teeth. The painting promises conviviality but yields disquiet, above all a sense of loneliness.

If he had died in 1930, at 36, as Christopher Wood did that August aged only 29, how would we see BN now? William is considered a *petit maître*, a fine painter and printmaker of

limited range, ambition and achievement. BN could well have seemed another such, differentiated from his father by style and ideas but remembered, like him, primarily for the grace and good humour of his art. He looked towards Paris, we would say, seemed about to venture boldly into Modernism of a post-Synthetic Cubist sort, especially around 1924, but then drew in his horns and stayed with an English version of Fauvism or primitivism, a lightly poetic artist fond of line and colour and light, of friendly subjects, and of the newish principle, more apparent in some works than others, that a picture is, first and foremost, a thing of beauty and only secondly a representation. We would note his variability and associate that and his need for rural settings with his light touch: not for him the major work that comes over like a manifesto, but rather a flow of undemanding imagery, by no means conservative but aiming at a pleasing newness that makes no great demands on our taste or stamina as long as we are open to un-academic uses of line and paint. A fine, but in the end minor, visual poet equivalent, say, to Edward Thomas whose 'delicate

The 1920s

yet vigorous intuition' Walter de la Mare praised in 1920.

Winifred Nicholson might have been assessed similarly at that stage, and to some extent still is in spite of the long career as painter she enjoyed until she died, aged 88, and in spite of her move into succinct abstraction for a while in the 1930s. Observing her work up to 1930 we would note a clearer sense of purpose in what seems a more focused programme, but wonder what exactly the programme was. Not, surely, to enjoy the sight of flowers, landscape and sunshine and to deliver that in fresh, uncomplicated paintings? Perhaps we would glimpse, as Christopher Neve put it, 'things partly guessed at, sensed rather than seen', in short a habit of celebrating selected sights as intimations of immortality. 'In a way', Neve adds, 'the paintings are a question', and that question is about another world that manifests itself symbolically in things but the bridge to which is light.[28]

BN shared Winifred's transcendentalism in some measure. He witnessed the healing power of Christian Science in her miraculous recovery from a broken back

67

and safe delivery of a healthy first child. But his work of the 1920s, though it exhibits some of her admiration for light and for the colours and dynamic forms of nature, is both more rooted in the visible world than hers and less patient with representing it. Art is style, and BN, though stylish indeed, did not in the end – had the end come then – find the one style that would always be his and incorporate his priorities to the full. More rooted in the material world, he would strike us also as more footloose, brilliant in many small respects, uncertain at the core.

In 1931, not long after the birth of Andrew, BN left his family in Cumberland and went to London, presumably in order to work with more concentration, perhaps also to strengthen his place among Britain's younger painters through his presence at the centre. This was not the first temporary separation. At times Winifred had left BN working in London and gone north; at others he had left her and the children in Cumberland to come to London. This time it turned into a marriage breakdown and led to a divorce some years later. Winifred and Ben remained friends. He returned to Banks Head only to collect his personal belongings, but he did see her and the children in other places. Winifred moved to Paris in December 1932, staying first in Sèvres while she looked for a place in the city, then moving into a roomy flat overlooking the Seine on the Quai d'Auteuil. BN visited her and the children there a few days later, after the hanging and opening of his London show, and stayed nearby. 'My *first real* expression and so very very much of it is due to you', he had written to her, wishing she could see his display; 'there is a CLEAR LIGHT in several and some v. simple, living things which you have especially given me. ... I feel that light when I have found it has come especially from you.'[29] The show was at Tooth's, 9 November to 3 December, and he shared it with Barbara Hepworth.

Barbara Hepworth had first seen BN's work in 1930, in his show at the Lefevre Gallery. BN saw hers that October in an exhibition she shared with her husband, the sculptor John Skeaping, at Arthur Tooth & Sons'. Perhaps they met on one of these occasions. In the summer of 1931 Hepworth rented accommodation at a farmhouse at Happisburgh on the Norfolk coast, and invited a number of people to join her and her husband there for a working holiday. She asked Henry and Irina Moore, Ivon Hitchens, two non-artist friends Douglas and Mary Jenkins, and the Nicholsons. With a young child, a baby and another on the way, Winifred could not manage it but BN went by himself for a short stay. Skeaping arrived a week after the others, felt out of place and departed after three days, back to London where he already had a romantic attachment.[1]

Five years younger than Moore, Hepworth had been a student with him at Leeds School of Art and then also at the Royal College of Art in London where they had hesitated to let her in, only sixteen when she applied in the summer of 1920. She obtained her RCA diploma in 1924 and went to Italy for a year with a scholarship from her local authority in Yorkshire. There she met and married Skeaping, who was continuing his studies at the British School in Rome. They returned to London together at the end of 1926. In 1928 they moved to a small house with a studio and garden in Hampstead. That August they had a child, Paul, but by 1931 their marriage had broken down: 'Quite suddenly we were out of orbit … there was no ill-feeling – we fell apart,' she wrote later.[2]

Where Winifred had been strong and motherly, with some financial security stemming from her family but good at roughing it, confident in her work and in her pursuit of an other-worldly view of life, Barbara was strong but girlish, a slender creature who might have stepped out of some Pre-Raphaelite painting but who was armed with circumspect ambition. She and Ben were both first-borns. She emphasized the frugality of her upbringing, but it must also have been very secure. Her father, a civil engineer of Wakefield, 'gentle, kind and very intelligent', encouraged her to develop her talents. Driving about with him in Yorkshire, she early felt 'the sensation of moving physically over the contours of fulnesses and concavities, through hollows and over peaks'.[3] Her headmistress encouraged her to draw and to study art and then, once the girl's mind was clear, to sit for a scholarship at Leeds School of Art.

Like Moore, Hepworth gave priority to carving though instruction at Leeds and at the Royal College of Art had been in drawing and modelling. Carving had something rebellious about it, an engagement with the major historical materials of sculpture, stone and wood, and an insistence on direct personal action, without intervening processes or technicians. Skeaping's work tended to stay closer to idealized naturalism, with pleasing forms of figures and animals resulting from a benign balancing of the more harmonious aspects of nature against the mass and surface qualities of the material – in his case often bronze. He said himself later: 'I had little or no use for contemporary sculpture. … In truth, due to my teaching I mistook ingenuity and craftsmanship for art.' Hepworth's early work suggests knowledge of the sometimes primitivist work of Gaudier-Brzeska and Epstein, and demonstrates awareness of Moore's experimental exaggerations and distortions for the sake of dramatic presence. Skeaping credited her with having a strong influence on him: 'she was a great admirer of Henry Moore and all things modern,' he wrote,[4] and it seems she did her best to draw Skeaping away from the academic naturalism he had inherited from his painter father. In time he came to resent this domination, also her general disapproval

Chapter 3

# The 1930s: London

of his easy-going convivial ways when to her work, and progress in work, were everything; yet for a while they seemed marked for success professionally.

Ben, nine years older than Barbara (Skeaping was only two years older), looked remarkably like her father. Indeed, she and Ben were physically similar in some ways, with their slender figures and proud foreheads. Whereas Skeaping, though talented, was reluctant to see art as dealing with anything else than orderly representation, and in the end rejected any possibility of change in theory or practice, BN was intelligently aware of Modernism even if he had not yet found himself a definable place in it. Skeaping's autobiography makes no mention of Rodin, let alone Brancusi or Picasso, or indeed Paris as a significant centre. BN knew the Paris scene fairly well and saw modern art as a necessary, rejuvenating renaissance of an international kind.

He was also intent on taking a leading role in British art. Since 1926 he had been chairman of the Seven and Five Society. In 1931 he got the constitution of the Society altered, making it necessary for membership to be confirmed by annual votes; thus he and his friends were able to remove members whose work they considered too staid. Hepworth and Moore became members in 1932, and John Piper, then the painter of Cubism-inspired abstracts, in 1934. The Seven and Five became an avant-garde focus. That year the rules were altered to give the Society a new character altogether: only non-representational work would now be shown. 1935 saw the first British exhibition of abstract art only, put on by the Society at the Zwemmer Gallery. BN and Piper, who had become the Society's secretary, went on to plan an international abstract art exhibition, but in fact there were no further shows after 1935 and the Society came to an end.

In late 1931 BN moved in with Hepworth. She was living and working in Hampstead, in no. 7 The Mall, a spacious studio which was one of a group of eight single-storey studios behind Parkhill Road. In the spring of 1932 they visited Paris where they got to know Arp and Brancusi. Then they went south for Easter, to Avignon and to nearby Saint-Rémy. On their way home they visited Picasso in the Château Boisgeloup at Gisors, on the road from Paris to Dieppe. They were again in France in the summer, first in Dieppe for a short visit, then in Paris where they visited Calder, Miró and Giacometti. In January 1933 BN was in Paris without Hepworth and visited Braque. He was very taken with him, writing to Hepworth: 'he is a dear person – a big & simple person whom one is very fond of – a most beautiful thought'; he understands 'so simply and immediately'. That April and again in September BN and Hepworth were in Dieppe and visited Braque at his house in nearby Varengeville. Braque became a close and important friend. When BN and he did not meet they corresponded, and this exchange appears to have continued for many years, certainly into the 1950s. Some of BN's paintings of 1933 come close in method and manner to Braque's personal post-Cubist work. This did not involve a dramatic change in BN's art since he had also worked his way through aspects of Cubism to a personal idiom centred on still life; the most striking effect of contact with Braque seems to have been BN's positive use of collage in some of the 1933 paintings. Sophie Bowness, in her study of the relationship, makes the point that, though Braque was twelve years older, 'it seems to have been a relationship of equals'. She also states that, in late 1932 and the first months of 1933 BN and Hepworth considered seriously whether they should settle in Paris. Winifred had done so, and BN made frequent visits to her and the children. For Hepworth that could have been a double-edged reason.[5]

They were in Paris in the summer of 1933 and made a

lasting friend of the painter Jean Hélion who introduced them to Mondrian and invited them to join Abstraction–Création, an association formed in 1931 as a successor to Cercle et Carré, itself founded only the previous year as a product of the first international exhibition of abstract art to be held in Paris. Abstraction–Création was dedicated to promoting truly abstract art, as opposed to art in which natural appearances were reduced to near-abstraction, but otherwise was broadly inclusive, giving room to all available forms and movements of abstract art, most of them not Parisian in origin or base. Russian, Dutch, German, Italian and East European abstract art and artists met in the association's permanent exhibition and annual journal – and from 1933 on, also British through the membership of BN and Hepworth. Hélion kept in close contact with BN during the next years, visiting London and contributing to exhibitions in England, notably Britain's second abstract art exhibition, organized by Nicolete Gray in 1936 under the title *Abstract and Concrete*.

In 1934 BN visited Mondrian's studio for the first time, and again in 1935. His description of the place, set down for Summerson, is worth quoting yet again and more fully than in Summerson's book:

His studio … was an astonishing room: … very high & narrow L shaped (or rather ⌐ shaped) with a thin partition between it & a dancing school & with a window on the 3rd floor looking down onto thousands of railway lines emerging from and converging into the Gare Montparnasse. He'd lived there for 25 years & during that time had not been outside Paris & he'd stuck up on the walls different sized squares painted with primary red, blue & yellow – & white & pale grey – they'd been built up during those 25 years. The paintings were entirely new to me & I did not understand them on this first visit (& indeed only partially understood them on my second visit a year later). They were merely, for me, a part of the very lovely feeling generated in the room. I remember after this first visit sitting at a cafe table on the edge of a pavement almost touching all the traffic going in & out of the Gare Montparnasse, & sitting there for a very long time with an astonishing feeling of quiet & repose (!) – the thing I remember most was the feeling of light in his room & the pauses & silences during & after he'd been talking. The feeling in his studio must have been very like the feeling in one of those hermit's caves where lions used to go to have thorns taken out of their paws.

The words and tone are characteristic BN, and we shall see that they are relevant to aspects of his own work. Did it strike him that Mondrian was the same age as his father? Probably not, Mondrian looking almost ageless now that he had shaved off his romantic young-man's beard and donned a neat business suit. But BN may have pondered the differences between them, as men and as artists, one outgoing and debonair, a charmer with a sense of fun and a great need for friends, especially women friends, the other almost a hermit, friendly but deeply thoughtful and letting the same principles control his daily life and his art; one making intelligent and, in his best works, sensitive use of inherited purposes and methods, yet ready to earn success by supplying society with superficially agreeable portraits, the other pioneering a radically new art in the conviction that it would lead mankind toward a saner world. William Nicholson was a very skilful, sometimes poetic entertainer; Mondrian was a prophet and a priest. BN will certainly have pondered the nature of Mondrian's art and thought (he drew the line at reading Mondrian's didactic texts), so alien even to what in London counted as avant-garde work, so extreme and yet to BN's eyes so calm and consoling. Mondrian was something of a model, a yardstick for him in the 1930s and always one of the modern artists BN most admired. Hepworth said later that 'Mondrian showed us how completely possible it was to find a personal equation, through courage and exceptional faith in life itself.' Winifred Nicholson, living in Paris from 1932

on, became one of Mondrian's most supportive friends, and he appears to have seen her as an ally because of the purity and spirituality of her art. BN was to be instrumental in Mondrian's move to London in 1938.[6]

In 1933-5 BN and Hepworth participated in Unit One, a group of artists and designers and an exhibition which opened in London at the Mayor Gallery in April 1934 and toured to Liverpool, Manchester, Hanley, Derby and Swansea, closing in 1935. Herbert Read presented Unit One as 'the modern movement in English architecture, painting and sculpture' in the book he edited to accompany the exhibition. In the group were two sculptors, Hepworth and Moore, seven painters, John Armstrong, John Bigge, Edward Burra, Tristram Hillier (replacing Frances Hodgkins who was on the original list), Paul Nash, BN and Edward Wadsworth, and two architects, Wells Coates and Colin Lucas. The book presented statements by the eleven participants (Burra opted out of that and a text about him was supplied by Douglas Cooper), photographs of them and, in the case of artists, not architects, of their hands, and illustrations of their work.[7]

The idea for Unit One had been Paul Nash's. In March 1932 *The Listener* had printed an article by Nash in which he expressed his urge to work towards a 'more practical, sympathetic alliance between architect, painter, sculptor and decorator'; from this would come an 'acceleration of an important movement'. Forming the group involved discussions and disagreements, not least with BN. In 1923-4 Nash and BN had been close, with BN visiting the Nashes at Dymchurch and them visiting the Nicholsons at Banks Head. But by 1933 BN had been distancing himself from lyrical naturalism, and in 1934 he introduced the abstract-only rule into the Seven and Five Society. He must, tacitly or openly, have objected to the inclusion of such painters as John

Armstrong, a visionary painter who had toyed with Cubist abstraction but was now close to Surrealism, and Edward Burra with his pictorial dramas performed by figures that might have come out of Diaghilev's ballets and were painted with folklorique exactitude. Nash's work too was becoming more in-turned, dealing with the stuff of dreams and reveries in a spirit that could be thought Romantic but would soon be labelled Surrealist. BN must have wondered how some of the art produced by members of the group supported Nash's idea of a 'more practical, sympathetic alliance' between artists and designers. It seems that Nash sensed something of BN's doubts. 'Ben is a good fellow but I do not regard his judgment as entirely sound – & I believe you agree on this,' he wrote to Henry Moore in January 1933.[8]

The first shoots of an English Surrealist movement were in fact beginning to show, and hindsight suggests that Unit One hovered precariously between at least two stools. BN and Hepworth represented in it abstraction of a radical sort; the others were more or less consciously preparing the ground for Surrealism. The Mayor Gallery was working to make the Surrealism of Paris known in London, exhibiting Arp, Miró, Ernst, Picabia and Klee in April 1933, with an admixture of Armstrong, Nash and Moore. Dali was to be shown twice in London in 1934, both times at the Zwemmer Gallery. The response of the British press, of most art critics as well as reporters, mingled disdain with pretended horror. It serves to remind us that, however serious the differences of aim and principle among progressive artists such as those Unit One brought together might have been, they all confronted the old enemy. Britain seemed immovably wedded to the idea that good art was pleasant, pretty, unproblematic art. Artists not willing to supply this were, as the *Sunday Times* critic Frank Rutter said in 1933 about Picasso, 'led astray by the desire for novelty and a restless

craze for new inventions'. Unit One was unambiguously against conventionally tasteful art and it was a more public phenomenon than the Seven and Five.

Nash was a friend and he wanted BN and Hepworth as members and contributors. They must have welcomed his idea of associating progressive art with innovative design. He had tried this out on Wells Coates and Colin Lucas, well-chosen young and youngish men (born 1895 and 1906 respectively) committed to bringing the international style of function + geometry + concrete to England, and they responded positively. Moore was an early consultant for the project, and he is likely to have argued for inclusiveness rather than a narrow view of what counted as correct; later he refused to take sides in the abstract *versus* Surrealist skirmishes of 1936 and 1937. In a letter in *The Times* of 2 June 1933 Nash announced the existence of the group, listed its members, and stated its aims in terms that would have reassured BN. He asserted 'structural purpose' as the characteristic lack in English art, associating this lack with a dereliction of responsibility, and warned against the emergence of a new 'Nature cult'; the artists of Unit One, he claimed, were 'interested in other matters which seem to them more engrossing, more immediate. Design, for instance – considered as a structural pursuit; imagination, explored apart from literature or metaphysics.' He also stressed the members' individuality and the fact that they represented different priorities. They did not all produce abstract art and were not all 'interested in an architectonic quality', but 'together they stand for the expression of a truly contemporary spirit … in painting, sculpture and architecture'.[9]

To help contributors to write their statements, and in the hope of giving these statements a common framework, Read had sent them all a questionnaire. Some, as he said in his introduction, ignored it entirely but others took some of their ideas from it. BN's contribution appears to have taken him by surprise. He speaks of BN as 'regarding art as an exercise in almost metaphysical abstraction. It is true that the word "life" does occur in his statement, but it is regarded as something infinite which must be made actual and real in the world of art.' The BN works illustrated belong to 1933, in transition (we would say) from the *St Rémy* figures and heads to his first relief. BN's text is indeed off-beat for that context. It is also the shortest and least rhetorical:

I

One can express a thought by taking a piece of stone & shaping it, or 2 pieces of stone & shaping them for 200 years, one in relation to the other & both in relation to time and space, or one can take a piece of cardboard and cut out a circle one depth, or 2 circles 2 depths, or 600 circles 6,000 depths, or one can take a board and paint it white & then on top put a tar black & then on that a grey & then a small circle of scarlet – then scrape off some grey leaving black, some black leaving white, some white leaving board, some board leaving whatever is behind that – only stop when it is all the form & depth & colour that pleases you most, exactly more than anything has ever pleased you before, something that pleases you even more than pleases yourself then you will have a living thing as nice as a poodle with 2 shining black eyes.

II

I have been asked to answer a great many questions. I would like to quote the following from a speech made by Eddington at Cambridge in 1931:

'Of the intrinsic nature of matter, for instance, Science knows nothing, … for all we know matter may itself be mental.

'The old view therefore, that atoms and electrons are the ultimate reality, and that by interacting on one another in accordance with the laws of Nature, they produce our minds, with all their hopes and

aspirations, has no longer any scientific basis. ... Indeed, not only the laws of Nature, but space and time, and the material universe itself, are constructions of the human mind. ... To an altogether unexpected extent the universe we live in is the creation of our minds. The nature of it is outside Scientific investigation. If we are to know anything about that nature it must be through something like religious experience.'

As I see it, painting and religious experience are the same thing, and what we are all searching for is the understanding and realisation of infinity – an idea which is complete, with no beginning, no end, and therefore giving to all things for all time.

Certainly this idea is to be found in mind and equally certainly it can never be found in the human mind, for so-called human power is merely a fantastic affair which continues to destroy itself until it finally evaporates.

Painting and carving is one means of searching after this reality, and at this moment has reached what is so far its most profound point. During the last epoch a vital contribution has been made by Cézanne, Picasso, Braque, Brancusi, and more recently by Arp, Miró, Calder, Hepworth and Giacometti. These artists have the quality of true vision which makes them a part of life itself.

So art is the making of an object that pleases deeply, out of discovery rather than system or theory; making it is an inquiry akin to 'religious experience' and at this level it joins with all profound inquiry. Sir Arthur Eddington was a pre-eminent astronomer, physicist and mathematician of the day who saw it as part of his duty to speak to the general public about his understanding of the functions of science. A Quaker by family, education and conviction, and a declared pacifist in the First World War, he insisted that a true understanding of the world would come not from science but through a clear apprehension of a spiritual reality lying beyond the material one.

Hepworth's is the only British name in BN's list of those who have made 'a vital contribution', and it is quite possible that she would have supported BN's desire to

credit modern art with transcendental aims. Her parents were interested in Christian Science; she called on Christian Science practitioners at times, especially when her children were ill. Yet her statement is more recognizably English: a celebration of sensory experience recollected in the calming presence of stone and in the act of shaping what must be 'so essentially sculpture ... so very quiet and yet with a real vitality', all justified by being rooted in 'the contemplation of Nature'. In this it is close to Moore's with its specific appeal to 'Observation of Natural Objects', meaning figures but also 'natural objects such as pebbles, rocks, bones, trees, plants etc.'[10]

It appears that from 1935 on BN and Hepworth remained in Britain, except for a holiday in Varengeville in 1937 when Braque and Miró were there too. In 1935 BN's work was included in international exhibitions in Lucerne and Brussels, and in 1938 in an abstract art exhibition at the Stedelijk Museum in Amsterdam. One wonders whether BN visited these exhibitions and met his co-exhibitors. In any case, he and Hepworth felt that London was beginning to replace Paris as the centre for advanced art, with Gabo, Moholy-Nagy, Gropius, Mondrian and others coming from the Continent to evade political oppression. As Hepworth put it, 'suddenly England seemed alive and rich – the centre of an international movement in architecture and art. We all seemed to be on the crest of this robust and inspiring wave of imaginative and creative energy.'[11] And in London BN was now a central figure in a circle devoted to the development and the promotion of abstract art as well as a participant in anti-fascist exhibitions embracing a wide range of art, held in London in 1936 and 1939. Yet, of course, in comparison with Paris, London was still a grey and guarded place and a very limited art

**69**
*1932 (painting).*
Oil, gesso and pencil
on canvas, 74 × 120 cm
Tate Gallery, London

world dominated by indulgent imagery and polite tastes.

Some artists – perhaps not only artists – from time to time find themselves in positions in their work and their domestic lives that look satisfactory and even comfortable, yet are suddenly sensed by themselves as insupportable. Picasso is the outstanding example of one whose life and work can be seen in distinct phases related to his domestic arrangements. BN was another such, happily on a lesser scale. Life with Winifred had given both of them much: the light and air of the Ticino and of Cumberland, mutual encouragement, criticism and example, the exchange of thoughts and aspirations on the basis of much common ground. He may, in the end, have thought she was too certain, too complete. She did not want to surrender her husband to the younger woman, the father of her three children and in so many ways a kindred spirit, and she delayed their divorce until 1938. Her response to his 1931 decision to be with Hepworth was to move to Paris and engage more closely with the artists she knew there, as though she too felt that the moment for a more thorough

internationalism had come. For her Paris was new music, poetry, architecture, ballet, excitement, 'the new vision', liberty for women, for children; 'nothing was taboo any longer'. Her memories were of a golden age where everything seemed possible: 'What an easy way we unfettered and manifested our inspiration in the 1930s."[12] Her paintings of the 1930s are in many instances wholly abstract and employ geometrical forms, straight lines and sometimes flat colour, even when they originated in a still-life motif.

One senses BN's need for a new and passionate relationship with a younger artist, mature yet still girlish, forceful but admiring, eager for a place on the international art stage. 1931 seems to have been for him an unproductive, perhaps unsettling year. The 1932-3 paintings signal a honeymoon period, with Barbara and with Paris, but also renewed exploration of the elements of art. Her profile appears again and again – the last time we find the human image in his paintings. And there are drawings of the naked figure of his lover. Face and perhaps the body too are idealized in classical terms, the fluent line suggesting

**70**
*1933 (coin and musical instruments).*
Oil on canvas,
105.4 × 121.3 cm
Richard S. Zeisler
Collection, New York

Picasso's neo-classical drawings of the late teens and early twenties, but there is no doubting BN's delight in the subject and in the lines on paper. A profile that must be hers appears in a succession of paintings, and at times a pair of profiles, his and hers, as in the double image he entitled *St Rémy, Provence* [plate 71] and which we call a portrait for lack of a more exact term. It certainly celebrates a couple, but does so in humorous terms, borrowing a formula that goes back to ancient coins and medals. In it BN gives more attention to the echoing fluencies of profiles and hair and a dramatic intervening shadow in black as well as gentler ripples from a grey pencil shadow than to portraiture.

Meandering, wavy lines had become a major constituent of painting with BN's *1932 (painting)* [plate 69], a unique work which can be read as landscape, still life and reclining figure yet appears to be wholly abstract. A similar composition is spelled out more legibly in the almost monochrome painting *1933 (coin and musical instruments)* [plate 70]. The coin with the woman's head on it is placed just where we would expect to see a head if there were a

reclining woman in *1932 (painting)*. In both paintings there are hints of a table top and table legs as well as lines that have no specific descriptive purpose. Much the same table reappears so often in BN's work over the years that it can serve as a brand image. In *1932 (profile – Venetian red)* [plate 72] it lends an element of real presence to an otherwise extraordinarily subtle and multiple composition, all peasant heftiness and at the same time all delicacy. The table and its mighty legs, the unexplained dark form on the right, the careless spotty curtain and other dark shapes under the table, and even the overlapping white rectangles in the centre, speak of want of skill or want of interest in skill; the rest, the jug and mug, the delicate profile, the carefully weighed tones and densities, speak of care as well as natural grace. The mode is Synthetic Cubist in the way the image is compiled and assembled though it is all done with paint and pencil.

In *1932 (crowned head – the queen)* [plate 76] the same applies, but the old-masterly richness of *profile – Venetian red* is now replaced by fairground jollity, with stage-like

**71**
*1933 (St Rémy,
Provence).*
Oil on board,
105 × 93 cm
Private collection

**72**
*1932 (profile –
Venetian red).*
Oil and pencil on
canvas, 127 × 91.4 cm
Private collection

**73**
*1932 (head and mug in
a Greek landscape).*
Oil and pencil on
canvas, 31 × 36.5 cm
University of Hull Art
Collection

**74**
*1933 (St Rémy –
self-portrait with Barbara
Hepworth).*
Oil and pencil on canvas,
27.3 × 16.8 cm
National Portrait
Gallery, London

The 1930s

**75**
*1932 (prince
and princess).*
Oil and pencil on
board, 29.5 × 46.7 cm
Private collection

**76**
*1932 (crowned head –
the queen).*
Oil and pencil on
canvas, 91.4 × 120 cm
Abbot Hall
Art Gallery, Kendal

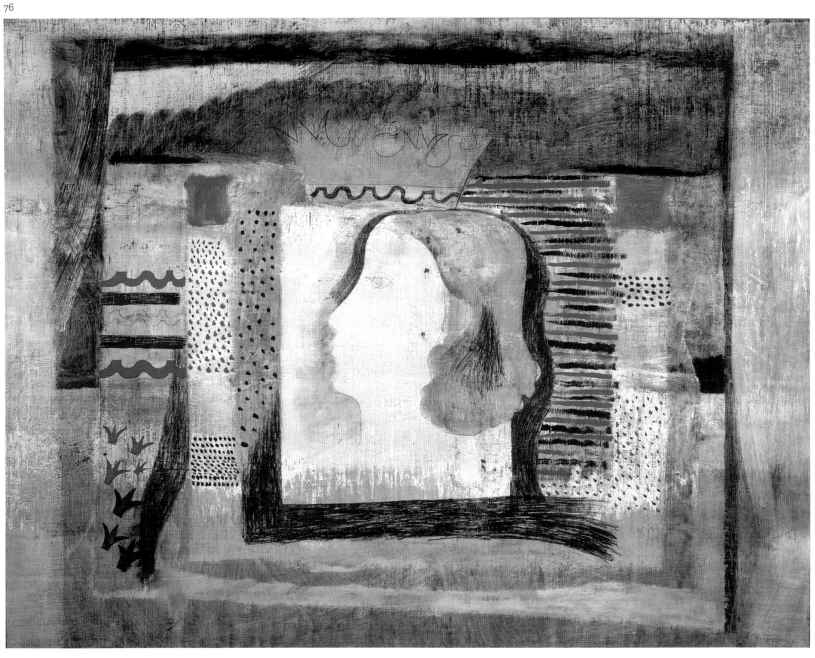

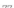

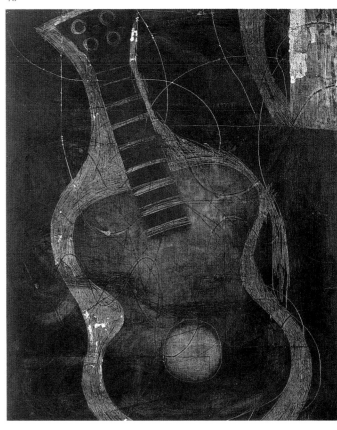

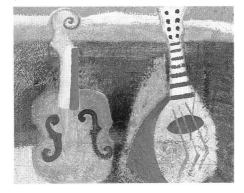

**77**

*1932-3 (musical instruments).*
Oil on board,
104 × 90 cm
Kettle's Yard,
University of
Cambridge

**78**

*1932 (violin and guitar).*
Oil on board,
62.8 × 74.8 cm
Private collection

**79**

*1933 (guitar).*
Oil and gesso on
canvas, 67 × 53.7 cm
Kettle's Yard,
University of
Cambridge

curtains and other props framing the more developed but utterly delicate crowned head at the centre. The Cubist allegiance is more pronounced in *1932 (Le Quotidien)* [plate 80] in which a newspaper supports a mug and cup, serving both as table and as the landscape background that will so often go with his still lifes in the 1940s and after. The newspaper, the emphasis on its lettering, rendered with exactness and then left incomplete and not quite right, just like the pattern on the cups, all this points to Cubism; the slightness and fluency of everything and also the insistence on the rectangular board as the only real thing, is BN. Other 1932 paintings bring in musical intruments – guitars or violins – borrowed by him, one feels, a not particularly musical man, from his friend Braque, and, again, an inheritance from Cubism. But BN did not fracture them as Cubism did: he fed them through each other as objects consisting primarily of lines, in *1932-3 (musical instruments)* [plate 77] even more blatantly than in *1933 (coin and musical instruments)* [plate 70], leaving other lines to contribute their music.

The way the guitar and violin embrace each other in

*musical instruments* pre-echoes the embracing figures in *1933 (St Rémy, Provence)* [plate 71], BN's most outspoken image of love and desire, yet characteristically delivered in a playful version of Picasso's itself sometimes waggish neo-classical imagery. Did BN have an inkling that those musical instruments have their own anatomical symbolism, and that for the Spaniard the guitar was an image of the desired woman as well as of courtship? The third face, in the mirror, facing hers and echoing his, makes as though to kiss both of them and is as much a benign third presence in the picture, come to bless the couple, as a mirror-image. His use, at this time, of mirror and other reflected images began with the faceless mirror in *1930 (Christmas night)* [plate 64]. It is wholly separate, in spirit and in presentation, from Paul Nash's contemporary exploration of the Surrealist symbolism of mirrors in art, inspired in part by Cocteau's use of mirrors as the membranes through which we move from life to death. Yet BN's new work inhabits quite a different world from that of *Christmas night* if we consider its style and references. BN's paintings of 1932-3 are much less British, less marked

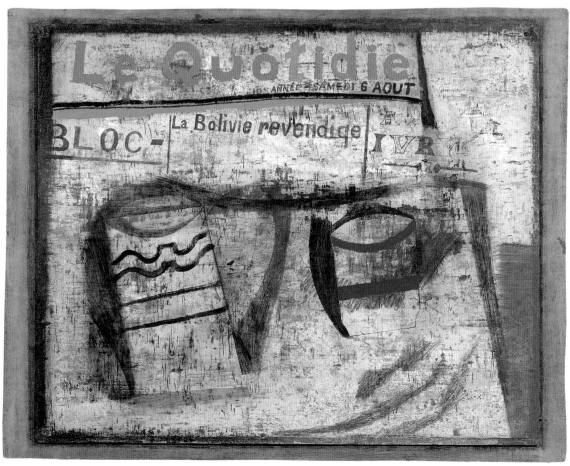

**80**
*1932 (Le Quotidien).*
Oil and pencil on
canvasboard,
37.5 × 46 cm
Tate Gallery, London

**81**
*1932 (Au Chat Botté).*
Oil and pencil on
canvas, 92.5 × 122 cm
Manchester City
Art Galleries

by a rustic-poetic lyricism that announces itself as English, and closer to Cubism, in some respects also more ancient. The other reference built into the image of lovers, besides the echo of Picasso's post-Cubist graphic idiom and Braque's undying love and use of musical instruments, is to Athenian vase painting of the sixth century BC.

*1932 (Au Chat Botté)* [plate 81] announces its Cubist heritage in the prominent lettering and in the two patches of white that hint at *papiers collés*, and does in some ways come close to late Cubist paintings by Picasso and Braque. That said, it is rich in BN characteristics, above all his un-Cubist insistence on representing objects whole, unfragmented. The painted and scrubbed table is entirely familiar, but the jug and bowl are on this occasion someone else's, lacking the Nicholson ingredient of cheerful decoration; the dummy head is a newcomer too, but the spotted curtain on the left is an old friend. BN had long – at least since 1924 – been able to make pictorial space a layered representation, with planes in front and behind each other. This device was a major element in Braque and

Picasso's move from Analytical to Synthetic Cubism around 1912. Fragmentation and the use of small, tonally tilted planes had made space and things ambiguously fluid, coming forward in front of the picture plane as well as receding behind it, but with the introduction of *papiers collés* and collage and, with this, the use of larger and flatter forms, the image appeared to be, and often physically was, built up on the picture plane. *Au Chat Botté* is all paint and pencil on canvas, as is usual with BN, yet there is a marked sense of layered space as well as a sense of space receding into the canvas beyond the edges of the table.[13]

BN himself wrote about the space in this painting in 'Notes on Abstract Art' published in *Horizon* in 1941. Cyril Connolly founded this august and elegantly produced magazine in 1939 to assure literature and the arts of a platform amid the fears and restrictions of wartime. BN will certainly have considered his essay with care. In it he associated abstract art with 'liberation of form and colour' and suggested that this liberation was 'closely linked with all the other liberations one hears about' in that wishful time.

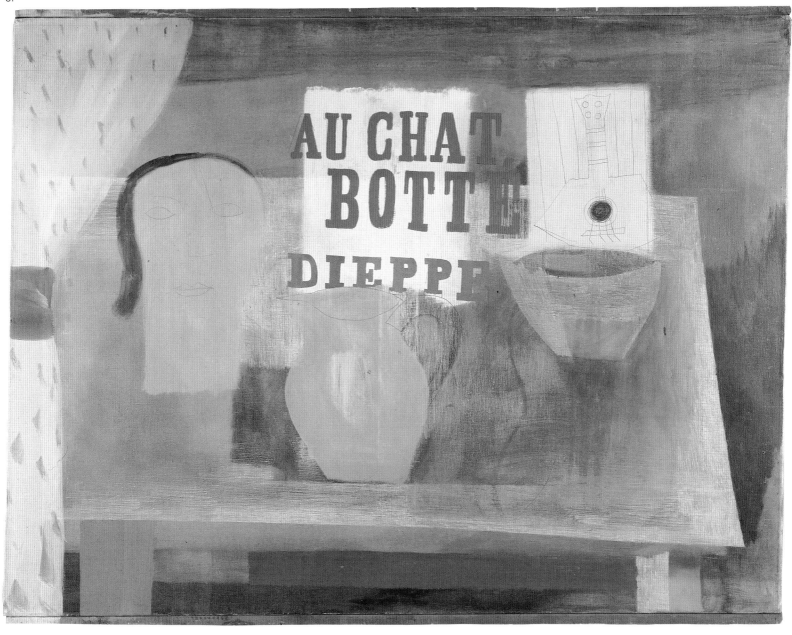

The 1930s

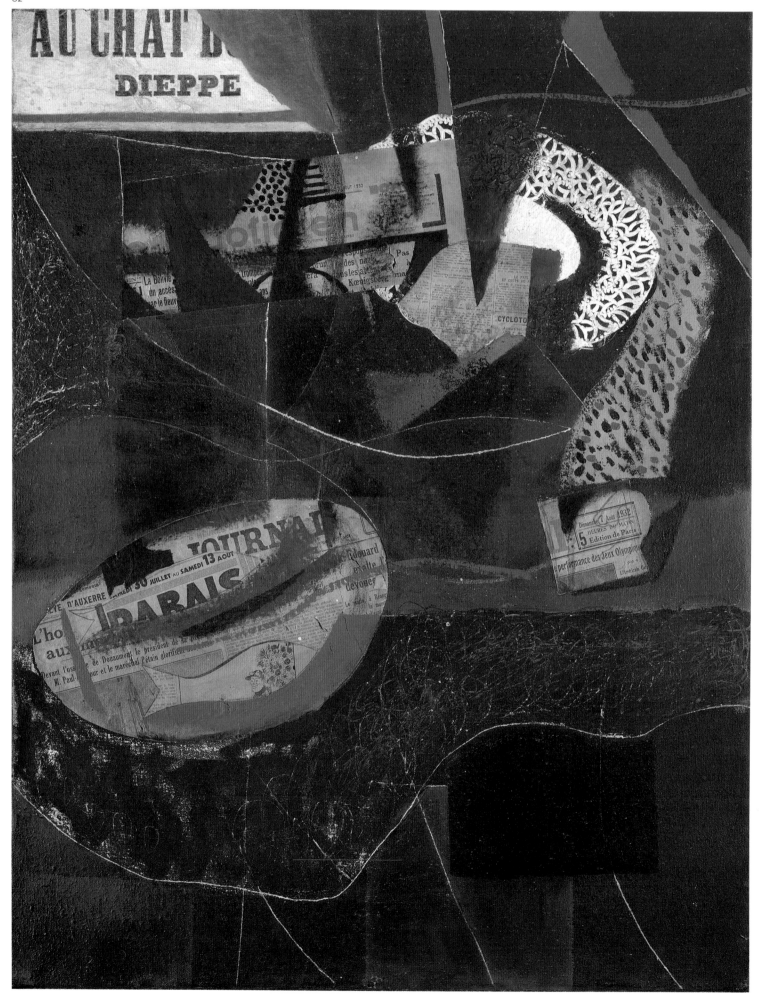

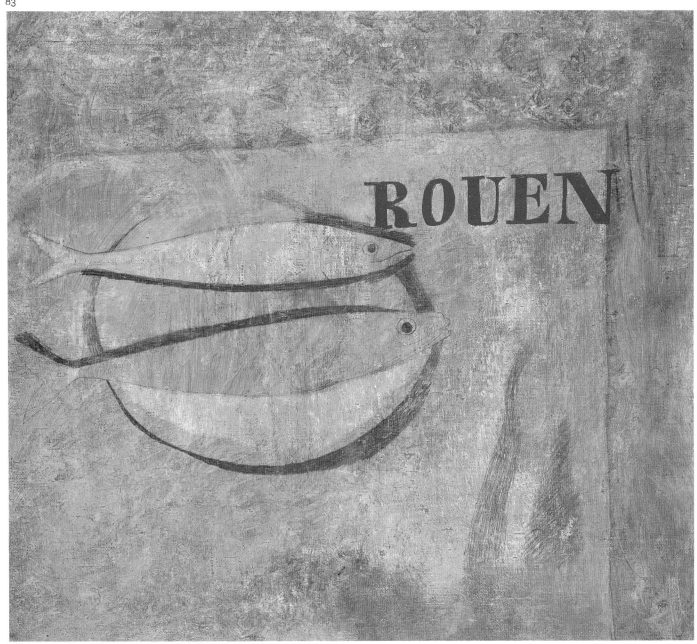

**82**
*1933 (collage).*
Oil, collage and pencil
on canvas,
85 × 67.4 cm
Private collection

**83**
*1932 (Rouen).*
Oil and pencil on
board, 67.2 × 74.8 cm
Private collection

The 1930s

**84**

*1932 (Auberge de
la Sole Dieppoise).*
Oil and pencil on
board, 90.1 × 74.8 cm
Tate Gallery, London

**85**

*1932 (still life –
Bocquet).*
Oil and pencil on wood,
64.8 × 50.8 cm
Private collection

The 1930s

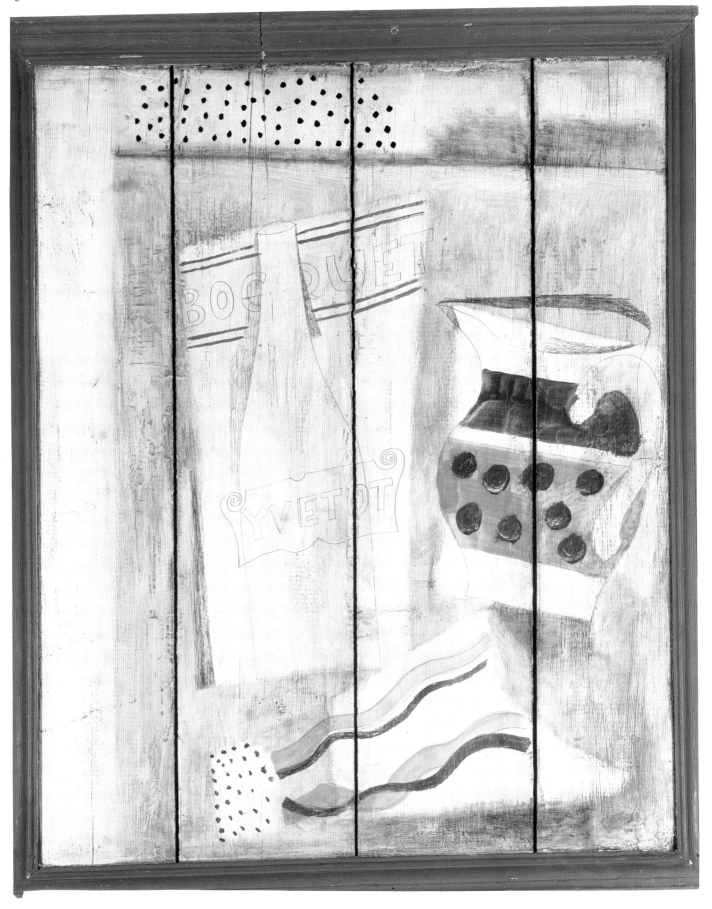

The 1930s

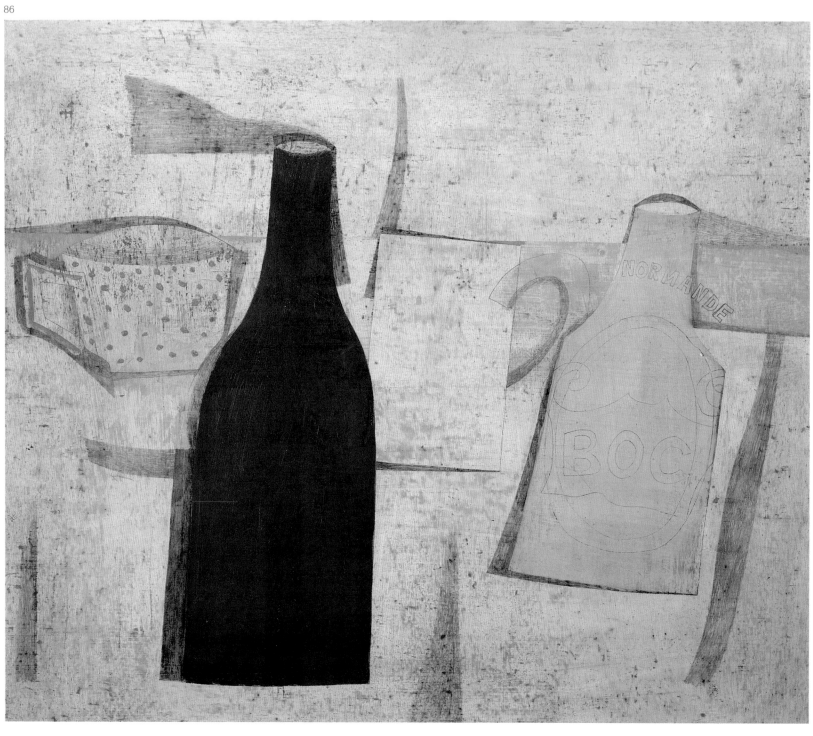

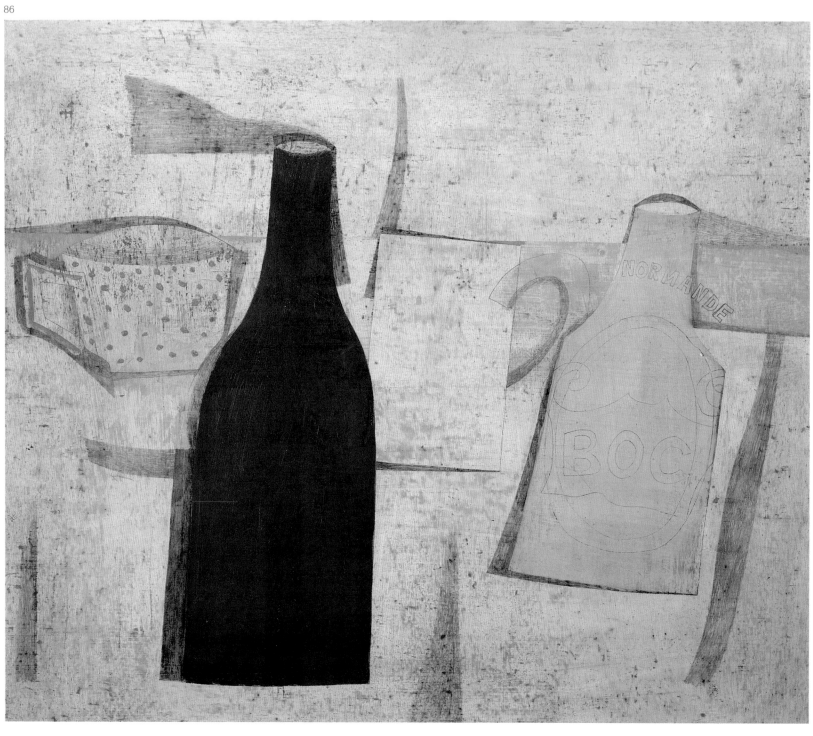

The 1930s

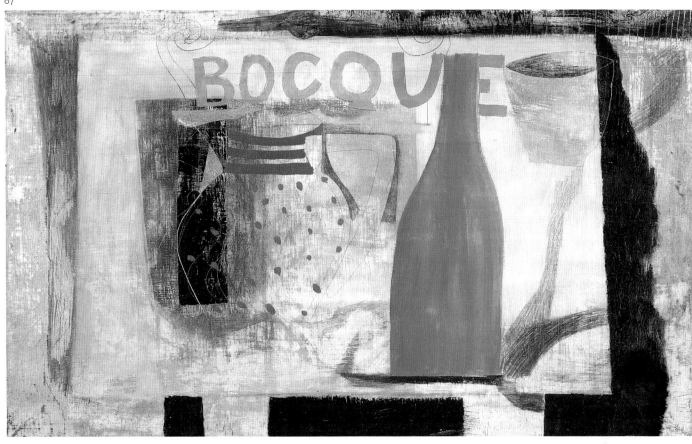

**86**

*1932-5 (Boc).*
Oil and pencil on
board, 51.4 × 59.6 cm
Private collection

**87**

*1932 (Bocque).*
Oil and pencil on
board, 48 × 78.5 cm
Arts Council
Collection, London

The 1930s

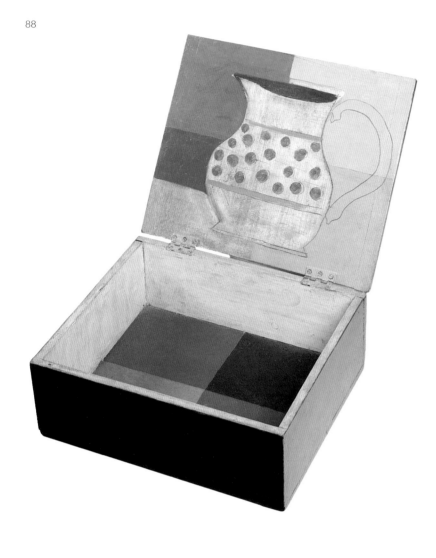

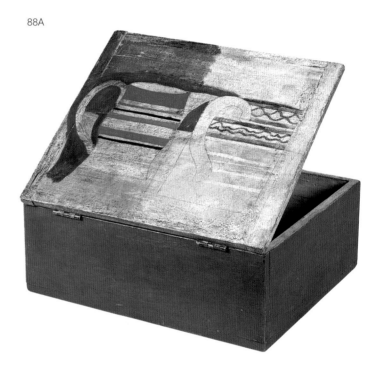

89

**88, 88A**
*1930 (box).*
Oil and pencil on
wooden box,
28 × 33 × 12.5 cm
Private collection

**89**
*c. 1930 (box).*
Oil and pencil on
wooden box,
10.1 × 10.1 × 5.7 cm
Private collection

**90**
*c.1933 (bus ticket).*
Oil and pencil on
board, 1.5 × 14.8 cm
Private collection

The 1930s

*1933 (vertical painting).*
Oil and pencil on wood,
47 × 14 cm
Private collection

**92**
*1933 (painting).*
Oil and pencil on
canvas, 20 × 35.5 cm
Private collection

One of the abstract artist's powers is the remarkable one of creating space, 'not "literary" space but actual space', and he devoted a paragraph to showing what he meant:

About space-construction: I can explain one aspect of this by an early painting I made of a shop-window in Dieppe though, at the time, this was not made with any conscioous idea of space but merely using the shop-window as a theme on which to base an imaginative idea. The name of the shop was 'Au Chat Botté', and this set going a train of thought connected with the fairy tales of my childhood and, being in French, and my French being a little mysterious, the words themselves had also an abstract quality – but what was important was that this name was printed in very lovely red lettering on the glass window – *giving one plane* – and in this window were reflections of what was behind me as I looked in – *giving a second plane* – while through the window objects on a table were performing a kind of ballet and forming the 'eye' or life-point of the painting – *giving a third plane*. These three planes and all their subsidiary planes were interchangeable so that you could not tell which was real and which unreal, what was reflected and what was unreflected, and this created, as I see now, some kind of space or an imaginative world in which one could live.

He defines the three planes with didactic firmness, and then proceeds to speak of subsidiary planes, of the interchange between them and of the dissolution of the conceptual barrier between real and unreal in the picture's play of perceptual forces as though confusion was his aim. The ambiguities we meet in this simple, friendly painting are multiple and essential. The head is the dummy's but also Barbara's reflected. The lettering in red and grey is on the glass – handsome and certain, until we notice that a little of it disappears behind the jug. The jug and the bowl stand on the table behind the window, no doubt about that except for the usual matter of the vertical or steeply sloping table top and the almost profile treatment of the two objects, all familiar from previous BNs. Behind the lettering, some way behind it, is a white rectangle, soft-edged perhaps because our focus is on the lettering in front of it. The other white rectangle, on the right, seems a little further forward optically but is pushed back by the bowl and its own placing further up-stage. On this rectangle we see a graphic image of a mandolin. This and the bowl were put in to replace a guitar

*1933 (painting).*
Oil and gesso on
board, 73.6 × 90.7 cm
Crane Kalman Gallery

**94**

*1933 (milk and
plain chocolate).*
Oil and gesso on
board, 135 × 82 cm
Private collection

whose curving, feminine shape can still be read through the thin paint of the table. The thin, rubbed paint distances the internal space of the shop window from the firmly coloured and delineated lettering on it and the relatively clear head on the left. Yet all that leaves us uncertain where, optically as against logically, the curtain on the left belongs. The multiplicity and the mobility of all this, in our perception and our understanding of the picture, recall BN's words earlier on in the same article, using the word 'force' in at least two senses:

A Raphael is not a painting in the National Gallery – it is an active force in our lives.

   … One can say that the problems dealt with in 'abstract' art are related to the interplay of forces and, therefore, that any solution reached has a bearing on all interplay between forces: it is related to Arsenal *v.* Tottenham Hotspur quite as much as to the stars in their courses.

Those who reject abstract art, he continued, misunderstand it just as dictators misunderstand the freedom of the individual. It is possible to see BN's appetite for ambiguity as an

unconscious alternative to his father's magical handling of tone, apparently wrought to give each part of a picture its particular place, space and material quality.[14]

   In other paintings of 1932-3 BN developed the linear theme we have seen him use in more or less abstract and also in figurative ways into self-sufficient pictorial structures that are abstract. An outstanding example is *1933 (milk and plain chocolate)* [plate 94]. The two browns specified in the title are painted over a solid gesso ground, and the lines in the picture, and some of its shapes, are drawn negatively by being incised, removing the browns just as the etcher's needle removes the coating on the metal plate. If the painting had any other subject it has been surrendered to this play of lines and forms, the play of pictorial forces. Miró had for some time been using his paintings as tablets on which to inscribe his symbols, and these are often largely linear. Miróesque, too, is the horizontal division of the two browns, making an earth/sky duality. Calder's structures had brought out BN's taste for coloured disks and other shapes kept mobile in a pictorial space. The vertical and horizontal

The 1930s

95

*1933 (profiles).*
Linocut,
36.8 × 43.2 cm
Kettle's Yard,
University of
Cambridge

lines in white that seem to frame the inner area of the painting may echo the cages that contain some of Giacometti's Surrealist inventions. The only hint of Cubism in this work is the cream and yellow shape right of centre, given a thin shadow line to imply that it is collage. It is typical of BN's conjuring at this stage that he should make something look as though it were stuck on to the picture and then seem to place over it the white triangle which is actually formed by removing plain-chocolate brown and thus must be behind the yellows.

Soon after, at the end of 1933, BN began to make reliefs. In March 1934 he exhibited white reliefs in the Seven and Five Society's show at the Leicester Galleries. After the complexities, the multiple methods, directions and influences of 1932-3 and earlier, the change seems willed, a response to a call to order. After multiplicity the clarity of basic geometrical forms. After dark and light paintings, after still-life objects and naked bodies and abstract or nearly abstract conceits, the strait, clear language of rectangles and circles. After so many effects and illusions of space, the reality of

physical space given by relief. After dark and light colours, bright and suave, firm or soft, the factual absoluteness of white. So it would seem, and one would want to applaud it, but the facts of the matter are far more intricate.

That he should turn to making reliefs can be foreseen only by those armed with hindsight. Living with Hepworth must certainly have led him to think about sculpture and physical space. He was already alert to the reality of pictorial elements *per se*, and he was sensitive to their space-making powers, in themselves and in relationship to each other. Several of his paintings suggest an inner tablet set on to an outer one, and this is usually projected forward; we often call it a table top but the point is that it is a plane brought towards the front of the picture on which BN displays other forms. To make this plane a physical projection and to place forms on it and cut forms out of it was both a major step in BN's development and not a very long one. There was nothing to inhibit his turning to sculpture, including using a sculptor's tools and carving into stone or building up layers of stone, white marble perhaps, especially with Hepworth's

96

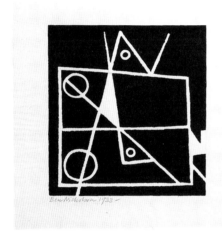

1933 *(Foxy and Frankie 5)*.
Linocut, 15.7 × 14.6 cm
Private collection

**97**
*1933 (profile)*.
Linocut, 43.1 × 38 cm
Kettle's Yard,
University of
Cambridge

example at hand. But of course he might well have gone the other way, into drawing and painting that advertised its drawingness and paintingness and minimized its burden of physicality, leaving the reality of wood or stone and of three dimensions to his partner. He had already found his own equivalent of his mother's scrubbing the kitchen table in his rubbed paint surfaces: painting had long been a partly physical process for him. He could have decided that the absoluteness of geometrical forms was quite foreign to him − and this turns out to be an important hidden truth, as we shall see, even though for a time making white geometrical reliefs was his primary concern and remains one of the climaxes in his career.

He started making reliefs by accident. As he incised lines into one of his paint-over-gesso surfaces, a piece of the gesso fell out, tempting him to explore the possibility of having layers of real space, or shallow relief, in a painting. Lewison makes the point that this interest in real space comes at a time when BN had minimized the depiction of space. He also suggests that BN's experience over some

years of making linocuts accustomed him to a process akin to that of carving into board.[15] BN had made little linocuts of still-life themes since 1926, and in 1933 also of heads similar to those in the 1933 paintings [plates 95 and 97]. These were not editioned but hand-printed occasionally in very small quantities. In 1933 he made a series of linocuts, developing one design through several states, and subsequently titled them after two cats, Foxy and Frankie. It is striking that the later states include areas where geometrical pieces of the linoleum were removed so as to print negatively, i.e. white on white paper, giving the block, more obviously than before, the character of a geometrical relief. The last of the series is *1933 (Foxy and Frankie 5)*, with two such negative areas as well as incised lines [plate 96].

But all this still did not make the white reliefs inevitable or even foreseeable. Each stage in what we call an artist's development confronts him or her with a whole spectrum of possibilities, and often the intention is to do a work on the same lines as yesterday's but somehow better. If a major change occurs it is natural to ask why and to seek internal

The 1930s

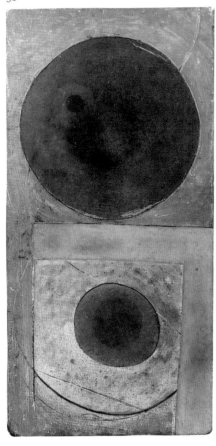

98

**98**
*1933, December
(first completed relief).*
Oil on carved board,
54.5 × 25.4 cm
Private collection

**99**
*1933 (painted relief).*
Oil on carved board,
44 × 29 cm
Private collection

and external impulses, but these too are not likely in themselves to predetermine the specific nature of the new work born from that change. Retrospectively it all makes sense, but this should not let us diminish our curiosity and saddle artists with predestination. For all change means loss as well as gain, and the artist knows this best.

In the summer of 1933 BN was in touch with a range of abstract art and artists in Paris through Abstraction–Création. That December he was in Paris again, visiting Winifred and the children, and it was there, in a rented studio not far from Winifred's flat, that he made the first works that appear to have been intended as reliefs. They combine inexactly inscribed disks with rectangular areas and were painted after the carving was done; their colour was not revealed by the cutting as when he incised lines in painted gesso. *1933, December (first completed relief)* [plate 98] is at once bold and tentative, revealing changes of mind in its surface as well as the basic confrontation of disks and rectangles which becomes the idiom of the white reliefs. Flying back to England on 30 December, he experienced, as

he wrote to Winifred with evident excitement, not only the sight of French fields 'all laid out in small squares' and a sea of white clouds 'stretched out on one plane to the horizon', with infinite blue sky and bright sunshine above, but also the surprise of dipping down suddenly through the solid medium of clouds to reach the grey of winter at Croydon airport.[16]

But at this stage he coloured the reliefs, mostly in creams, ochres and terracotta. The darker colours go into the recesses, as in the L-shaped *1933 (painted relief)* [plate 99]. Here the board itself is relatively thick and the carving is deeper than in his other early reliefs. The sides of the roughly circular hollows are painted the recess colours – as though what had been removed was a disk of solid colour. *1933 (six circles)* [plate 100] is five times larger but shallower, with free-hand incised lines as well as circular hollows. Again, the colour is added, mostly a pale ivory though a rectangular area bottom right is given a deeper shade of cream; the circles are filled in with a range of gentle colours, from ivory top right to reddish brown top left and a muted pink at the bottom. It is striking that the ochre of the circle at centre left

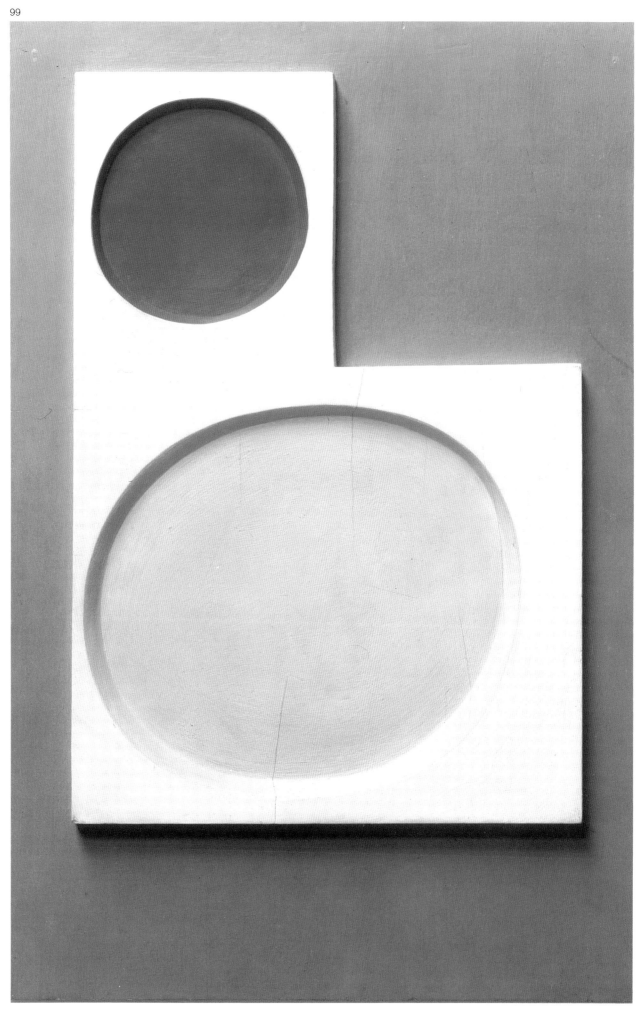

The 1930s

The 1930s

**100**
1933 *(six circles)*.
Oil on carved board,
114.5 × 56 cm
Private collection

**101**
*1934 (painted relief)*.
Oil and pencil on
carved board,
15.5 × 16.5 cm
Private collection

**102**
*1934 (relief)*.
Oil on carved board,
10 × 10 cm
Kettle's Yard,
University of
Cambridge

has been allowed to spread on to the front of the relief, beyond the carved line, just as it had been BN's habit to leave his colours in a free relationship to the drawn lines in his recent paintings.

In *1934 (painted relief)* [plate 101], a tiny, exquisite piece, relief is combined with painted forms, and its two different whites go with a lot of pale blue and small areas of a darker blue and of ochre and red. A rectangular patch of red at the top is left incomplete and the surface of some of the recessed areas is rougher than the rest, as though to assert that two distinct processes have been involved, each with its own characteristic effects. *1934 (relief)* [plate 102] is even smaller, a roughly square board with three circular hollows and two cut-away rectangular areas. The colour of the board itself is revealed in the bottom area and in the raised portion that dominates the upper two-thirds: this board was once painted grey and much of this old paint has been rubbed away. Significant, too, is the way we are made aware of the varying depths of the hollows. The largest circle is white and feels shallow because of its size; the deepest is the middle-

sized one, painted a pale grey that barely distinguishes it from its field; the shallowest is the smallest, coloured black. The degree to which these recessed colours appear to advance and recede depends on the light in which the relief is seen and thus would tend to vary with the time of day and the seasons.

Then, within weeks, came the first white reliefs, ready for exhibition that March. For reproduction in the book *Unit 1* he supplied photographs of his studio, taken by Hepworth, and of *Composition, 1933*, which we know as *1933 (milk and plain chocolate)*, and the very first relief, *1933, December (first completed relief)*, there titled *Two Circles, 1933* [plates 94 and 98]. Either the subsequent reliefs were not ready early enough or BN was holding them back for display in less mixed company; perhaps he sensed that they might cause problems within the group. He did not hesitate to make his priorities clear when asked, in 1934, to contribute to an international production. A portfolio of twenty-three prints by contemporary European artists was to be published in Paris as an *édition de luxe*, including works by Picasso, Miró, Arp,

Kandinsky, Ernst and De Chirico. BN would be the only British artist invited. He made his first and last woodcut for it. It could also be called a small wood carving, and is in fact a little larger than the last two reliefs discussed above. Its vocabulary is all rectangles and circles, white and black and a textured black-and-white that reads as grey. Sloping lines and the inexactness of angles and circles demonstrate his free-hand method. The composition is set within a more orthogonally correct white outline, beyond which there is a margin of grey; it has been suggested that this shows a vestigial table top and that the composition still has something of the still life about it.[17] This print has been known by various titles, the most descriptive one being *1934 (5 circles)* [plate 103]. It is striking that, without benefit of real space and using only black ink, BN was able in it to organize a surprising range of effects – of projection and recession, but also of interaction as well as separateness among its few elements. But of course it is a two-dimensional work and relatively small as well as done in a relaxed, free-hand manner.

The first white reliefs use only carved rectangular and circular forms and white paint. Their simplicity is deceptive. In art – indeed, in the arts at large – limitation can be a means to eloquence. These so self-evident works, lacking all variations of colour or tone, and holding to a minimal idiom of forms, turn out to be full of mystery. This cannot have been accidental. BN was now in touch with a large circle of abstract artists meeting and exhibiting in Paris. With some of them, partly through Winifred Nicholson's outgoing ways, he had good personal relationships. Their example and influence must have contributed to the great series of white reliefs, and indeed to BN's turn from paintings that with few exceptions still referred to the visible world to an art that was taken for abstract and certainly made no references of that

kind. Acquaintance with Mondrian's work [plate 104], backed by his visit to the Dutchman's studio, must have removed any doubts, if there were doubts in him, that art could be abstract and significant and also employ a deliberately limited vocabulary of forms and colours.

Mondrian mounted his Neo-Plasticist paintings on boards a few centimetres larger than themselves. Thus, with their backing boards fixed flat to the wall, the canvases would stand proud of them and display their unframed sides. There was no mistaking them for windows opening on to another world; they are constructions in paint on canvas, in effect canvases turned into reliefs. That is how BN saw them in Abstraction–Création exhibitions, and that is how they appeared in Britain's first international show of abstract art, Nicolete Gray's exhibition *Abstract and Concrete*, shown during 1936 in Oxford, London, Liverpool and Cambridge. By that time BN had already learned to show his reliefs in white-framed glazed boxes to keep them clean, and that is how we often see the Mondrians too, but in 1936 these were still shown as described [plate 431].

Arp's recent work included assembled reliefs in which shaped pieces of wood were mounted on a framed board, and these involved a lot of white paint and sometimes were white only [plate 105]. BN will also have been aware of Malevich's career, probably without having had contact with original pieces, through the Bauhaus book of 1927, *The Non-Objective World*. The text would not have appealed to him, resistant as he was to theory, even had he been able to read German. The illustrations, mostly of drawings done by Malevich to represent his paintings plus two photographs of Suprematist architectural sculptures in white-painted wood, are likely to have interested him. They do not include any of the Russian's white-on-white paintings, but give prominence to the repeated opposition of black to white,

**103**
*1934 (5 circles).*
Woodcut, 17 × 21 cm
Kettle's Yard,
University of
Cambridge

The 1930s

104
**Piet Mondrian**
*Composition with
Yellow and Blue*, 1931.
Oil on canvas,
50 × 50 cm
Private collection

with the white gaining ground as the work developed.[18]

White was and is the colour of light, and light had before now been one of BN's – and Winifred's – artistic goals: white as the colour of spirituality. For Malevich it was the colour of the infinite and the primordial, light as God's first and essential creative act, white the colour which includes all others as black is the sum of material pigments. In 1934 Hepworth began to make relatively frequent use of white alabaster and white marble in sculptures which use forms that are almost geometrical. White was also the colour with which William Nicholson had, against the fashion of his time, transformed the old panelling of Chaucer's House at Woodstock where the Nicholsons lived when Ben was little. When writing about his father BN recalled the 'black and white Vermeer checked floor' William had laid 'with his own hands' in the 'spacious sitting room hall with a staircase running down into it' in their house at Rottingdean.[19]

The themes of relief, whiteness and light meet in a peculiarly persuasive form in the thought and writings of Adrian Stokes (1902-72), writer, psychologist, art critic and, from 1936 on, painter. Margaret Gardiner brought Stokes to BN's studio early on in BN's Hampstead period, and the two men became close friends through playing tennis at the Hampstead Tennis Club and through endless talk. One senses that BN had not had anyone to talk to and listen to, anyone with wide-ranging thoughts and experiences linked to a lively conception of the mental world, since leaving Winifred. Stokes's mind was in full flood after years of thought and study, including a long period in Italy; he was eloquent and he had enormous charm. In 1930 he had published his first article on a subject in Italian quattrocento art, the Tempio Malatestiano in Rimini, developed by Alberti from a Gothic church and bedecked with carved reliefs by Agostino di Duccio and his assistants. Stokes's first book

was *The Quattro Cento*, published in 1932. It is on aspects of Italian Renaissance art, and focuses particularly on the attachment he found in the best of it to stone and mass as bearers of emblematic images and poetic shapers of space under light. Stokes's second book was an extended consideration of, especially, Agostino's reliefs: works in white marble, most ingeniously inflected by shallow carving and revealed in their significance and their beauty by light. This book, *The Stones of Rimini*, published in 1934, can be read as a paean of praise for white stone, low relief carving and its manifestation in light. Carving is for Stokes a male process, moulding or modelling a female process, and he ends his book with the assertion that the future of art is directly linked to the values of carving and its shaping of our perceptions of space. BN and Stokes shared a passion for early Italian art and they must have spoken of this and other art matters on many occasions. In October 1933 Stokes reviewed BN's work in the Nicholson and Hepworth exhibition at the Lefevre Gallery; he reckoned that BN's natural development lay in the direction of carving. BN designed the jacket for the first edition of *The Stones of Rimini*.

There is no certainty that BN read Stokes's books through. He was a reluctant reader of art theory, having inherited his mother's aversion to such stuff. Opinions in this case are divided: either he put Stokes's writings aside, in which case we can say it did not matter since they are known to have spent so much time talking to each other. Or BN did read them, drawn into them by admiration and friendship and finding them so unlike the kind of writing he disdained, sensitive, tentative and deeply personal where others almost without exception were dogmatic and dry. Many years later BN wrote to me asking what I thought of Stokes's use of language, and commented: 'I like some of it very much – but can read only a little at a time – but some of

105

his ideas go deep and this is felt often, too, in the English?'[120] Stokes's understanding of art was enriched by his involvement in Kleinian psychology. BN was at this time entering an artistic mode that would be seen, with praise or blame, as abstract, pure, and a contribution to the international growth of what Gabo called the 'Constructive idea'; simultaneously Surrealism was taking root in Britain as a mode associated with the discoveries of Freud. Stokes's writings may well have seemed to BN to offer a corrective both to Surrealism and to a narrow, materialist reading of geometrical abstraction and its Constructivist dimension. For Stokes, as for BN, art was ultimately a form of magic.

Later in his life BN was sometimes tempted to see his reliefs as wall-sized works; at this stage, making them over a wide range of sizes but none bigger than a man, he was certainly not competing with or emulating architecture. Yet geometrical abstraction was widely thought of as providing common aesthetic ground for art and design: De Stijl, Constructivism and Central European Elementarism, then being promoted at the Bauhaus, all asserted this consonance. And white was the colour of the new architecture. What became known as architecture's International Style, with its idiom of white-painted reinforced concrete, was taking root in England, with Amyas Connell, Wells Coates and Colin Lucas as proponents. Each year saw a growing number of buildings in the new style. In 1931 the Isokon company was formed, dedicated to producing soundly conceived and built houses, flats and furniture, with Coates as their designer. Then came Nash in 1932 making a public issue of the unity of modern art and design with his proposal for a 'more practical, sympathetic alliance' between artists and designers. BN will have met the idea also in Paris. Like Winifred, he greatly admired Le Corbusier's recent and new buildings. Parents and children, the whole Nicholson family

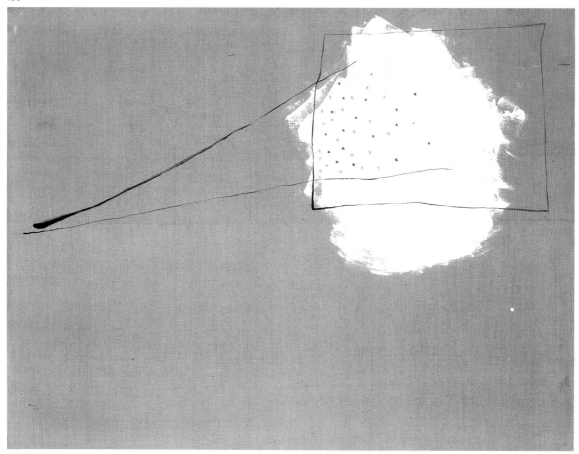

The 1930s

sought them out in Paris. In Britain Le Corbusier was then known principally through his publications, notably *Towards a New Architecture*, available in English since 1927 in the translation made by Frederick Etchells, the former Vorticist painter; the French original was published in 1923. Le Corbusier's architecture, classical at heart and responsive to the functional character of modern ships, aeroplanes etc., was often referred to as the 'white style' in modern design. In 1937 he presented his principles and perceptions in a new form in his book *Quand les cathédrales étaient blanches* (ten years later published in English, *When the Cathedrals were White*). Moreover, BN's younger brother Christopher (Kit) entered into architectural practice in 1933 and during the next years was responsible for a number of interesting designs marked by Le Corbusier's influence; some of these were realized, such as the studio he designed in 1933 for Augustus John at Fordingbridge on the edge of the New Forest and the London Gliding Club at Dunstable, designed in 1935.[21] Pioneering examples of the new architecture had begun to be built in England in the late 1920s. By 1932 it was enough of an issue to produce such vehement conservative reactions as Reginald Blomfield's book, *Modernismus*, in which the International Style of modern architecture was associated with German aggression. There is no reason why BN should not have been as aware of these developments as Nash, and they may have illuminated his path to the white reliefs.

These impulses were available to other artists too but did not lead them into work as apparently absolute as BN's, let alone as elusive. Although by the middle of the 1930s there were a number of artists in Britain whose work could be presented as abstract, very few of them used geometrical forms and most of them would better be classified, for that time, as abstract Surrealists: Henry Moore, Arthur Jackson

and Eileen Holding, for example, contributors to the *Abstract and Concrete* exhibition. John Piper developed an abstract idiom out of the overlapping planes of Synthetic Cubism; Cecil Stephenson arranged flat, abstract shapes on canvases in concentrated compositions that come closer to De Stijl; in Paris Winifred Dacre (i.e. Nicholson) produced some intensely personal abstract paintings in which circular and ovoid forms are penetrated and accompanied by linear and other elements, suggesting signals across cosmic space; Hepworth's sculptures of 1935-6, influenced by Giacometti and probably by BN, were at their most abstract and most nearly geometrical, eschewing hints of anatomy or organic life; Moore's sculptures of the time made bold use of organic forms and could mostly be read as cyphers for the human figure. For all their positive qualities, these artists and their works exhibited neither the single-mindedness of BN nor his work's harmony with the new architectural aesthetic. Yet they were the British artists closest to BN in spirit as well as socially, and they would soon be brought into the book *Circle* (1937) to represent their country, alongside BN, in this 'international survey of constructive art'.

Meanwhile, BN was seen as *chef d'école* of geometrical abstract art and as such drew fire from those who saw it as a dangerous aberration from art's traditional priorities and from those who saw it as too limited and inexpressive. Almost all his supporters recommended his art in absolute philosophical and aesthetic terms. In *Art Now*, published in 1933, Herbert Read had done his best to provide abstract art with an honourable theory, quoting Plato on the absolute beauty of 'straight lines and curves and the surfaces and solid forms produced out of these by lathes and rulers and squares'. The *Philebus*, he added, 'is Plato's last work, and here we have a definite abandonment of the unfortunate theory of *mimesis*, or art conceived as the direct imitation of the appearance of

things'. He went on to interpret Cézanne's emphasis on geometrical structure as an appeal to that beauty, and to commend its revival in Cubism and developments out of Cubism, some of them echoing machine forms. He also suggested that geometrical abstraction, associated in other cultures with a turning away from the chaos of the surrounding world, in modern society can bring the artist close to serving the practical needs of society. For once, in this case, BN did read a theoretical text – a brief one, written by a friend and in a book which included reproductions of his own work. Here was public support from an eminent writer for his work and that of those close to him, but privately he knew it missed out what mattered to him. He said as much to Winifred, in a letter he wrote on 19 October that year: 'You must know what I think – I think it is a very interesting point of view (especially for London to take seriously & digest) but of course without the v. necessary C.S. idea to clarify and give it substance.'[22] 'C.S.' stands for Christian Science.

*The Listener* was then the forum in which cultural and social questions of the day were given the widest airing in articles, illustrations and letters; it also printed the best-informed and most sympathetic reviews of modern art. In *The Listener* for 2 October 1935 Kenneth Clark (the future Lord Clark) opened an attack on contemporary art. His article, extra prominent through being the first piece in that issue, is entitled 'The Future of Painting'. This is followed by the generous editorial note: 'The Director of the National Gallery presents an analysis of modernist movements in art'. Clark begins: 'The art of painting has become not so much difficult as impossible'. The Royal Academy is now only a 'period piece', though enjoyed by many; 'sensitive and educated people' continue to take pleasure in the work of 'belated impressionists or pure painters' because of the 'delicate perception and sensitive handling' it purveys, but this has little general appeal and may be thought lacking in 'criticism of life'. What is now considered advanced art is art requiring to be judged by its theoretical position. Mr Read alone can speak on this, but what is to be noticed is that this art derives all its truth and beauty from theory instead of the other way around. Cubism and its descendants, and Surrealism are the movements of our day. History shows that art's tendency to geometrical abstraction always demonstrates weakness; Surrealism is merely an 'art of escape – escape from boredom'. We must accept, as might have been said by Italians confronting art after Michelangelo, that painting can die. Perhaps we shall be able to 'create a new style'; it will be 'something unpredictable'.

Herbert Read answered a week later in an article headed 'Ben Nicholson and the Future of Painting', with two BN reliefs for illustration. He saw BN's work as 'being moulded … by the senses of the artist reacting to plastic material', not to nature. He said BN was 'something of a mystic', seeking to express a reality that has nothing to do with realism. He appealed to the analogy with music, claiming art's freedom from discursive meaning, but he also stressed this art's association with 'the modern movement in architecture' through 'sympathy and common understanding'. Correspondence followed over the next few weeks. It was obviously unfortunate that Read's defence of painting dealt only with carved reliefs, but Clark's narrow view of modern painting came under fire too. One letter, from Geoffrey Edgar in the issue for 23 October, said bluntly that BN's reliefs were merely 'tasteful and negatively distinguished – admirable in their inoffensiveness'. The 30 October issue printed a general reply from Read, adding little.[23]

Other critics and commentators too had difficulty in seeing anything of interest or value in BN's arrangements of shapes, with and without colour. Such work seemed as

devoid of feeling as of painterly skills: 'a lavatory art form, a clean antiseptic bathroom art', according to Hugh Gordon Porteus; David Gascoyne said BN was 'preparing the death rites of painting'. Even Geoffrey Grigson, soon to become one of BN's admirers, found BN's reliefs images 'of infinity, ordered by saying "no" rather than "yes"'. Though admirable in their technique and taste, they are 'too much "art itself", floating and disinfected'. Exhibitions such as that presented at the showrooms of Duncan Miller in 1936, *Modern Pictures for Modern Rooms*, may have made it easier for work such as BN's to be seen as merely decorative. All three, Grigson, Gordon Porteus and Gascoyne, were at this time associated with promoting Surrealist ideas in Britain and with writing Surrealist prose and poetry; BN's work must have struck them as thoroughly remote from Surrealism's plot to reveal the images we all censor within ourselves. It was the architectural critic J. M. Richards, reviewing BN's 1935 show at the Lefevre Gallery, who warned against the tendency to 'recognise in these carvings an affinity with the superficial appearances of modern architecture' and thus to class them as 'spots of decorative relief work', similar to the plaster cornice and the marble mantelpiece of the gallery. In his reliefs, BN 'is exploring the potentialities of light on differentiated surfaces', and using his limited formal vocabulary in order to achieve 'absolute release from organic associations'.[24]

It was generally recognized that abstract art fell outside the range of ordinary people's understanding and would remain the interest of the few. Left-wing critics therefore condemned it. Less orthodox but left-inclined critics such as Herbert Read accepted the disjunction and tried to make a virtue of it. In *Art Now* he argued that abstract art represented 'a world of absolute and permanent values placed above the shifting world of appearances and free

from all the arbitrariness of life'. In *Art and Industry* (1934) he asserted that 'we need the abstract artist, the artist who orders materials till they combine the highest degree of practical economy with the greatest measure of spiritual freedom.' Thus the artist would guide society even without society's consent. But also in 1934, in his introduction to *Unit 1*, he conceded that 'the present unsatisfactory structure of society' renders the artist 'to some extent … anomalous, and his practice inconsistent. Meanwhile, all that the artist can do is to maintain his integrity, which means that he should concentrate on his technique and perfect his sense of form … to the rejection of every other irrelevant consideration.' Paul Nash had hoped to demonstrate in Unit One the social value of truly contemporary art and design because of their shared priorities and language; the artists are individuals, but together they form 'a hard defence, a compact wall against the tide, behind which development can proceed and experiment continue'.[25] At a time and in a country of doubt and conflicting tastes, it was difficult to assert both the high aspirations of artists and their role in the real world.

BN appears to have tried to strike a balance between standing above dissension among progressive artists and involving himself in the contemporary art life of London, difficult though that must have been. He was of his nature against all authoritarianism – and thus against any political persuasion that sought to limit thought – but he was also competitive and wished to gain ground not only for himself but for the values he represented. In the increasingly politicized London cultural world of the 1930s he wanted to be seen to stand for ideals that transcended the moment and its immediate needs. At the same time he did not feel he could stand apart from those needs. In November 1935 he contributed to an *Artists against Fascism and War* exhibition organized by the Artists' International Association (AIA),

founded in 1933 by a group of young communist artists and designers; Hepworth and Moore also sent work and there was a foreign section of exhibits from France, the Netherlands, Poland and Russia. In 1936 he gave work to an AIA exhibition intended to raise funds for the anti-fascist International Brigade fighting in Spain. In 1939 he contributed to the *Art for the People* exhibition at the Whitechapel Art Gallery in London's East End. These were all wide-ranging shows, bringing together artists normally separated by styles and art politics to show their underlying unity as individuals committed to creative work in a world more and more openly bent on oppression and destruction. There seemed to be no opportunity for artists like himself, who wanted a free art but did not want to appear anarchic, and whose expression was to be uplifting and optimistic and not devoted to the passing emotions of everyday existence, to make their mark in words or works.

*Circle* was conceived by BN, Hepworth and Gabo in June 1936. They had been to see the International Surrealist Exhibition at the New Burlington Galleries and agreed that some sort of counteraction was needed. The exhibition had been thoroughly advertised and prepared for with hints of offering excesses of several sorts, and its opening attracted all the attention normally given to a great national scandal. BN had been aware of Surrealism in Paris and had watched its emergence in England since the early 1930s. A Miró he saw in 1932-3 had pleased him enormously: 'The first *free* painting that I saw and it made a deep impression – as I remember it, a lovely rough circular white cloud on a deep blue background, with an electric black line somewhere'.[26] This was probably one of Miró's 1925-7 paintings in which he used a soft white form in a firmament of sonorous colour and one or more black lines to disturb the harmony [plate 106]. Miró became a friend, as did Arp who had been one of the

first Dadaists and had become a Surrealist in 1925 as well as a member of Abstraction–Création in 1931.

BN could see Arp and Miró as partial allies, as members of the organic branch of abstraction, along with Moore, while he himself belonged to the geometrical branch. But he had no patience with the multifarious theories of Surrealism nor with many of its practices and products. Freedom of action had been the mainspring of his art ever since he turned from 'Vermeer', and he did not need a movement to liberate him. Anything like automatic drawing, practised by a few of the Surrealists but central to Breton's ideas for Surrealist art, was anathema to him since his drawing relied on the intimate interacting of instinct sharpened by experience with a conscious sense of physical aptness. Perhaps it was for the sake of the pun that he mocked Klee's talk of 'taking a line for a walk': that was too pedestrian for him, he said. He was wholly impatient with the English Surrealists. The spate of Surrealist publications that followed the June opening of the exhibition, as well as lectures and other events, and the founding of 'the Surrealist Group of England', including Moore, Nash and Read, must have made him feel even more keenly the need for a strong counter-statement.

1937 saw the publication of *Circle. International Survey of Constructive Art*, edited by BN, Gabo and the architect J. L. Martin. They intended it as the first collection in an annual series. Read was invited to contribute, but not to edit or introduce or in any other way take a leading role in this compilation because he had proved too busy a champion of the enemy, Surrealism. The essay he wrote for it, 'The Faculty of Abstraction', was as solidly philosophical as he could make it, and ended on a high note. Whether he actually understands the sciences or not, the abstract artist is inspired by the 'abstract concepts of physics and dynamics, geometry and mathematics'. These are 'part of our mental

107

*1934 (white relief).*
Oil on carved board,
15.2 × 20.3 cm
Private collection

108

*1934 (relief).*
Oil on carved board,
71.8 × 96.5 cm
Tate Gallery, London

ambience', and the artist can 'make this ambience actual. He can make it actual in detached and non-utilitarian works of art; or he can make it actual in architecture and the industrial arts. In either case he is serving the highest interests of humanity ...' Many of the other texts in *Circle* reiterated the familiar theme of the modern age, finding in this art and these designs the general visual language of its time. Gabo, in the introductory essay 'The Constructive Idea in Art', asserted that this idea revealed the independent language of art and design and thus made possible the expression of 'those human impulses and emotions which have been neglected' in modern times.[27] BN's written contribution to *Circle* will be quoted and discussed below. His illustrations come third in the book, after one Malevich drawing and four Mondrian paintings of 1934-6: they are of four white reliefs of 1935-6, including plate 117.

The small *1934 (white relief)* [plate 107] is in many respects akin to *1934 (painted relief)* [plate 101]. Though all in white it has a similar playful character, partly because of its size and the size of its five recessed circles and many

projecting rectangles. Texture is very important, varying considerably and drawing attention away from the complex spatial relationship of the planes to each other. An element of enhanced formality is introduced by mounting the carved relief on a larger rectangle and that on yet another. Seen as a flat design, the relief has complexities enough if one looks for any logical system as the source for the play of forms. Nothing explains or justifies anything else.

The larger work in the Tate Gallery, *1934 (relief)* [plate 108] – twenty-two times the area of the preceding – shares its medium and method and its restriction to the same basic forms, but could scarcely be more different. In spelling this out we may come to understand the nature of this phase of BN's work. We observe a circle and a square, or rather a rectangle, but the emphatic way they are placed, not unlike one of Malevich's diagrams, makes one want the rectangle on the right to be a square. Both forms are negative, recessed. But they are not recessed to the same depth: they do not both reveal one plane. The nearest plane, which they pierce, is the major element in the composition and it is a

**109**
*1934 (white relief).*
Oil on carved board,
34.9 × 61 cm
Private collection

**110**
*1934 (relief, version 1).*
Oil on carved board,
20.3 × 30.5 cm
Private collection

very complex shape – all straight lines and right angles, but hand done, not exact – with no name and not easy to remember because it is an odd form lacking any sort of logic. At the top, left of centre, we see a strip that must be part of a plane behind this first one. It may or may not continue in the plane we see, behind the first one too, in the bottom left area. If they are one, then somewhere, hidden, are a couple of angles or perhaps a non-rectilinear growth from its width at the top to its wider dimension at the bottom. We gauge the depths by the widths of the shadows, which means that we have stronger convictions where the shadows are clear and none at all where there are none, as above the circle. Given the idiom of rectangles and circles, the all-over shape of the work is quite strange, but it is then tied together, so to speak, by the rectangular board on which the carving is mounted. The *1934 (white relief)* [plate 109] of an in-between size – only seven times the small relief in area – is much more succinct, though it turns out to be more complex than the first glance suggests. On the left a vertical rectangle, almost a square, on the right a circle, both negative. The

circle is cut into a raised rectangle that says it is a square until we look hard and find that it is a horizontal oblong. The circle is placed so near to its top edge that it seems in danger of breaking it. The rectangle on the left does in fact go to the edge of the relief and thus break its framing function. The placing of every element, in spite of the all-over neatness, appears arbitrary when we question it: no dimensions, no margins seem to match one another, so that even so concentrated a composition as this is revealed to be essentially loose.

This sort of conceptual analysis is tiresome in words but in truth reveals the heart of the work. In experience it is what the reliefs are about, once one has confronted their luminous clarity. Their meaning centres on the play of fact against sensation, knowledge against enlightenment through perception. All-over size and internal scale are very important. Some seem mighty, some more delicate: all are beautiful. None of them is 'constructive' if the word is associated with Constructivism. That stands for a logical, intelligible process of design and making. BN's process is wholly intuitive. He

**111**

*1934 (white relief).*
Oil on carved board,
55.8 × 80.5 cm
Ivor Braka Ltd

**112**

*1934, October 2
(white relief – triplets).*
Oil on carved board,
120.5 × 60.9 cm
Private collection, on
loan to High Museum
of Art, Atlanta

would certainly have thought himself far from the original, Moscow-centred, camp of Constructivism with its emphasis on the efficient use of available materials and on practical applications. In 1946 he found it necessary to distance his work and Hepworth's from 'Constructiv*ism*', adding, 'Constructive is a different matter, not a label but a covering of all the things one likes in all arts past & present.'[28]

It is said that many of the reliefs, and sometimes forms in them, come close in proportion to the classical ratio known as the Golden Section. This may be true but does not tell us much. A keen-eyed artist like BN would tend to find satisfaction in relationships that approximate to some of those consciously honoured in classical design. Many a lesser artist has been shown to have divided a composition – say, put his horizon in a landscape painting – where the Golden Section would place it. Perhaps it proves a 'good eye', or 'taste'. In the case of BN, for every form that suggests the Golden Section there are many others that cannot be allocated any specific proportion. He avoided exact squares. As far as we know he embarked on these carvings without

predetermining their appearance, and made his decisions as he worked. The material may at times have influenced his action, some boards being thicker and/or harder than others, but we cannot think of him working on the reliefs with the same freedom to respond to the character of the material that Hepworth enjoyed sometimes and Moore often. His materials and tools would not have allowed for that. But for BN to arrive at these deeply satisfying results implies a process of profound thought or concentration, including periods of contemplation, persisting through the long and, one would have thought, wearisome handwork demanded by cutting and digging and filing and smoothing or texturing the forms. The point is that his attention must have gone very largely into the physical process; the thought or, as he called it, the idea, would develop as he worked, and perhaps re-form, become more complex or simpler, though always within the fine limits he set himself. The physical and the mental must not be seen as separate; they can function as complementary opposites. The hard-worked product, its material form determined, is then invested

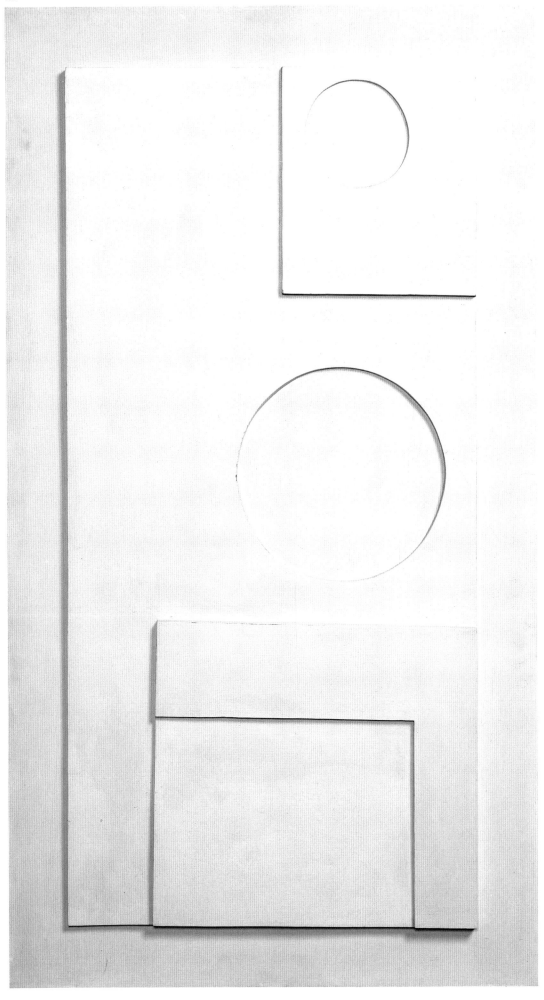

The 1930s

in its alb of white paint and thus ordained to spiritual status.

By 1935 BN was using instruments to make his compositions more exact, but merely rulers and compasses. The Tate Gallery's *1935 (white relief)* [plate 115] shows both the new exact and the old free-hand methods; it is also the largest relief done up to that date. It is a highly complex work. To draw attention only to one of the many built-in uncertainties: the two recessed circles, close in size, appear to be the same depth, judging by the shadows cast within them. It is possible that the circle on the left reveals the back plane of the relief, i.e. that which we see in the bottom corners, right and left, and along most of the top of the relief – but, on second thoughts, can we be sure that those visible areas are all part of one plane? The circle on the right must pierce deeper, to some other stratum. Emphatically oblong, the relief feels stretched in the horizontal dimension; to some people it seems that the panel in which the smaller circle is located has been slid out of the thicker part of the relief to its left. Edinburgh's *1935 (white relief)* [plate 114] is much smaller and consists of remarkably few elements – a circle and

a rectangle that is almost a square, cut into (out of?) an encompassing rectangle. The negative rectangle is taken out of the left bottom corner of that, so that it seems both there and absent at the same time. The surface revealed is textured and thus different from that revealed by the circle; in any case, the shadows suggest that one is deeper than the other. Thus three elements are brought into uncertain relationships – or should we say five elements, since the planes shown by the circle and the squarish rectangle also ask to be distinguished?

The reliefs did not progress in any definable way. Very small ones always have a quality of innocence or charm that the more monumental counter with their epic weight, in spite of the sense of lightness these give at first encounter, especially when seen among other works of art. Some reliefs appear to be content to present their basic forms in a basic manner; others announce more eccentric arrangements. One is tempted to speak of one sort as being freer than the other but since the directness of the former turns out to be illusory one ends in thinking of them all as essentially free inventions,

**115**
*1935 (white relief).*
Oil on carved
mahogany,
98.9 × 164.9 cm
Tate Gallery, London

**116**
*1936 (white relief)*.
Oil and pencil on
carved board,
54.5 × 70.5 cm
Private collection

**117**
*1936 (white relief)*.
Oil on carved board,
73 × 99 cm
Private collection

made within narrow limits (like Mondrian's paintings of the 1920s and 1930s) but not predicted nor predictable. BN always spoke of art being a realization of the artist's 'idea', but working through examples of his use of that word one is forced to conclude that the idea is the work, the whole work and nothing but the work, not a separate or separable formula or parable that can be summarized in words. Perhaps it would be true to say that for him the 'idea' is that which gives life to a work of art yet cannot otherwise exist. The reliefs have no ulterior function and thus cannot be justified by it. All they have to attain, in his judgement, is that quality of life, and in this they are not essentially different from his earlier or subsequent openly figurative art.

If *1934 (white relief)* [plate 109] was exceptionally succinct, this is even more the case with *1936 (white relief)* [plate 117]. More than three times the size of the other, this shows a circle and something very like a square (actually slightly broader than high) on an otherwise uninflected and comfortably proportioned rectangle. It seems the most severe of all the reliefs, yet there is the usual gamut of

irrational arrangements. The relative sizes of the negative circle and the positive 'square'; their placing in and on the ground rectangle, rather higher than one might have expected, so that they seem sometimes to float in spite of their material positive and negative presence. The gaps between them and between them and the edges of the big rectangle are inexplicable: they do not relate to any other measurements, just as the proportions of the big rectangle are not those of the Golden Section nor of any other time-honoured ratio – a ratio of approximately 1:1.35; the Golden Section is approximately 1:1.6. Yet the work announces itself as a final, definitive pronouncement.

Another *1936 (white relief)* [plate 116] is almost as severe though it embodies more distinguishable elements and even breaks what one would have thought was one of the rules of the genre. There are a circle and a square: the circle is hollowed out of the square. Both seem to come towards us, on account of their position a little to the right of centre and also because the rather shallow plane forming the square is projected from another square (in fact rather taller than

The 1930s

**118**
*1934 (relief)*.
Oil on carved board,
38 × 15.2 cm
Private collection

**119**
*1936 (white relief)*.
Oil on carved board,
178 × 73.5 cm
Gimpels Fils

wide), which itself comes forward from the oblong base rectangle. Its proportions are again what I call 'comfortable'. We are surprised to find on it a drawn horizontal line, in effect a shadow line that is not a shadow line. Since we tend to read it as a shadow it may be accused of creating an illusion, and thus to be a departure from the 'real space' exercise the white reliefs are often said to be about. BN never said that they were about using real space as against the virtual space of perspective or interacting colours. It seems unarguable that the life of the reliefs lies specifically in the perceptual tensions caused by their illusory appearance of clarity. The apparently finite becomes infinite, the self-evident reveals itself as infinitely mysterious and ungraspable. The one more or less clear thing he said about them related to his mother's response to art talk: 'I think my reliefs are not unlike scrubbing the much scarred wooden kitchen table.' Writing to Read in 1946 BN associated the 'severity' of these works with his feeling for his mother: 'She gave up her promising painting and put all her creative powers' into her children: '*I owe absolutely everything to her.*'[29] One is tempted to see

them as acts of homage and, perhaps, reparation, to the mother who died when he was twenty-four and far away. Perhaps also as bulwarks against that painful fact: she left him when he was still quite uncertain about who and what he was, in the shadow of his vivid father and his preferred brother. Then Tony died in the war. Marrying Winifred may have been an act of restitution as well as of self-definition. Doing so he entered on the path that led to this first climax of his career.

One of the most powerful white reliefs is the tall *1936 (white relief)* [plate 119]. He had made a vertical white relief in 1934 and associated it in its title with the triplets born to him and Barbara that year [plate 112]. This relief is bigger, the height of a fairly tall person, and it is a remarkably complicated work. Like a stone monument, it steps back twice as we read our way up it; it is strongest at the bottom, where a monument would meet the ground. The upper half has a base rectangle which is seen only as a margin on the right and at the top. On it is a rectangle which steps forward to become the main feature: a vertical area with a circle

The 1930s

**120**
*c.1937-8 (white relief).*
Oil on carved
mahogany,
64.1 × 125.6 cm
Albright-Knox Art Gallery,
Buffalo (gift of Seymour
H. Knox, 1960)

**121**
*1934 (white relief).*
Oil on carved board,
27.5 × 15.5 cm
Private collection

The 1930s

The 1930s

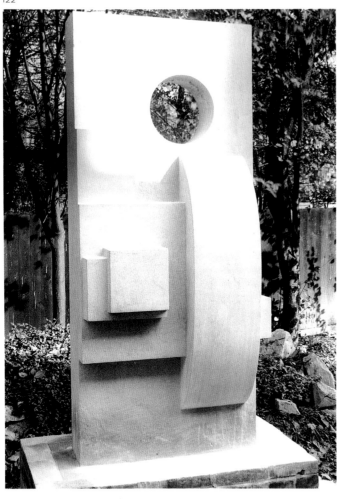

122

**122**
**Barbara Hepworth**
*Monumental Stele*,
1936.
Blue Ancaster stone,
height 182.7 cm
(damaged in war and
destroyed)

**123**
*c.1936 (sculpture)*.
Painted wood,
228 × 305 × 241 cm
Tate Gallery, London

hollowed out of it, perhaps revealing the plane of the base rectangle. Such events are familiar from the reliefs we have already discussed. What is here so surprising that one doubts one's eyes is the fact that neither the bottom line nor that at the top is horizontal. Nor, in fact, are they straight, both giving a suggestion of concavity to the planes they terminate. As far as the eye can tell, the top plane is indeed dished. Looking again, we discover that the whole relief is not rectangular at all but is narrower at its slanted and thus not very monumental bottom than at the top. Hepworth made a rather similar vertical carving in the same year, her *Monumental Stele* [plate 122] in blue Ancaster stone; slightly taller than BN's relief, it was destroyed in the war. Both works have something totemic about them. Hepworth's was quite massive, with deep projections, a relatively small circular hole near the top and, below it, a broad band of stone rising from the main face of the stela to bridge over horizontal rectangles. This muscularity distinguishes the Hepworth sharply from the BN which, for all its complexity, reasserts itself as a visual rather than a physical encounter.[30]

In and around 1936 BN tried his hand at three-dimensional works that have to be called sculptures. He had previously enjoyed making utilitarian things into works of domestic art, as when he printed his own textiles for Banks Head from linocuts or carved and part-coloured the lid of a box as a white-and-red relief in 1933. But these are sculptures, nothing else. A small one in plaster sticks to the circle plus square or rectangle formula and uses it quite subtly, with the recessed circle for once a dished form rather than an opening to a plane. The larger *c.1936 (sculpture)* [plate 123], in the Tate Gallery, is a composition of rectangular solids in wood, painted an off-white that makes one think of stone. It is the nearest BN comes to Constructivism in that it has the quality of logical assembly: one feels that, given the right key, one would be able to unlock it, releasing the half-dozen integral elements that grouped themselves together to make the sculpture.

The white reliefs continue without loss of energy into 1939. *1938 (white relief)*, in the Kröller-Müller Museum [plate 124], includes a surprising circle, not carved but firmly

The 1930s

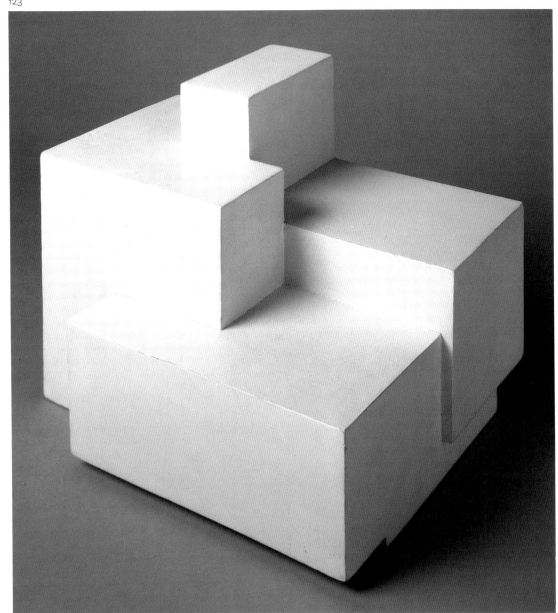

The 1930s

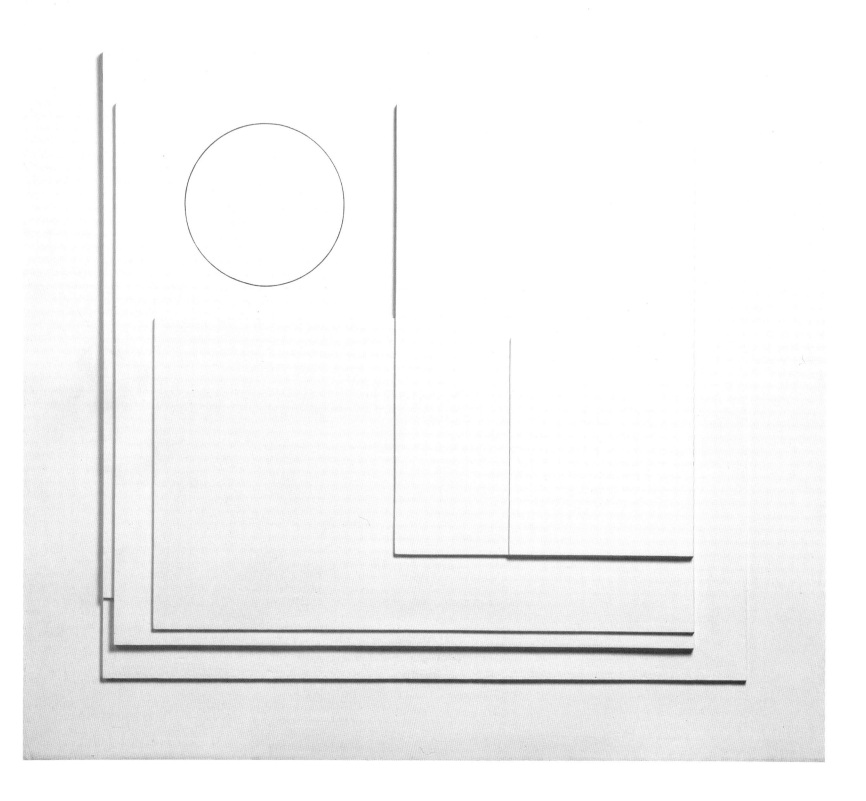

The 1930s

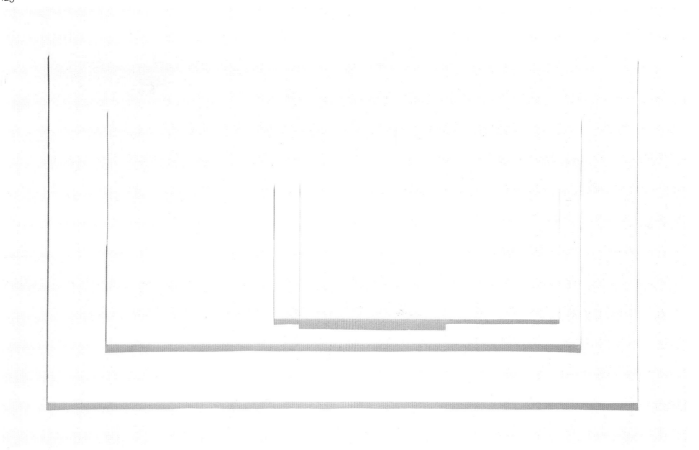

inscribed in pencil on the painted board. This draws the eye away from the particular complexities of the relief, where the base rectangle itself seems disrupted by changes of plane. The plane that bears the circle appears to be square but we are allowed to see only a small part of it and assume from force of habit that it continues under the three smaller rectangular forms projecting from it. Lewison sees the drawn circle as indicating the return of 'illusionism' into BN's work. We noted a drawn line in *1936 (white relief)* [plate 116] and how it can be mistaken for a shadow line. This misreading cannot happen here because the shadows in recessed circles do not fall in this even way. But we do experience a perceptual/conceptual tension between the composition and divergent readings of its constituents, between the facts and the illusion, as we do throughout the series.[31] Confronting the Hirshhorn's *1938 (white relief – version 1)* [plate 125] is a relatively simple matter. It is strong and calm, a reassuring horizontal work consisting only of rectangles, the most prominent of which looks very much a square (but is wider) while another must be an L-shape (and another could be).

The prominent 'square' is located at the aesthetic centre of the work, i.e. a little to the right and below the geometrical centre. One wonders whether BN had intended to give this work too an inscribed circle, possibly in the upper left area again. Lacking a curvilinear element, it has a monumental gravity unique in the series.

BN had not ceased painting during the years of the white reliefs and he never ceased to draw the world. At no point did he renounce two-dimensional work. Had he claimed to be a Constructivist that could have been read as a rejection of painting. His statement in *Circle*, headed 'Quotations', is the last and most concise text in the 'Painting' section, and it could not be further from such a claim. Here it is, in full:

1. It must be understood that a good idea is exactly as good as it can be universally applied, that no idea can have a universal application which is not solved in its own terms and if any extraneous elements are introduced the application ceases to be universal. 'Realism' has been abandoned in the search for reality: the 'principal objective' of abstract art is precisely this reality.

2. A different painting, a different sculpture are different experiences

**126**
*1938 (white relief)*.
Oil and pencil on
carved board,
57 × 59 cm
Private collection

**127**
*1939 (white relief)*.
Oil and pencil on
carved board,
77.4 × 73.6 cm
Private collection

just as walking in a field or over a mountain are different experiences and it is only at the point at which a painting becomes an actual experience in the artist's life, more or less profound and more or less capable of universal application according to the artist's capacity to live, that it is capable of becoming a part, also, of the lives of other people and that it can take its place in the structure of the world, in everyday life.

3. 'Painting' and 'religious experience' are the same thing. It is a question of the perpetual motion of a right idea.

4. You cannot ask an explorer what a country is like which he is about to explore for the first time: it is more interesting to investigate the vitality of the present movement than to predict its precise future development; a living present necessarily contains its own future and two things are indisputable – that the present constructive movement is a living force and that life gives birth to life.

These epigrammatic statements distance him from almost all the claims made in the book, particularly anything that could be understood as defining the future. He is at one with other contributors in asserting that the art presented in the book, in not taking its subjects from the visible world, aims at a truer kind of reality. Only he says it more pointedly. And where they

mean the material reality of the elements of art and what they convey without recourse to literary subject-matter or illustrative references to the natural world, the reality he refers to is of a non-material sort. In his few words he takes us on to a different plane of discourse, speaking of a work of art almost like a priest speaking of divine grace. The third paragraph is wholly against the grain of the book. Even Winifred's eloquent essay, 'Unknown Colour', avoids any reference to religion or transcendental thought; the nearest she comes to that is when she uses a capital letter in speaking of music's discovery 'by the Spirit of man'.[32]

In 1935 BN had insisted that the Seven and Five show should be exclusively of abstract art. His 1937 show at the Lefevre Gallery included still-life paintings referring fairly directly to the visible world. He had not in fact worked exclusively on his abstract reliefs during these years. In 1934 he embarked on a set of designs for a ballet to be created based on Beethoven's Seventh Symphony. This was probably not a commission but rather a project that formed in his mind through getting to know Leonid Massine, then in London as

The 1930s

**128**
*1934 (white relief).*
Oil on carved board,
20 × 25 cm
Private collection

**129**
*1934 (act-drop curtain
for Beethoven
7th Symphony ballet).*
Oil and pencil on
board, 25 × 28.5 cm
Private collection

**130**
*1939 (white relief –
version 2 – décor
for Beethoven 7th
Symphony ballet,
4th movement).*
Oil on carved board,
38.5 × 49.5 cm
Norton Simon Art
Foundation, Pasadena

The 1930s

The 1930s

131

*1934 (still life – Italian).*
Oil and pencil on
canvas, 32.7 × 70.9 cm
Private collection

132

*1933-5 (still life with
bottle and mugs).*
Oil and gesso on
board, 49.5 × 59.5 cm
Private collection

the Russian Ballet's leading dancer and choreographer. BN
may well have caught the passion for ballet from Stokes. He
certainly enjoyed Massine's animal vitality and is known to
have admired his driving. The fact that Massine contributed
an essay on choreography to *Circle* may have been BN's
doing, and perhaps he was the unnamed individual who
supplied Massine with questions he in part answered in his
piece. It ends with a sentence that could almost be BN's: 'I
think that political tendencies do as much harm to politics as
to the dance.'

BN made a design very much in the manner of his first,
relatively informal reliefs of 1932-3 as an *act-drop curtain for
Beethoven 7th Symphony ballet* [plate 129]; it is reproduced
in colour in the 1948 Lund Humphries monograph with a
caption that adds '(designed for L. Massine)'. BN also made
what he called a *sketch* for what may have been thought of
as another curtain but could equally be the artist's
suggestion for abstract forms to be moved about or worn by
dancers, much as some of the Bauhaus's dances involved
hiding the dancers' figures in or behind abstract forms. BN's

forms are not unlike those of goblets and other still-life
objects, though less specific. He also made an abstract relief,
presumably as a backdrop; this exists in three versions with
dates that vary up to 1939 [plate 130], suggesting that BN
valued the composition even when the thought of a ballet
had long passed.

During 1935-6 he reworked still lifes he had started
around 1930. *1933-5 (still life with bottle and mugs)* [plate 132]
involves some relief in his use of a thick gesso ground and
digging back into it through the dark brown paint. The white
lines and patches dominate the picture so that it has
something of the quality of a negative engraving. A table top
forms a rough rectangle on the picture surface and on it we
see bottle, glass, mug, jug and other objects, set in profile
against that rising rectangle. Large curved lines cut across
them, hinting at a bowl and other objects. A line sloping
down and a rising line meet in a right angle on the mug firmly
established lower right, and do not seem to belong to any
particular object. The wavy lines we see at the top also
appear to be independent of the still life, but recall lines in

**133**
*1929-35 (still life)*.
Oil and pencil
on canvas, 66 × 81 cm
Private collection

**134**
*1932-40 (still life)*.
Oil and pencil on
canvas, 54 × 67 cm
Pier Arts Centre,
Stromness, Orkney

*1932 (painting)* [plate 69] and may be read as a distant landscape. The near-black/white contrast recalls the 1934 woodcut, abstract yet suggesting a still life [plate 103].

In other paintings of the time BN presented still lifes with something of the severity and precision that went into his white reliefs, in some cases with exact pencil lines drawn with compasses and rulers, substituting for the physical edges in the reliefs. In *1931-6 (still life – Greek landscape)* [plate 135] gentle colours and tones are played against sharply established forms, most especially the rectangular forms of the table and table legs, and other straight lines in the outer areas of the painting as well as within the table-top area. Similarly, dark areas and shapes we read as shadows give a sense of three-dimensionality though the composition as a whole emphasizes flatness. Other paintings use the same abstract formal language as the reliefs. *1935 (painting)* [plate 139] is almost colourless. Its rectangular areas are black or white; the circle and the surrounding margin are an off-white or ivory colour. As a composition this has the succinctness of some of the reliefs but also an added

element of drama because of the subtle colour contrast in it. This mutes the contrast between the opposed black and white and the much less readable, unnameable colour of the rest.

In the Edinburgh *1937 (painting)* [plate 143] a still life is presented in terms of rectangles only and without any suggestion of space other than that inferred by the assumed overlapping of coloured planes, all on a pale brown form we easily identify as a table. The still life's colours here are the bright ones we associate with international abstraction: white and black, and the three primaries, red, yellow and blue, plus two areas of grey and a creamy grey, and areas of blue, a light blue and an even lighter blue, on the right. To be more precise: there is a primary red and a primary yellow, and there are three blues none of which has the presence of primary blue (though of course there is no absolute correctness in pigment colours, as opposed to light colours). These coloured forms make a group, and one calls it a still life because it is so clearly presented on a table, and the table is set against another, rather reticent, colour and thus has a

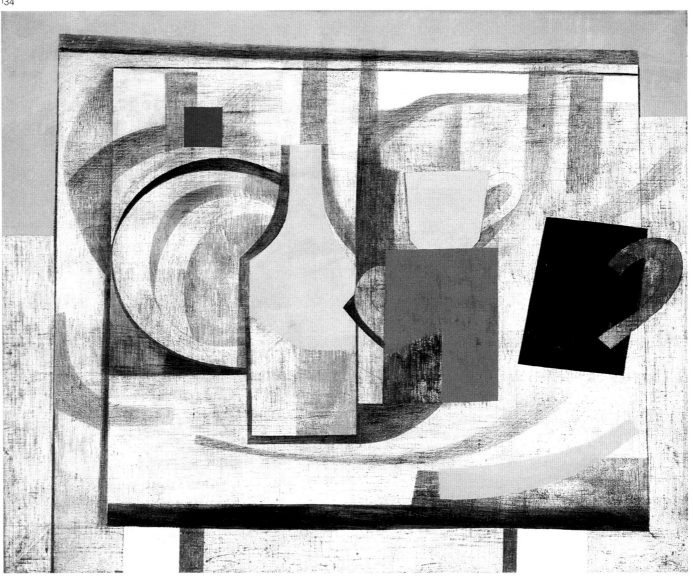

The 1930s

**135**
*1931-6 (still life –*
*Greek landscape).*
Oil and pencil on
canvas, 67.9 × 76.1 cm
The British Council

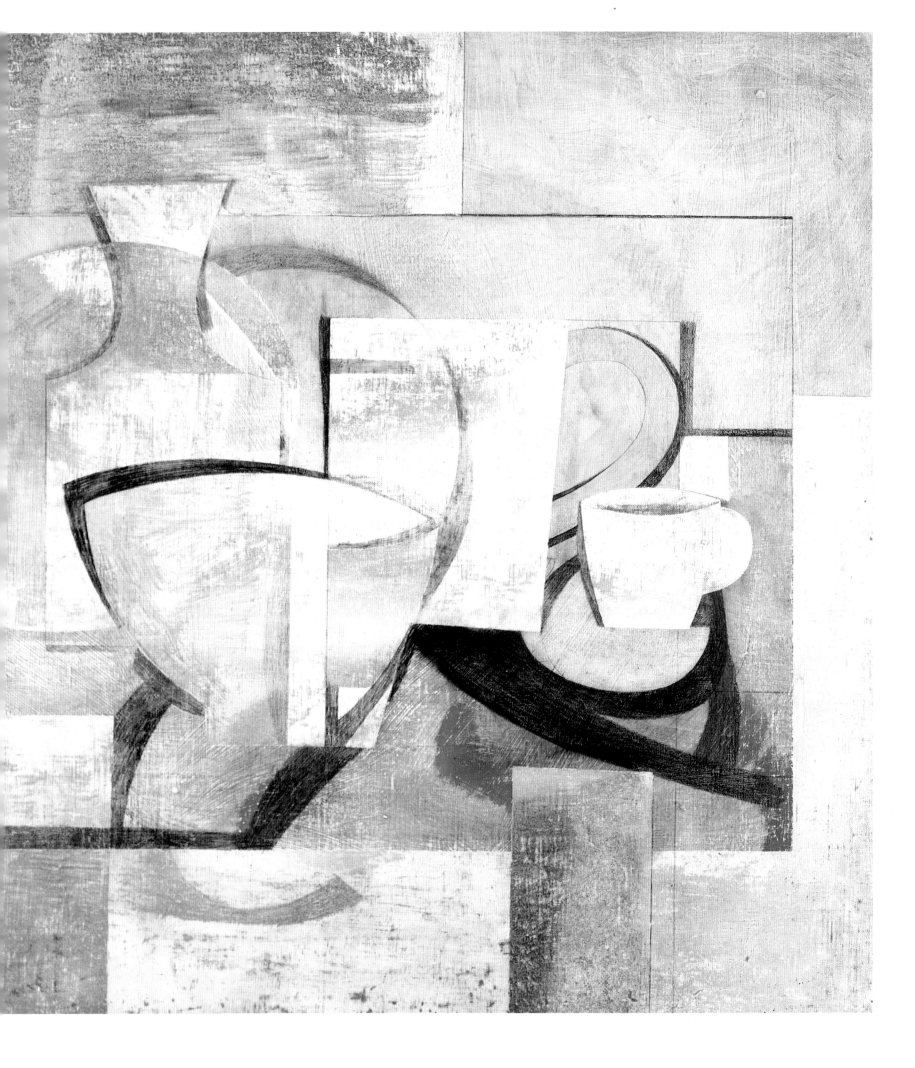

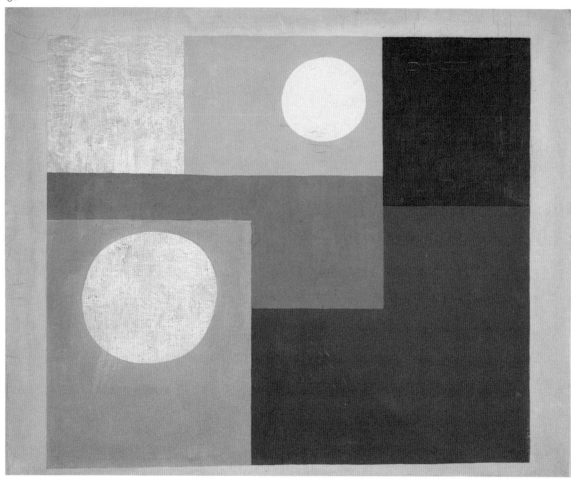

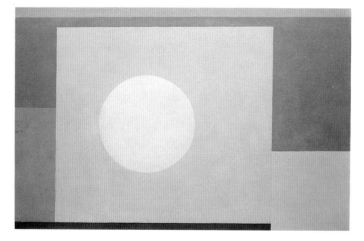

**136**
*1934 (painting).*
Oil on board,
37 × 45 cm
Pier Arts Centre,
Stromness, Orkney

**137**
*1935 (painting)*
Oil on canvas,
62.3 × 93 cm
Private collection

**138**
*1934 (painting).*
Oil on canvas,
72 × 101 cm
Kunstmuseum,
Düsseldorf

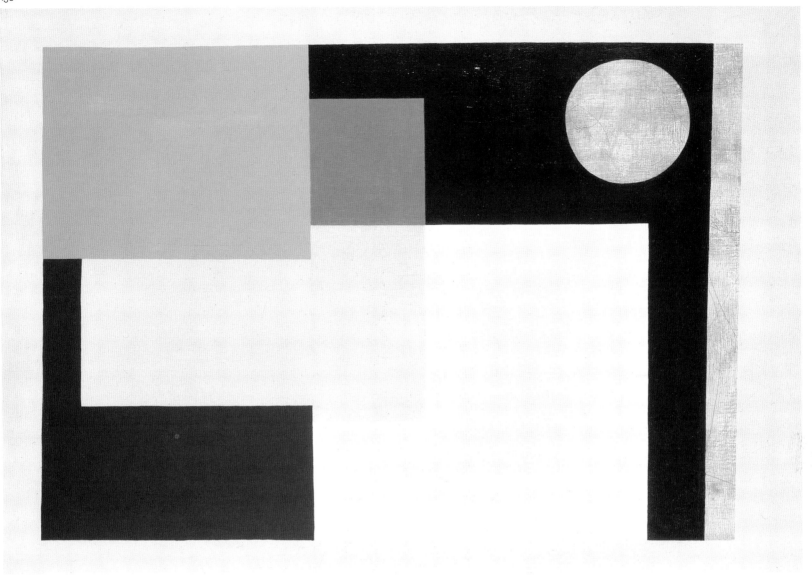

The 1930s

The 1930s

**139**
*1935 (painting).*
Oil on canvas,
101.6 × 105.4 cm
Private collection

**140**
*1939 (painted relief).*
Oil on carved board,
102 × 96.5 cm
Pier Arts Centre,
Stromness, Orkney

The 1930s

**141**
*1937, June (painting).*
Oil on canvas,
159.5 × 201 cm
Tate Gallery, London

**142**
*1937 (painting).*
Oil on canvas,
79.5 × 91.5 cm
Courtauld Institute
Galleries, London
(Hunter Bequest)

**143**
*1937 (painting).*
Oil on canvas,
50.6 × 63.5 cm
Scottish National
Gallery of Modern Art,
Edinburgh

The 1930s

**144**
*1939 (composition).*
Oil on canvas,
53.3 × 68.5 cm
Private collection

**145**
*1936 (painting –
cadmium red, lemon
and cerulean).*
Oil on canvas,
176.5 × 107 cm
Private collection

The 1930s

The 1930s

The 1930s

**146**
*1936 (gouache).*
Gouache on card,
38.1 × 50.2 cm
Victoria and Albert
Museum, London

**147**
*1939 (painted relief).*
Oil on carved board,
38 × 66 cm
Marlborough
International Fine Art

148
*1938 (relief).*
Oil and pencil on
carved board,
38 × 48.2 cm
Private collection

**149**
*1939 (relief off-white).*
Oil and pencil on
carved board,
48.2 × 38 cm
Private collection

background. Is this an abstract painting with characteristics that make one see it as a still life, or is it a still life the constituents of which have been rendered abstract without abandoning the representational formula?

Similar bright colours in a framework of quiet greys and buffs make up paintings such as *1937, June (painting)* in the Tate Gallery and *1937 (painting)* in the Courtauld Institute Galleries [plates 141 and 142]. For BN to adopt such a strong colour range combined with rectangular forms is surprising in an artist much of whose work testifies to his delight in textures, transparencies, suavely modulated tones and hues and general mobility. He has stepped into the world of Mondrian and Calder. But then, just as with the reliefs, we find that BN's clarity and directness are misleading. Both these paintings are organized in terms of what, in the reliefs, we called a base rectangle, in the Tate picture a cool grey L-shape, in the Courtauld picture a warm grey L-shape, which we tend to read as the visible part of a rectangle *on* which BN has located his smaller elements in brighter colours. There is also a margin or background colour, greys of two

different sorts. But this is disturbed in its supportive function by L-shapes (or rectangles) of deeper greys, top left in the Tate picture, top right in Courtauld picture. The effect of these corner pieces is to project the base rectangle and its burden forward, sending them hovering in front of the picture surface – not in physical fact but in the fact of experience. But then space is made quite emphatically where he uses these L-shapes, in both pictures, switching what seemed to be a flat, interlocked arrangement of colour areas into three-dimensionality.

The extent to which the base rectangle in these pictures serves as a kind of table top becomes clearer if we consider a painting in which there is none because there is no margin or background: the base rectangle is the whole painting. A strong instance is the Victoria and Albert Museum's *1936 (gouache)* [plate 146]. This strikes one as furthest removed from the spatiality of a still-life composition, and as the most self-evidently pure composition of juxtaposed rectangles. But here too there are L-shapes, inevitable notions of overlap and thus virtual space. Also, making the top edge of the central

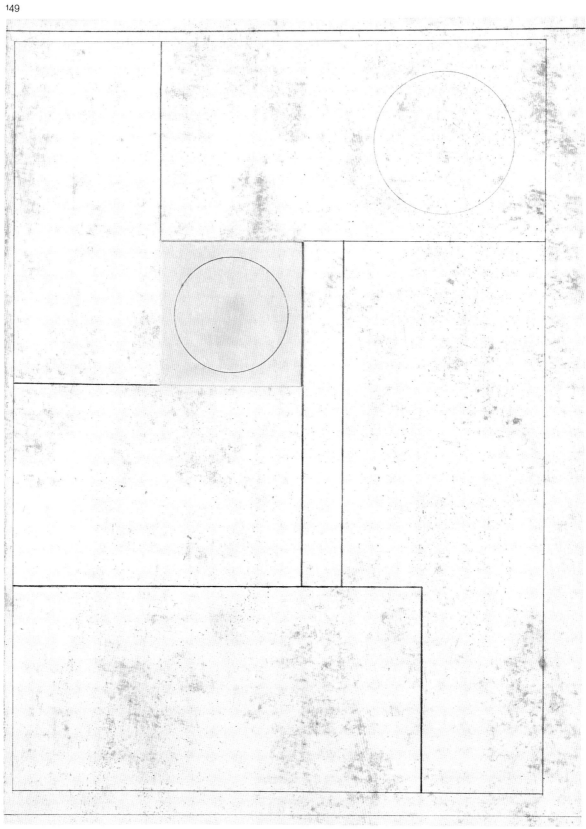

The 1930s

*1939 (painted relief –*
*version 1).*
Oil and pencil on
carved board,
83 × 5 × 114.5 cm
Museum of Modern
Art, New York
(gift of H.S. Ede and the
artist (by exchange))

black and red elements higher than the bottom edge of the black area on the right produces an effect of projection.

A terminus in the first great series of reliefs is reached with the Museum of Modern Art's *1939 (painted relief – version 1)* [plate 150], previously the property of H. S. Ede.[33] It would be interesting to know for certain when, in that year of changes, BN completed it. It is a two-part composition, right and left, an arrangement found also in other works of around that time but intimated earlier in such works as the Tate's *1935 (white relief)* [plate 115]. BN's normal way, by contrast, was to centre his compositions in the classical manner followed also by Cubism and much Modernism (but not always, *inter alia* by Arp), or to present a frieze-like array without a focal centre. The new relief has two centres and could be a pair of compositions. But what is particularly striking about it is the colouring. After years of white reliefs and then also of paintings characterized by fresh colours dominated by primaries, he used here a stone-like grey as the dominant colour and small areas of green and deep Indian red as – one is tempted to say – jewels in the

ensemble. White is there too, but as a background colour in the left half, apparently demoted but effective in enlivening the whole work. Before the end of 1939 BN and his new family left London for Cornwall in expectation of war and aerial attack on the city. In Cornwall he partly returned to landscape painting, and one wonders whether the colouring of *1939 (painted relief)* announces that return. Had he painted it white, perhaps complete with pencilled circles, before covering most of the white with this more earthly garb?

We have touched on but not confronted a key question regarding the 1930s reliefs: how abstract are they? They have always been seen as abstract, and their abstractness has been treated as a primary fact by admirers and critics. After the 1920s, when British art hovered on the edge of Europe and at the frontiers of Modernism, BN seized the moment, putting himself at the forefront of an avant-garde tendency as yet uncertain of its direction, and enrolled it under the banner of 'Constructive Art': international and impersonal, associated with established new tendencies in international design, and promoting timeless aesthetic values through its

abandoning of realism for reality. Already in 1932 he had been questioned by *Studio* magazine about his abandoning the goal of 'faithful rendering of natural objects'. He replied that there had never been such a thing as that 'faithful rendering', but then, asked 'by what standard are we to judge?', answered: 'Why not judge it as you would a piece of music or any other abstract idea, by its capacity to reveal to you some new quality of truth?' The problem he gave critics was not whether or how much his work should be seen as essentially abstract but whether his abstract art was sufficiently charged with personality and meaning for it not to be accused of decorative vacuity. He stressed that the new art was not there to destroy the old but as 'the natural unfoldment of it'.[34]

That the reliefs represent an 'unfoldment' of his own art is unarguable: the physical nature of, particularly, his still-life paintings, his appetite for creating light, the unmistakable echoes of still-life structures in the reliefs, and so on, all argue for development rather than a new start. In any case, his constructive vision dominated over the objective facts of

the subject before him almost from the first, certainly from 1920 on. He himself, as we have noted, spoke of the new works in two ways: their reality as objects, with built-in recollections of his mother's kitchen table, and their symbolic presentation of universals and transcendental implications: 'what we are all searching for is the understanding and realisation of infinity. … Painting and carving is one means of searching after this reality, and at this moment has reached what is so far its most profound point,' he wrote in 1934.[35]

Yet in the early 1950s BN privately spoke of his white reliefs as akin to a breakfast table: the circle is the cup, the rectangle a breadboard, another rectangle a newspaper, the base the table.[36] We need not take these identifications too literally or as wholly specific: the point is that in presenting those forms in those ways he was not denying their origins or associations. It can be argued that all forms of abstract art refer us back to forms of figurative art, to the genres distinguished in the Renaissance on the model of Greco-Roman literary forms and defined and set in a hierarchy of esteem by French art theory in the seventeenth century.[37]

With those distinctions went formal expectations. History paintings were normally large and imposing, and executed in a grand classical manner; low genres such as landscape and still life were expected to serve mostly as decorations and could be more relaxed in style; often done for specific locations, they could also be many shapes in order to fit into the décor of a room. The nineteenth century saw much mixing of the genres, partly to refresh them, partly to break down the hierarchy and its implications in the name of democracy. The academies' continued assertion of the genres and the proprieties they required were under attack, yet to give a peasant burial the character of a grand History painting, as Courbet did in 1850, is also to reassert the priority of History painting as a form of communication. Many of that century's avant-garde achievements were made in landscape and still-life painting, and Cubism was predominantly a further development in still life. Mondrian's Neo-Plasticism had grown more directly out of landscape painting, rural and urban. BN's abstract art of the 1930s adheres to the still-life form. This does not preclude its transcendental spirit. The

essential point is that he himself, when not feeling the need to insist on its abstractness before a dismissive public, knew the basis of his abstract art.[38]

In terms of Modernism the association of still life with monumental abstract art in BN's reliefs of the 1930s – and later also the association, as we shall see, of landscape with his abstract reliefs – make us aware that he was fusing genres, and here in a particularly bold and significant way. Courbet used the History painting format to claim for everyman the full dignity of art. The geometrical abstraction BN adopted and adapted came to him from such pioneers as Malevich and Mondrian and is associated with art's loftiest ambitions. It is the twentieth century's History painting. Malevich painted icons in simple abstract forms in order to be able to address timeless, quasi-religious issues in mankind's relationship to the universe. Mondrian, similarly but separately, constructed his painted images out of black bands and blocks of primary colour, white and grey, as images of general relevance, incorporating every sort of visual experience in a way that brought out their positive, life-

**152**
*1938 (you can be
sure of Shell).*
Poster for Shell Mex
and BP Ltd,
75.4 × 113.5 cm
Victoria and Albert
Museum, London

enhancing power. Malevich made his move about two years
before Russia experienced her long-expected revolution;
Mondrian took the essential step in 1917 when, not many
miles away from where he worked in neutral Holland, the
young men of Europe were dying by their thousands in the
mud of Flanders; he finalized his Neo-Plasticist idiom during
the first post-war years.

BN's abstract reliefs show him adopting the most serious
idiom in Modernism, and in pursuing them and, for a time,
making them his brand image before the world he was
dissociating himself from the anarchism, and sometimes also
the passionate Marxism, of the Surrealists. The whiteness of
his reliefs together with their apparent formal purity confirms
the status of that idiom. Self-evidently they belong to a
nobler class of discourse than the friendly still lifes and
landscapes and the honeymoon invocations of love. In
admitting, then, to the reliefs' essential kinship to still-life
compositions, he could be accused of lowering the tone not
only of his own reliefs but of the class to which they
belonged, and perhaps this made him assert their distinction

on some occasions. But that does not make the admission in
any way self-denying or trivializing. It reveals his refreshingly
broad view of what matters in the world. We saw it already
in his text for *Unit 1* where, within a few lines, he turns from
saying art is making something that 'pleases you ... more
than anything has ever pleased you before ... a living thing
as nice as a poodle with 2 shining black eyes', to asserting
that 'painting and religious experience are the same thing'.
We may say that these are two distinct categories of
statement, commonplace and elevated; we may also prefer
to see them as two approaches to one entirely human need,
the reception and the experiencing of joy.

That during these years BN and artists around him bent
their minds to commercial advertising should not surprise us.
They needed money – the Nicholson-Hepworth family was
in severe straits, and both BN and Hepworth were willing to
undertake commercial design work, for knotted rugs and
printed textiles among other things [see plates 155 and
(later) 220] – and they were eager to make contact with
a wider public. That had been an aspiration voiced by *Circle*

FASTER EMPIRE AIR SERVICES
FLY TO
EGYPT IN 30 HOURS
SOUTH AFRICA IN 5 DAYS
INDIA IN 3 DAYS
SINGAPORE IN 5½ DAYS
AUSTRALIA IN 8 DAYS

IMPERIAL AIRWAYS

**153**
*1938 (faster air services).*
Poster for Imperial Airways,
98.2 × 60.4 cm
Victoria and Albert Museum, London

and implied by Unit One. Advertising would call for a special idiom but the example of the American-born Edward McKnight Kauffer had already shown that unflinchingly Modernist design could produce posters welcomed by adventurous people in commerce and also abreast of the most avant-garde international art. A commission came to BN in 1938 from Marcus Brumwell and the Stuart Advertising Agency. What was required was a poster for Imperial Airways featuring the words *faster air services*. BN produced a powerful image, with a red disk on blue for our planet and a firmly abstracted aeroplane form seen twice, soaring over the disk and appearing again below, in the text area of the poster. Everything in it was asymmetrical and dynamic; the means were strikingly minimal for the date. The text varied in language and information depending on the public it was addressing: for London, 'Fly to EGYPT in 30 hours ...'; for Rome, 'GRECIA in 5 ore di volo EGITTO in 10 ore di volo', and so on [plate 153].

Shell Mex and BP Ltd, formed in 1932 as the United Kingdom marketing branch of the international Shell Group,

had an energetic and knowledgeable advertising manager in Jack Beddington, and he had found in offset lithography an efficient means for producing lively printed images from originals worked in a variety of ways. Beddington commissioned posters from a range of young artists who included Graham Sutherland, John Armstrong, Tristram Hillier and, in 1938, BN. The idiom of the results varied widely and they must have been an entertaining as well as striking sight as, measuring approximately 76 × 114 cm, they were trundled about on the sides of lorries. BN's contribution is quite different from his Imperial Airways poster and belongs to the world of the humorous drawings with which he entertained his children and his close friends, often in letters. In 1937 he had provided images and designs for Alastair Morton, fellow abstract painter and founder of Edinburgh Weavers. These could be variations on his reliefs or a 'piece of nursery realism' as BN called it when he gave Morton the original painting in 1940. It is not far removed from his 1928 landscapes but is wholly flat, except for the spatial message we draw from changes of scale, and the shapes used are

The 1930s

**154**

*c.1930 (numbers).*
Linocut on cloth,
100 × 30 cm
Kettle's Yard,
University of
Cambridge,

even more simplified versions of nature while the colours are all light and cheerful [plate 155]. It was left to Morton to turn the image into a repeating pattern, and BN was eager to credit his friend with his important share in the result. The Shell poster, *You can be sure of Shell. These men use Shell* [plate 152], shows a guardsman in front of his sentry box, with tall railings and more distant classical and medieval buildings hinting at Whitehall and St James's Palace. The whole image is very much a drawing with colour and as printed retains excellently the freshness of BN's line and colours, including the broken area of black for the man's bearskin. There are no extraneous jokes: the humour is in the lines and the composition, and in the notion that such personifications of tradition, who stand or march or ride horses, should guarantee the excellence of oil and petrol.

BN will have welcomed the commissions for financial and career reasons and we need not assume he undertook them at all reluctantly. He had enjoyed printing textiles for curtains, bedspreads and cushions for home use in the early 1930s [plate 154]. In the 1940s he was happy to see some of the

blocks reused by his sister Nancy who printed his and her own designs for sale in her Belgravia shop. He was, in his way, connecting with his father's activity as a graphic artist, especially with William's brilliant and essentially humorous woodcut series that began with *An Alphabet* in 1896-7.[39]

Legally BN's marriage to Winifred ended on 28 September 1938. He and Barbara had meanwhile changed their names to Hepworth-Nicholson by deed poll, for non-professional purposes only. In 1934 they expected a baby and rented a little basement close to the studio to have some basic accommodation away from their work, and there their triplets were born, Sarah, Simon and Rachel. This abundant gift was a delight and a great worry, financially of course but also in invading their parents' time, principally, it must be said, Hepworth's. On 17 November 1938 BN and she were married at the Hampstead Registry Office in the presence of their fathers and with John Summerson, Barbara's brother-in-law, attending as a witness.[40] The correspondence between BN and Winifred, affectionate and concerned, continued until she died in 1981, and of course they met from time to time.

The 1930s

155

156

**155**
*1937 (George
and Rufus).*
Machine-printed
cotton made by
Edinburgh Weavers as
a nursery fabric from a
BN painting, one of
a series intended for a
children's book.
Edinburgh Weavers,
Bolton

**156**
*1938 (George
and Rufus).*
Oil and pencil on wood,
38.1 × 48.3 cm
Private collection

The 1930s

At the end of August 1939, just a few days before Britain declared war against Germany on 3 September, BN and Hepworth put their family into an old car and left a London threatened with bombing, and a glass-roofed studio, for Cornwall. Adrian Stokes had invited them to stay with himself and with the painter Margaret Mellis, whom he had married the previous year, in their newly acquired house at Carbis Bay. Come for a holiday, they had said; if the war starts you'll have to stay. Carbis Bay is on the north coast of Penwith, the westernmost peninsula of England and about as far from Continental Europe as it is possible to go without crossing the seas.

Along the bay to the north-west is St Ives, the small town that had developed into an artists' colony in the last decades of the nineteenth century. Tradition ruled there in the 1930s. The sea and local scenery naturally dominated painters' choice of subjects, plus occasional portraiture. Stylistically they tended to find a place somewhere between the naturalism fostered by the Barbizon and the The Hague Schools of sixty to eighty years earlier and the more vivid ways of Impressionism, moderated by English diffidence. Borlase Smart (1881-1947) and Leonard Fuller (1891-1973) were the leading painters there when BN and Hepworth arrived; they were, respectively, secretary and chairman of the St Ives Society of Artists, founded in 1927. There was also the potter Bernard Leach (1887-1979), who had opened his St Ives pottery in 1920 after years of steeping himself in the culture of the Far East. But the natives of Cornwall did not readily receive strangers – foreigners, indeed, from beyond the Tamar which (Cornish folk say) is the frontier between Cornwall and England. And the tradition-bound artists there kept well away from BN and Hepworth, associated as they were with anti-nature and anti-British, even anti-art London innovations. In time both of them were

to be received as Cornish artists: Hepworth and Leach were both awarded the freedom of the Borough of St Ives in September 1968, a few days after she had had the, to her, even greater honour of being received into the Gorsedd of Cornwall as a Bard. BN missed out on such honours because he had left St Ives before his reputation was clearly established at home (abroad there was more recognition for him by the 1950s), but he too found himself adopted as a cultural property of the county. He was offered the freedom of the Borough in 1968 but that would have required him to come and receive it in person, so he did without. He was always impatient of social formalities and fuss, even when they focused on himself.

Sharing the house was not altogether easy. It was not large and soon felt crowded. The Nicholsons had arrived on 25 August, complete with nursemaid and cook. The visitors could help Stokes in the market garden he had started, but of course everyone longed to be able to get on with some real, professional work, and that was well-nigh impossible though BN is said to have started work on a relief at once. Antagonisms developed between people normally good friends. After Christmas the Nicholsons moved to a house nearby, Dunluce. Stokes paid the rent; BN gave him pieces of work from time to time, in response to Stokes's keen, supportive interest as much as to repay his financial help. No one seemed very keen to buy it anyway. But Dunluce too was cramped. They were there until September 1942 when they moved a little further south in Carbis Bay, to a house with more space for them – 'a large and very shabby old house', Chy-an-Kerris, with a garden and a nearby railway line along which, regular as clockwork, a little train puffed its way, linking St Ives to the town of Penzance and through Hayle to England.' An upstairs bedroom became BN's studio.

They painted Dunluce white inside, and some of its

Chapter 4

# The 1940s: Carbis Bay and St Ives

outside too. Life was hard. They had left their Hampstead circle of avant-garde artists, British and foreign, and also Herbert Read, its resident champion before the world. They were far away from the friends who had also been occasional patrons in the 1930s: Helen Sutherland, Cyril Reddihough, Leslie Martin, Margaret Gardiner, Marcus Brumwell (though some of these managed to visit Cornwall during the war). The arrival of the triplets in 1934 had made financial matters critical: Hepworth said later that she had known 'fear for the first time in my life, as I was very weak, and wondered how on earth we were to support this family on white reliefs and the carving I was doing'. But 'Ben was a tower of strength', and 'the children were an inspiration, each one giving us very great joy'. In Carbis Bay 'the day was filled with running a nursery school, double-cropping a tiny garden for food, and trying to feed and protect the children'. Hepworth still had the help of a nursemaid, but even so the real work, she said, happened only after dark, when she could draw and make sculpture. This sculpture, for some time, was only in the form of plaster maquettes and none of it remains. BN was mostly out at night, for the Home Guard or as air-raid warden. So was Adrian Stokes, and it is said the two men talked through the nights with more intensity than was good for the security of the country.[2]

They were safe, though at the time that safety seemed less certain. There were several occasions when St Ives was machine-gunned by Messerschmidts, and two landmines came down near Carbis Bay, destroying a house. On 17 August 1940 BN wrote to Herbert Read, who had left London for Beaconsfield on the road to Oxford. The total evacuation of British forces from the Continent had occurred at the end of May; it was a retreat, and a German invasion seemed likely. The bombing of London was at its fiercest. BN expressed fears many felt:

Perhaps this is the blackest moment before the dawn – certainly it's black alright – the whole thing is completely incredible & I keep on expecting to come to & find it's all a bad dream, very much overdone. … I think one must assume that one *may* be bumped off – & perhaps along with all the things one has ever cared & worked for. … I am hoping soon to have the brown uniform & forage cap & gun with which to collect parachutists – I only hope it's a Bren gun & not a rook rifle![3]

Thus BN, in his late forties and father of six, accepted the call to arms.

Hepworth had not been to Cornwall before and was unhappy about leaving London, but her Yorkshire years had opened her to landscape. In fact, St Ives was to become her permanent home. BN was returning to Cornwall with happy memories of discovering its landscape and towns in 1928. In any case he was used to working in and with landscape – with Winifred in the Ticino and in Cumberland almost continually from 1920 to 1931. Until 1974 he was to occupy one landscape or another. Yet for him too leaving London must have meant leaving a field of operations he had come to know and had mastered to some degree. Could he have become the 'Constructive artist' he appeared to be without a metropolitan setting – without, indeed, two capitals to work with? 1930s London must have seemed far away and a piece of history. Anyone who had thought in 1939 that the war would soon be over knew better by the summer of 1940. Occupied Paris was not a magnet now but a disaster.

Soon after arriving in Carbis Bay the Nicholsons persuaded Naum and Miriam Gabo to come there too. They also tried to persuade Mondrian. Early in September 1938 Mondrian had written to BN in London. He was thinking of leaving Paris for New York but feared that life would be too expensive for him there; an alternative would be London though London could expect to be bombed when the war

started. BN wrote back promptly and helpfully, advising him about the price of rooms for rent and sending a formal letter of invitation. Mondrian had written to New York too, to Holtzman, Kiesler and Xceron; they also replied with invitations but too late. Winifred brought him to London where BN had found him a room at 60 Parkhill Road, a few steps away from the Nicholson studio, and put a bed into it. There were money problems, and his health troubled him at times, but Mondrian came to like London and enjoyed his new 'spiritual surrounding'. Winifred offered to have him at Banks Head and BN wrote to suggest that he too should come to Carbis Bay. But Mondrian, who had actually been to Cornwall in 1901, preferred urban Hampstead (though after Montparnasse it must have seemed an uncertain sort of urbanity). As the bombing got worse he tried to get a visa for New York. When his windows were blown in by a bomb he was already packed and, after a few days in a small hotel, he sailed for New York.[4]

Gabo had left Russia for Germany in 1922, and Berlin for Paris in 1932. He visited England in 1935 and settled in London in 1936 when he married a painter, Miriam Israels, related to the noted Hague School painter Josef Israels. The Nicholsons stood as witnesses for the wedding. The presence near them now of the world leader of Constructive art, a good-humoured man four years older than BN and with a background so different from his in culture and training, must have been a great enrichment for both the Nicholsons. In the summer of 1940 Gabo too felt the pressure of events and pondered the fate of 'the whole constructive idea'. He wondered about going to the United States but friends persuaded him this would amount to an admission of failure: he should stay in Europe and lead them. But then, he said to his diary, they

had not had his experience of the world, in Moscow, Berlin and Paris. 'They stand on the threshold and see the future in the bright light of constructive ideas – but I know how slow and how painful the processes of history can be. I do not foresee the triumph of the constructive idea in the near future.'[5]

BN does not seem to have suffered doubts of this sort, but then his attachment to 'the constructive idea' was not as central or essential. His statement in *Circle* had been about art as a form of 'actual experience', about 'the perpetual motion of a right idea', about the artist as an explorer who would not want to predict the future development of his work. None the less, war mocked the global aspirations voiced in *Circle*. The same countries whose artists' thought and work had met in the text and illustrations of the book were now locked in the bitterest of conflicts and intent on exploiting for destructive ends the technology that had seemed to give support to Constructive art. One tried to remind oneself that the conflict was not between the Germans and the British but between fascism and democracy. In any case, where art in England was concerned the war had the effect of marginalizing both the international movements of the 1930s, Constructive art and Surrealism, and giving centre stage to Euston Road realism and now also an insular Neo-Romantic movement, charged with nostalgia and a sense of apocalypse, with Piper, BN's former ally, among its leaders. War answered the artists' efforts to take a stand against the advance of fascism; not even the British government had noticed them, let alone foreign dictators.

The war seemed to come closer amid rumours of German landings on the south coast and almost daily news of massive air raids on London. Bernard Leach

**157**
BN at work, late 1930s

159

became a friend. Peter Lanyon, born in St Ives in 1918 and something of a Stokes protégé, became BN's paying pupil for some months, receiving 'a great stimulus' from him, while Margaret Mellis, Mrs Stokes, found BN a 'very helpful and exhilarating' informal tutor over her paintings. In 1977 she wrote an account of the time, based on her diaries, which includes those words and the following:

Ben never stopped working and if he wasn't actually painting or making reliefs he was writing letters to people who were interested in the [Constructive] movement. They might show works, buy them or write about them. When he wasn't doing that he was looking round St Ives for new people who might be interested. He had already begun to work towards what might eventually become the Penwith Society in 1949. His aim was always to help people to do good work and get it shown and to stimulate a wider interest in modern art. He enjoyed manoeuvring people and arranging events.

In 1943 BN and Hepworth were sought out by Borlase Smart as the secretary of the St Ives Society of Artists. Smart was fifteen years older than BN and never ceased being a naturalistic painter, but he was eager to bring new life and

new art into the Society, unlike many of his fellow members. In 1944 BN sent work to its spring and summer exhibitions, then held in the Porthmeor Studios, as well as to a one-day show on 2 March in Smart's studio, where his 'group of geometrical designs for which he is famous' contrasted sharply with the normal local product.[6]

Though he still chose to present himself as the leading painter in the Constructive movement, the early 1940s saw BN turning away from his concentration on geometrical forms and abstraction to a broader range of production including representational painting. What touched him most deeply, on returning to the St Ives area and seeing it again and again, was the light, more Mediterranean than English and all the more joyous for being less reliable than in Italy. Inevitably he drew the landscape he was in, as he had in Cumberland and in Switzerland, around Sutton Veny and during his first visit to Cornwall. The inclination and the habit lived on, and he was experiencing many of the same impulses. For example, Alfred Wallis still lived and painted in his house just along from the Porthmeor Studios. BN kept on

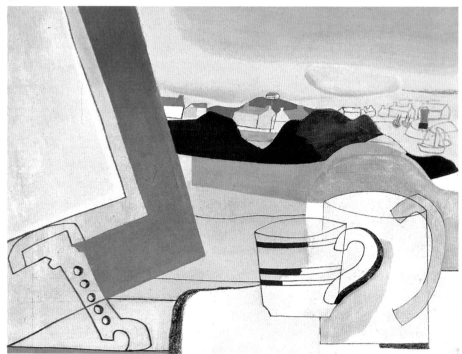

The 1940s

**161**
*1940 (St Ives, version 2)*.
Oil and pencil on board,
38.4 × 46 cm
The Phillips Collection,
Washington

**162**
*1942 (Cornish village)*.
Oil and pencil on board,
25.5 × 32.3 cm
Private collection

making reliefs, but the granite houses and the abandoned engine houses of the old tin mines fascinated him as exact shapes planted on firm land often within sight of the restless sea. There was no reason why he should not do abstract work and representational side by side; they were not opposites to him. Also, there was the thought, encouraged by his dealers, that his landscapes might actually sell.

Painting still lifes set against landscape could be seen as a bridging operation. The form was not new; it was frequent in Winifred's work in the 1920s, BN had used it occasionally and so had some of their associates in the Seven and Five Society. It now takes on a new life in BN's hands, a new intensity, and one way of understanding this is to see the paintings he made using it – which in different guises continue until his death – as fusing his reliefs and the landscape paintings that preceded them. The relief forms and tensions, now given more or less overt figurative meaning, are combined with broadly abstracted, firmed-up transcriptions of Cornish scenery. *1940 (St Ives, version 2)* [plate 161] illustrates this. The cup and mug in the right

foreground, rendered mainly by line and bands of shadow, recall the reliefs, and so does the bold and repeated rectangle of the window, as though it were a base rectangle swung open to reveal the world beyond. Its formality is mocked by the metal fixture – the casement stay – which manages to be both flat and three-dimensional and domesticates what might have become too severe a statement. Brown hills contribute their odd shapes in the middle distance, and beyond them is a bright little vignette of St Ives houses before a green hill, all flat and crisp and echoed humorously in the drawn houses and boats of the far distance. There is light and lightness everywhere, as well as a return to the playful note of innocence that sounds from some of the 1928 Cornwall landscapes and also from such occasional pieces as the textile design of 1937, *George and Rufus* [plate 155]. But it is not a simple art. Apart from the motif-and-space game of the double subject there is, more vigorously than ever before, the play of line against plane, pencil against paint. It is a long way, aesthetically, from the lines of the mug and the window frame to that fat grey cloud.

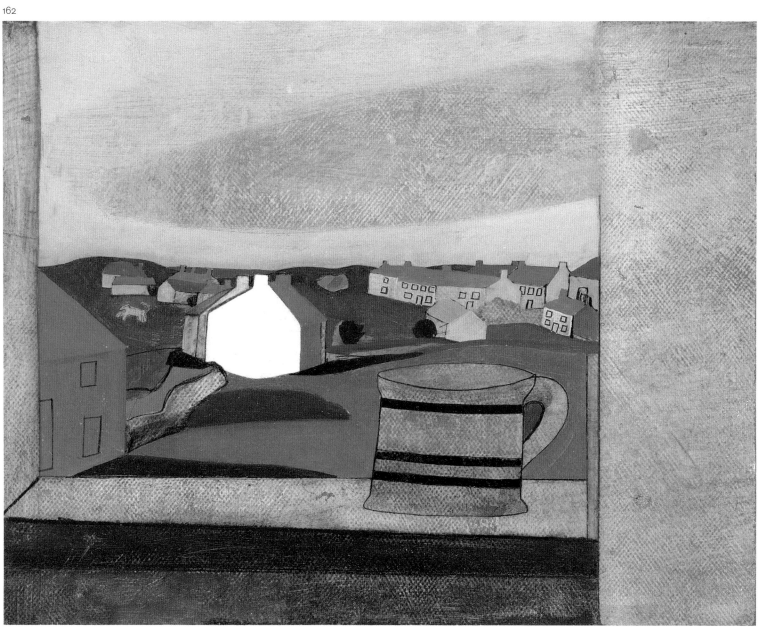

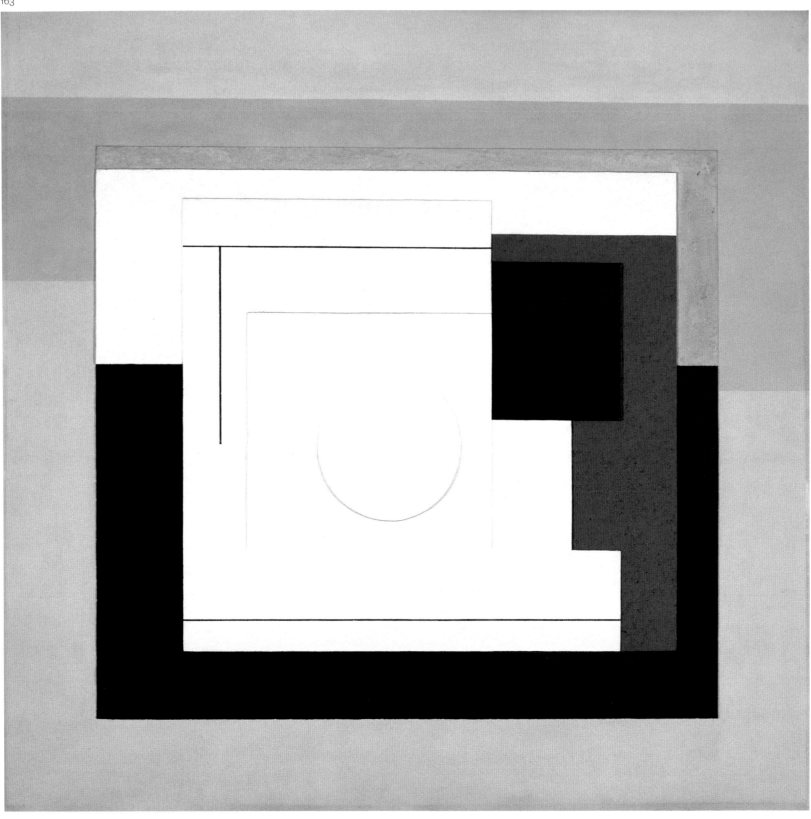

The 1940s

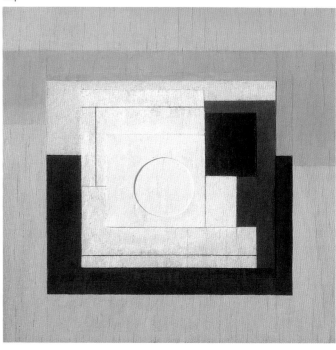

**163**
*1944-5 (painted relief)*.
Oil on carved board,
72.3 × 73.6 cm
Pier Arts Centre,
Stromness, Orkney

**164**
*1944 (relief project)*.
Oil, pencil and paper
on carved wood,
20 × 20 cm
Private collection

In the same year BN completed a painting begun eight years earlier, *1932-40 (still life)* [plate 134]. Here abstract relief and legible still life come together, established by flat design and reinforced by spatial illusion. Firm rectangles dominate the still-life elements, including a dark red square (top left) that carries no particular reference. The table top is quite vertical, and appears to be in front of a larger plane, rectangular and vertical also, displayed only on the left and at the top; behind both is another stratum, a backdrop in two colours divided by something like a horizon. Colour is muted but texture is brought in lavishly to work against areas of opaque, flat colour; pencilled areas of shadow accentuate and develop some of the objects and also suggest landscape forms seen through the table and the second plane as though they were a window. How close such a figurative piece is to an abstract relief is made clear in *1944-5 (painted relief)* [plate 163] with its similar composition, muted colours dominated by black and white, and its background in three tints and horizontal layers that could be read as sand, sea and sky. The essential difference between such works is in

the transparency of the one and the more opaque surfaces of the other: the relief is flatter. A small preparatory version of the *painted relief* exists. *1944 (relief project)* [plate 164] is almost identical in design, though the proportions are very slightly different, but quite different in its colour. The black areas in the larger version are a deep, resonant blue in the small one, and the shape between them, a dusty brown in the former, is a deep olive-green in the latter. Both colours suggest landscape, and there is something mysterious and poetic about the way the deep blue of the lower part of the baseboard reappears on the projecting plane. And then, in the *relief project*, there is an upper L-shaped margin of the serenest pale green, an unexpected colour in this company, bringing out the pinkness of the adjacent part of the background. This background is relatively larger, in effect more spacious, than that of the *painted relief*, making the whole more generous and relaxed than its big brother.

The sand, sea and sky effect of a triple background is marked in *1940-2 (two forms)* and its variants. The Southampton painting [plate 165] is more than twice the size

The 1940s

165

**165**
*1940-2 (two forms)*.
Oil on canvas,
91 × 91.7 cm
Southampton City
Art Gallery

The 1940s

**166**
*1940-3 (two forms).*
Oil on canvas,
60.5 × 59 cm
National Museum
of Wales, Cardiff

The 1940s

167

**167**
*1940 (painted
relief – version 1).*
Oil on carved board,
52.5 × 50 cm
Private collection

**168**
*1940 (painting).*
Gouache and pencil
on board, 19 × 20 cm
Private collection

**169**
*1943-4 (painted relief).*
Oil and pencil on
carved board,
81.2 × 98.9 cm
Private collection

168

184

The 1940s

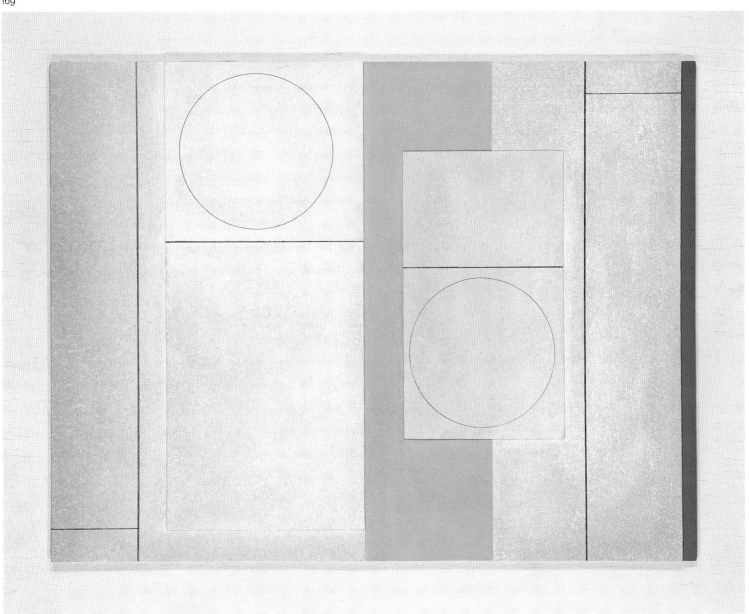

**170**

**170**
*1941 (painted relief)*.
Oil and pencil on
carved board,
68.1 × 142.5 cm
Private collection

of the Cardiff version [plate 166] and differs also in some of the colours and proportions. Size is all-important, of course, but the differences of detail also make the Southampton painting more monumental, more confrontational. The Cardiff painting, for all its severity, is prettier. Its smaller size makes it less imposing, but at least as important is the fact that it has one more element, a yellow band in the right-hand form, and this by itself lightens the composition, especially as it addresses a blue square in the left-hand form. More important is the proportional increase in the size of the white square in the smaller painting. On the back of the Southampton picture are detailed colour notes in BN's hand, listing the constituents of each. If our eyes have not told us so already, we learn that the white of the square and of the lower background are differently constituted. Thus the square has two top coats of 'bl. d'a.', that is *blanc d'argent*, known in England as Cremnitz white, while the lower background band has top coats of flake white or, as BN noted it, 'fl. wh. no 2 (Winsor & Newton)'; the upper background, the 'top grey surround', is made up of ivory black,

yellow ochre and *blanc d'argent*, and so is the 'centre grey surround', the same colours used in different proportions. And so it goes on, through twenty lines of data.[7] All this and the character of the image argue for a particular exactness on this occasion, yet it seems that at least some of the forms were drawn free-hand. Its general neatness leads us to expect that the top edge of the white square (which is not square) and the top edge of the black area in the other form line up: they don't, and the latter slopes. In both versions, the two forms confront us like personages and with some of the presence of sculpture, yet the suggestion of space is slight, given by the advancing white, the implied overlaps given by L-shapes and the tone-by-tone receding background. We noted a similar double image in the Museum of Modern Art's painted relief of 1939 [plate 150] but there the two forms touch and the background is one uniform, encompassing plane, a true 'surround'. Cleveland's *1941 (relief)* [plate 171] is a double image assembled vertically, with the same sense of a dual presence underlined by the use of two drawn circles of different sizes. It is a small, crisp work, painted white but with

**171**
*1941 (relief).*
Oil and pencil on
carved board,
62 × 43 cm
Cleveland Museum
of Art

drawn circles and three straight horizontal lines; two short ones, in the upper half, create a stepped horizon similar to the horizons in the *two forms* paintings.

Some accounts of BN's work associate the move to Cornwall with a marked change of direction. Charles Harrison writes that the contrast between working in London and Carbis Bay and St Ives was extreme, 'and Nicholson's art underwent a proportionate change'. If I am right in thinking that the colours of *1939 (painted relief – version 1)* [plate 150] were added in Cornwall, then it would almost be correct to say that BN stopped making white reliefs when he left London; the Cleveland relief just mentioned and a white relief made in 1962 (to be discussed below) are two major exceptions. Harrison's subsequent statement is true, that 'the intense concentration of the thirties was inevitably relaxed'. He stresses BN's isolation during the war years, spiritual as well as physical, as Euston Road gentle realism and Neo-Romanticism made his more absolute and international art seem remote and idiosyncratic again, and whatever gains had been made for it in British consciousness were lost.[8] BN,

on the other hand, was armed with an unusually self-reliant personality, built up in childhood in spite of and in response to his ill health and at least partial insecurity, and possessed a core of faith, general rather than linked to any one set of beliefs, enabling his spirit as man and artist to outstare difficulties. His artistic resources were rich and well-founded. He worked less for a while, and on a smaller scale. The family finances were so tight that when he wanted to buy a radio from a local electrician he had to persuade the man to accept a painting in exchange instead of real money. But the work moved forward, fed by the past and his present environment. He and Gabo saw a lot of each other, yet it is striking that BN's work, unlike Hepworth's, bears no witness to that closeness. Adrian Stokes had worked at the Euston Road School during 1937-8 and may have argued before BN the case for observation-based paintings of ordinary subjects. Most important, with every day BN's sense of light, colour and space – and probably also of movement – was refreshed by his experience of sky, land and sea, so that there were always new things to attempt as well

The 1940s

**172**
*1943 (painting)*.
Gouache and pencil
on board, 34 × 41.5 cm
The British Council

**173**
*1943 (Seven Pillars
of Wisdom)*.
Gouache and pencil
on board, 24 × 29.5 cm
Private collection

as tried ideas and methods to develop further.

The British Council's little *1943 (painting)* [plate 172] is another, in its way unique, exploration of relief-type compositions on the flat. It incorporates, in a manner not available to BN before the move to Cornwall, landscape colours alongside the primaries, black and three whites. About the same time he painted *1943 (Seven Pillars of Wisdom)* [plate 173]. When he gave it to one of his children as a Christmas present he wrote on the back: 'I hope you will like this ptg – it came from reading a book "The Seven Pillars of Wisdom" about the Arabian desert which had some lovely descriptions of desert landscape.' The book was T. E. Lawrence's famous account of the Arabian campaign, published in 1926; we do not know when BN read it, and it could well be that the title and the explanation came after the painting. The simplicity/complexity of this small work – gouache in white and brown and a few dusty tints, vertical and horizontal lines plus two circles, all in pencil – is astounding. In 1944-5 he made a painted relief subtitled *Arabian desert*.[9] This too reflects his interest in Lawrence's

book, but the point has to be made that he never based any of his work on a literary theme. Here the colours he was using invoked memories of a book he had been reading; it is certain that neither of these images was suggested by the text. BN's natural, innate source was the visual world, and while reading could implant imagined sights, it was where he was living and also where he was travelling that supplied him with essential experiences and stimuli. BN had not travelled outside Europe since committing himself to art and of course the war prohibited anything of that kind. His teenage visit to New York and Pasadena remained a potent memory – associated with a lasting passion for ice cream and westerns. In later years, when he could travel freely, he went no further than Turkey, feeling his art was best served by his staying within the geography of Europe and its broad cultural range, from cave painting to the present day. That did not prevent him from admiring the art of other ages and cultures. He did not like museums but that did not stop him from using them, and of course there were books and reproductions.

There was a broadening, as well as a relaxation, in the

The 1940s

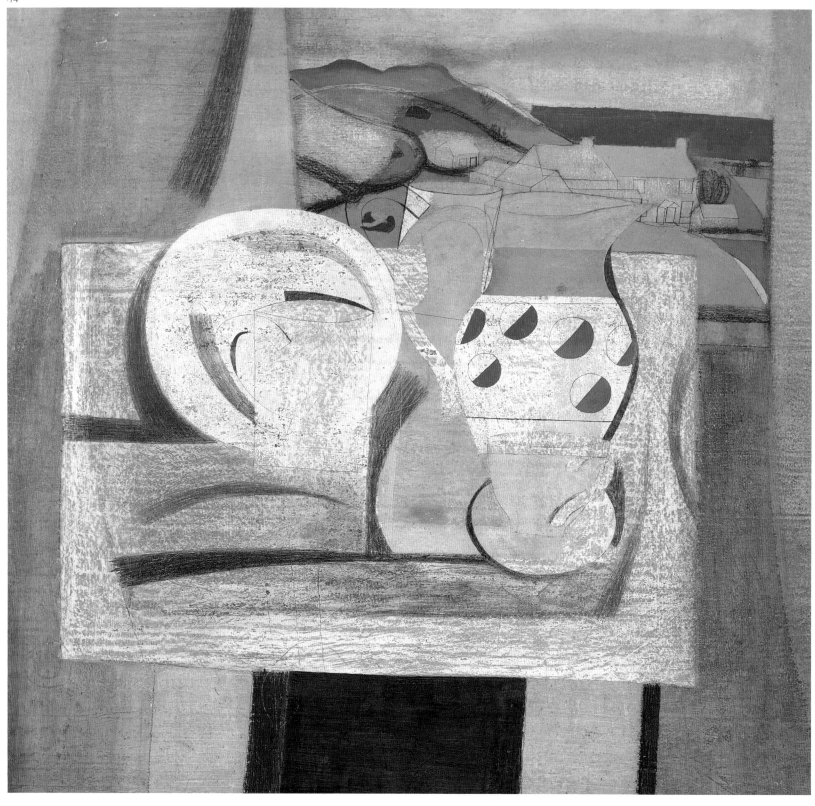

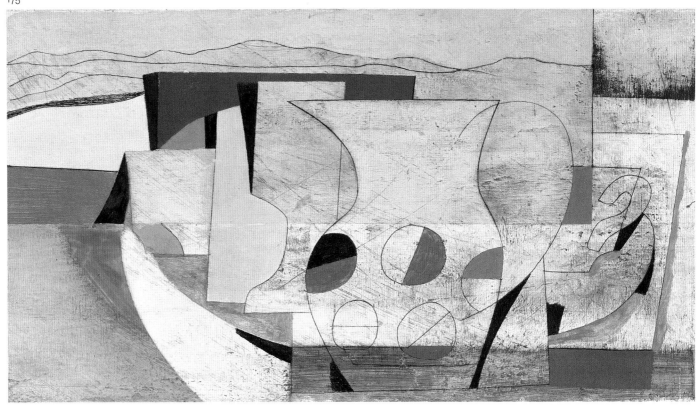

**174**
*1944 (still life and Cornish landscape).* Oil and pencil on board, 78.6 × 83.7 cm Collection IBM Corporation, Armonk, New York

**175**
*1950, November 3 (still life, winter).* Oil and pencil on board, 43.1 × 63.3 cm The Phillips Collection, Washington

manner of his work. *1944 (still life and Cornish landscape)* [plate 174] is characteristic of the time in its presentation of a relatively large still-life group on a vertical table top, but exceptional in the way the landscape is seen through a small window opening, making us more than usually aware of inside and outside. The upper parts of some of the objects overlap the landscape, the outlines of jug and mug mingling with those of the farmhouse in the middle distance, so that our minds have to leap readily from near to far. Pencil lines provide crisp detail and bunch together to make shadows in the foreground and stone walls in the landscape. Yet there is delicacy too. The table itself is not a hard form and is altogether muted by its rubbed texture. The colours are soft and transparent too, giving no sense of firm surfaces, except perhaps in the warm brown area between the table legs at the bottom, the grey-blue band of the sea, neither of them quite clear or firm, and the divided disks that are the jug's proud ornament.

What may be the same jug reappears in the Phillips Collection's *1950, November 3 (still life, winter)* [plate 175].

Here the still life is not only large within the stretched horizontal composition – a seascape format – but the landscape is limited to a few fine wavering lines that describe distant hills. There are many crisp lines elsewhere and some opaque patches of colour, but these are enhanced and countered by gently textured areas. Again, it is not that BN at this stage was tending towards one or the other, hard or soft, but that he enjoyed the range of instrumentation his processes afforded and his eye could command. Contrast, here as in the preceding work – and in some sense in all his work from 1920 on – is the key. A list of all the contrasts at work in the Phillips picture would have to be very long indeed. What is most unusual here is the prominence of forms it seems impossible to identify. What looks like an Indian red slab (a chairback?) pushes the still life forward and holds the landscape back, making an unusually firm divison between the two spaces.

The sheer variety of BN's work in the mid-1940s speaks of a positive, experimental spirit. In another artist one might have feared loss of confidence or direction; in BN it signalled

The 1940s

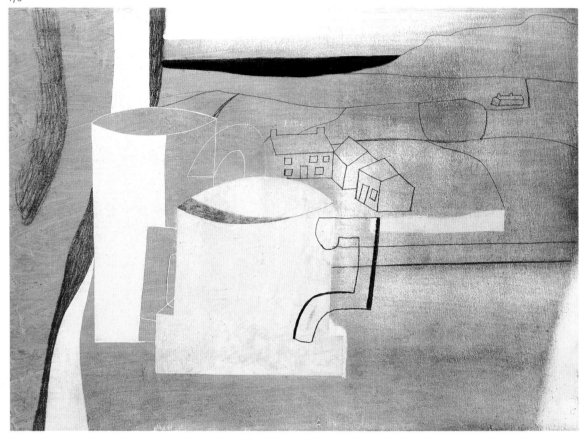

**176**
*1943 (Towednack, Cornwall).*
Oil and pencil on
board, 38.5 × 48.5 cm
Private collection

**177**
*1943 (St Ives).*
Oil and pencil on
canvas, 38.4 × 48.5 cm
Private collection

The 1940s

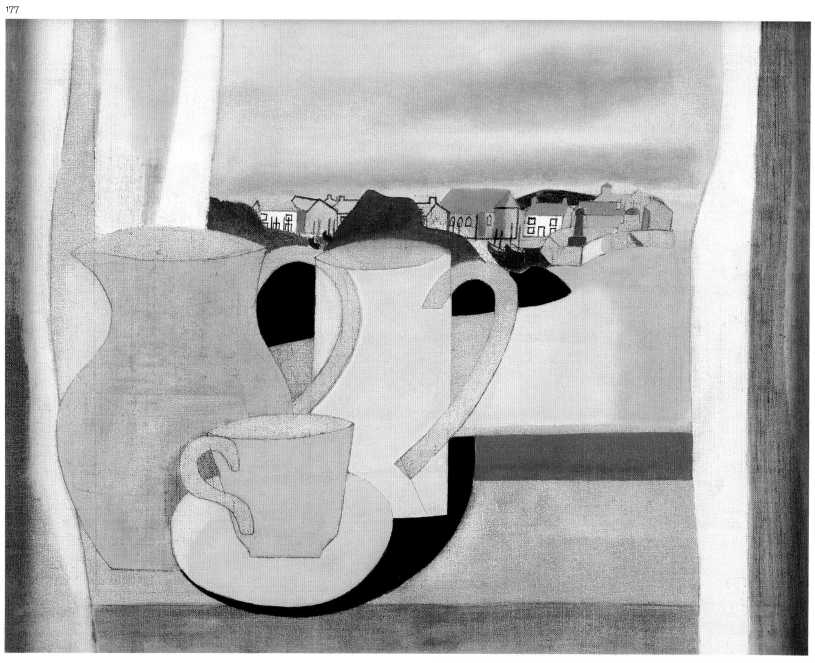

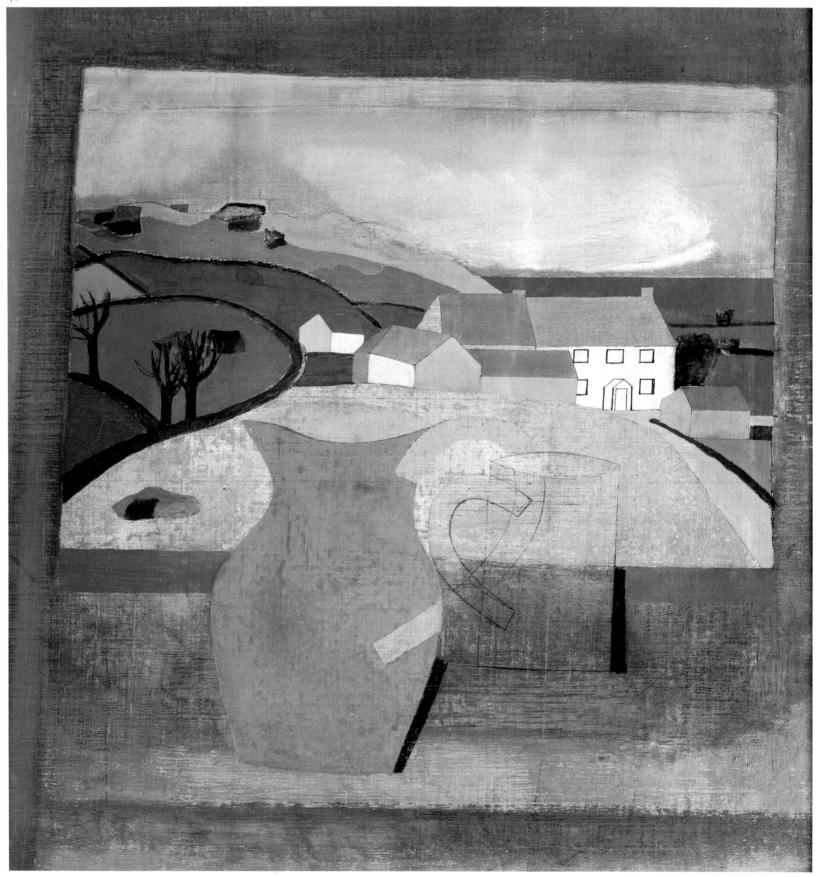

The 1940s

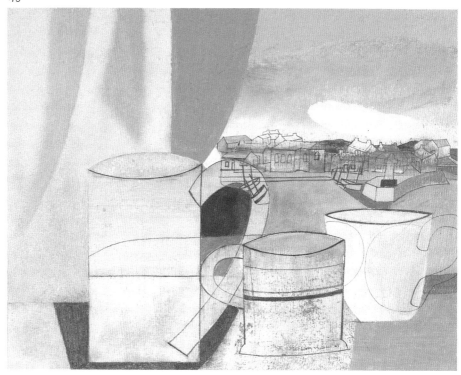

a return to the openness of his 1920s production. The 1930s made him look a signed-up contributor to a particular movement, but we know that even then his work ranged more widely than this would imply. He never presented himself as a doctrinaire adherent of anything. The end of the war was clearly approaching and it came, for Europe, in May 1945. As the dangers of enemy action receded, the Nicholsons' friends surfaced again, visiting St Ives from time to time, notably Herbert Read and Margaret Gardiner. July 1945 saw a landslide victory for the British Labour Party, bringing hopes of important changes in the life of the country. Rationing continued and victorious Britain's immense loss of material strength and international importance would gradually become apparent. But life was coming back to normal; fresh air was again blowing through the land after years of enclosure. It was no longer necessary to have blackout on one's windows in order to hide from the enemy in the sky.

In 1944 BN had sent work to the St Ives Society of Artists' spring and summer shows, as well as to the one-day show

mounted in Borlase Smart's studio. The Society's summer 1945 exhibition, which opened the day of the general election, 26 July, included paintings by BN and, at last, new sculptures by Hepworth. Thanks to Smart's efforts, the Society now had more extensive premises in the Mariners' Church, between Porthmeor Studios and the harbour. Earlier that year John Wells, until then working as a doctor in the Scilly Isles, had moved to Newlyn, a few miles away on the south coast, to paint full-time, and he exhibited alongside BN and Hepworth. Gabo departed for America in November 1946, leaving BN and Hepworth as undisputed leaders in the field of 'advanced' art in the West of England. On them centred a swelling group of artists, Wells as an admired and admiring friend, also Lanyon, Denis Mitchell, Wilhelmina Barnes-Graham, Bryan Winter, Terry Frost, Patrick Heron and others.[10]

A look at five of BN's pictures of 1945 will show his amazing versatility around this time. *1945 (2 circles)* [plate 180] is another relief-type composition presented as a flat painting though with discreet painted shadows. The colours

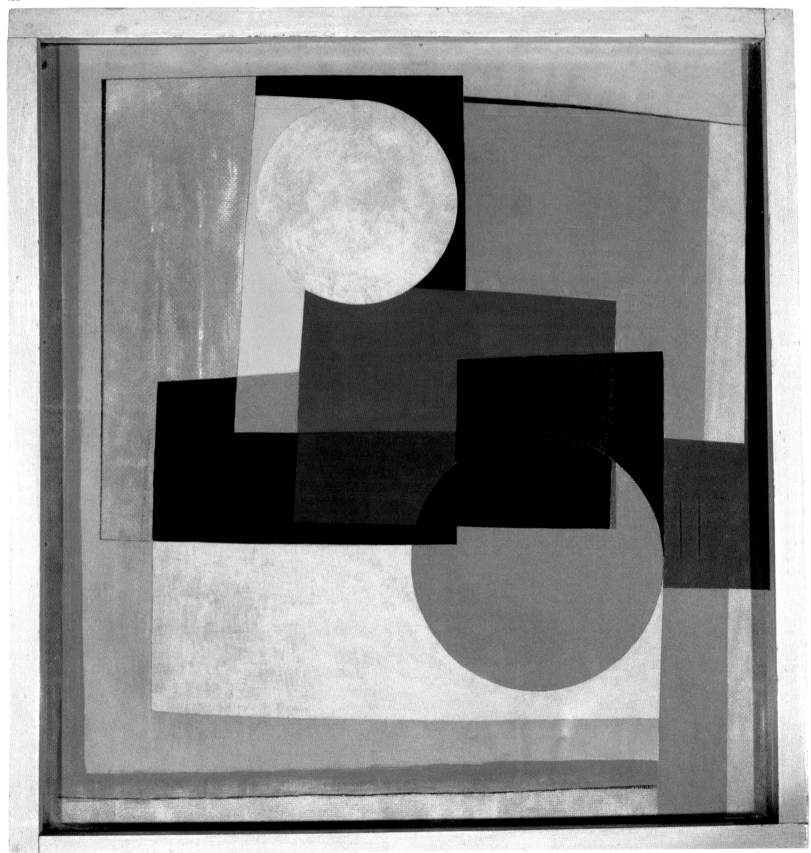

**180**
*1945 (2 circles)*.
Oil and pencil on canvas,
48.5 × 46 cm
Pier Arts Centre,
Stromness, Orkney

**180A**
Verso of plate 180

The 1940s

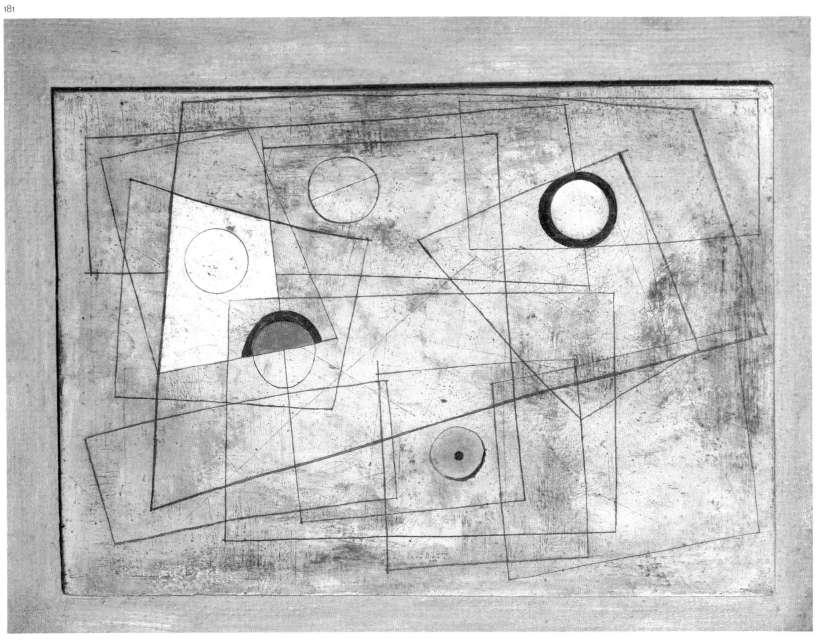

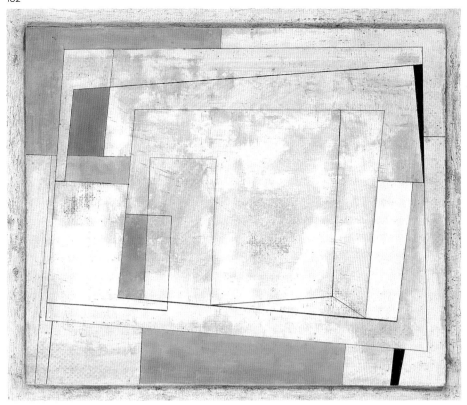

**181**
*1945 (parrot's eye).*
Oil and pencil on
board, 19 × 24 cm
Private collection

**182**
*1949, January 23
(box and cox).*
Oil and pencil on board,
29.8 × 33.7 cm
Private collection

are surprising: a range of greys and whites, black, two reds, deep blue and deep green and a sharp, bright yellow; also areas of rubbed, transparent paint next to areas of solid colour. Surprising too is the general disposition since there are hardly any verticals and horizontals in the array but many lines tilting this way and that. They remind us of *1924 (first abstract painting – Chelsea)* [plate 19], but the greater firmness of the circles and almost-rectangles now makes for a sprightliness not found twenty-one years earlier. Then the idiom reflected Cubist collage; now it implies an interest in abstract painting as it developed, not without Cubist influence, in Eastern Europe, out of Kandinsky and Malevich. The use of interference colours – by which I mean a colour change when one apparently opaque colour area overlaps with another – probably came from Moholy-Nagy, who had seen it in Kandinsky's work from 1920-1 on and made an important feature of it. Moholy, working in London from 1935 to 1937, had an article in *Circle* on the growing use of light and colour in modern times and the need for an 'Academy of Light', and four black-and-white reproductions of his

paintings as well as one photogram. Two of the paintings include the use of interference colour; even without colour in the reproduction one can understand the method and guess at its effect.[11] BN knew Moholy and thought highly of him, so he is likely to have seen his one-man show at the London Gallery during December 1936–January 1937. The effect of such colours is to imply that opaque colour too is light rather than matter, a film rather than a slab. In BN's hands this play of light and lightness in a context suggesting the physicality of relief, together with the tilting of most of the lines, this duality of solidity and transparency, gives his image an unusual mobile, harlequin character.

*1945 (parrot's eye)* [plate 181] is another painting that comes close to being a drawing, since it is mainly a work of pencil on a prepared board and shows only a few patches of added colour. The 'eye' of the subtitle is a circle carved into the board and given a tint of its own and a small black pupil. Another circle seems to project forward because of its dark halo; yet another is in two halves, recalling the bisected circles on the jug in *1944 (still life and Cornish landscape)*

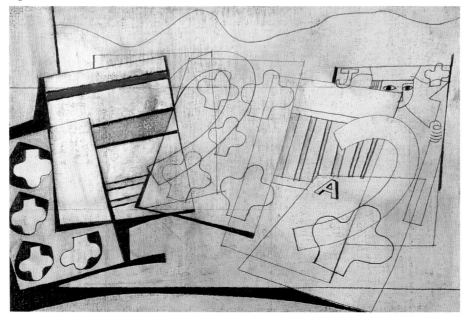

183

**183**
*1945 (playing cards)*.
Oil and pencil on
board, 23.2 × 29.8 cm
Private collection

**184**
*1945 (playing cards)*.
Oil, watercolour and
pencil on board,
14 × 21 cm
Private collection

[plate 174]. Otherwise the composition consists of lines
running this way and that over a textured off-white ground
and forming four-sided figures. These are wholly transparent,
except where a patch of white paint overrides one line while
yielding to another. They are also free-hand, most of them
straight with the exactness BN's hand could command,
others sweeping along in extended curves of a sort we shall
get to know better when we look at his reliefs of the 1960s.

About the same size as *parrot's eye* is *1945 (playing
cards)* [plate 184] where the pencil again plays a major role
in defining objects, proposing shadows and other black
forms that cannot be shadows and, by means of just one
wandering line near the top and a short horizontal line below
that, setting the still life in front of a deep landscape. The
designs on the cards lead BN into various adventures. The
Jack's staff becomes a kind of barber's pole, striped spirally
in red and pale blue. BN had brought some pencils striped in
this way from Venice many years before. The same colours
enact the pattern on the cup in the centre, almost white in
a context of antiqued off-white. The red reappears in the

Jack's cap. His sharp eyes make him a witness to the scene,
the more so for the black background BN has arbitrarily
given to the head. This is an exceptionally cheerful work,
descended from a line of fireworks and bus-ticket pictures in
BN's earlier work [plates 43-4 and 90] as much as from the
generally more elaborate line of still lifes. In any case we
hesitate to attribute anything like all-out seriousness to any
of BN's works, at least until the last decades, lest he should
catch us out with some tweak or twist.

So one hesitates to call *1945 (still life)* [plate 204]
majestic, though that is how it seems in its context. This
painting, in Buffalo, is square and concentrated, almost
sculptural. We are made aware of the table top straight away,
a mighty form on a modest scale. It is ambiguously tilted (on
the left) and almost vertical (on the right). We discover that
it is a double plane, as though a sloping drawing board had
been set up on a table (on the left) and then somehow fused
with it (on the right). The scrubbed pale brown is much the
same on both planes, and indeed continues through much of
the still life to reappear as a slight variant in the background.

The 1940s

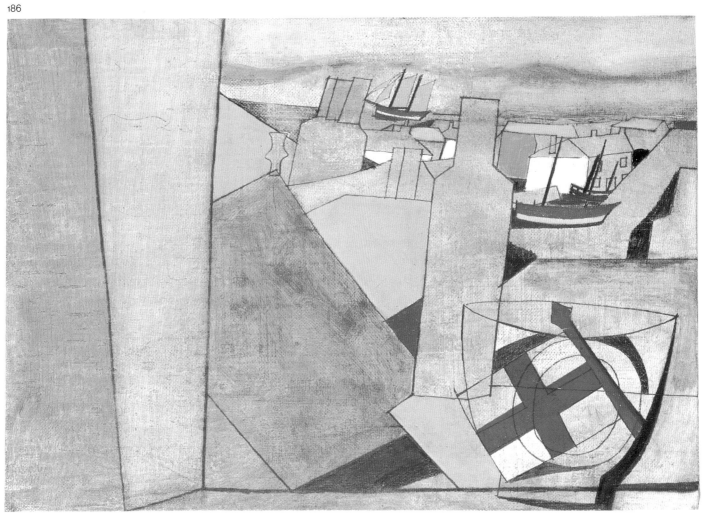

**185**
*1945 (still life
with 3 mugs).*
Oil and pencil on
board, 40 × 14 cm
Private collection

**186**
*1945 (St Ives).*
Oil and pencil on
canvasboard,
16.5 × 25 cm
Private collection

The 1940s

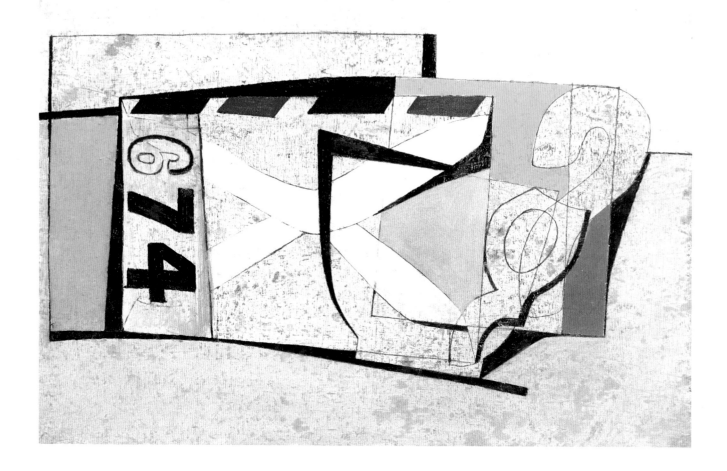

**187**
*1945 (airmail letter).*
Oil and pencil on
board, 15.3 × 21.8 cm
Private collection

**188**
*1946 (still life –*
*Fra Angelico).*
Oil and pencil on
board, 24.7 × 18.1 cm
Bernard Jacobson
Gallery

**189**
*1945 (still life).*
Oil and pencil on
board, 21.5 × 21.5 cm
Private collection

The 1940s

The 1940s

The 1940s

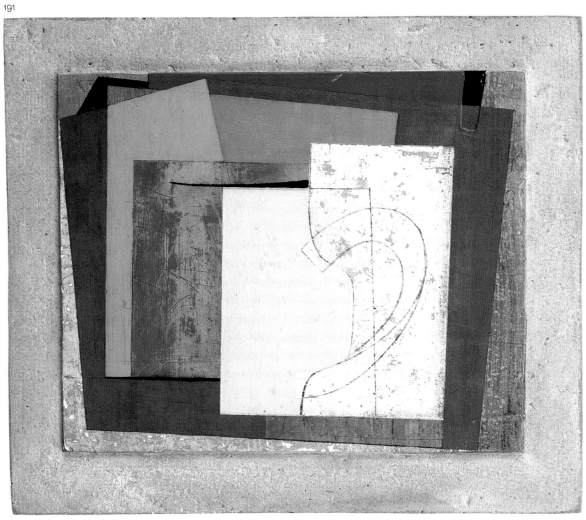

**190**
*1944 (three mugs).*
Oil and pencil on
board, 17 × 20.8 cm
Kettle's Yard, University
of Cambridge

**191**
*1946 (still life).*
Oil and pencil on
board, 32.5 × 37 cm
Private collection

The 1940s

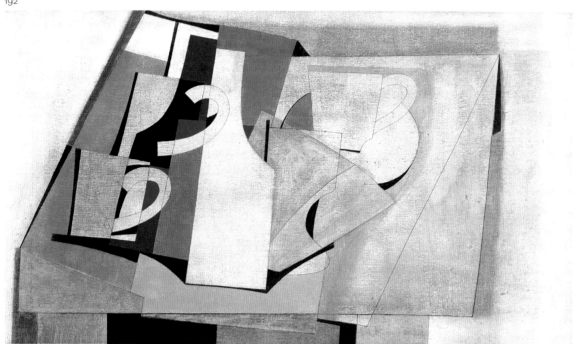

The 1940s

**192**
*1945 (still life).*
Oil and pencil on
canvas, 35.6 × 61 cm
Private collection

**193**
*1945 (still life).*
Oil and pencil on
canvas, 82.7 × 65.3 cm
Tate Gallery, London

There is a lot of solid, semi-solid and also translucent pencil work. These areas of deep shadow and lighter half-shadows give the painting a twilight quality. Into this BN breaks with small areas of opaque colour. Greeny greys firm up top and bottom to frame brighter colours flashing from the still-life group. It is almost shocking to find such a contrast in a painting. In theory it cannot work. In practice, the leaping colours combine with the almost black shapes and the lines that with them make up the still life to perform a stately dance on the planes of the table. *1945 (still life)* can in fact be seen as the starting point of a series that reaches its grandiose climax in the 1950s. There is another such painting in the Tate Gallery: *1945 (still life)* [plate 193], a vertical canvas much the same width as the Buffalo painting. The objects here are quite legible – whereas the colours fragmented them in the Buffalo painting – and the table is set mainly in the right half of the canvas, flanked by what we read as a strong shadow and then an interior space within the lighter border surrounding much of the composition.

The concentration found in these paintings stems partly from the absence of a landscape view, even of the most summary sort. In this respect they connect back to the white reliefs with their forms displayed on a backboard without any hint of a recessive landscape space. More still-life compositions of this focused, indoor sort follow in 1946. In them BN seems to want to explore further the use of very bright colours in a muted context. They are, mostly, indoor colours and they are presented with a sharpness that makes them feel artificial even when they could refer to nature. Thus the Arts Council's *1946 (still life)* [plate 200] presents parts of objects and also of abstract planes in terms of areas of flat colour so firm they look collaged on rather than painted. The light blue could be thought to suggest sky, but it is compositionally the most forward colour and shape, and the shape is vertical and refers us to a decanter or some such thing. In any case, its top is set against an area of delicate lilac, its left shoulder against a patch of bright red and its neck against an expanse of yellow. All these colours could perhaps be found in nature but that is not how they are experienced here, and the setting of the double plane that

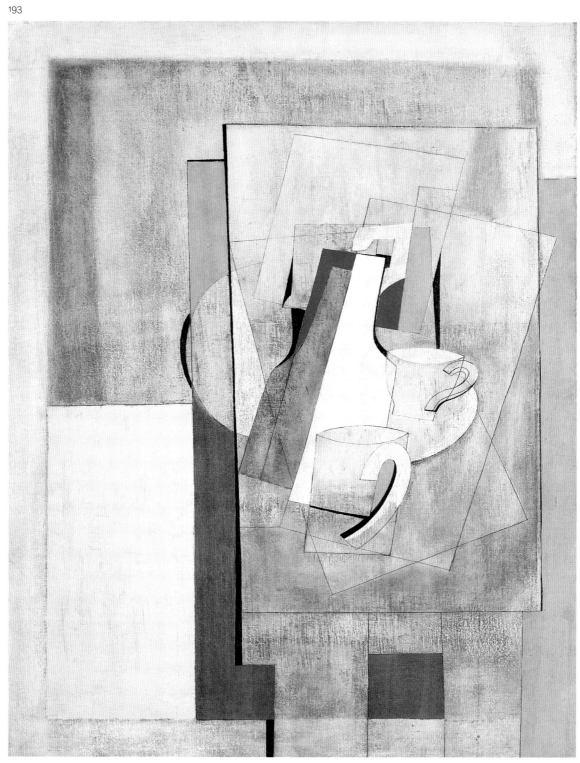

The 1940s

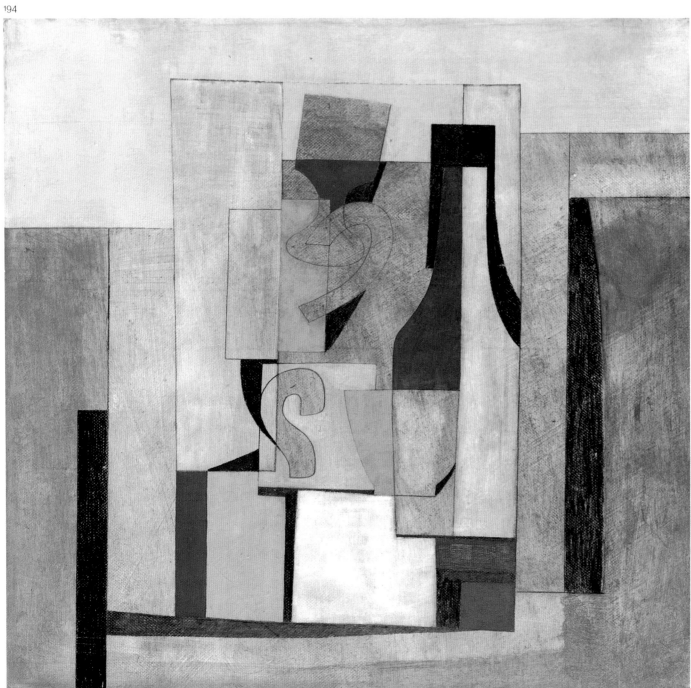

**194**
*1945 (still life)*.
Oil and pencil on
board, 47.3 × 49.9 cm
Private collection

**195**
*1945 (still life)*.
Oil and pencil on
board, 92.6 × 62.8 cm
Private collection

The 1940s

**196**
*1946 (cerulean
abstraction).*
Oil and pencil on
canvas, 63 × 61.5 cm
Pallant House,
Chichester

**197**
*1947, March 14
(still life – spotted curtain).*
Oil and pencil on board,
59.7 × 64 cm
Aberdeen Art Gallery

The 1940s

197

213

The 1940s

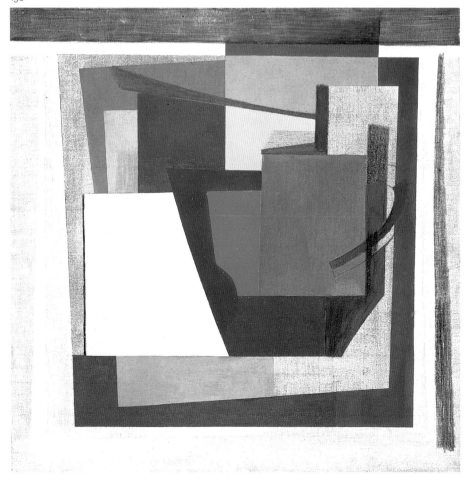

**198**

*1946 (composition, still life).*
Oil and pencil on
canvas, 43.3 × 43.3 cm
Manchester City
Art Galleries

**199**

*1946, January 19.*
Oil and pencil on
canvas, 44.7 × 62.2 cm
Private collection

serves for table top here counters any possibility of a distant view. Similarly in Manchester's *1946 (composition, still life)* [plate 198] flat colours present themselves with the neatness of toy soldiers, two of them at least speaking of a mug and cup, others less clearly referential, together presenting a tilting, shifting result not unlike that of the abstract *1945 (2 circles)*. Repeated edges and margins keep our attention on the central part of the square *composition, still life* where white, dark brown, bright red and yellow, and a subtle blue-grey jostle for the front position. Something of the same sort seems to be happening in the British Council's *1947, July 22 (still life – Odyssey 1)* [plate 203]: a still life contained in the visual centre, in this case by an oval table top with, it seems, rectangular support from a dado and other indoor shapes. The colours of the still life have much the same artificial bias and there are pencilled shadow lines and patches to add drama to the arrangement. But here we find a line of hills inscribed along the top band; slight though it is, it opens the picture to space and light, just as the subtitle opens the memory. But it is not only the hint of hills: the unusually tight

cluster of still-life objects, more or less contained within the oval line of the table, is set in a generous space in which gentle tones, abetted by one chunk of pencilled shadow, keep the air moving as the eye moves around the centre.

The Nicholsons stayed in Carbis Bay. If they thought of returning to London – the low price of London properties might have invited a move back had there been any way of raising a bit of capital, as well as the possibility of reclaiming their leading role in modern British art – the thought of all the ruins and rubble will have made them hesitate. Cornwall continued to give them much, and it was not at all clear that the art they represented would be seen as avant-garde in post-war England. In any case, travelling became easier again. Visitors came to St Ives more frequently, and it was easier now to get to London or elsewhere for special occasions. In 1944 there was a BN retrospective at Temple Newsam House, a part of Leeds City Art Gallery, mounted by Philip Hendy, subsequently director of the National Gallery in London. Presumably BN went north for that. Hendy made it a fine exhibition, but the British art

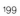

199

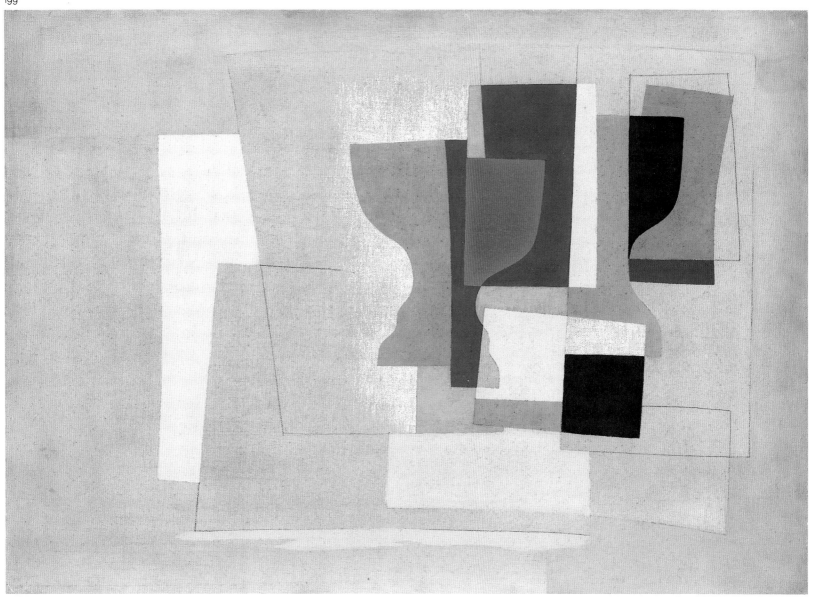

The 1940s

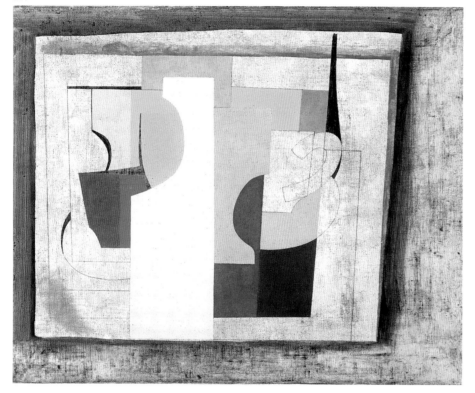

**200**
*1946 (still life).*
Oil and pencil on
canvas, 40.6 × 50.8 cm
Arts Council
Collection, London

**201**
*1947 (still life).*
Oil and pencil on board,
44 × 59 cm
Private collection

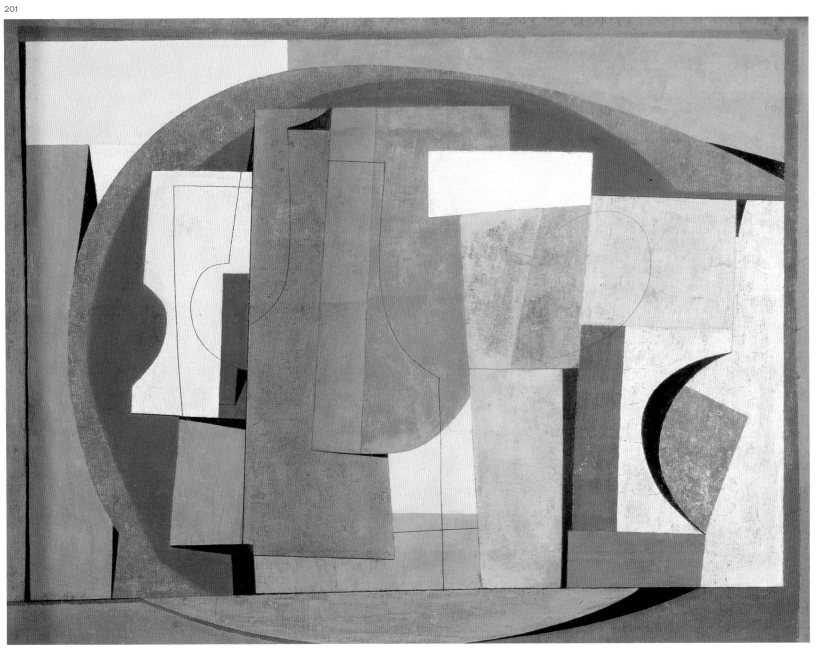

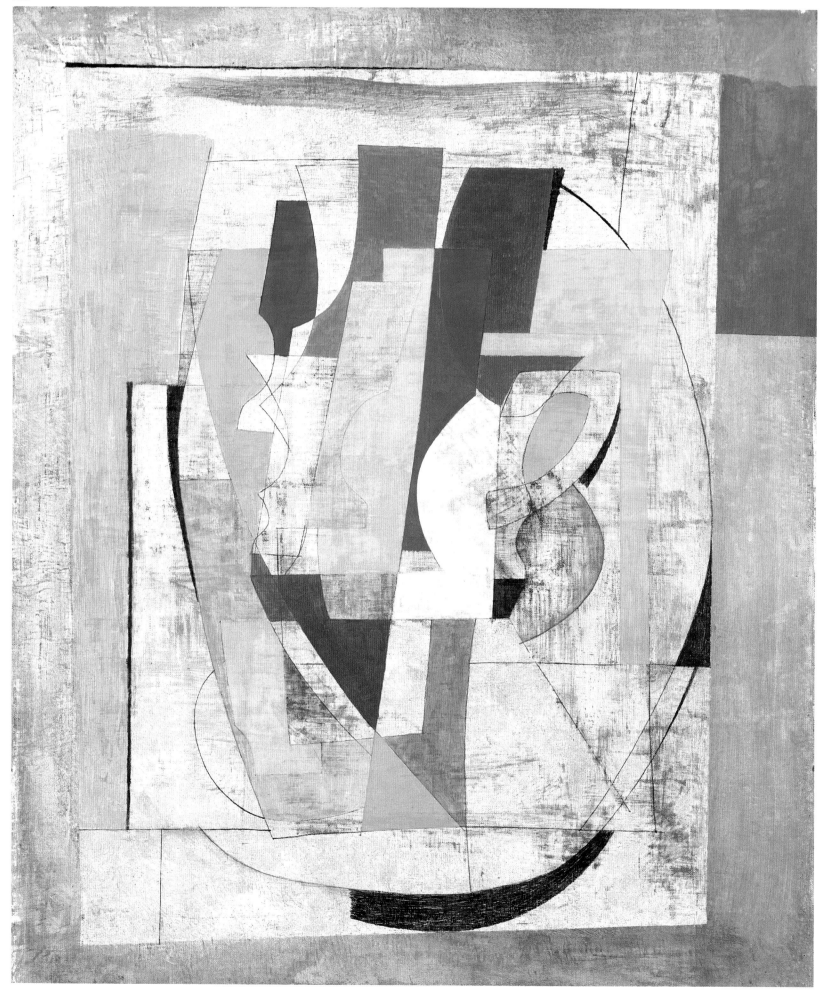

The 1940s

**202**
*1947, July 8*
*(still life – oval theme).*
Oil and pencil on
canvas, 61 × 52 cm
Private collection

**203**
*1947, July 22*
*(still life – Odyssey 1).*
Oil and pencil on
canvas, 69 × 56 cm
The British Council

The 1940s

The 1940s

**204**
*1945 (still life)*.
Oil and pencil on
canvas, 71 × 70.4 cm
Albright-Knox Art
Gallery, Buffalo
(Room of Contemporary
Art Fund, 1948)

**205**
*1946 (still life –
winter landscape)*.
Oil and pencil on
canvas, 59.6 × 56.8 cm
Private collection

world was too London-focused for it to have created a stir.

In 1948 the first of what became a two-volume set of BN monographs was published by Lund Humphries as *Ben Nicholson, paintings, reliefs, drawings*.[12] That will have entailed travelling as well as visitors. The same year saw a slender BN volume appear in the 'Penguin Modern Painters' series edited for Penguin Books by Sir Kenneth Clark, with an introduction by John Summerson.[13] BN took a keen interest in both volumes, words and images. He wrote to Summerson about his work and development and presumably had opportunities of speaking with him. What works were to be reproduced must have been of great importance to him since these books would represent him to a world he still had reason to consider largely hostile. The *Circle* circle had disintegrated through defections and departures. Euston Road and Neo-Romanticism were still dominant, and Moore, it seemed to both Hepworth and BN, had lost his fire. His *Madonna and Child*, commissioned for St Matthew's in Northampton and set up there in 1944 to the disgust of many of the parishioners, drew praise from Read

who disliked the Graham Sutherland *Crucifixion* hung in the church two years later. They disagreed: '… it's a bad carving', wrote Hepworth, '… smug & smooth & de-vitalised', whereas the Sutherland is 'a genuine achievement'. BN wrote that 'the G.S. "Crucifixion" seems to me a grand effort … the H.M. madonna & child – is just bunk – it is a sickly-sweet & highly competent compromise between his own living idea & a dead (C. of E.?) idea which he does not believe in at all.'[14] But how far all this was from BN's kind of art. He was over fifty and there did not seem to be much interest in his work in Britain. It must have galled him that his friend Harry should be achieving fame as well as notoriety, and money, with work that struck him as false.

Meanwhile, the St Ives art world was growing. BN and Hepworth had reason to feel useful there, as well as important, though BN always hated the civilities that went with being thought important: the work should draw attention, not its maker. In 1946 the painter Patrick Heron – who had worked for Leach during 1944-5 – spent July in Mousehole. From 1947 onwards he visited and worked in

**206**
*1946 (still life – Alice through looking-glass).*
Oil and pencil on canvas, 68.2 × 75.5 cm
Art Gallery of New South Wales, Sydney

**207**
*1945 (still life).*
Oil and pencil on canvas, 58.4 × 54.5 cm
Art Gallery of Western Australia, Perth

St Ives every year until 1955 when he bought a house, Eagle's Nest, at nearby Zennor. He was to be a key figure in St Ives art, but in the late 1940s he was particularly important in writing about the work of major St Ives artists in prestigious journals. He wrote regularly for *New English Weekly* and for *New Statesman and Nation* (1945-7 and 1947-50 respectively), and later for the New York magazine *Arts* (1955-8), making no bones about the international importance of some of his Penwith Society friends.[15]

To have two books on his work come out at this time, one cheap and accessible but in honourable company, the other a tome on its own and a milestone production, was obviously important to BN as challenge and as encouragement. He must have given them a lot of thought, and I suspect that the dating of some of his early paintings was decided at this time. The information he gave in writing to Summerson has remained the basis for all BN studies.

He must have considered his text in the Lund Humphries volume with especial care. Read's introduction was warmly supportive but also very general, more about abstract art at

large than about the particular characteristics and qualities of BN's contribution; by implication it made BN's figurative work secondary, a preparation for the real thing. For a motto at its head Read put Apollinaire's words, 'the plastic virtues: purity, unity, and truth, keep nature in subjection', and it is difficult to think of them not grating on BN. He wanted very much to be understood. His own contribution was his 1941 text, 'Notes on Abstract Art', reprinted from *Horizon*, but in a revised, cut and enlarged form. Most of the revisions are slight adjustments of wording, but one of them strikes me as revealing: the word 'abstract' in the title is now accorded inverted commas: 'Notes on "Abstract" Art'. The implication is that this is what people call it but BN would rather not: so-called 'abstract' art. Coming after Read's exegesis, rooted primarily in Worringer, the text distances what BN says from the introduction and from a lot of what was being written and said about abstract art, by supporters or antagonists, in the 1930s. The fifth paragraph of the *Horizon* article is now omitted. It deals with the tendency of some Surrealists to set bits of nature, parts of the human body often, into abstract contexts; BN finds

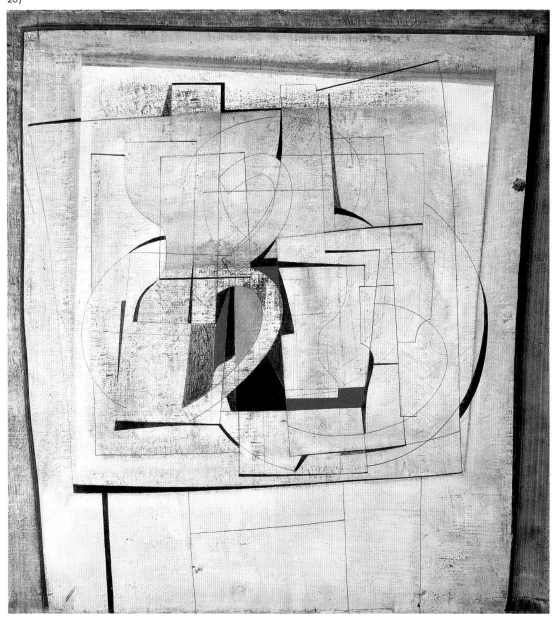

The 1940s

**208**
*1945 (Halsetown, winter).*
Oil and pencil on board, 22 × 33 cm
Private collection

**209**
*1946 (Towednack).*
Oil and pencil on canvas, 40.5 × 51 cm
Private collection

this pointless and probably distasteful. And it faults painters who are still doing Cézannes and Seurats without contributing anything substantial to what those masters provided. Here BN refers to 'the Bloomsbury artist', perhaps recalling Clark's praise of 'belated impressionists or pure painters' in his 1935 attack on modern art. Such artists do not understand Cubism, 'one of the big historical movements in painting', out of which Constructivism came. 'Everyone interested in contemporary painting and sculpture should read' the book Alfred H. Barr put together to go with his Museum of Modern Art exhibition, *Cubism and Abstract Art*, in 1936. So BN now cuts out what in his essay had been negative, historical and didactic. He featured in Barr's exhibition and book, and indeed this long remained the most useful account of Cubism and its aftermath.

In 1948 BN must have felt his task was to guide the reader towards understanding the particular nature of his art, not by the art historian's method of providing signposts nor by the critic's of focusing attention by promoting the hero of the hour and demoting others, directly or indirectly.

*Horizon*, founded by Cyril Connolly in 1939 as a cultural bulwark against war's tendency to shrink life to its lowest level, was of great prestige, and there can be no doubt that BN put his best efforts into that essay. But by 1948 he had had further thoughts and the Lund Humphries book was to him a far more important opportunity. He added a new paragraph and dated it. In it he explains, clearly and briefly, that he is after the excitement that painting which is 'both musical and architectural' can give him; the question of whether things are 'representational or non-representational ... slightly more or slightly less abstract ... is for me beside the point'. He ends there, and it sounds like a rebuff to Read's scholarly text. Further on in the book is a résumé in French of Read's introduction; BN's text is given a full translation.

The association of still life and landscape, of near and far, continued to attract BN as an area for further experiment and new satisfactions. *1947, November 11 (Mousehole)* in the British Council's collection, and *1947, December 13 (Trendine 2)* in the Phillips Collection [plates 214 and 212] are akin in some respects, quite diverse in others. A glance back at

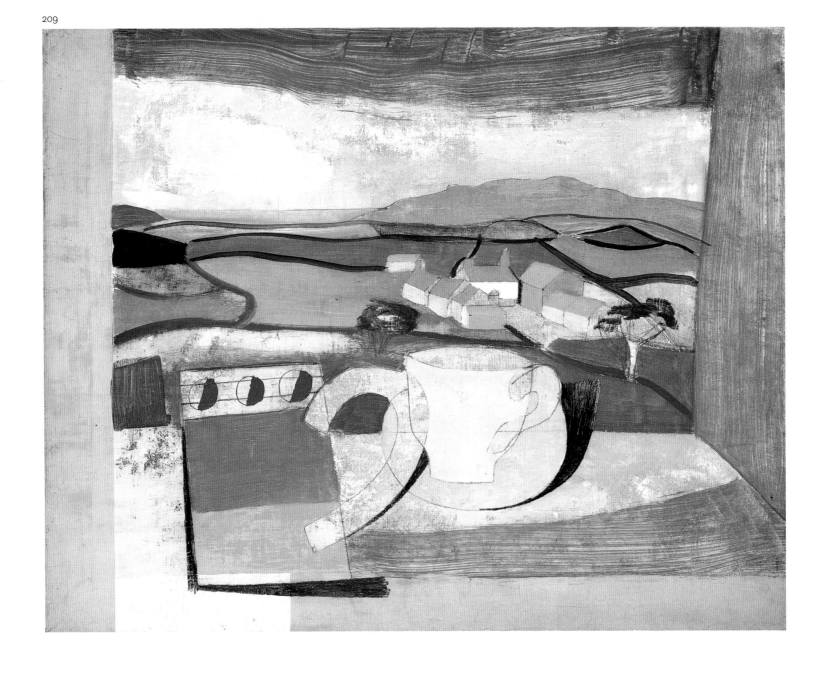

The 1940s

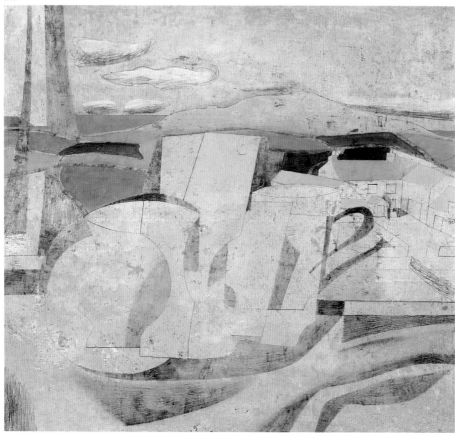

**210**
*1948, January
(Towednack).*
Oil and pencil on
board, 40 × 43.3 cm
Private collection

**211**
*1949, May 19
(rooftops, St Ives).*
Oil and pencil on
canvas, 45.5 × 70 cm
Menard Museum,
Komaki-shi, Japan

*1940 (St Ives, version 2)* [plate 161] helps to make this clear.
In all three the distant scene is presented in an idiom
different from that used for the still life in the foreground. In
the background, opaque and transparent patches of colour,
buildings and boats done in line, curving forms and neat
linear structures. In the foreground, still-life groups presented
in quite a different way. The cup and mug in the 1940 picture
are shown almost exclusively in line, the smaller in front of
the larger. The two curved lines denoting the top edge of
each of them suggest that we can look into them, but
otherwise they are rendered quite flat. The staggered group
of glasses and goblets in the Phillips Collection picture,
carefully outlined and shadowed in pencil, seems at first
sight more materially present, like paper collage carefully cut
and mounted, but dissolves as we look at it. The light tones
make it appear quite ghostly, and the objects merge on the
right with the group of houses beyond the window opening.
The division between near and far, clear in the 1940 picture,
is here cancelled, foreground and middle distance becoming
one zone while fields and much smaller houses form a

second zone. This merging is the more remarkable for the
red-brown sill BN places between the still life and the
nearer houses: having established an unusually firm frontier,
he counteracts it in his design and by not filling in colour to
the left of the still life. In the *Mousehole* picture the still-life
group seems almost a separate element, a cluster of forms
collaged over the landscape, a Cubist incident within a semi-
naturalistic account, a 1930s relief rendered flat and set
against a simplified account of man-in-nature. The duality
he confronts us with becomes more marked in these 1947
paintings. He may have been seeing, more or less
consciously, how far he could press it without fusing the two
elements. Echoing hues and textures create bonds between
them, yet we are left feeling that two different worlds
confront each other in these paintings, both harmonious
and welcoming but only precariously allied to each other.

The graphic work of this time shows him, in the drawings,
collecting shapes, lines and accents observed in the
landscape, and, in the six drypoint etchings of 1948,
translating these into complex linear structures that adhere

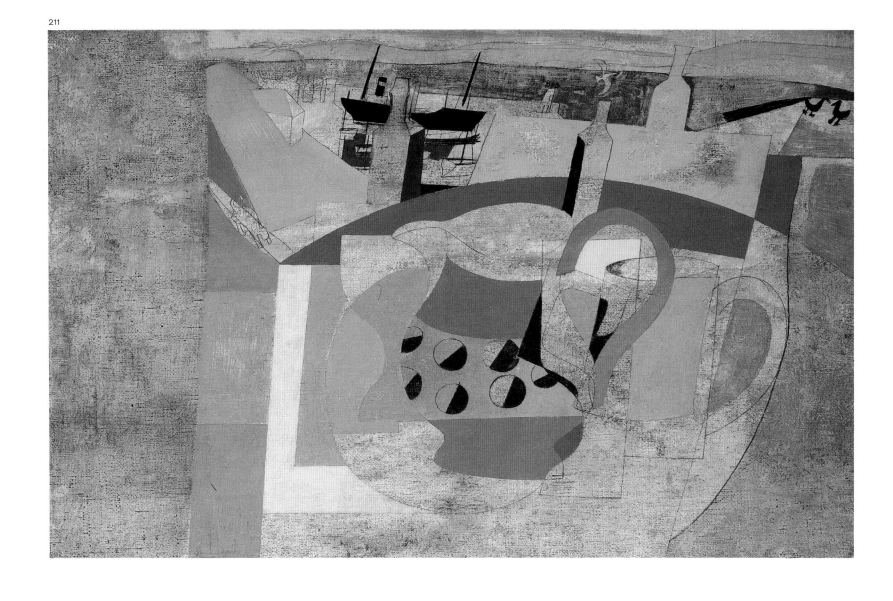

The 1940s

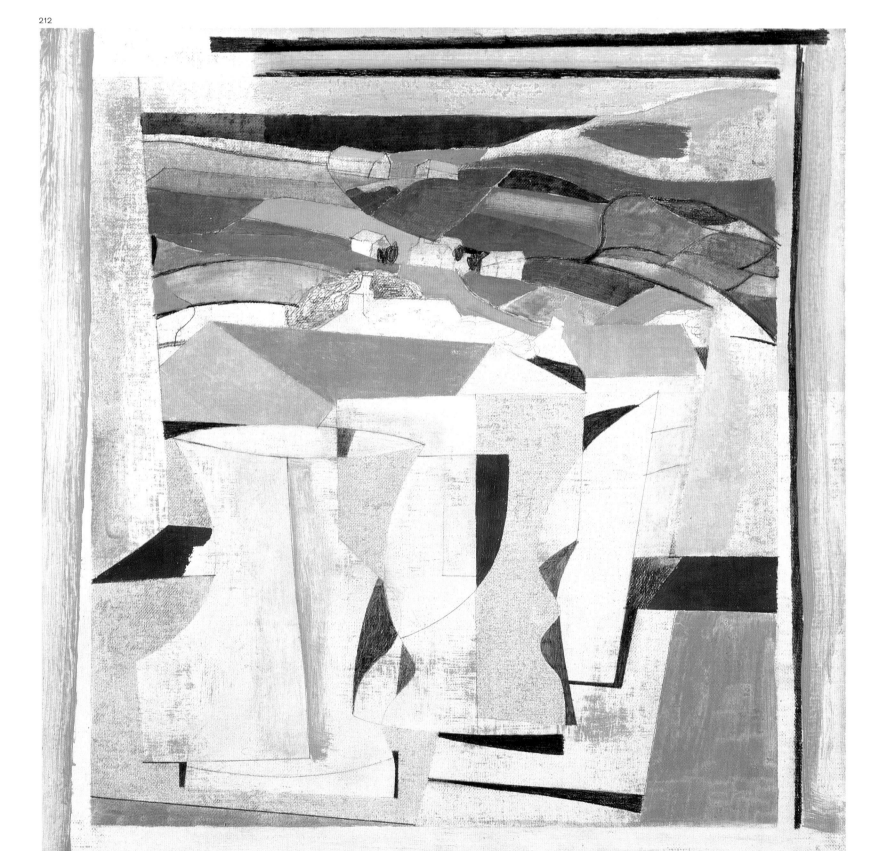

The 1940s

213

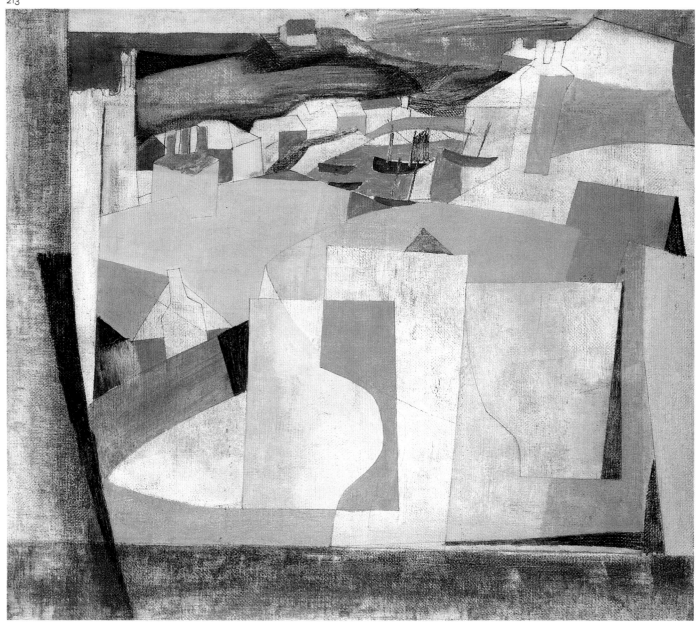

**212**
*1947, December 13
(Trendine 2).*
Oil and pencil on
canvas, 38.4 × 37.1 cm
Washington,
The Phillips Collection

**213**
*1949, July 15
(St Ives Harbour).*
Oil and pencil on
canvas, 35.2 × 40.3 cm
Paul Mellon Collection,
Upperville, Virginia

The 1940s

**214**
*1947, November 11
(Mousehole).*
Oil and pencil on
canvas, 46.5 × 58.5 cm
The British Council

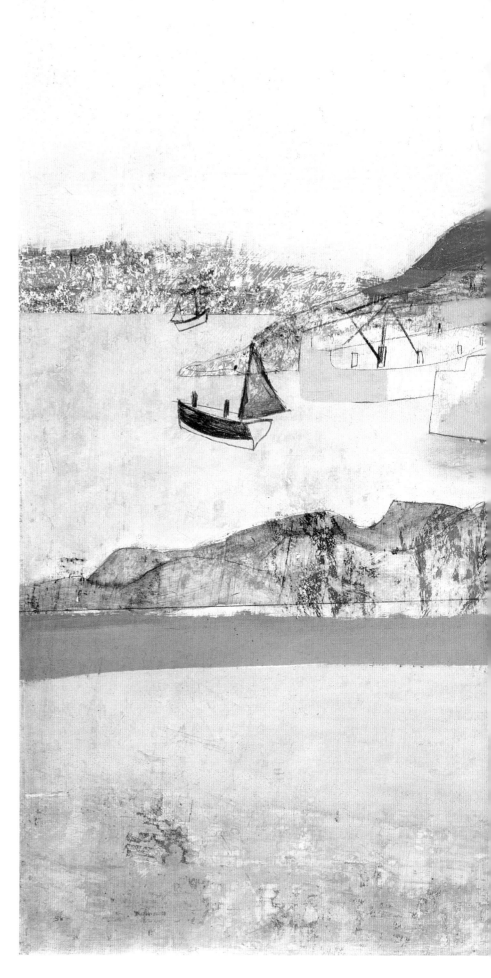

Ben Nicholson 1948                                    7/8

Ben Nicholson 1948                                    7/10

The 1940s

217

**215**
*1948 (Newlyn).*
Drypoint,
15.1 × 18.4 cm
Edition of 8

**216**
*1948 (ICI shed).*
Drypoint,
20 × 25.1 cm
Edition of 10

**217**
*1947 (St Ives Harbour).*
Pencil on paper,
23 × 35 cm
Private collection

more insistently to the surface of the paper. In *1948 (Newlyn)* [plate 215] he offers us a glimpse of a foreground in the transparent window frame and sill that offer some explanation of his high viewpoint. In *1948 (ICI shed)* [plate 216] a similarly high position is barely justified by a wavy line cutting across the concrete fencing posts. Everything man has here contributed to the scene seems to be transparent; only nature is allowed solidity.

In February 1949 the Penwith Society of Arts in Cornwall was founded. Founder members included BN and Hepworth, Wells, Lanyon, Leach the potter and Guido Morris the printer. As this implies, craftsmen could be members. There was also a lay member category. Herbert Read agreed to be its president and came down to give a presidential address that September. More members joined quickly by invitation, including Bryan Wynter and David Leach (Bernard's son and colleague). Hepworth put forward BN's proposal that artists should be divided into groups A and B, i.e. representational and abstract, and should mark their work thus in submitting it to one of two distinct juries, while craftsmen submitted their

work to a crafts jury, C. This system produced dissension within and without the Society, followed by resignations and secession. But it also drew attention to the association's existence and activities.

In the summer of 1949 BN was given the tenancy of one of the purpose-built studios backing on to Porthmeor Beach in St Ives. He applied for this in writing to Philip James, director of art at the Arts Council, which controlled the tenancies. He was working in a bedroom, he wrote, which 'imposes a very definite limit on the size of paintings I can make'; when the children were home on holiday (from Dartington College) he could scarcely work at all. He had a commission to paint two sizeable panels for a New Zealand ship and that alone called for more space. But when he was sent the lease for the new studio he objected to a clause in it, prohibiting any form of music making in the studios. He was able to get the clause deleted: 'I frequently work to a radio – I find it extremely helpful in removing my thoughts from surrounding noises and in enabling me to become "subconscious".[16] Mondrian too worked with music as a

The 1940s

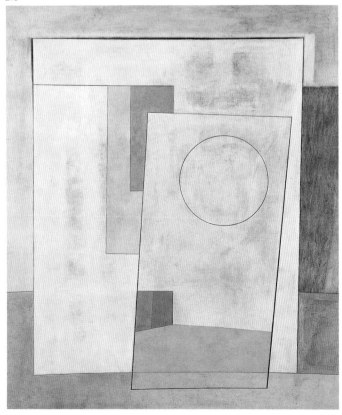

**218**
*1949, October
(Rangitane).*
Oil and pencil on
curved wood panel,
192 × 164 cm
Gimpel Fils

background. BN went on doing so wherever he was, preferring light music that would not demand his attention. Well lit from above, the studio had no windows to distract the eye. David Lewis, then a writer living in St Ives, married to the painter Wilhelmina Barnes-Graham and during 1951-4 curator of the Penwith Society, later described BN's new studio and some of his working practices:

Ben made most of his paintings and reliefs in one of a group of large studios located where the granite town forms an edge like a medieval wall against the Atlantic Ocean. You couldn't see the ocean from his studio, but you could hear its ceaseless rhythms, even on calm days, and through the skylights came the reflected light of sea and sky.

The studio was white inside and its whiteness plus the light from the sea made sharp colors incredibly intense. Around the walls were stacked canvases; and on a shelf were the bottles and glass goblets which appear in so many of his paintings. His palette was a simple tabletop.

At the end of every day he would clean the unused oil colors on his tabletop with turpentine and white rags, and he would scrub the thinned oil colors onto raw canvases or onto sheets of drawing paper; making a 'ground', he called it.[17]

In October 1949 BN painted two panels for the steamship *Rangitane*. The commission came from the architects working on the ship's interior, Easton and Robertson, and was for a pair of curved panels. The compositions BN developed for both were abstract and rather severe, and it is thought that they were not much liked. Certainly they were wholly distinct from the visual diet, chic and charming, then offered to upper-deck clients. The panels remained in place until the ship was refurbished in 1963. One has been lost sight of but may be in a Swiss collection. A photograph of BN's studio shows most of it as well as the panel illustrated here and establishes that they were similar [plate 219].

*1949, October (Rangitane)* [plate 218] could be called a flat relief, i.e. a painting echoing the forms and structural relationships of BN's reliefs. Emphasized lines hint at the edges of raised planes, and at the top of the main rectangle BN has painted a dark smudge which is unambiguously read as a shadow and gives a strong illusion of space between a projecting plane and its background. But the work has a character that separates it from what we have seen in the

**219**
BN's studio in St Ives,
showing, among other
works, the two
*Rangitane* panels and,
on the far wall, *1949,
October (West Penwith)*,
October 1949

**220**
*1948 (project)*.
Wool rug after a
design by BN of 1948,
170 × 180 cm
Private collection

220

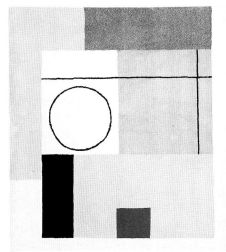

reliefs and the related paintings so far. It is not just that the
plane apparently closest to us leans to the right, taking on a
particular character (an abstract personage on an abstract
stage?). This plane also appears to be both transparent and
opaque. The line cutting through it a little way above its base
line continues the line of the large rectangle behind it, and
the colour of that band of the leaning plane continues the
colour of that part of the background. Both signal
transparency. The old-ivory colour of the rest of the plane is
the same as that of the larger rectangle in the upper half but
differentiated in tone in the lower area. In this lower part of
the sloping plane we see a five-sided form and a pair of
quadrilateral forms: we are drawn to ascribe perspective to
them together and can read them as showing the corner of
a room. The sloping plane may be a mirror, reflecting
something behind the viewer (as we saw also, though in
entirely different terms, in *1930 (Christmas night)* [plate 64]).
That the sloping plane is opaque is asserted by its appearing
to lean against the larger plane behind it, obscuring part of a
composition of rectangles behind its top left corner. This and

The 1940s

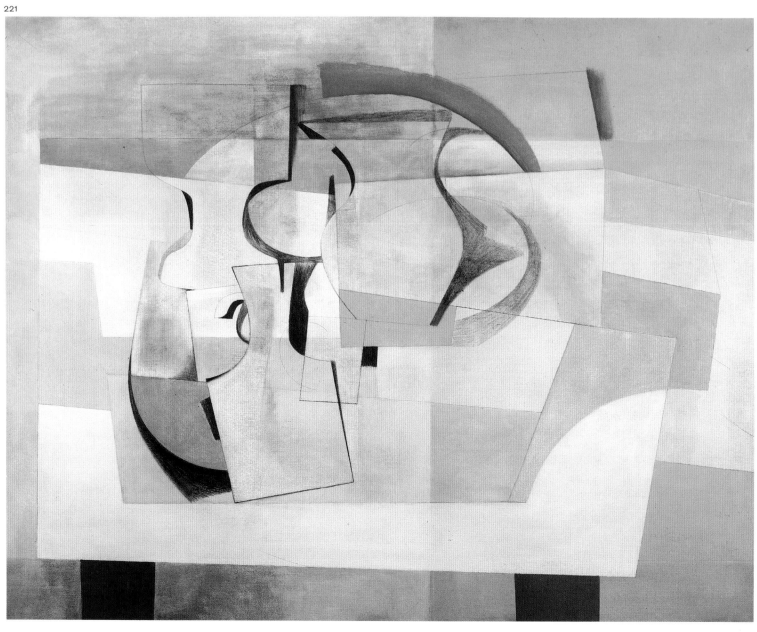

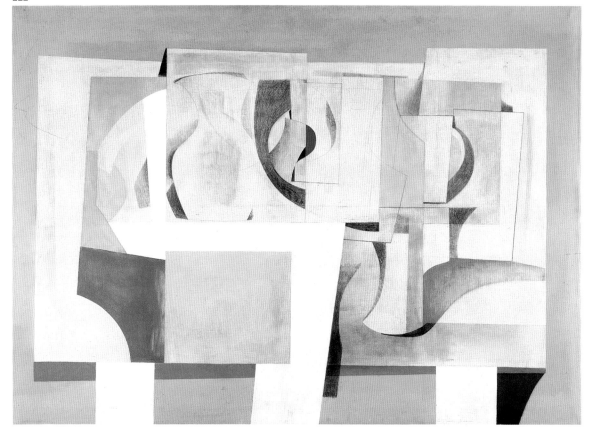

**221**
*1949, December 5
(poisonous yellow).*
Oil and pencil on
canvas,
124.4 × 162.4 cm
Galleria Internazionale
d'Arte Moderna di
Ca' Pesaro, Venice

**222**
*1950, April (still life –
Abélard and Héloïse).*
Oil and pencil on
canvas,
119.7 × 165.4 cm
National Gallery
of Canada, Ottawa

other devices – such as the brown going across the bottom of the panel and offering itself as a floor area on which stand both the vertical forms and the slightly ominous shadow on the right – give the composition a quality one can only call Surrealist. Thus a neat abstract composition, exhibiting delicate tints of ivory, blue-grey and several browns, becomes a difficult, ambiguous experience and was probably felt to be antagonistic to the décor of its setting. Its implied association is not with still life or landscape, as we would expect, but with built interiors. The other panel had much the same structure and character. The curvature (in both cases) is not very marked and need not have affected BN's invention. None the less, the fact that he was making panels for an interior, and that these embraced part of the space, may have caused him to think on this occasion of manipulating an anti-rational, ungraspable group of forms in what was intended to be a decorative panel. He had been accused of making empty, decorative reliefs in the 1930s; here was a pair of disconcerting compositions made specifically for decorative use.

Other relatively large paintings followed rapidly, and the commission offered in 1950, for a mural painting approximately 180 × 400 cm, could hardly have been accepted had BN not had the use of a large studio. Some of these paintings are vertical, such as the British Council's *1949, March (Trencrom)* which will be discussed below together with some of the vertical compositions of the early 1950s. Others are horizontal and surprisingly different from those he had managed to produce in the bedroom studio of Chy-an-Kerris. One is *1949, December 5 (poisonous yellow)* [plate 221]. Compared with the 1947 still life with landscape paintings [plate 212 and 214], this is a harsh work, an almost unyielding array of planes and still-life emblems. On the left the table echoes closely the edges of the picture and comes forward from a light-toned background. On the right the table dissolves into a multiplicity of planes, so that foreground and background become one just after a patch of shadow, top right, had promised space. The objects are presented in terms of pencil lines and shadows; they are all glass, all

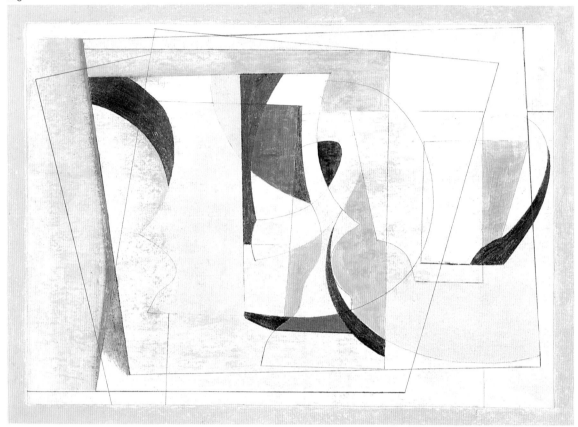

**223**
*1949 (still life –
Copernicus).*
Oil and pencil on
board, 25.4 × 35.5 cm
Private collection

**224**
*1949, February 14
(bottle).*
Oil and pencil on
board, 32.5 × 21.6 cm
Private collection

transparent, all insubstantial and offering no resting place
as they tilt this way or that and our eyes run through
them to the grey and lime-green patches on the table.
A grey curve arches without explanation over part of the
centre. The geometrical shapes on the table, some sharp-
edged, some soft, make even that element unreliable: just
to the right of centre a vertical shift of tone implies that
even the table is transparent. Only the deeper grey
patches of the table legs reassure us.[18]

*1950, April (still life – Abélard and Héloïse)* [plate 222]
is much the same size and gives much the same first
impression. If anything it feels the more solid painting of
the two, the more trustworthy, and indeed, with that
subtitle in view, one wonders whether something had
occurred in BN's life to encourage a more positive spirit.
BN may well have known Helen Waddell's novel, *Peter
Abelard*, first published in 1933 and many times reprinted.
It was deservedly admired both as a compelling historical
romance, based on deep research by a specialist in
medieval Latin literature, and as a sequence of

intelligently reconstructed scholastic discussions.
The table in BN's *Abélard and Héloïse* is set against an
almost unmodulated grey background and seems, thanks
to grey shadow below it and a deeper patch of shadow
bottom right, to stand forward from it. Rather gentler
lime-green areas dominate the colour composition in
spite of a white shape that offers itself as a third table leg
and a partial background to the lime-green rectangle that
in effect is the painting's most forward element. It is also
the clearest element, for once we have accepted the
calmer, clearer key signature of this painting we rapidly
find ourselves wrestling with a host of uncertainties.
Some of the still-life shapes are quite legible; others are
fragmentary or obscured by shapes without names or
justification. Pencil lines are very important, as fine
outlines and as shadow areas, and some of these do not
appear to belong to any object. The table itself seems to
become a faceted surface on the right, and left of centre
a plane rises above the line of the table and seems to
turn back into it as though it were a piece of folded card.

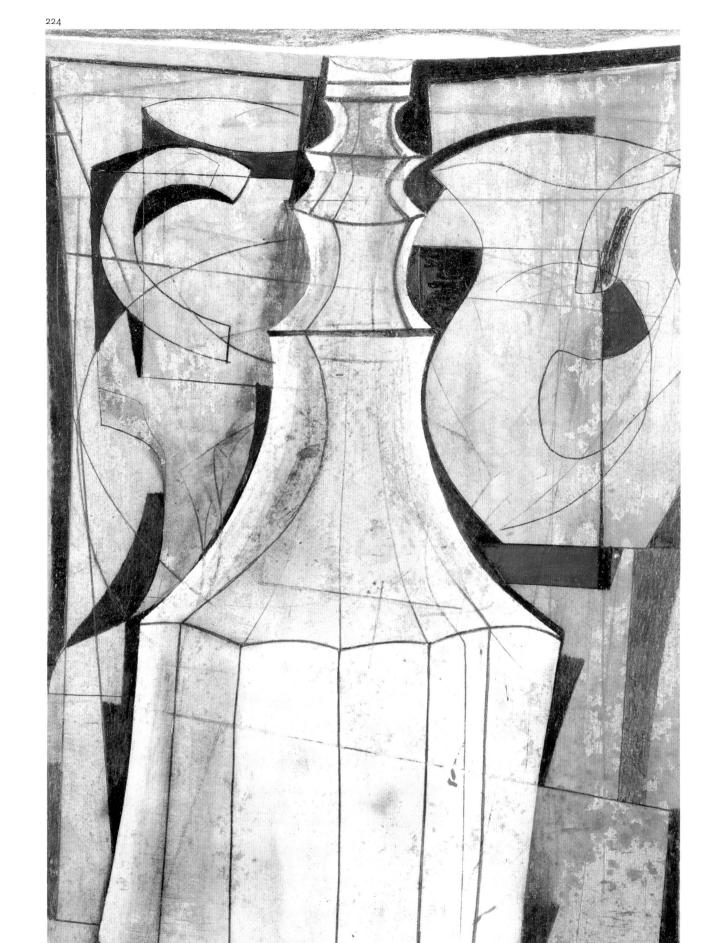

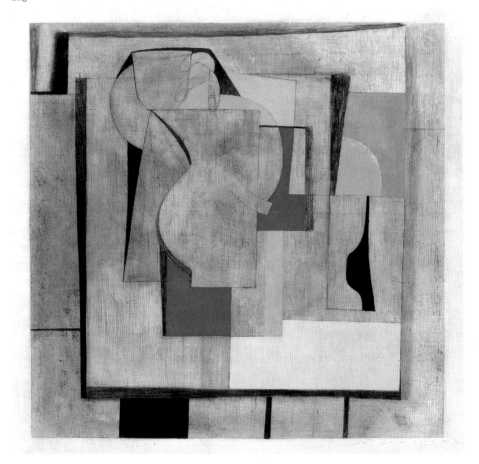

225

**225**

*1946 (still life).*
Oil and pencil on
canvas, 59.1 × 59.1 cm
Private collection

**226**

*1949, June (Lorca).*
Oil and pencil on
board, 37.2 × 38.7 cm
Bernard Jacobson
Gallery/Agnew's

The 1940s

228

**227**
*1949 (St Herbot Huelgoat).*
Pencil and wash on paper, 33.5 × 51 cm
Bernard Jacobson Gallery

**228**
*1948 (Penzance).*
Pencil on paper, 34.9 × 50.7 cm
Private collection

**229**
*1950, April 11 (Newlyn (JW)).*
Pencil and wash on paper, 35.5 × 50.8 cm
British Museum, London

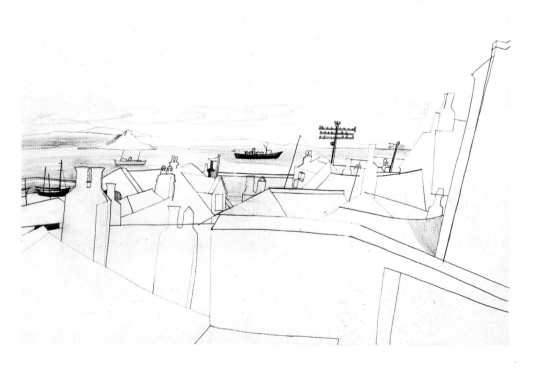

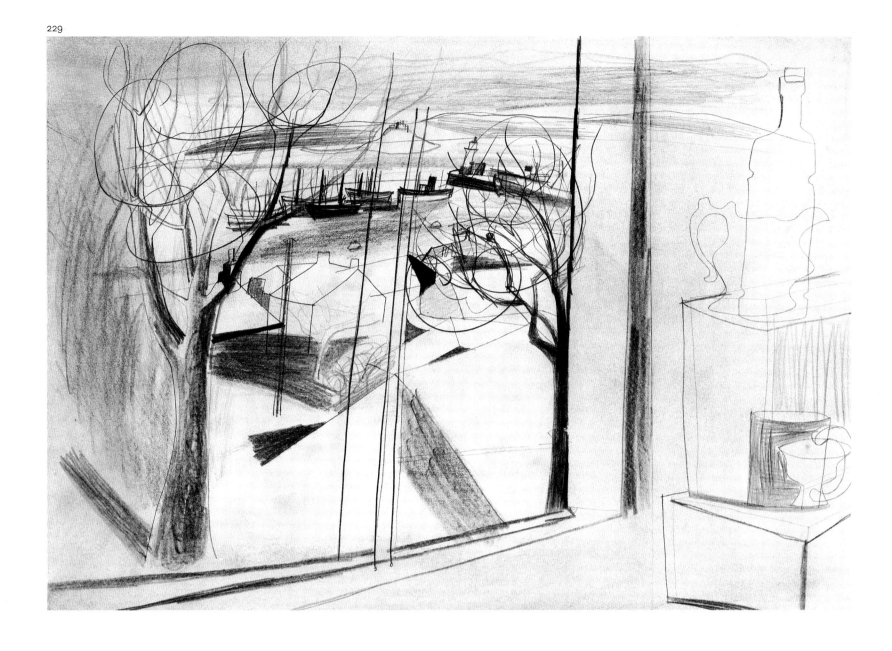

The 1940s

In 1951 BN wrote that 'so far from being a limited expression, understood by a few, abstract art is a powerful unlimited and universal language'. He was then producing large abstract and powerfully abstracted paintings, two of them in response to commissions, in a country where 1930s Modernism was a distant memory and where observation-based art was dominant, the Euston Road sort attempting a sensitive mapping of the motif and the Neo-Romantic sort inviting more poetic, often nostalgic responses. Asked, twelve years after, whether he had anything more to say about that, he answered: 'No, nothing to add. I'd just like to say it all over again." The fact is that none of BN's statements ever needed withdrawing or justifying in terms of what he was doing at a particular time. The underlying message was constant. He never adopted the more or less dogmatic terms used by any movement; he never gave his art or his response to art proscriptive limits. Leslie Martin had written in 1949 that BN 'in his recent paintings does not find it the least incongruous to combine abstract and representational forms'. Martin thought it a mistake of critics to see the early, romantic and representational work as essentially distinct from the abstract work of the 1930s; change in BN, he said, was a matter of emphasis. BN's continuing concern was with a 'brilliant and subtle range of proportions, colours and forms for which architects and designers will owe him a lasting debt'.[2]

But all around him art presented itself in terms of contending movements. BN's words of 1951 may have been meant in part to lend support to a new but quite small abstract art movement emerging in London, perhaps also to defend the murals he completed that year, then seen as wholly abstract though we would recognize their roots in his work with still life. Martin's words turned out to have a prophetic side to them. The 1950s saw

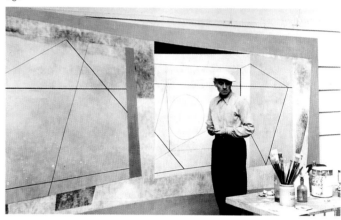

BN producing paintings of exceptional brilliance and subtlety, incorporating still-life motifs but in compositions blatantly governed by purely aesthetic considerations. Then, at the end of the 1950s, he returned to making reliefs, apparently abstract again.

The new movement was associated first of all with Victor Pasmore (born 1908). He came to St Ives at BN's invitation in 1950. Having made his name as a fine painter of the Euston Road School, Pasmore had developed his wartime painting in ways that used visual information ever more selectively and abstractly and, most recently, had become wholly abstract by combining elements of Synthetic Cubism and Klee. With Adrian Heath, Kenneth and Mary Martin and Anthony Hill, he had joined in an informal group dedicated to developing abstraction in two and three dimensions. They saw in BN a British pioneer of abstraction and sought his interest and support. Pasmore and BN will have talked at length about their work; the visitor also spent some days on Porthmeor Beach making drawings of the sea which soon after fed into his abstract paintings as spiral forms. He returned from his time in Cornwall encouraged by this contact and in 1951 turned what began as a two-dimensional mural in a bus

Chapter 5

# The 1950s: St Ives

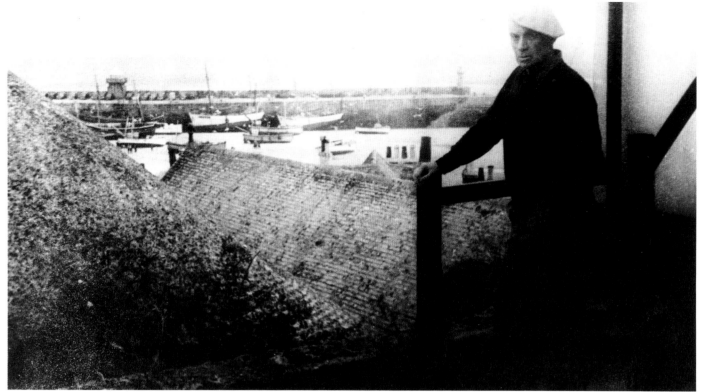

station, in Kingston, Surrey, into a three-dimensional construction very much in the spirit of BN's reliefs but without their latent still-life form and without their whiteness. That summer Adrian Heath visited St Ives for some weeks. Heath too devoted some of his time in Cornwall to making drawings of the sea; like BN and Pasmore, he saw nothing contradictory in seeking experiences and motifs that then served for abstract development.

When Pasmore and the others began to exhibit together – the first time in the AIA Gallery in Lisle Street, subsequently quite informally and briefly in Heath's Fitzroy Street studio – they invited BN and Hepworth to show with

them. This they did, feeling (according to Heath[3]) indulgent towards this younger group who were doing things they had engaged with earlier. In fact there were important differences in the ideas and methods that informed BN's work in the 1930s and theirs in the early 1950s. One of these is fundamental. Pasmore and his circle, influenced by such books as D'Arcy Thompson's *Growth and Form* and Hambidge's *Dynamic Symmetry*, took natural structures and man-conceived geometrical systems as the basis of their abstract work, seeing them as cognate. BN did not adopt systems or given structures, nor did he devote himself to the exact measuring and construction that must be the means to

**232**
*1950 (cloisters,
San Gimignano).*
Pencil and wash on
paper, 38.1 × 50.8 cm
Arts Council
Collection, London

**233**
*1950, May
(early morning from
San Gimignano).*
Pencil on paper,
36.5 × 54.2 cm
Private collection

their realization in art. In addition, of course, BN did not
then share their conviction that art had to be abstract,
let alone the further conviction Pasmore soon came to
express, that abstract art had to go into three dimensions.
Thus what we might call the Fitzroy Street group was
not a group of BN disciples though they honoured him.
It is likely that privately, as when he spoke to Heath about
the white reliefs, he emphasized the unity of the whole
range of his art and refused to give abstraction any sort
of priority or exclusive importance.

In any case, the 1930s were not the 1950s. 1951 was to see
Britain celebrating her survival of the war in the Festival of
Britain, a programme of exhibitions and other events all over
the country that had its climax, 100 years after the Great
International Exhibition that filled the Crystal Palace, in a
complex display of the national heritage and of national
innovation in buildings and displays set up on the south bank
of the Thames. Stylistically the result was confusing, with
traditional and progressive ideas and images cheek by jowl,
pointers to the future and nostalgic visions of the past. In the

sphere of art this was particularly so. Commissions went to
conservative and to avant-garde artists alike. Among the
latter were Moore, Hepworth and BN. He was charged with
preparing a mural panel for a curved wall outside one of
the restaurants on the South Bank site. The result was its
severest piece of modernism.

BN's panel [plate 230], measuring 214 × 488 cm, showed
an even background against which hovered a near-rectangle,
beginning parallel to the edge of the panel on the left, and
then broadening and slipping a little down the panel as it
continued towards the right edge. This large rectangle was
painted with soft, mottled colours but on it were two further
four-sided forms executed more crisply: an almost square
form on the left, the other almost twice as wide and designed
to suggest a double panel, divided vertically by a change of
colour. Across them the painter laid straight black lines of
varying thickness and one circle (roughly on the centre
axis of the composition). Some of these lines appeared to
connect with, or at least echo across, the forms but none
crossed the space between, and they made shapes that lay

The 1950s

**234**
*1952 (mural)*.
Oil and pencil on
board, 325 × 274 cm
Time-Life Building,
London

**235**
*1951, December (opal,
magenta and black)*.
Oil and pencil on
canvas, 116 × 161 cm
Museum of Modern Art,
Rio de Janeiro

more or less flat on the mural's surface. The horizontal lines, especially, stabilized what would otherwise have been an insubstantial arrangement, at the same time keeping it light and cool. As a whole the painting recalls *1945 (parrot's eye)* [plate 181], with its unsystematic web of straight lines and punctuating circles, but the mural was both less charming and less busy. Its lines seemed calm, and the spatial quality of the large near-rectangle made for a relaxed feeling that countered the stern look of the lines and shapes themselves. This work was destroyed together with the exhibition itself (the Royal Festival Hall, designed by J. L. Martin, is the only substantial part to survive), but the commission led to another for a mural in the entrance hall of the Time-Life Building in Bond Street, 325 × 274 cm, executed in 1952 [plate 234]. This composition is squarer. The background is partly mottled and in front of it hovers a double structure of painted planes and lines, each half identified with an inscribed circle. It sits well in the lofty entrance hall of the building, a restrained rather than an imposing presence. Its light tones combine with small areas of more assertive colour

to give it a playful character; the structure is relatively severe yet seems to unfold. The combined effect is one of reticent generosity. Both these works are abstract, in the sense of making no reference to objects in the visible world. In this respect they are exceptional in BN's work of those years.

One of the most severe paintings of the early 1950s, almost without colour, is the large still-life composition in Rio de Janeiro, *1951, December (opal, magenta and black)* [plate 235]. The table top and its weightless burden of bottle, vase, goblet, cup, are all in line and thus seem transparent and immaterial. The merest hint of a shadow at the edge of the table, top right, refers to the possibility of space; we can see that there was more of it before BN painted over it with the off-white/ivory colour that occupies most of the surface. The kink in the table's top edge charges it with understated energy, and there are lines descending from that edge and meeting others to make non-referential shapes on or off the table surface. These, like the structure of the Time-Life mural, seem to unfold. On them hovers the still life, a network of sharp lines, straight and curved, partly ignoring, partly

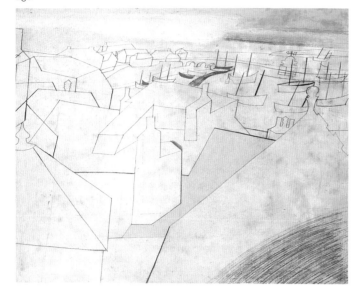

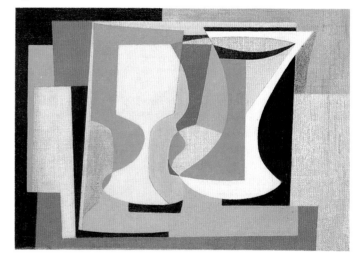

**236**
*1951, October (St Ives harbour from Trezion).*
Oil and pencil on
board, 45.5 × 52 cm
Private collection

**237**
*1949, February
(still life).*
Oil and pencil on
canvasboard,
41.5 × 51 cm
Private collection

interfered with by the other lines on the table. There are
two small patches of opaque colour, opal and magenta
as announced in the subtitle: we are left debating with
ourselves and with the painting whether they belong or do
not belong to the still life. But almost a third of the painting
is given to something else. A firm, broad oblong shape
descends from the lower edge of the table, partly to the
bottom of the painting. A dark area under the table? The
front of what we should see not as a table but as a box
or chest? In the general near-whiteness of the painting it
makes a powerful impact, especially as it is partnered by the
whitest part of the picture, a patch of white that begins, slight
and soft, to the left of the table and becomes a hard, sharp
form along the bottom. From its right end, silhouetted in or
against the black, springs another hard, sharp shape. This
one is in ivory. It has a straight lower edge and a keen,
asymmetrically curved top edge – a shape without a name
or reference however hard we strive to know it. Its needle-
pointed right end almost touches the corner of the white
shape; the ivory shape seems hinged to the white and to be

rising on that hinge, opening slightly and slowly like a vast
lid. We are here confronted by an abstract invention that
answers the still life above like a counter-statement, severe
and almost sculptural where that is airy and delicate. Both
the severity and the delicacy are extreme. One would not
expect to find them in the same phase of an artist's career,
let alone in the same medium and the same work.

We shall find a comparable sharpness and an even more
marked sense of assertive, almost sculptural form in works of
1955. It is not unreasonable to think of the unsettled state of
BN's domestic life in the early 1950s. In 1951 BN and Barbara
Hepworth divorced. In 1949 she had bought Trewyn Studio in
the heart of St Ives, where no one complained at the noise of
hammering. It had a garden which was to become
increasingly important to her as a space for showing her
sculpture, and a view of the sea. She moved there now. BN
subsequently moved into a St Ives house called Trezion, up
the steep little alley called Salubrious Place, a stroll away
from his studio. (In 1957 he renamed it Goonhilly, a Cornish
name that for him had the additional charm of invoking the

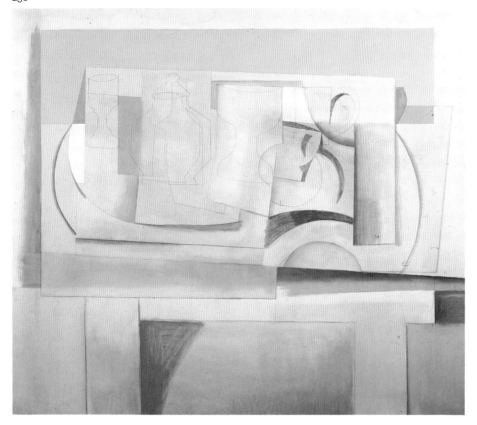

*1950 (still life)*.
Oil and pencil on
canvas,
203 × 228.3 cm
Manchester City Art
Galleries

memory of his favourite radio comedy series, 'The Goon Show'.) But we must resist the temptation to explain his actions too readily in this manner. The curved ivory shape near the bottom edge of the painting, silhouetted against black, is a dramatic innovation, yet pre-echoed in the curved white, relatively hard form, in a context of slightness, in *Cortivallo, Lugano* [plate 18], about thirty years earlier.

Setting a linear structure, spread or concentrated, against contrasting flat surfaces and spaces was BN's major programme at this time. One almost inevitably uses musical terms in speaking of it – polyphonic lines over a ground bass of formal chords, or some other such analogical language. BN himself had recently written: 'The kind of painting I find exciting is not necessarily representational or non-representational, but it is both musical and architectural, where the architectural construction is used to express a "musical" relationship between form, tone, colour and whether this visual, "musical", relationship is slightly more or less abstract is for me beside the point'.[4] In other statements of the time BN strove similarly to bypass the

abstract–figurative division that troubled people so, art critics as well as the wider public. Responding to the charge that *1950 (still life)* [plate 238], acquired by the Manchester City Art Gallery with the assistance of the Contemporary Art Society, was 'too modern', BN wrote about the 'new freedom' art had gained thanks to Cézanne. He offered the following response to the stock question, 'But what is it supposed to represent?': 'The answer to that is very much the same as one might give if asked what a flower is supposed to represent. Each flower exists in *its own right* – it does not represent anything but itself'. Ignore subjects and titles and try to engage with 'the particular artist's idea or thought expressed and experienced in paint'.[5] In a short text he wrote for the catalogue of his first Tate Gallery retrospective, in 1955, he used the words of his friend John Wells:

How can one paint, as John Wells has remarked, the noise of a beetle crawling across a rock? The poetic experience of such an event can only be realized in a painting by an equivalent, out of the painter's total experience, when it can become all things to all men, all beetles to all rocks. ... 'Cubism' once discovered could not be undiscovered

and so far from being that 'passing phase' so longed for by reactionaries it (and all that its discovery implied) has been absorbed into human experience as we know it today. Painting today, and it was Cézanne who made the first vital moves, and Picasso and Braque – and Mondrian – who carried the discovery further, is a bird on the wing.[6]

BN delighted in the precision and grace of animals' movements and likened them to the actions of the most perfect sportsmen. To me in 1980 he praised and particularized the batting of the English cricketer David Gower and seemed a little disappointed in my much vaguer approval of him. But in this statement of the 1950s one senses also a considered attempt to help his countrymen through the barrier of prejudice and misconception to a relaxed approach to art by appealing to their liking for nature. The terms he had used in public in the 1930s and 1940s had usually been in themselves abstract and the associations he had offered were mainly with contemporary design.

It is striking that in many of the major paintings of the early to mid-1950s BN's still life has to exist without the

partnering landscape he had accustomed us to. The near/far duality is not, as in *1950, April (Abélard and Héloïse)* [plate 222], replaced by an unambiguous interior setting, concentrating all spatial action on what is on the table and its relation to the unified background, but usually by something much less specific. Our attention is sought first by the play of lines that represent the still life, secondly by the supporting planes that were the table, and only thirdly by the wider setting and its implications of space and location. Each element has surrendered the major part of what made it recognizable, and thus these still-life compositions strike one as abstract, though their mode of abstraction is utterly different from that of the white reliefs. In the same years BN was making fine, confident, pleasure-conveying drawings and etchings of landscape and townscape: there is no suggestion that his fondness for such sights and for transforming them into graphic art had in any way diminished. Travels in Britain and abroad, mainly in Italy, provided further stimulus.

A prefiguration of the still-life series of the early 1950s is to be found in *1949, March (Trencrom)* [plate 239]. It exhibits

The 1950s

The 1950s

241

**240**
*1951, November 25
(Isles of Scilly).*
Oil and pencil on
canvas, 56 × 76.2 cm
Private collection

**241**
*1951, November 11
(oval).*
Oil and pencil on
canvas, 55.8 × 60.9 cm
Bernard Jacobson
Gallery/Crane Kalman
Gallery

255

The 1950s

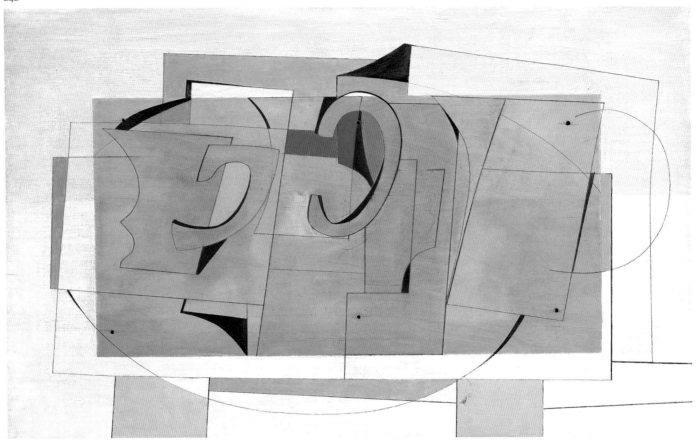

**242**
*1951, October
(six eyes).*
Oil and pencil on wood,
50.1 × 81.2 cm
Private collection, on
loan to High Museum
of Art, Atlanta

**243**
*1951, November
(still life – 7).*
Oil, gouache and
pencil on paper,
51 × 37 cm
Private collection

The 1950s

**244**
*1952, October 16
(October landscape)*.
Pencil and oil on paper,
19 × 22.2 cm
The British Council

**245**
*1952, June 4
(tableform)*.
Oil and pencil
on canvas,
158.8 × 113.7 cm
Albright-Knox Art
Gallery, Buffalo
(gift of Seymour
H. Knox, 1956)

the characteristic verticality, the absence of a definite view of landscape and the free, only semi-referential use of the lines that should deliver the still life; their interaction becomes more adventurous as the years pass, until we find ourselves satisfied to recognize a bottle, jug or goblet by a part or a characteristic detail. The colours in *Trencrom* are unassertive, almost faded; the lines vary in strength and there are some patches of pencilled shadow as well as painted ones. Most exceptional is the clarity of the outlined rectangle that functions as the vertical table surface and within which we see all the smaller shapes and lines. Only in the lower part does this clarity waver: the right edge of the table almost imperceptibly abandons verticality to turn in slightly, echoing other oblique lines that become noticeable down there, and also echoing the off-vertical and off-horizontal rectangle outlined in the top left corner. Whether this is intended to hint at a window opening is left uncertain by the only very slight variation of the colour wash in that area. The subtitle refers to an Iron-Age fort in the Carbis Bay area and in this sense echoes the aged quality of the painting's colours.

*1952, June 4 (tableform)* [plate 245] is the first large painting in the series, at nearly 160 cm almost as tall as BN himself. Again, a configuration of lines that familiarity enables us to recognize as a cluster of still-life objects, a vertical plane that must be the table top, a background. Here, though, each of these is made extra complicated. The table is a multiplicity of planes: at the top it is stated fairly clearly though divided into two colours, but within and below the still life it splits into many forms, one, a firm grey plane, breaking away horizontally towards the left edge of the canvas, others made structurally dubious by undergoing shifts into other colours. Hardly anything is quite vertical or horizontal; nothing, one feels, quite arrives where it set out to go to. Except the fine still-life lines: our eyes return to them for reassurance. Though they are not easy to read as representing particular objects, their polyphony is benign. Even here, though, there is something new to assimilate. The dark, often attenuated shapes we have come to call shadows, frequently put in with a soft pencil, are here painted and developed into something with its own presence.

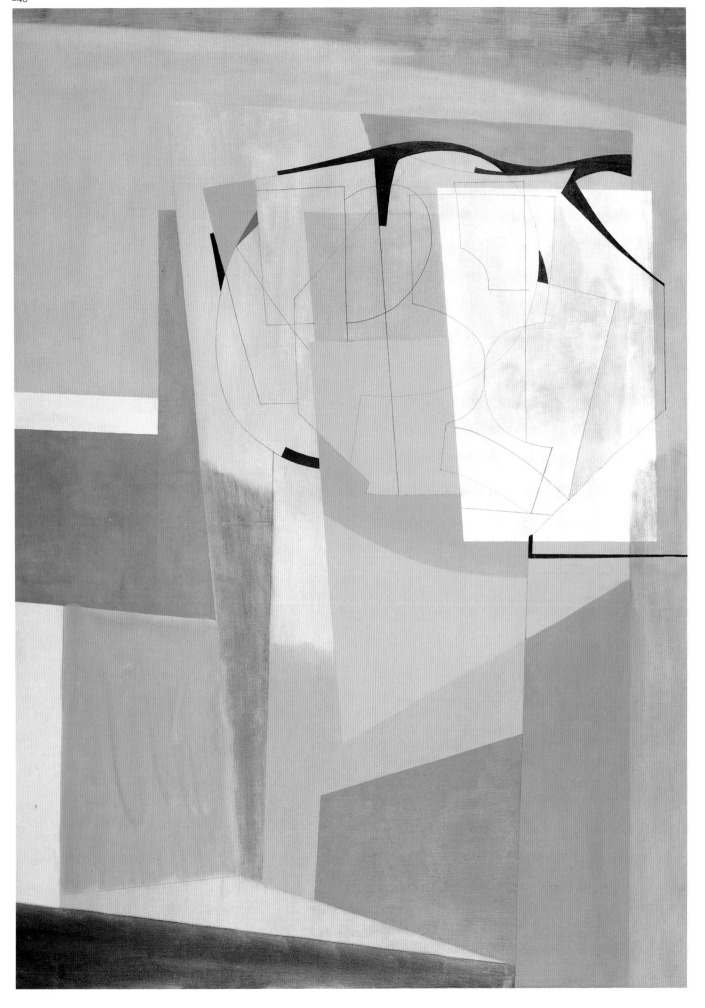

The 1950s

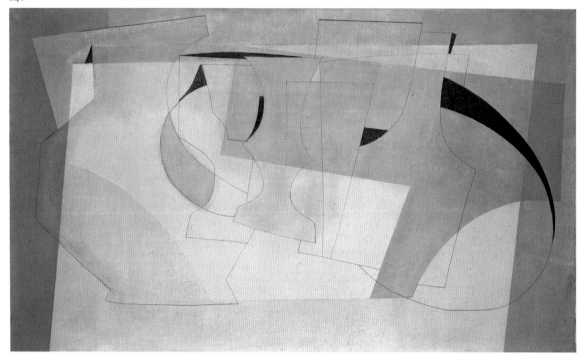

**246**
*1952, March 14.*
Oil and pencil on
canvas, 58.4 × 99.1 cm
Bernard Jacobson
Gallery/Waddington
Galleries

**247**
*1951, December
(St Ives – oval and
steeple).*
Oil and pencil on
board, 50 × 66 cm
City of Bristol Museum
and Art Gallery

The dark grey shape above the still life seems to be several shadows joined up to become a shape of their own, a feline creature almost, that picks up on the still-life shapes to overshadow them. The other new feature is the blue – the several blues – of the background. It is rarely possible to escape the associations colours bring with them. Blue equals sea and sky. In *tableform* we seem to have both in generous measure. This could be a still life on a balcony, affording glimpses of water below and a broad view of the sky above.

In the slightly earlier horizontal painting, *1952, March 14* [plate 246], blues play a similar role though they are placed right and left of the table and still life, and the variable sandy colour of the table speaks of the beach, available to the painter just outside his studio. A black shape is announced above two glasses in the middle of the composition to reappear on the right as a masterful sweeping curve. By some magic, it is counterbalanced on the left by the softest suggestion of light within the outline of the angular vase where it extends beyond the protection of the table. Such great scimitar curves appear in other paintings of the time,

and speak of positive energies, confirming what lies within them. A major example is the modest-sized painting in Bristol, *1951, December (St Ives – oval and steeple)* [plate 247]. Here a closely interwoven area of still-life lines gets entangled with the lines of the St Ives roofscape. A black curve makes a bid to separate them and is part of an almost complete oval continued by line and by marked changes of colour. This oval makes an inner space in the composition, invaded by the steeple and other bits of town but holding its own. The outer space is defined by lines that make an unfolding plane of the sort we saw in BN's contemporary Time-Life mural.

The polyphonic series of vertical compositions continued into and through the mid-1950s, a strong, widely varying sequence produced at a time of emotional uncertainty and difficulties. Some of the compositions are large, up to nearly two metres high (there is also a horizontal composition of 213.5 cm); some are of a modest, domestic size. One could think of these as chamber music, the others as orchestral and perhaps symphonic, but we must not assume that the

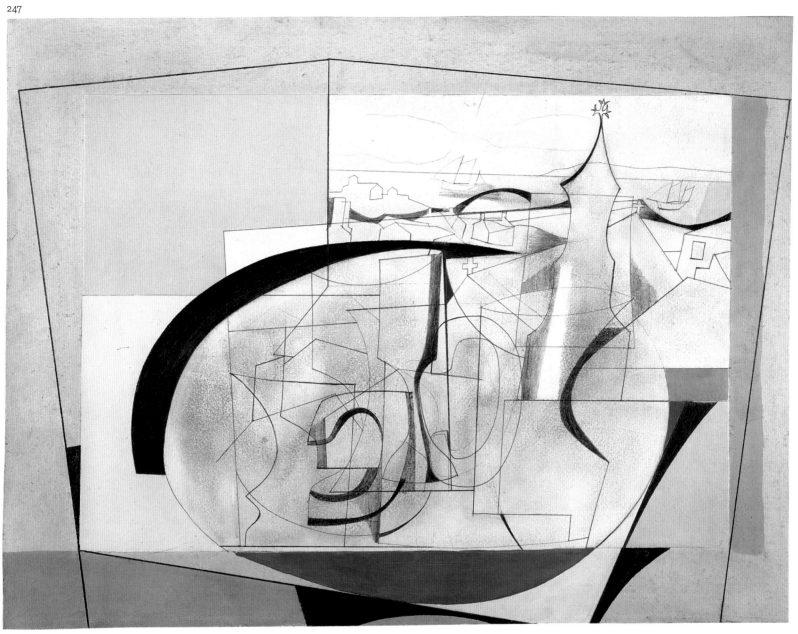

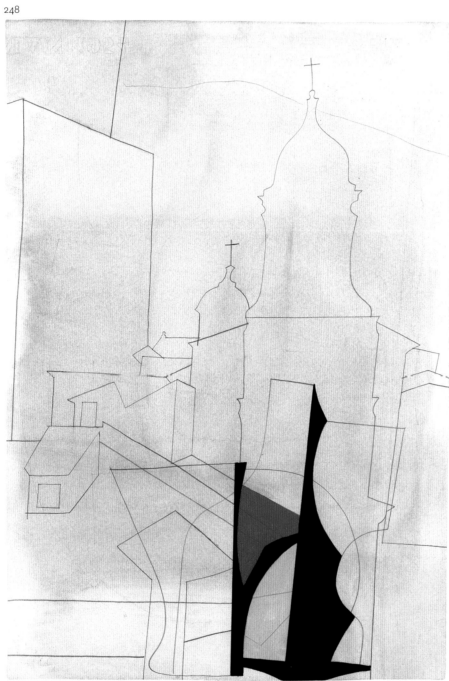

**248**
*1954, July 30 (Rome).*
Oil and pencil on
paper, 58 × 39 cm
Private collection

**249**
*1953, August 31
(quartz).*
Oil and pencil on
canvas, 124.5 × 92.5 cm
Private collection

The 1950s

The 1950s

**250**

*1953, March (Lucca).*
Oil and pencil on
board, 44.5 × 35.5 cm
Musées Royaux des
Beaux-Arts, Brussels

**251**

*1951 (St Ives – still life,
steeple and ship).*
Oil and pencil on
board, 20.3 × 35 cm
Private collection

**252**
*1953, February 28
(vertical seconds)*.
Oil and pencil on
canvas, 75.6 × 41.9 cm
Tate Gallery, London

**253**
*1953, February
(contrapuntal)*.
Oil and pencil on
board, 167.6 × 121.9 cm
Arts Council Collection,
London

smaller works are slighter in any way, any more than quartets
became with Mozart and Beethoven. A comparison of the
Tate Gallery's *1953, February 28 (vertical seconds)* with the
Arts Council's *1953, February (contrapuntal)* makes this
evident [plates 252 and 253]. The latter is six times the area
of the former. To make this more real: the former has the
width of two easy hand spans; the latter, light as it is, requires
two people to move it (though BN will have moved it around
himself) and a sizeable wall space to accommodate it.
Yet in many senses *vertical seconds* is the more complicated
of the two, the more intricate: one feels there are more lines,
involving a larger portion of the painting, more contrast and
more apparent depth.

Whereas *vertical seconds* seems steady and evenly
paced, *contrapuntal* sweeps up and a little to the right in
one great right-handed gesture. That is what one sees
first, encouraged by the column of near-white that seems
the nearest as well as the clearest element, rising from
the bottom edge almost to the top with only the gentlest of
inflections. In *vertical seconds* the lines of the still life are

firmer than is usual at this time. Colour confirms parts of the
objects but there is also what was almost allowed to be a
square of red, but it is not really square and the top edge of
a self-asserting mug lops a tiny corner off it, the transparent
object obscuring the opaque colour. Blue and yellow at the
top bring in thoughts of sea and sunshine but there is
nothing to suggest an outdoor view. The background of
*contrapuntal* is varied with whites and warm greys, painted
softly, suggesting if anything curtains some way behind the
still life and its support. The table area is mostly white too.
So luminous is the background that one sees the table
*contre-jour*, a light thing against the light, like some Degas
ballet dancer in class. The still life itself comes both as
outline and as solid colour. The colours are bunched to the
left of the white column, a swarm of twelve or so shining
colours, opaque in themselves but pretending to
transparency by means of the interference method noted
earlier. Thus the sweep of a line, the edge of a shape, seems
to continue under another shape apparently laid over it: all is
clear, all is ambiguous. Perhaps the most unexpected factor

The 1950s

The 1950s

**254**
*1953, August 11 (meridian).*
Oil and pencil on canvas, 124.5 × 94 cm
Private collection

**255**
*1954, May (Delos).*
Oil and pencil on canvas,
197.9 × 106.6 cm
Private collection, on loan to The Whitworth Art Gallery, University of Manchester

in the picture is the loosely brushed-in area of sandy yellow to the right of the column. That display of colour to its left called for an answer on the right, and one might have expected the painter to produce another array of colours or perhaps another version of the black shadow. Adding that formless patch of almost colourless colour is a remarkable move. It works by silhouetting the right edges of the still life, giving them a dynamism that somehow answers to the colour on the other side. When there was enough of that pale yellow, BN stopped. One of the most potent actions in this large painting is the way exceptionally vague forms are played against the most succinct, all without violence or extraneous dramatics.

*1953, August 11 (meridian)* [plate 254] has something of the sweep of *contrapuntal* and some of the delicate squareness of *vertical seconds*. The whites and blues of the central table, abetted by pinks and patches of lilac and including one sharp shape in red, counter the glowing yellow on the right, a muted, dirty-pale olive yellow on the left and thinner versions of these in the top band, above what one

reads as a horizon. The lines play with each other in a way that is both intricate and clear: we can follow them through, experiencing their interaction in detail and as a whole. The thickness of the lines varies, the heavier ones lifting their forms slightly by suggesting a shadow and some of them broadening into shadow shapes. Additional shadows are put in by means of smudged darker tones, but altogether this, like *contrapuntal*, is a light composition in a shallow space.

With *1954, May (Delos)* [plate 255] we reach another variant. The still life here is a sparse group, a few objects, a few long pencilled lines. Otherwise the painting presents bright colours, including another red near-square, in a context of gentle tints and gentle shadows. There are some strong but unexplained shadow forms in the lower middle of the composition, associated with a surprising little patch of green. There is also the bright blue shape, slightly arched along its top. The green and that blue make us think of outdoor space and light. Were that blue anywhere else in the picture we might think its surround as representing a window opening; since it is at the bottom its surround is

The 1950s

**256**
*1953, July (Cyclades).*
Oil and pencil on
curved board,
76 × 122 cm
Private collection,
on loan to
Kettle's Yard,
University of
Cambridge

table and table legs, more emphatically shown than in other works in the series.

The series continues, until 1957 at least. But it was never more than a part of BN's activity. One wonders whether he saw it as a series, a continuing programme or pursuit – presumably he did at some stage realize this when he was making his white reliefs. Perhaps to speak of a series implies a conscious plan and a self-conscious varying of solutions to a defined question. This would not be BN's way. There is no evidence that he ever set out to do a number of these tall compositions, or even that he was consciously producing what turned into a related series. What he must have been conscious of, working in his spacious but visually insulated studio, was power. Where his domestic and family life was concerned, he was in what must have been a difficult phase of his life, involving pain and perhaps some self-questioning. His work as a painter confirmed his strength, both the quantity and the quality.

It was a period of success in the eyes of the world. In 1954 he represented British art at the Venice Biennale and

gained the Ulisse award. That display became a touring show, going on to Amsterdam, Paris and Zurich. He had separate one-man shows the same year in Brussels and at the Lefevre Gallery in London, and in 1955 the retrospective exhibition at the Tate Gallery as well as a one-man show at Gimpel Fils in London. 1956 brought him the Guggenheim award – first prize in the International Guggenheim Painting Competition – and there were other marks of international recognition as well as a surge in sales. Exhibitions are planned in advance, especially major ones, and serve as something of a stimulus. Artists feel encouraged by the prospect, and put on their mettle. They know their work is wanted. They also know it has to stand up to being seen in quantity. Certainty of public interest may have made it easier for BN to cope with private questions. That year his daughter Kate, aged twenty-seven, came to St Ives, to work as a painter and incidentally to help her father; no doubt he helped her in her work as he helped others before and after.

Barbara Hepworth too became an internationally successful artist in these years. In 1950 her work was shown

*1953 (Balearic).*
Oil and pencil on
canvas, 109 × 120 cm
Gimpel Fils

in the British Pavilion at the Venice Biennale, together
with paintings by Constable and by Matthew Smith. A
retrospective exhibition, shown first at the Whitechapel Art
Gallery in London in 1954, toured the United States in 1955-7,
and in 1959 the British contribution to the São Paulo Bienal
was a retrospective Hepworth show. She did some of her
finest works then. In the 1940s she had begun to carve
rounded wood forms, partly opening them and hollowing
them out and painting the insides white (e.g. *Wave*, 1943;
*Pelagos*, 1946). In the 1950s these found their apotheosis
in such works as *Oval Sculpture (Delos)*, 1955 [plate 263],
*Corinthos*, 1954-5, and *Curved Form (Delphi)*, 1955, all in
scented guarea from Nigeria. In his last years BN spoke
of these works with especial enthusiasm.[7]

Among the 'non-series' works of these years, the early to
mid-1950s, are a number of quite diverse paintings, set apart
from the series not only by their horizontal format. *1953, July
(Cyclades)* [plate 256] is primarily a graphic work on a
painted surface: pencil lines on a curved plane divided into
four areas by faint colours over which the lines float almost

like a wire construction. The colours propose an unfolding
pair of planes against a background; the lines start with
a firm angular statement on the left, framing a complex and
very satisfying linear choreography, with this and then that
form taking charge only to yield its place to another the
next moment, and end with a large handle-like curve on
the right. This curve does not appear to belong to any
discernible object, and there are other curves and also
straight lines of which this might be said. The whole
performance is magnificent.[8]

*1953, September 6 (Aztec)* [plate 258] is a squarish
painting that could be counted as one of the vertical series
but warrants a place outside it on account of its particular
character. As in *contrapuntal*, bright, hard colours are set into
an otherwise almost colourless composition. Here black and
white have to be counted among those colours; the rest is
a variety of greys that function both as areas of still life and
as setting. A shadow line lifts the bottom edge of the table;
another reinforces its bottom right corner. Horizontal lines
right and left near the top hint at a horizon, implying space

258

259

The 1950s

and perhaps a grey sky. The still-life forms are large for their context, as they are also in *Cyclades*. Their boldness and that of the bright colours confronts the suavity of the modulated greys of the rest. Most of the grey is painted so thinly that one experiences it as stained canvas, sometimes continuous with, sometimes raised in front of, the grey background. This spatial play is subtle but an essential part of what we encounter. The strong yellow form, for example, seems to be *on* one area of grey and *under* another.

*1955, May* [plate 260] is a similar size and shares some characteristics with *Aztec*. It is a square painting, where the other was only relatively square, yet it asserts verticality in the more or less rectangular areas that occupy much of the centre of the composition. Two of these, right and left, are partly white, partly pale grey, and of course BN persuades us that the grey, the more receding tone, lies over the advancing white. There are little patches of refreshing colour in the upper centre of the picture, with again a near-square patch of red making an appearance. There are also rare but not unprecedented dabs of a darker grey near the centre, a

vague area of visual texture that almost amounts to a pattern – a distant echo of Picasso's and Braque's use of patterned areas in their Synthetic Cubist paintings. It is clear that the spots do not belong to any one of the still-life objects indicated. These are not easy to distinguish though the lines themselves are clear and firm. As in *Aztec*, the thin, canvasy greys seem to come forward: grey over white and then also – upper right – darker grey over pale grey, as this shape seems to rise towards us, only to be sent back by the slightly overlapping grey-and-white rectangle on the left. A strong angled band of ivory at the bottom of the picture acts like a threshold, pushing the still life back into the picture space. There it hovers, on a pictorial stage that is given additional recession not only by the perspective signalled by a pointed blue patch near the bottom and the clear break in colour and tone almost half-way up the picture on the right, but also by the darkness of the background. Dark blue, dark brown, charcoal grey and black together provide a dramatic setting, in their turn pressing the ivory band forward and almost out of the painting.

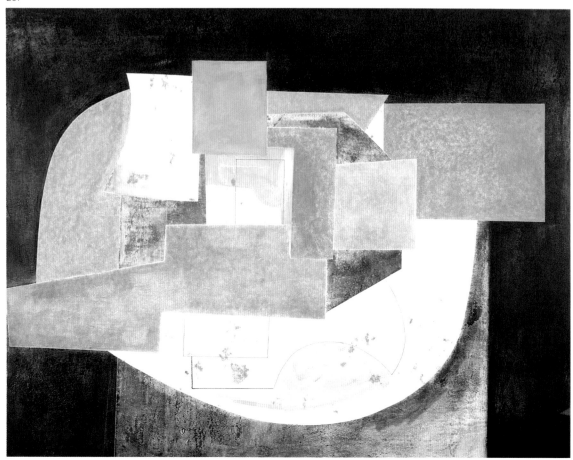

**261**
*1955, November (nightshade).*
Oil and pencil on board, 96.3 × 127 cm
Private collection

**262**
*1955, December (night façade).*
Oil and pencil on board, 107.9 × 116.2 cm
Solomon R. Guggenheim Museum, New York

We speak of BN as a painter of light, meaning not only one who paints subjects in which light is a major presence but also one who makes light in his paintings by means of colour and tone control. We are now speaking of him as a painter of greys and of a dark, nearly black setting. Of course, this does not mean he is not concerned to create sensations of light: Rembrandt too made light positive by giving it a dark context. Yet BN's use of so many dark, one is tempted to say negative, tones is surprising. Only *1930 (Christmas night)* [plate 64] gave such prominence to darkness, and there it was an essential part of his subject; in any case he delivered it by means of glowing colour. *1928 (Pill Creek)* [plate 45] seems a dark painting because of his usual pleasure in whites and light colours, but most of its darkness is only skin deep: the white gesso is bared in so many places that it becomes the main element.

There are two 1955 paintings in which the forms come at us out of darkness, *1955, November (nightshade)*[9] and *1955, December (night façade)* [plates 261 and 262]. Both use an almost black background, the more awesome for its flatness,

there being no sense of a stage floor: the darkness goes from top to bottom of both paintings. In *nightshade* we are confronted by a cluster of planes. A few of these give some hint of still life, and there is one linear motif, on the large white shape, that we would certainly receive as a bottle or jug were it upright and not on its side. (We know from this that BN has persuaded us that jugs and other such things are what they are only when they are upright or more or less so, i.e. when they are in their functionally correct position.) Mostly the planes are abstract, and presented in tones and positions that make us see them as a relief. It is in fact a work on hardboard and all one surface except that some lines have been inscribed in it and rubbed with white to make them set off adjacent planes. This is true even of the pale blue rectangle that seems to float towards us because of its position, apparently overlapping other planes, and because of its positive colour; it too is level with the rest. Most strange is this work's sculptural character. The curved pale brown shape on the left (hardboard colour plus white) and, even more, the white and off-white shape that is the lowest

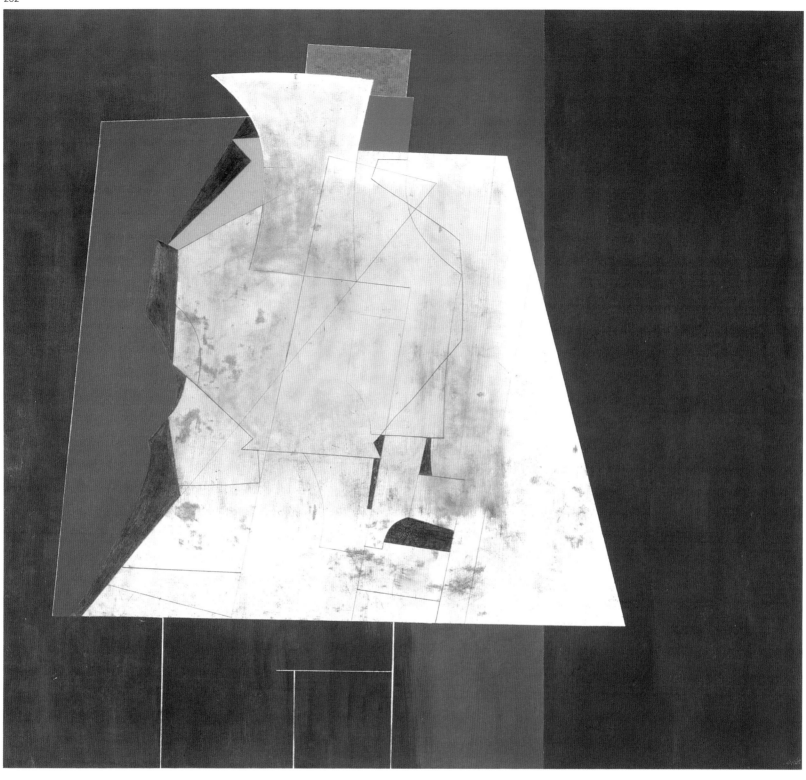

263

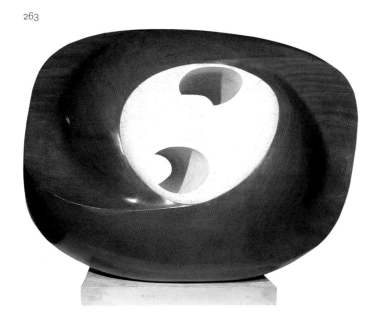

**263**
**Barbara Hepworth**
*Oval Sculpture
(Delos)*, 1955.
Wood and polychrome,
length 122 cm
National Museum
of Wales, Cardiff

element of the cluster speak of mass rather than merely planes, the more so since the whole group seems to be poised on a rising grey form that could be a pedestal.

In *night façade* table and still life make a reassuringly clear appearance, and what still-life objects we can make out appear to be upright, especially when we accept BN's convention – in drawings almost always, in paintings often – that anything on a line rising a few degrees to the right of vertical (to the left in prints) is still vertical. These objects are indicated by means of lines and, in one instance, by means of colour, a patch of blue that seems to have become detached from the angular jar that owns it. They are accompanied by shadows in almost solid pencil: odd little patches in the lower centre, a sequence of strong, sharp shapes down the left side of the still-life group. Some of Picasso's late Synthetic Cubist paintings of the 1920s make a similar use of a shining blue against black and employ shapes that seem displaced from their true, comforting places. Picasso was there manipulating the Cubist idiom, with its many freedoms and few disciplines, to Surrealist effect. Something of the same

sort applies to *night façade*. BN is using his own still-life form, partly rooted in Cubism but almost always associated with pleasure or at least ease, to give a sense of foreboding. That sense comes in part from the darkness; it comes mainly from the off-white table top. Its trapezoidal shape might have indicated perspective and recession, but the way it is presented makes us read it as flat and its sharp corners as dangerous. The blade-like bits of shadow on the left, silhouetted against a bland brown surface (a dislocated part of the table) do not explain the still life but seem rather to disorder any reading of it. Below the table incised lines, showing white underpainting, are too brittle as supports for the table and add to the sense of danger.

Are we right to imply a state of mind in reading a single work or even a group of works? The dates BN gave his paintings need only refer to their completion. Other works of the same year, we shall see, suggest a different mood. There are reasons for thinking that 1955 and thereabouts was a difficult time for him. Work is a comforter, especially when it takes one out of one's daily setting and brings recognition

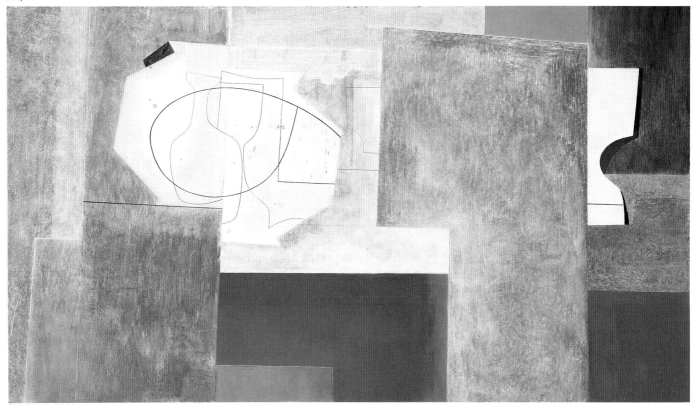

**264**
*1956, November
(Pistoia).*
Oil and pencil on
board, 122.5 × 214 cm
Private collection

from another world. One of BN's strengths must have been his ability to enter his own particular world in entering his studio. His family life was conditioned by a keen need to step out of it sufficiently often and with sufficient completeness. His art, radically dependent on visual experience, was determined too by his mental as well as his physical state. He knew there were days that would be good for drawing and painting, and others better devoted to letters, stretchers, preparing canvases, framing and other such business. Travelling was a way of leaving some relationships and tasks for a while and also of refreshing the eye and feeding the mind. He was never any kind of expressionist, if that means making personal, sometimes passing emotions the subject-matter and symbolically the manner of one's art. Wordsworth's double statement that 'poetry is the spontaneous overflow of powerful feelings: it takes its origin from emotion recollected in tranquillity' seems to fit the case of BN well. Feelings, often of deep pleasure, and then isolation in the studio and the insulation provided by the processes involved in making a painting or a relief,

themselves adding their own excitements and tensions. Yet we need not rule out the possibility of finding pain, or perhaps perplexity, in some works just as we may note a particular gladness in a drawing of a naked woman and when we find her profile echoing through several canvases. These are exceptions of course: the human image is rare in his work. But that does not mean human relationships were kept out of his work while other experiences informed it.

Like many another creative individual BN used work as a bulwark against difficult aspects of life and as a source for self-esteem. That his self-esteem was uncertain or at least challenged as a child can be inferred from his recourse to both seriousness and developing outstanding skills at a variety of sports. What school reports remain from his intermittent education show him successful, in sport outstandingly so. Especially in this regard, his asthma must have been seen by him as a kind of failure. He hesitated to become a painter because that would have required beating his father at his own, widely admired game, but he had the courage to make that bold choice and his first marriage must

**265**
*1956, August*
*(La Boutique Fantastique).*
Oil and pencil on board,
122 × 213.5 cm
Private collection

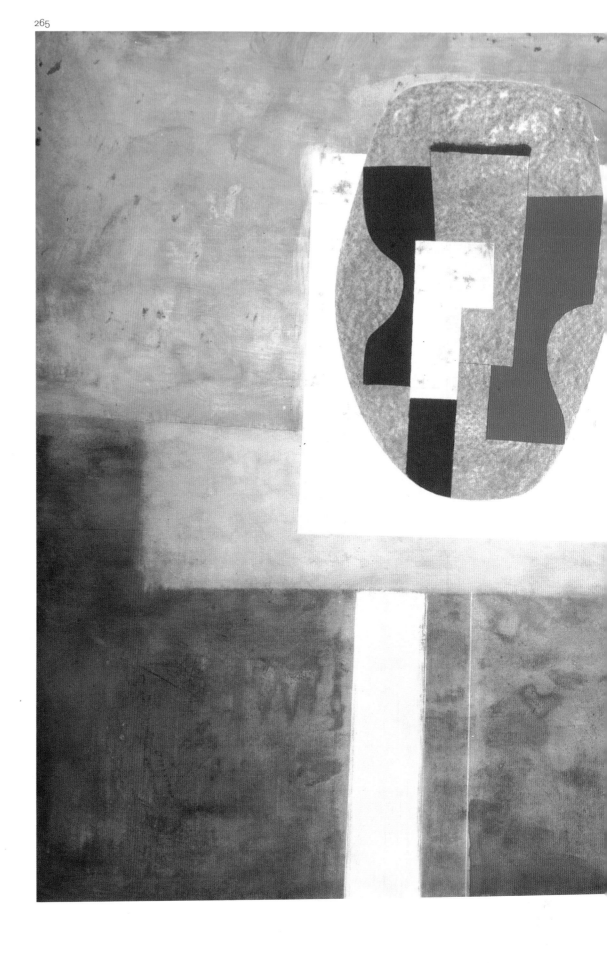

The 1950s

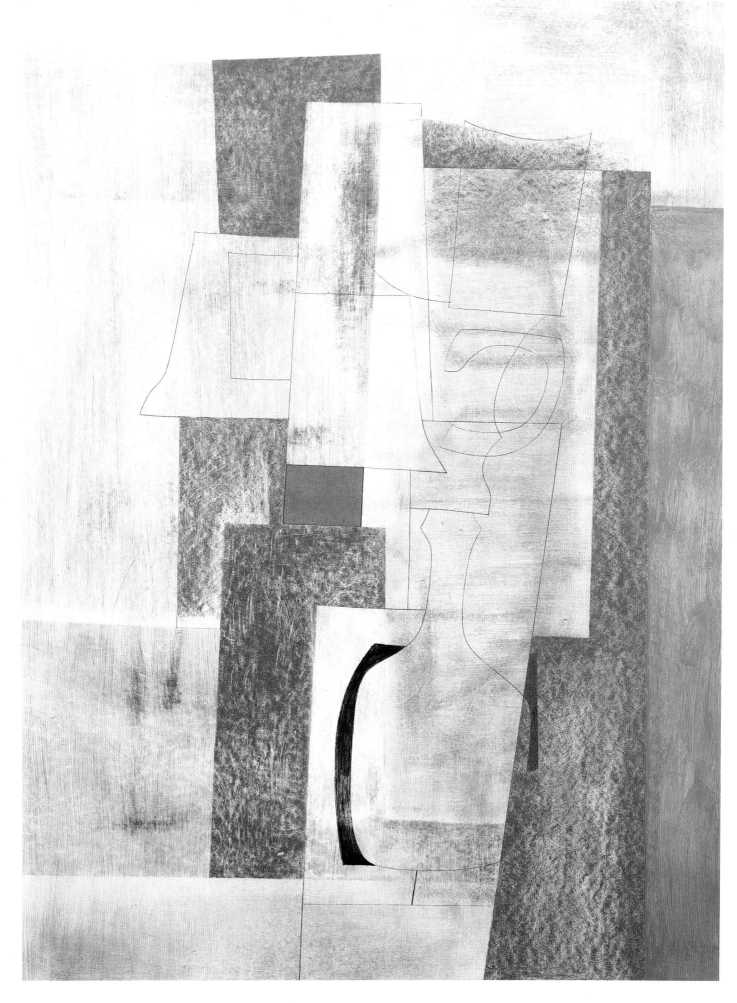

The 1950s

**266**
*1955 (Périgord).*
Oil and pencil on
board, 123.5 × 90.8 cm
Private collection

**267**
*1956 (Etruscan).*
Oil and pencil on
board, 61 × 132 cm
Private collection

The 1950s

**268**
*1955 (starlings)*
Oil and pencil on
carved board
54.6 × 69.9 cm
Private collection

**269**
*1956, January*
*(Zennor Head).*
Oil and pencil on
board, 52.4 × 114 cm
Private collection

The 1950s

**270**
*1957, December
(Goonhilly).*
Oil and pencil on board,
122 × 60.3 cm
Kunsthalle, Hamburg

**271**
*1957, October (FV).*
Oil and pencil on board,
122 × 104 cm
Private collection

The 1950s

**272**
*1955, August
(Cantabria).*
Oil and pencil on
carved board,
85 × 77.5 cm
Private collection

**273**
*1956, February
(menhir).*
Oil and pencil on
carved board,
98 × 30 cm
Peggy Guggenheim
Collection, Venice

have helped him make it. But he needed recognition among
artists and in the wider world. Hence his tendency to join and
take over art associations; unlike most artists, once he joined
a group he gave thought and energy to its purposes and
actions. Interviews he mostly avoided, but he was willing to
make occasional public statements, as we have seen. His
marriages were important factors in his life as an artist as
well as in his personal being, but none of them, it seems,
could take away the pain of losing his mother, his one
security during the first twenty-four years of his life. He
sought her in his wives, and then no doubt resented being
mothered. He needed female companionship with someone
he could respect as an active individual, but he needed
to know he was the stronger partner. He enjoyed many
friendships with unconventionally creative men and
women, but these do not seem to have been very close.
One feels that letters were often his preferred means of
communication. Of course, his generation still wrote letters
where we would make telephone calls, and to him a letter
was a graphic occasion, using words and dashes as visual

elements, and abbreviations and significant intervals and
breaks, as well as expressive lines escaping from the text
here and there. So they were for him soliloquies that involved
some of the same skills and pleasures as his art; they were
one-way performances and he knew he was good at them
[plates 432, 436 and 439]. There was a quality of loneliness
about him. One seems to see in him a child-man whose best
joys and fullest sense of being alive came from his delight in
the perfect flight of a ball or a bird, in the infinite variety of
natural phenomena and in the shapes and intervals added by
mankind, and thus also in the making of pictorial structures
in which these precious confirmations could be identified as
his own and put before the world.

   In the year of his two dark paintings BN also produced
some of his most powerful and optimistic works. In many
ways, *1955, August (Cantabria)* [plate 272] marks a return to
the painted reliefs of the late 1930s, more particularly to the
meeting of white-relief absoluteness and earth colours we
noted in *1939 (painted relief – version 1)* [plate 150]. Now the
colours are more emphatically earthy: four browns which are

The 1950s

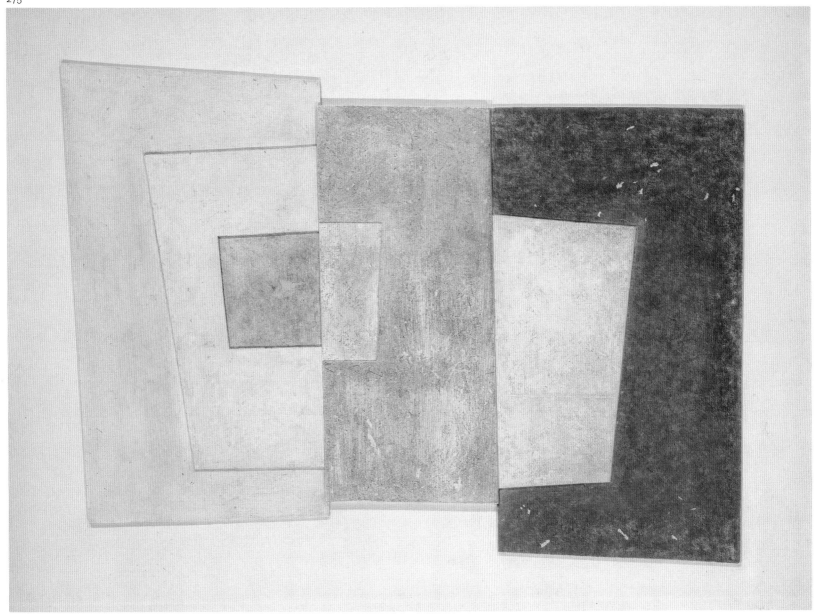

**274**
*1956, February
(granite).*
Oil and pencil on
carved board,
50 × 62 cm
Private collection

**275**
*1957, April (Lipari).*
Oil on carved board,
57 × 72.5 cm
Private collection

The 1950s

276

**276**
*1955, May
(green chisel).*
Oil and pencil
on canvas,
61.6 × 61 cm
Private collection

**277**
*1955, May (Gwithian).*
Oil and pencil on
canvas, 106 × 106 cm
Yale Center for
British Art, New Haven
(Paul Mellon Collection)

the board's colour variously adapted and a patch of deep brown-red paint; also a rectangle of transparent grey and an area, an implied partly hidden rectangle, of firm white at the top. Many of the surfaces are rubbed or distressed in some way so that they have their own visual character. Most remarkable is a compositional variation easily overlooked: the relief broadens beyond the width of the baseboard. In earlier reliefs lateral shadows sometimes hinted at forms going beyond its limits. Here it happens physically, and the general effect is a loosening of the composition, a freeing of its constituents.

   One of the most masterful of BN's vertical painting series is *1955, May (Gwithian)* [plate 277]. It is in fact a square canvas but its structure is emphatically vertical, spreading a little as it rises in a soft field of blue and greeny blue-greys. Large, magisterial lines speak of still-life objects in the upper part of the composition, making a horizontal array that continues on the right over the blue background. Some apparently overlapping shapes near the middle are picked out in bright colour, using the familiar interference device.

They embrace a small patch of strong warm black. To their left, the highest form in the composition and also apparently the one closest to us, is a long vertical rectangle of the same rich glowing black. We are inclined to associate it with the other black in terms of location; were it alone it could take off, so light and dynamic does this rectangle seem although one would have expected it to be heavy and recessive. Matisse had died in 1954, an event that drew attention to him and especially to his latest work with the result of re-establishing him as a one of the key masters of modern art; his late paper cut-outs suddenly became much better known than they had been. 1955 saw a great commemorative exhibition in Paris. It was visited by many British artists and occasioned much admiring discussion of his work. Was BN aware of the black form hovering near the top of Matisse's *The Snail* (1953)? We need not assume a connection. The combination of bright colours (including white) and a range of blues with this emphatic black gives *Gwithian* a particular character, one that seems quite the opposite of the dark paintings of November and December. It

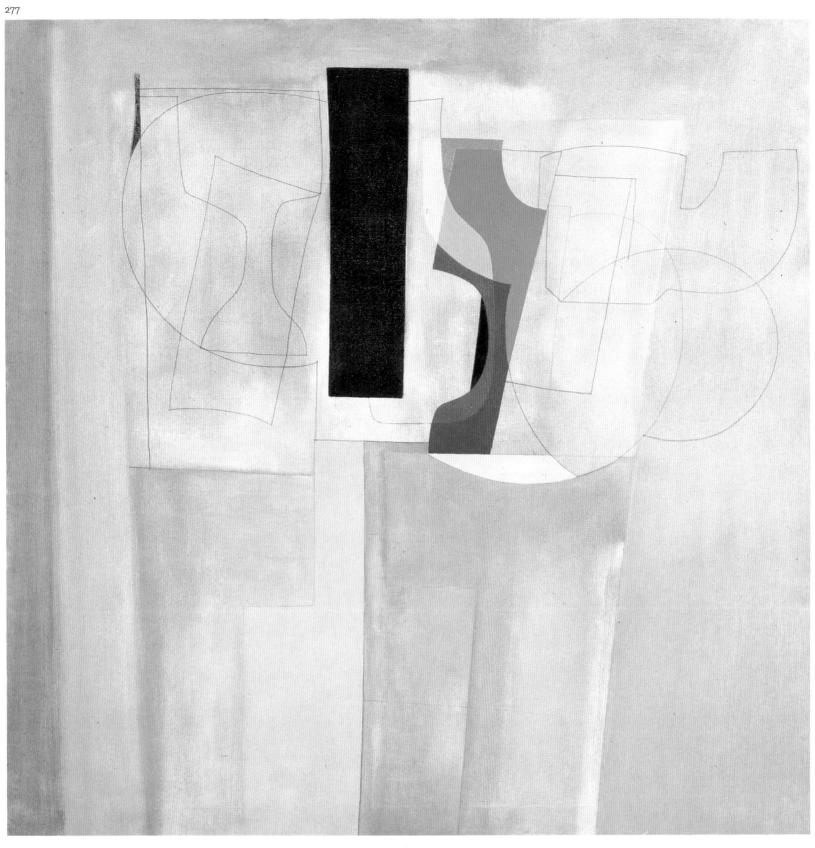

The 1950s

**278**
*1956, August*
*(Val d'Orcia).*
Oil and pencil on board,
122 × 214 cm
Tate Gallery, London

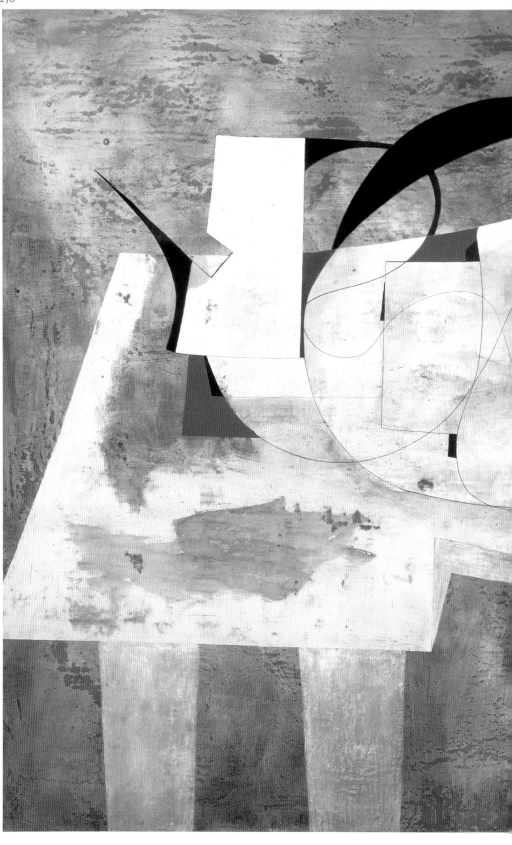

The 1950s

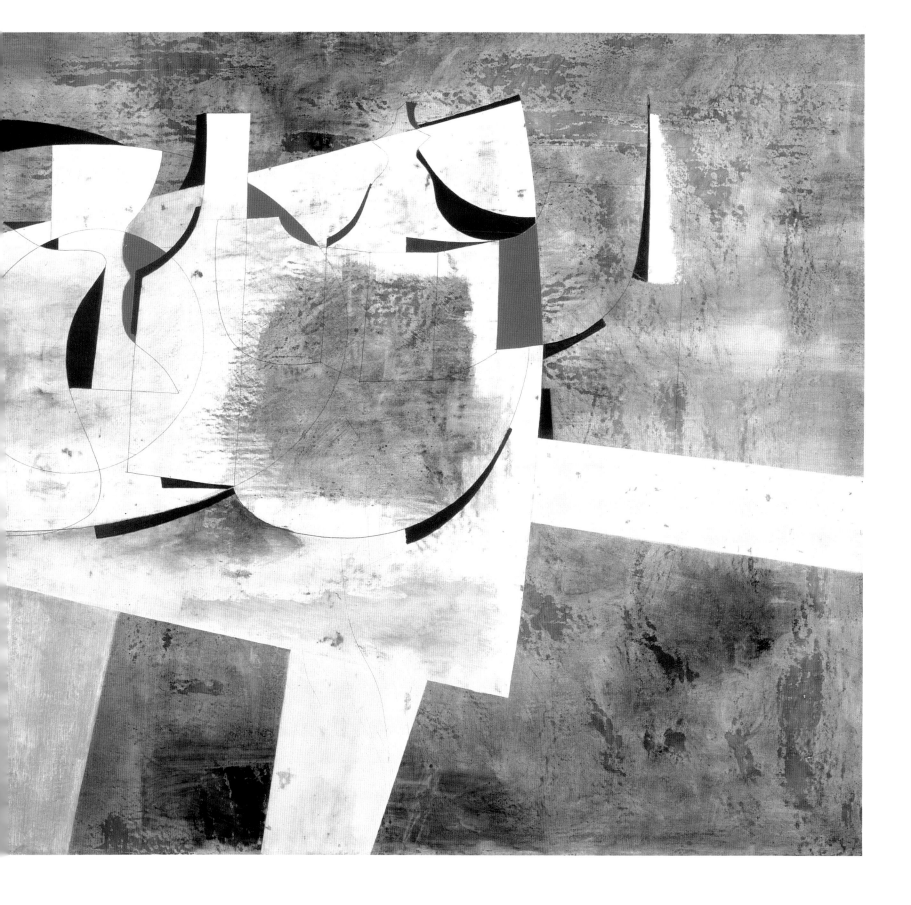

BN in his studio, St Ives, 1949. The painting on the wall is *1949, October (West Penwith)*, 119.2 × 182.6 cm; the one BN is holding is *1949, October (Roché)*, 118.9 × 88.8 cm

feels strong, triumphant even, certainly optimistic.

*1956, August (Val d'Orcia)* [plate 278] is assertive. The background of this large horizontal painting on board is heavily mottled and streaked, the left half in an orangey yellow, the right in greys, each a square area but not sharply divided. An unusually lively structure hovers in front of it, ambiguously solid and unstable. There appear to be two tables, in an off-white that is at once firm and broken in ways that could mean it was worn through or marked or distressed by wear and grime, each with its pair of sturdy legs close to the front of the picture – or perhaps it is one extended table, judging by its top edge. This and its right edge are boldly curved, making a shape that suggests an axe-head. The still life on this double table is a bold, sometimes sharp display of fine lines. Some of the curved ones take off from the objects that engender them to soar over long distances. Hard patches of shadow, in paint, not pencil, underline their paths and silhouette parts of the objects, and there are patches of opaque terracotta that join the dark patches to make the entire surface a jumpy interaction of firm and broken, clear

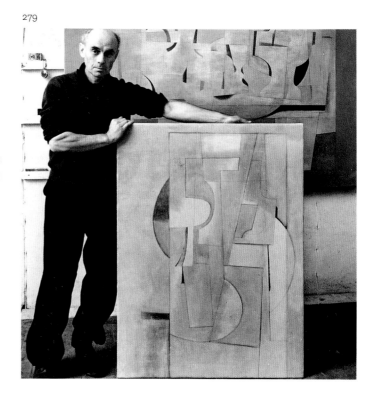

279

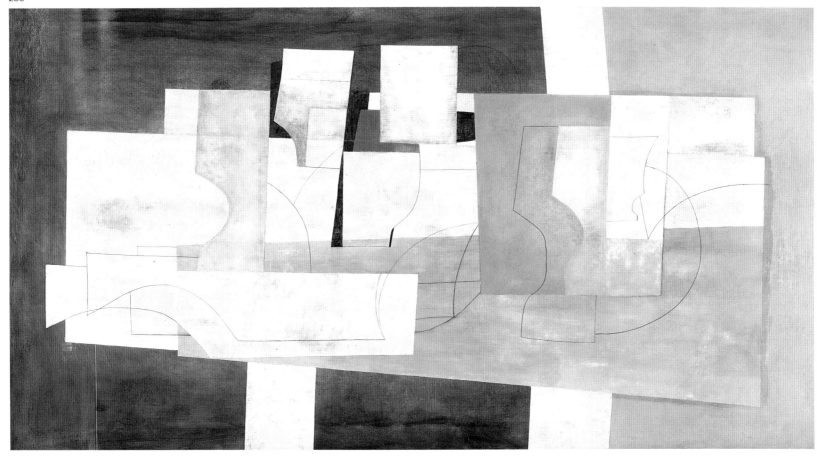

**280**
*1959, August (Argolis).*
Oil and pencil on
board, 121.8 × 228.3 cm
Private collection

and ambiguous. The whole arrangement seems to move or press to the right where what could be a fifth table leg links it to the painting's right edge. Lines and a needle-sharp shadow project well beyond the table in this area, echoing a similar thrusting dark form on the left: these and the way they are silhouetted recall Miró's work and BN's admiration for its freedom.

BN was one of the first British artists to respond positively and with conviction to American Abstract Expressionism, sampled in the exhibition *Modern Art in the United States* shown early in 1956 at the Tate Gallery. In January 1957 he contributed work and words to an exhibition of current British abstraction at the Institute of Contemporary Arts and its catalogue. Entitled *Statements*, the show invited visitors to consider those on the walls and those printed. Many British artists and almost all critics had been dismissive of the examples of Abstract Expressionism shown at the Tate (and later also of the much stronger showing of the new American painting in a Tate exhibition in 1959), especially of the Action Painting then associated almost exclusively with

Jackson Pollock's dribbled and poured works. BN's comment on that is unambiguous and warrants quoting. Indeed the whole statement is brief, if not entirely unambiguous:

1. 'Action Painting' is, as I see it, a particularly healthy, free painting development.
2. However 'non-figurative' a painting may appear to be it has its source in nature.
3. Idea and form content in a painting are inseparable.
4. My 'still life' paintings are closely identified with landscape, more closely than are my landscapes which relate perhaps more to 'still life'.[10]

That teasing last sentence points to a new interaction of landscape and still life in BN's work of the later 1950s. New but not unprecedented: he had set still-life groups in front of landscapes often in 1940s paintings and had sometimes seemed to view landscape as a slightly remoter form of still life in the late 1920s [plate 50]. But now the coupling is different: fusion rather than confrontation or the switching of roles.

In *1959, August (Argolis)* [plate 280] scale and

**281**
*1955 (red and silver).*
Oil and pencil on
canvas, 76 × 68.5 cm
Private collection

horizontality speak of landscape though the subject is still life. Sea and sky invade the table, setting some of the objects afloat. Landscape colours had already tended to overrun BN's still-life compositions, denaturalizing familiar goblets, jugs and vases. This is most marked in *1956, January (Zennor Head)* [plate 269], whose title refers us to the coast west of St Ives. *1957, December (Goonhilly)* [plate 270] shows that earth colours by themselves do not create this effect. In spite of the browns *Goonhilly* suggests a still life, primarily because of the painting's vertical format.

The more complete fusion occurs in the works we call abstract. These are reliefs, and BN's reliefs had been rooted in still-life experience from the start. That this is still the case in the 1950s is clear in *1955, August (Cantabria)*, for all its earth and stone colours, and also in *1956, February (menhir)* with its delicate, floating forms and tints [plates 272 and 273]. But none of the colours and tones of *1956, February (granite)* and of *1957, April (Lipari)* [plates 274 and 275] denote still life. The former, *granite*, can be read as a still-life composition but its space and airiness take us outdoors, while the wedge

forms, emphasized by that discontinuous, almost horizontal pencil line in different thicknesses, give a sense of pressure and of shifting stone. The forms of *Lipari* press against each other horizontally too, but seem hinged rather than overlapping and thus to unfold on vertical axes rather than being pushed upwards by geological forces. Indoors or out, still life or landscape? The tones and textures suggest nature and the title refers us to the volcanic island north of Sicily, yet we could be indoors, looking at old leather-bound books for instance. What is clear is BN's pleasure in setting these tones and textures side by side and using positive and negative forms that, for all their underlying harmony, vary greatly in scale and physical presence. One could doubt that the large painting *1956, August (Val d'Orcia)* [plate 278] is by the same artist: delicate and hushed *versus* rough and strident. *Val d'Orcia* too is a still life made to carry landscape sensations, in its space and in its earthy colours and their rough, eroded look. Miró, I suggested, may have contributed to its design; Klee's example could well have seeded the formal idea of *Lipari*.

*1958 (English red on green ground).*
Pencil and oil on paper,
43.5 × 44.5 cm
Private collection

The drawings of the 1950s seem remote from these developments, as BN goes on distilling scenes and details that captured his attention into concentrated statements that transmit his pleasure in his motifs and media. Drawing, in paintings and in graphic work, continued to invite playful, sometimes epigrammatic, invention. He could not, for example, be BN and fail to notice that the rising outline of the decanter in *1957, October (FV)* echoes many a steeple in other paintings and in drawings: in *1951, December (St Ives – oval and steeple)*, for example [plates 271 and 247]. The pun will have pleased him, but with it goes a subverting of large and small, near and far, which touches on important issues of pictorial structure and communication. Was his quick and positive response to Action Painting one facet of a more general sense that art was on the move and sighting new horizons? His own sights until now, it is fair to say, had been on European painting of all ages and on aspects of Oriental art. Now there was much talk among St Ives artists about recent events in New York painting, with Patrick Heron an especially perceptive and well-informed source of

information about it, and one wonders whether BN's changing attitude to the two key formats of his work, still life and landscape, does not reveal a deep desire for change.

One of the 1950s drawings stands out among the others for going beyond the parameters BN appeared to have established for his graphics. *1955 (Torre del Grillo, Rome)* [plate 298] may record a meal taken on the terrace of a restaurant: hence the foreground of fruit bowl, jug, glass, table and chairs and the middle and further distance of Rome's buildings and hills. But its encompassing plenitude as a thing of lines and solids, of mingling objects near and far pulled into and exploding out of that central fruit bowl, displays openly a joyous energy normally reined in. What was happening in New York may well have encouraged this openness and this appetite. His surprising, uncalled-for statement of unqualified support, in January 1957, sprang from this excitement.

A few months later BN met Felicitas Vogler. Dr Vogler was German, a young woman in her twenties, a writer and a student of Eastern thought. She was working on broadcasts

**283**
*1957, November
(yellow Trevose).*
Oil and pencil on
canvas, 190.5 × 68 cm
Kunsthaus, Zürich
(Society of Zürich
Friends of Art)

in Germany and Austria on this and other subjects – e.g. the thought of Martin Buber, Albert Schweitzer and Carl Gustav Jung – and came to London in 1957 to finalize plans for an extensive visit to India. Having a special interest in Katherine Mansfield, some of whose letters she had translated into German, she thought she should visit Zennor, to the west of St Ives. A friend suggested she should also visit the artists' colony of St Ives with a view to making a programme about it. She called on a number of artists there, including Hepworth. Hepworth more or less insisted that she make contact with BN and phoned on her behalf, persuading a BN reluctant to spend time with a reporter to allow Dr Vogler a brief visit. The half-hour call became a five-hour conversation during which BN proposed a day's trip into the Cornish countryside for the following day. That trip was followed by another the day after. Felicitas Vogler was to visit friends in Wales before returning to London. BN wrote to Wales, wanting to join her, and together they went on a journey out of Wales to Glastonbury and to BN's sister Nancy, living in Wiltshire, back to St Ives and then to London. They married

quickly and honeymooned in Yorkshire in the house of Cyril Reddihough, long a friend of BN's and from early days one of his steadiest collectors. They called on Herbert Read at Stonegrave, a Georgian rectory Read had acquired in 1949, and visited Rievaulx Abbey, a Cistercian ruin, where BN made some outstanding drawings. Then they returned to St Ives and Goonhilly as a couple.

That summer BN had a one-man show of recent work at the Gimpel Fils gallery in London. He sensed the dawning of a good phase, promising good work. He was sixty-three years old. *1957, November (yellow Trevose)* [plate 283] is a large vertical painting that may be thought to celebrate his new life. Its title recalls visits with Felicitas to Trevose Head on the Cornish coast, and the view it gave of Trevose Lighthouse. The weather was splendid, and they continued their excursion to Tintagel, with its rich historical associations, and Boscastle. Exceptionally narrow in its proportions and exceptionally tall, this painting is the lightest as well as the most luminous of the vertical series. What used to be read as table top has now become a sequence of floating planes, on

The 1950s

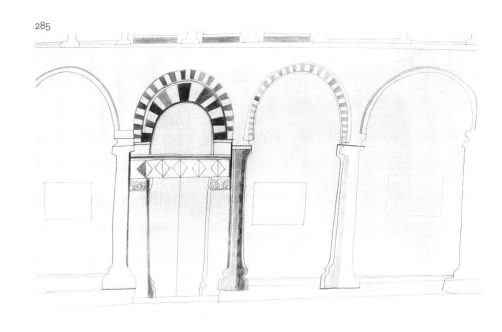

284
*1957, May
(Siena campanile).*
Pencil, pen and
wash on paper,
53.5 × 42.5 cm
Private collection

**285**
*1959, May (Pieve).*
Pencil and
wash on paper,
32.3 × 50.1 cm
Private collection

and over parts of which BN inscribed his objects in cheerful, levitating lines. White lies over off-white over pale grey over a gentle yellow, and so on. Among patches of solid colour, all on the left and part of the upwards drift, is an area of black interlocked with a blue shape. Behind them are the palest creamy grey and a fine bluish grey. The overlappings of course signal space but there is no significant recession. Even the solidest elements here are wafer thin and weightless. A variant, *1957, December (blue Trevose),* is almost as delicate although its background is brown and black. Most of the rest of the painting is mottled off-white floating above the table, a muted light grey-blue for the table itself – a clear shape but utterly insubstantial – and half an object in solid terracotta. The series appears to end with this work, and its most surprising aspect is that a broad area near the top and a squarish rectangle on the table are painted to resemble the hardboard BN had by him in the studio as the material for reliefs and as an occasional alternative to canvas. This is a Picasso-ish joke, a play on what is and what is not real in an age when collage rivals imitation.

Life in St Ives was marked by family tensions that surfaced particularly around Christmas that year. BN felt it might be best to distance himself from Barbara Hepworth, and Felicitas felt isolated from her Continental background and contacts. She proposed the Ticino as an ideal location and was surprised by BN's enthusiastic response. He recalled with pleasure his long visits there in the early 1920s, but she recommended Lago Maggiore with its epic landscape. In March 1958 they left Britain for Ascona and rented a two-roomed house overlooking the lake at nearby Ronco. BN joined the Ascona golf club but also got down to work at once, on a relief. Subsequently, using an architect but with BN largely dictating its design, they built a house outside Brissago, looking east across the lake, a calm, clear environment with marvellous views from its windows and garden.

The 1950s

The 1950s

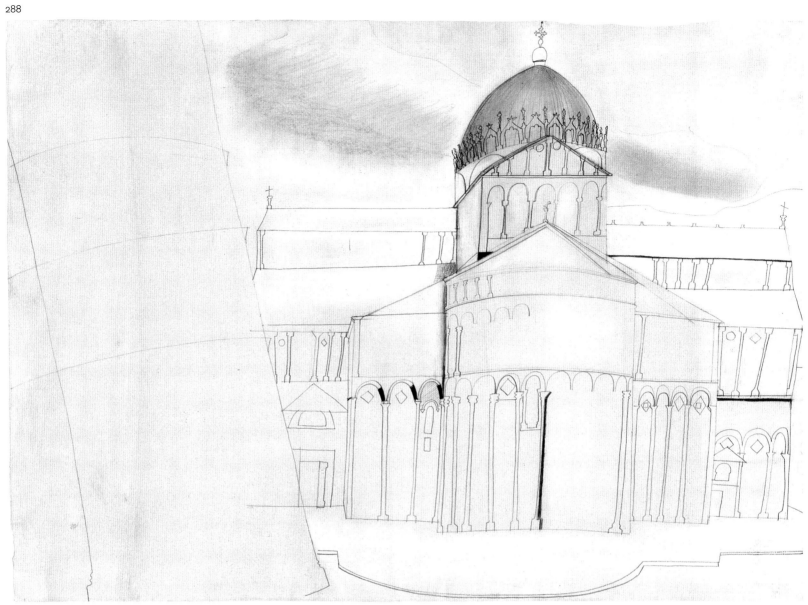

**286**
*1950, May 21*
*(San Gimignano).*
Pencil on paper,
35.5 × 51 cm
Private collection

**287**
*1959 (Kos).*
Pencil and wash on
board, 48 × 35.2 cm
Private collection

**288**
*1960, May*
*(Duomo, Pisa).*
Pencil and wash on
paper, 36.8 × 50.7 cm
Private collection

The 1950s

**289**
*1954, October
(Rievaulx Abbey).*
Pencil and wash on
paper, 57.2 × 38.8 cm
Private collection

**290**
*1957 (Rievaulx Abbey).*
Pencil and wash on
paper, 35.6 × 47.6 cm
Bernard Jacobson Gallery

**291**
*1955, October
(cathedral, Pienza).*
Pencil and wash on
paper, 53.3 × 38.1 cm
Cecil Higgins Art
Gallery, Bedford

The 1950s

292

293

The 1950s

294

**292**
*1958 (Ronco church).*
Pencil and wash on
paper, 61 × 48 cm
Private collection

**293**
*1954, October (invisible
white cat, Stonegrave).*
Pencil on paper,
34.3 × 52 cm
Private collection

**294**
*1959, May
(Porta San Jacopo,
San Gimignano).*
Pencil and wash on
paper, 46 × 60.7 cm
Private collection

**295**
*1956 (San Jacopo).*
Pencil and watercolour
on paper,
36.8 × 45.7 cm
Private collection

The 1950s

**296**
*1959, May (San Macario in Monte).*
Pencil and wash on paper, 34.5 × 49 cm
Private collection

**297**
*1955, October (chapel, San Quirico).*
Pencil and watercolour on board,
36.7 × 47.7 cm
National Gallery of Canada, Ottawa

**298**
*1955 (Torre del Grillo, Rome).*
Pencil and wash on paper, 28 × 49 cm
Private collection

The 1950s

BN was now an international artist, living and working at the heart of Europe, making international friendships and connections, and taking possession of the Continent through exhibitions and through travel. Exhibitions and prizes had already established his art and reputation further afield, from New York and São Paulo to Tokyo. His close friendships with artists were not numerous but now became more international. He had been friends with Braque since the 1930s, and also with Mark Tobey whom he had met in England at Dartington Hall where Tobey taught in the 1930s. Tobey now lived in Switzerland, as did Jean Arp whom BN had got to know in Paris; Julius Bissier, the German painter who settled in Ascona in 1961 and whose meditative art reflected a deep knowledge of Oriental thought, was a fellow spirit in many ways and became a friend. In 1963 BN, Arp and Bissier showed together at the Galerie Beyeler in Basel.

BN's solo exhibitions were now to be seen all round the world. His London dealers were Gimpel Fils and then Marlborough Fine Art from 1967 until Waddington took over in 1975. The Crane Kalman Gallery in London put on occasional shows of BN and of BN and painters associated with him; Andras Kalman, of Hungarian origin, a spirited dealer and also a keen tennis player and tennis watcher, became a friend and an occasional companion at the championship matches at Wimbledon. Durlacher Brothers had shown him in New York during the 1950s. André Emmerich took over there in 1961; in 1965 he collaborated with Marlborough-Gerson in a two-part exhibition in New York, filling both galleries. Charles Lienhard showed BN in Zürich in 1959, 1960 and 1962; then Gimpel Fils and the Hanover Gallery opened a joint space in Zürich and showed BN there in 1966. Two years later Beyeler showed him in Basel. In 1959 the prestigious Kestner-Gesellschaft of Hanover presented a major BN exhibition, which then went on to three other important German centres and galleries, in Essen, Mannheim and Hamburg; in 1967 the Kestner-Gesellschaft showed him again in an exceptionally fine exhibition of his drawings, seen also in Lübeck, Munich and Berlin. Other galleries and other cities wanted his work too: in the 1960s Bern (Kunsthalle, 1961), Sankt Gallen (Kunstmuseum, 1963), Dallas (Museum of Fine Arts, 1964), Chicago (Richard Gray Gallery, 1964), Rome (Marlborough, 1967) and Turin (Galleria La Bussola, 1967) – not counting his contributions to group exhibitions around the world, several in the 1950s, almost incessant in the 1960s and 1970s. The retrospective exhibition at the Tate Gallery in 1969 was wide-ranging and well catalogued, a milestone event serving, together with a variety of smaller London exhibitions, to assert his status and remind Britain of his existence and qualities. A year earlier, in 1968, the Queen had awarded him the Order of Merit, the OM. This pleased him. It is certainly the most honourable distinction available, and limited in the number of individuals who may hold it at any time. He had been offered the CH (membership of the Order of the Companions of Honour) some years earlier and had refused it. He told his family that he had written to the Palace to decline, explaining that his car in Switzerland already had one. One hears of the OM primarily as an honour reserved for outstanding figures in the arts, but that is the Civil Division; BN was certainly put out that other OMs he met were mostly admirals and generals.

He travelled much more frequently, though not beyond Europe plus Turkey. It was not necessary, would not be sensible, to go everywhere. But he enjoyed flying, as he had done since his first experience in 1933. He enjoyed driving good cars and could now own them (in the late 1940s he had owned a motorbicycle). His health, on the whole, was good. (Whenever it was not, he invoked the healing thoughts and

Chapter 6

# The 1960s: Brissago

their subtitles to particular places. At times it is a specific form or relationship of forms the words refer to; often they indicate a broader response, to space, mass, light. Returning to the Ticino released in him a youthful responsiveness discovered in the first years of his first marriage. A letter to Winifred, presumably of 1958, expresses something of this:

…We have bought a piece of land not far from here and are working on plans of a house and studio – rather exciting but also quite a problem as the site is a steep one but in a heavenly position – I wonder if I shall do any work once I get there – it would be easy to stay all day and every day and look at the changing landscape. The lake here is much wider and more open than Lugano lake. The dark brown mountain sides are a wonderful colour and the snow caps are seen against a more or less miraculous winter blue. When the bare, brown, branches of trees above us are seen against a deep blue sky they remind me of a watercolour you made on Monte Bré – the feeling in that painting made an impression at the time which is as vivid as ever – perhaps even more vivid, I wonder? …[2]

Winifred and BN continued writing to each other, about art in general and about each other's ideas and progress, in warm and encouraging and sometimes gently argumentative terms. They met in London in 1969 when the Tate Gallery mounted the great BN retrospective and Thames and Hudson published a fine book, with plates selected and laid out by himself and a thoughtful, appreciative introduction by John Russell. Another publication that year, a more modest production but of great interest and utility, was the special issue of *Studio International*, edited by the painter and teacher Maurice de Sausmarez, bringing together a wide range of texts about and by BN. In a country not known for its interest in contemporary art, these publications (including the Tate's catalogue) indicated faith and recognition of an exceptional sort; only Henry Moore had been better served.

BN's painting did not suddenly cease but the 1960s saw

prayers of Christian Scientist friends and practitioners.) Life by Lago Maggiore brought a dramatic, often joyous round of seasons. In 1959 he had responded to an interviewer from *The Times* in unusually personal terms about the landscapes in which he worked:

St Ives and its surrounding sea and landscape did indeed, I hope, have an effect on my work. Living here in Switzerland also is most stimulating to my work, but by the way this is not Switzerland as most British people think of it, but the Ticino, which is Italian Switzerland a mile or two from the Italian border and with Italian as its native language. The landscape is superb, especially in winter and when seen from the changing levels of the mountainside. The persistent sunlight, the bare trees seen against a translucent lake, the hard, rounded forms of the snow topped mountains, and perhaps with a late evening moon rising beyond in a pale, cerulean sky is entirely magical with the kind of poetry which I would like to find in my painting.[1]

The new home environment and the more extensive travel programme made their mark on his art. Many works refer in

The 1960s

**300**
*1960, February
(ice – off – blue)*.
Oil on carved board,
122 × 184 cm
Tate Gallery, London

**301**
*1963, August
(electric blue)*.
Oil on carved board,
90 × 73 cm
Private collection

reliefs again becoming his chief production. Those of the early 1960s are mostly easel-painting sized but soon they are very large indeed, tall often but mostly very wide. These had to be worked not on a table but on the floor, with the artist crawling over the surface, physically on and in the work even more directly than Jackson Pollock had been in making his paintings of 1948 and after. 'You can find out a lot about a relief', BN said, 'if you crawl over it intelligently.'[3] He had sometimes wondered about making really large versions of his paintings and reliefs. In the 1930s he had painted and carved abstracts as proposed décor for a ballet on Beethoven's Seventh Symphony [plates 129 and 130];[4] in the early 1950s he had been commissioned to paint two large murals; in 1964 he made a maquette for a relief four metres high by fifteen metres wide for the third international Dokumenta exhibition in Kassel, executed in foamed concrete alongside a rectangular pool which seemed to double the wall's height when seen close to [plate 437]. At this time he was liable to write 'project for free-standing wall' on the backs of earlier reliefs, perhaps in considering them

as prototypes for the Dokumenta wall, possibly thinking they could well serve as the basis for other such structures.

Some of the ideas BN was to explore in the 1960s are proposed in the Tate Gallery's *1960, February (ice – off – blue)* [plate 300]. This is a large horizontal relief in a range of whites, blues and browns (the board colour variously adjusted). It confronts us with unusually large forms, set against each other sometimes with marked tonal contrast, sometimes much more subtly. The edges within the composition are haloed with white to set them off further, so that the whole work has a cool, powerful character, possibly to suggest shifting blocks of ice. Among the large forms are smaller ones that make the large ones seem even mightier, and among the opaque colour surfaces are a few transparent ones in which we see white over blue and white over brown, again suggesting ice. In the bottom corners are darker patches made by scraping through the white coat to the board beneath, quite firmly on the left, more sketchily on the right: hints of erosion and of frosted window panes. There are other rubbed areas (e.g. top centre) and areas where the

**302**
*1959 (Mycenae)*,
Oil and pencil on
board, 45·5 × 68 cm
Private collection

**303**
*1959, August (Gadero)*.
Oil and pencil on
curved board,
122 × 135 cm
Private collection

surface has been pitted. The whole composition seems to shift slowly, heavily, to the right. This abstract composition introduces a new type of BN relief. It is based on landscape. Still-life elements are wholly absent. The tendency to centralize arrangements, already weakened in frieze compositions such as *1953, July (Cyclades)* [plate 256] and the vertical polyphonies with some of their groupings stretched along the vertical axis, here yields to horizontal flow. This is more than a matter of seeing in it shifting ice where we are used to seeing jugs and goblets. It is a matter of scale and reach, in implications of space and in physical intervals within the composition. This is an exceptional work, a little disconcerting with its multiplicity of hard forms among the other compositions of the time; we shall find echoes of it in the reliefs that follow, and there is a large painting in a private collection that has rather similar form in a calmer, more orthogonal arrangement and with less tonal drama.[5]

BN's new work has a brightness and lightness that one readily associates with his new home setting. Too readily, perhaps: the ambition 'to liberate light' is one he had long

shared with Winifred (and one we could interpret as his ultimate answer to his father). When we see his Cornish works filled with light we think of the broad skies over that almost treeless land and the ocean, and then we remember that he had produced his most exclusively light-centred works in 1930s London. Yet of course he was an artist who responded to his environment, and especially to major changes in location, and it would have been surprising had the move to Brissago not shown in his new productions. That he never stopped working goes without saying, in spite of the dislocation involved in the change and although a lot of time and thought went into getting the new house built. In fact, 1959 was a particularly fruitful year, a pivotal period the products of which seem to look back as well as forwards though they generally exhibit an airy quality that seems to belong especially to that year.

The row of still-life objects that is the theme and composition of *1959 (Mycenae)* [plate 302] hovers mysteriously between material presence and transparency. Even the pale blue and the light olive green areas, though we

The 1960s

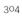

304

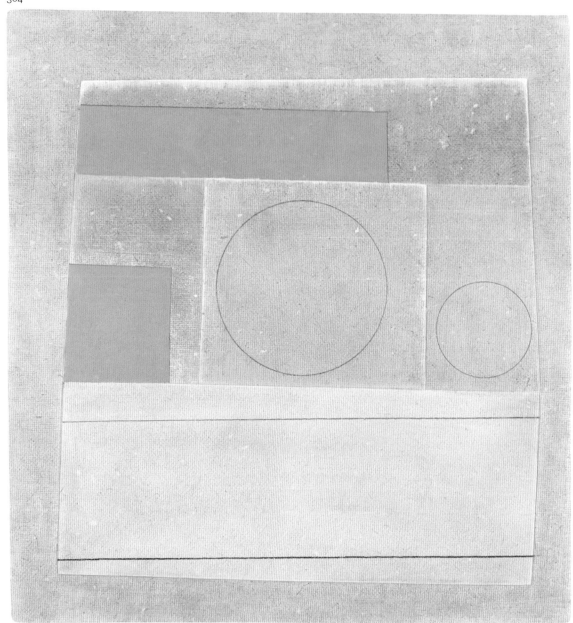

305

306

**304**
*1959, November
(Mycenae 3,
brown and blue).*
Oil and pencil on
carved board,
41.2 × 38.7 cm
Private collection

**305**
*1959, November
(Paros – two circles).*
Oil and pencil on
board, 39.8 × 47 cm
Private collection

**306**
*1962 (blue Paros).*
Oil and pencil
on carved board,
34 × 28 cm
Private collection

see them first as opaque colour patches, do not assert themselves as stable surfaces. Only the dark red band at the foot of the pale blue manages that. It is a very small element in the work yet strong enough to throw all the rest into doubt. The scraped surface of much of it is a mere memory of whiteness and the objects seem to disappear with it before our eyes, in spite of their clear lines and occasional shadows. *1959, November (Mycenae 3, brown and blue)* [plate 304] looks more matter-of-fact with its circles and rectangles, but we know better by now than to think that the end of the matter. There are some straight lines and a few right angles, and the circles are indeed circles, but almost everything shifts away from the horizontal and the vertical, and the subtle tones leave spatial relationships uncertain. Even the two blue forms, fresh and reassuring, cannot tell us where they are in space, in relationship to each other or to the rest of this gently shifting relief. In *1959, November (Cyclades)* [plate 310] almost everything speaks of air and space; even the pale blue wedge in the middle floats mysteriously – a distant echo of *1955, May (Gwithian)* [plate 277], though in

both cases the vertical form is a dark intruder in a luminous situation. The small Indian red rectangle which is its companion neither confirms its place nor sends its vague blue partner into the distance. They stay together, perhaps because of the fine black lines on either side, almost horizontal, almost parallel to each other. The sharpness of those lines relates them to the Indian red shape, yet it is the pale blue shape they flank and sustain.

Broken whites and an area of mottled whitish blue are the main offerings of *1959 (Paros)* [plate 308]. The way its forms identify themselves at first glance recalls the white reliefs of the 1930s. But in their case we could rely on some vertical–horizontal co-ordinates and, in most cases, right angles. Here it is only the recessed circle in the middle that makes itself known without reserve. Since everything around it is misty and mobile, even this strong form is left without anchorage but advances and recedes, grows and wanes, according to the light conditions in which we see it and also in response to the attention we give it. Three years after this, the title of *1962, January (white relief – Paros)* [plate 309]

The 1960s

The 1960s

**307**
*1962, March (Argos).*
Oil and pencil
on carved board,
51 × 60 cm
Kettle's Yard,
University of
Cambridge

**308**
*1959 (Paros).*
Oil on carved board,
46 × 86 cm
Private collection

**309**
*1962, January
(white relief – Paros).*
Oil on carved board,
61.3 × 63 cm
Scottish National
Gallery of Modern Art,
Edinburgh

**310**
*1959, November
(Cyclades).*
Oil, pencil and paper
on carved board,
51.5 × 45 cm
Private collection

tempts one to see this subtle work as a late addition to the 1930s series. Here all the forms are rectangular – or nearly so. Their arrangement recalls the still-life group in *1947, November 11 (Mousehole)* [plate 214]. Like the objects there silhouetted against the landscape, the white planes here tilt to the right. And to their right, dividing what we would otherwise read as a table-top support, is a shadow line that looks like a horizon. Because of it we can see this relief as a more wholly abstracted version of the still life plus landscape theme BN explored so eagerly in the 1940s.

There is no hint of still life in *1962, March (Argos)* [plate 307]. The background plane is divided in a way that suggests a horizon, whitened brown below, whitened blue above, so just possibly sand and sky. A deeper blue, a thin and uneven wash rather than a firm colour, fills the rectangle hovering in front of this background. In front of this hovers or rises a squarish rectangle, rather taller than wide, in colour a slightly paler version of the sand colour, except for its lower right corner which is pale blue – a gentle wisp of colour yet the firmest colour statement in the composition. (A similar

understated square of blue was placed close to the centre of *ice – off – blue*.) The lines are all clear – the edges that denote a change of level in the relief and, in the smallest rectangle, three pencil lines. The deeper blue of the central rectangle may refer to the sea, but as a form it is read as being in front of the horizon which it obscures, and the small, nearly square form is understood to be in front of that. In fact, the small rectangle is cut into the relief and reveals a lower level than 'sea' or 'sky'; 'sea' is indeed in front of 'sky' and 'sand' – all the more firmly so for its absolute centrality – but we are surprised to find that 'sky' advances in front of 'sand'. BN's reliefs have to be lit from above and slightly to one side. Here the horizontal edges between 'sky' and 'sand' show as fine, dark lines. Other edges in the composition have white rubbed into them, so that, for example, the bottom edge of the 'sea' rectangle does not cast a shadow line and the negative edges of the small rectangle glow with light. This form therefore seems quite weightless, an ethereal thing some unknowable distance in front of the rest, and the whole work has a magical light. Its design makes it one of the

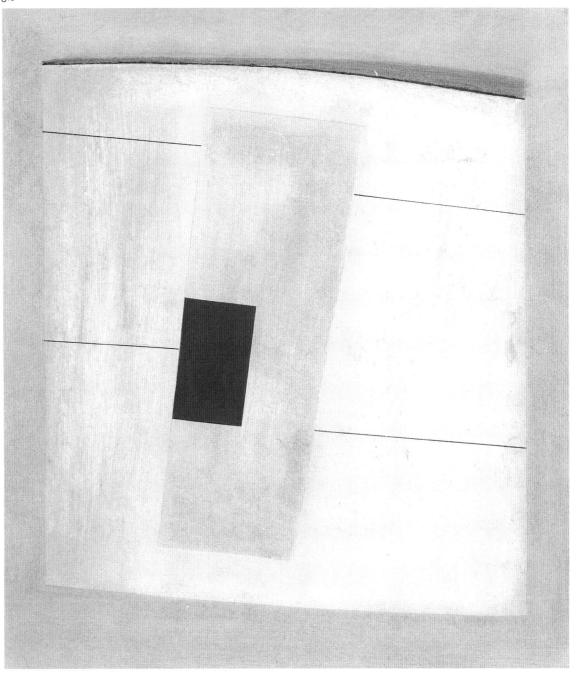

The 1960s

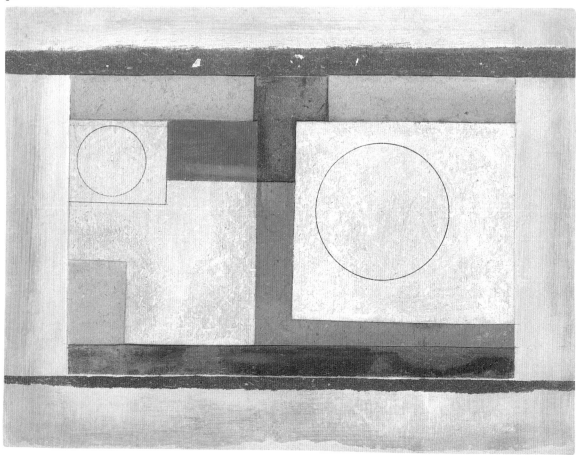

311
*1960 (Hampton Court).*
Oil and pencil on
carved board,
26 × 32 cm
Private collection

312
*1960 (Olympia –
project for free-
standing wall).*
Oil and pencil on
carved board,
24.8 × 34.9 cm
Private collection

firmest of BN's compositions, yet its subtle washes and relief
tempt one to see it as a contribution to the English tradition
of watercolour painting.

The squareness of *Argos* contrasts with the tilted forms
of *Paros*. Stable and calm though the latter may seem at first,
almost all the forms in it slide and slip to the right. The
baseboard itself has a slanting lower edge, adding a major
note of instability. Only its top, light-catching edge and the
shadow line on the right are horizontal. The one firmly seated
form is the tall rectangle holding the top right corner and
giving us the shadow line: but for that, the tilted planes could
well slide out of sight. This sense of instability is new to BN's
reliefs; it is announced in various ways in the paintings of the
1940s and 1950s – notably in the tall polyphonic paintings
whose planes can appear loose and transient [see plates
239, 245, 249 and 252-5] – but these are exceptionally
immaterial works made of delicate membranes of paint on
canvases that, at that size, can seem slender supports. *Argos*
comes close to denying the fact of its being a carved board;
*Paros* is an experience of light more than of mass. The small

relief *1960 (Olympia)* [later inscribed *project for free-standing
wall*; plate 312], earthier than these because of its browns
and olive, and more openly complex, combines some
of the squareness of the design of *Argos* with some of the
instablity of *Paros*; its landscape character is clear.

The forms of *Paros* may be thought to invoke the
buildings BN drew there (we see some of them reversed
in the etching *1967 (Paros 2)* [plate 345]); its whiteness,
a surprise at that date, may refer to the quarries of white
Parian marble which supplied mainland sculptors from the
sixth century BC on and are thus major contributors to
western civilization. There was no one-to-one relationship
between BN's paintings and reliefs and the places he
absorbed and often drew on his travels; at the same time
these surface in his abstract work and he acknowledged
their presence with pleasure. Felicitas Vogler describes vividly
how intensely he would look when he had found something
special. She is speaking of their first visit to Greece:

We were delighted by a gleaming white church with blue window
arches. I photographed it quickly because of the encroaching tide

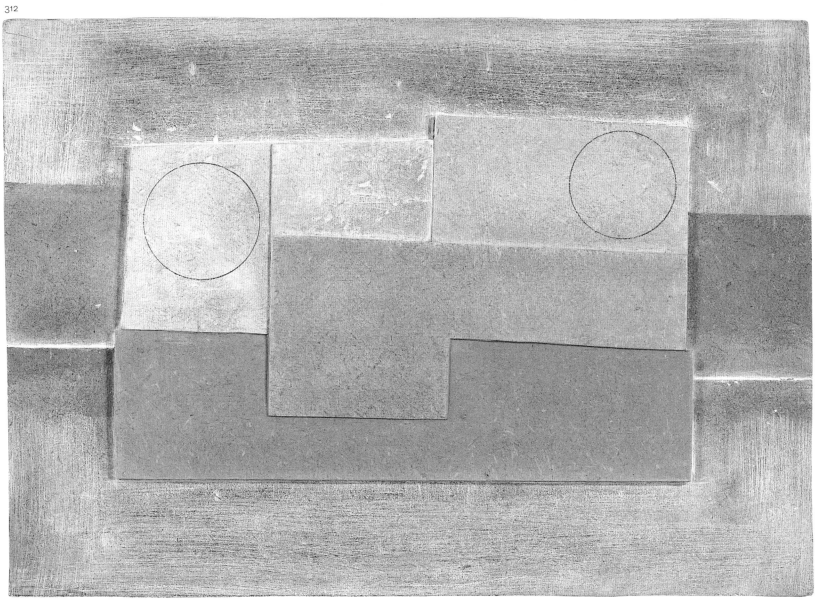

The 1960s

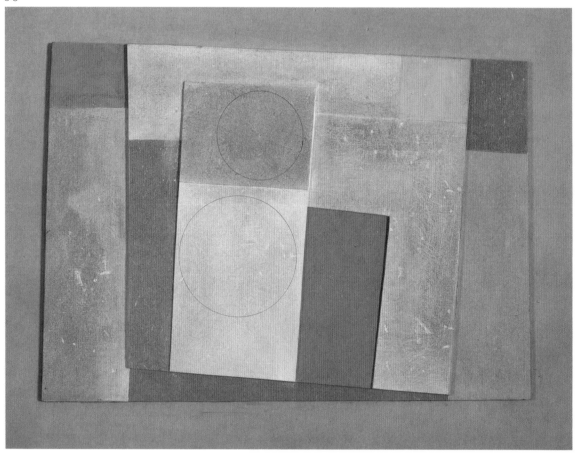

**313**
*1961 (blue rock).*
Oil and pencil
on carved board,
33.7 × 42.5 cm
Private collection

**314**
*1963, June
(Olympic fragment).*
Oil and pencil
on carved board,
40.9 × 19.6 cm
Private collection

of tourists, working with intense concentration. As I climbed higher up the mountainside, I saw BN grow smaller where he stood drawing in front of the church, until finally he was only a dot in the big square before it. When I returned more than an hour later, I found him standing on the white stone of the fountain, immobile, where I had left him.[6]

She was right to say, in the same essay, that BN's drawings are 'distinguished from a very early stage by clarity and the great art of omission'. The great art of omission, I would argue, is the key to all his work, the other side of the coin of contrariness that we have noted many times. Christopher Wood knew that this always distinguished BN's work from his own: BN, he wrote to Winifred Nicholson in reference to a painting he had just done, would surely tell him off for putting in too much.[7] In the drawings and etchings a few lines can offer space, light and scale, the essential character of the forms BN was looking at as well as his enjoyment of them; lines are as important as colour, tone and mass in the paintings and reliefs, and it is their economy that strikes one as much as their energy. The pioneers of Modernism had a

lot to teach him in this regard – Matisse, Picasso, Brancusi, Mondrian, Klee and most of all Cézanne – but the impulse came undoubtedly from his childhood and his first maturing thoughts about art. He could not bear the slick and froth of Edwardian culture as he found it in his father's portraits and even, much transformed, in his fine still lifes; one wonders whether it did not touch him in much the same way as asthma. For himself he needed fresher air, open skies, big sea- and landscapes. If he could make two or three lines or edges capture the experience of Paros, of travelling through Tuscany, of standing inside a Palladian villa, that would mean he could both take possession of it and leave it free to breathe air and light, have it for himself and let it be.

In this way BN's travelling takes on something of the nature of an ongoing pilgrimage, a journey that involved his physical being but also his mind and spirit. He does not seem to have lingered over the literary connotations of the places he visited, the mythological associations, say, of Olympia or Paros, but he had a sense of time as well as of place and space. Just as he and Barbara had honoured the ancient

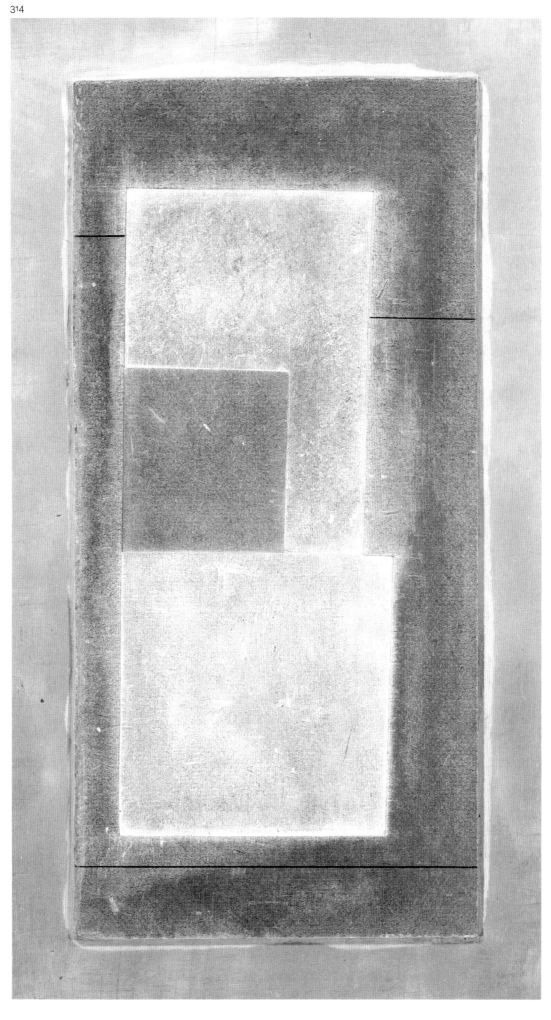

The 1960s

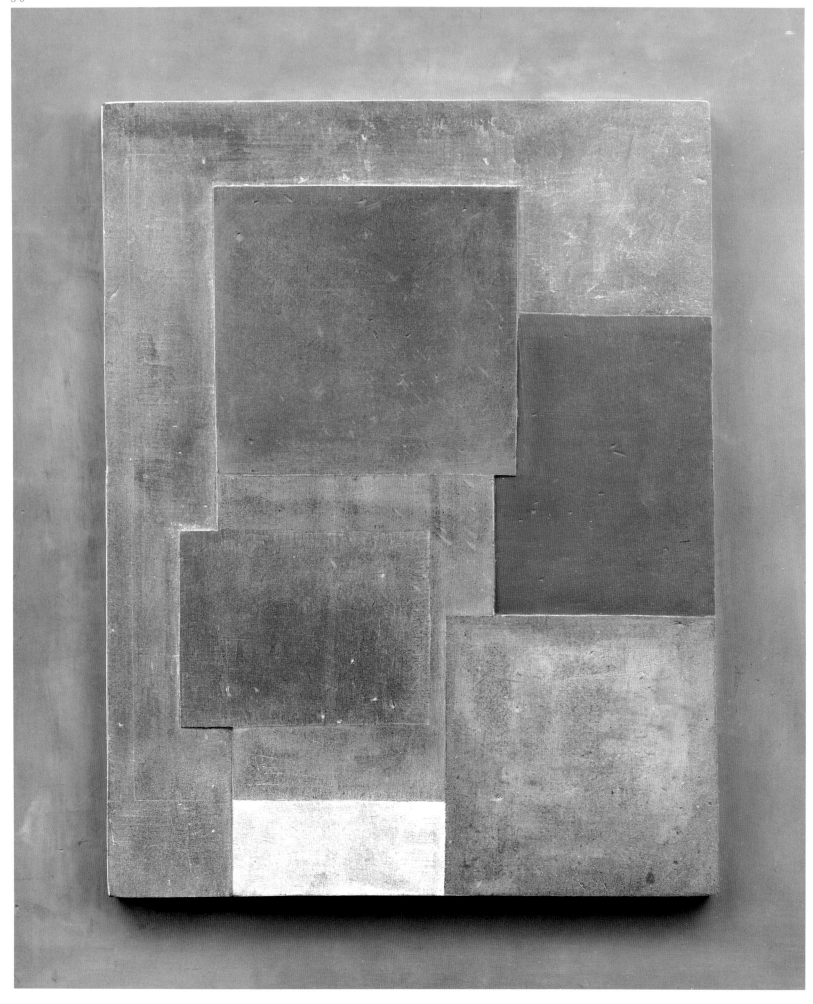

The 1960s

**315**
*1962, July (Ticino 444).*
Oil on carved board,
50.5 × 42 cm
Private collection

**316**
*1961, December
(clay green).*
Oil on carved board,
18.7 × 41 cm
Private collection

*1963, June
(rockscape).*
Oil on carved board,
55.9 × 66 cm
Private collection

**318**
*1958 (standing stone).*
Oil and pencil on
carved board,
115 × 52.5 cm
Private collection

stones of Cornwall, so now he was fascinated by other prehistoric and ancient sites: Mycenae, Altamira, Carnac and others. Many drawings are of particular places and many prints are developed from the drawings. In the paintings and reliefs direct references to specific scenes are rare; more often it is the general ambience that is evoked in them. In the drawings he makes his first distillation, further refined in many a print; in his larger works the sources are almost always transmuted. Abstracted, we say, but that seems a negative word, like 'distanced'. The point is rather that there is a process of metamorphosis in support of a different purpose. As in music, the constructed object does not imitate its subject but embodies qualities of it. We are not likely to recognize it without being told but that does not mean the invocation of it is arbitrary to the artist. Yet we must also guard against giving his subtitles too much weight – it feels typical of BN that he could make teasing use of something as central to him as his gathering experience of the world. Many are significant; others are playful. Some works were initiated by a recollection pressing for embodiment; in others

it may have arisen while they were in process, by way of analogy; in yet others it may have surfaced when the work was done and awaiting its name. In 1941 he had written:

One of the main differences between a representational and an abstract painting is that the former can transport you to Greece by a representation of blue skies and seas, olive trees and marble columns, but in order that you may take part in this you will have to concentrate on the painting, whereas the abstract version by its free use of form and colour will be able to give you the actual quality of Greece itself, and this will become a part of the light and space and life in the room – there is no need to concentrate, *it becomes a part of living.*[8]

(He used to say also that 'I don't feel that I know a painting until I've sat with my back to it for some months.')[9]

We know from those close to him that BN could also be stuck for a subtitle and adopt any word or name that pleased him, sometimes by way of a joke (as in the case of the 1968 drawing *jug, sexagonal*), sometimes quite arbitrarily. And, of course, he had an infinite resource in the still-life objects he had brought with him and to which he added from time to time; they provided a familiar but also endlessly variable

The 1960s

**319**
*1963, November
(violet de Mars).*
Oil on carved board,
63.2 × 63.2 cm
Private collection

indoors landscape for him, sometimes evoking travel associations as in the painting *1956, July (Arezzo).* In the relief painting *1958 (2 goblets – Piero)* he thought of Piero della Francesca's greatly satisfying and partly humorous way of juxtaposing images of contrasting tone or colour, notably two horses in the Queen of Sheba scene of his Arezzo frescoes. Never one to respect the genres' academical and traditional frontiers, he allowed himself the greatest possible freedom in such matters in his last decades, as well as working in an extraordinarily wide range of graphic, painting and relief forms.

In two examples from 1962, *white relief – Paros* and *Argos* [plates 309 and 307], we saw BN making a perhaps surprising return to the clear/unclear geometrical language of his 1930s reliefs. What is at once remarkable, however, is that this formal idiom does not go with one kind of reference only. The white tilting rectangles of the former suggest abstracted still-life groups set against landscape; the steadier forms of the latter bring to mind a luminous seascape. In reliefs of 1963 and after we are offered

distillations of landscape via similar forms: variations in the grouping and in the placing and surface treatment of the forms. Stone is the theme of *1963, June (rockscape)* [plate 317], an almost four-square arrangement of four nearly square areas and two relatively small elements of the same sort cut more deeply into the board. Different kinds of stone: this is a work rich in subtle variations of tone and colour and slightly different textures. The baseboard has one vertical and one horizontal side, but otherwise encourages a sense of shifting, as though the geological structure of the group was still to be resolved by natural forces.

*1963, November (violet de Mars)* [plate 319] is similar in several respects and quite different in its overall character. Four squarish forms again, with little overlap. But they are seen against a baseboard that is divided into two colours and two levels, and while the four forms may be said to suggest stone, the background is much less certain. On the right a colour close to the board's own, though mottled: wood, forest, earth. On the left, uneven also, the colour of the subtitle, a purplish pink which seems to come from another

The 1960s

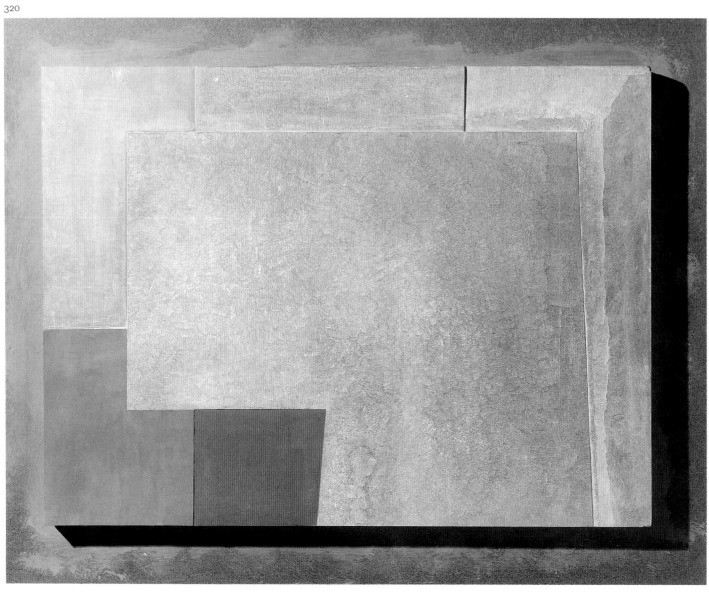

The 1960s

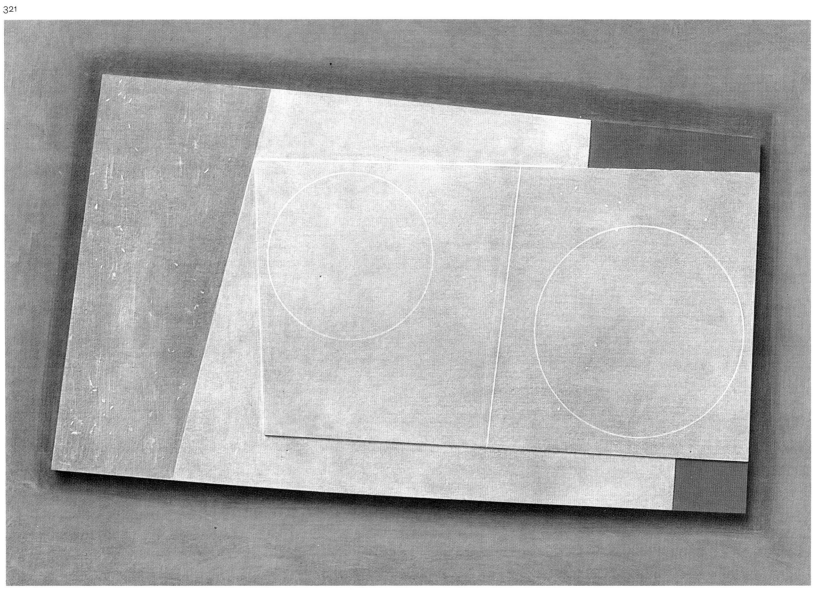

**320**
*1964, August
(Stonehead).*
Oil on carved board,
58.3 × 73.7 cm
Private collection

**321**
*1966 (domino).*
Oil on carved board,
81 × 114 cm
Private collection

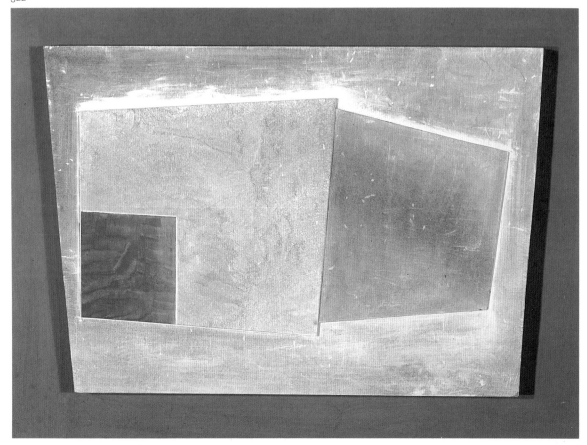

**322**
*1964 (poisonous green –
project for free-
standing wall).*
Oil on carved board,
48.3 × 63 cm
Private collection

**323**
*1967 (green quoit).*
Oil on carved board,
158 × 156 cm
Private collection

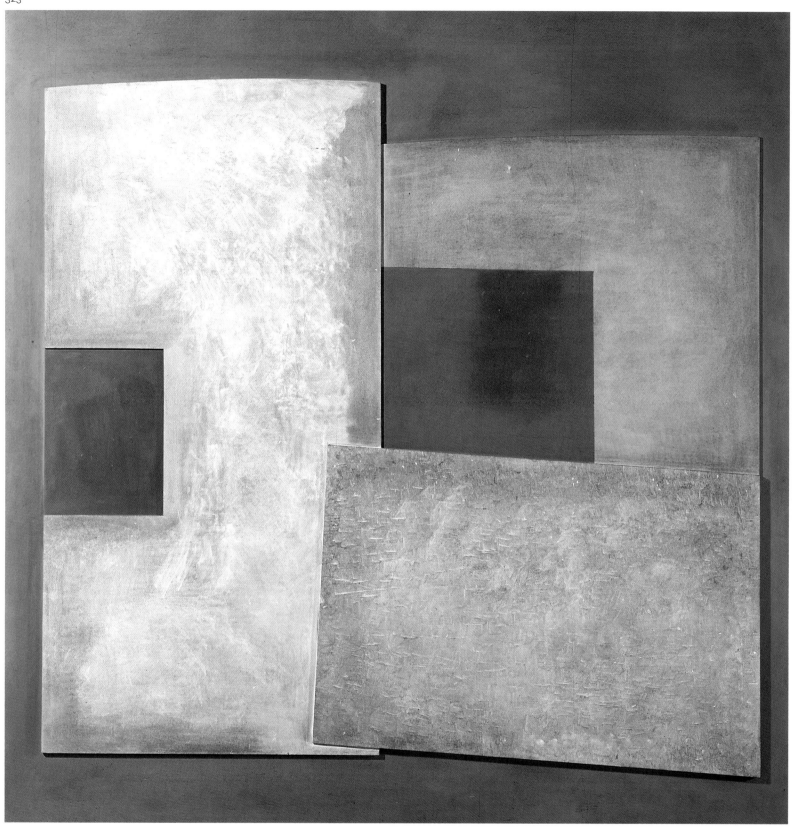

The 1960s

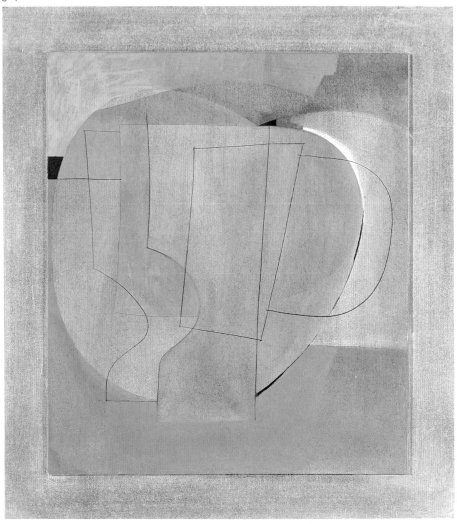

world and here makes, again, space and air and perhaps
fragrance. The discord created, between that pale violet
and the reticent orange-brown it flanks, is one of BN's great
inventions, a subtle, wholly personal combination
unprecedented even in the paintings of Vuillard and Bonnard.
This subtlety in the colour is matched by the use of levels.
The sequence from back to front, using the colours to
identify the forms, is violet, brown and orange-brown, whitish
mushroom-grey, flat mushroom-grey, whitish grey. As in many
other instances, notably *ice – off – blue* [plate 300], the
changes of level are quite slight but highly effective. Here
they underline a grouping that hints also at spiral motion.

*1964, June (valley between Rimini and Urbino)* and
*1964, August (Racciano)* [plates 325 and 326] speak of the
motion of travel, by car and by air respectively. Central Italy,
the cities of Florence, Siena, Arezzo, Pisa, Urbino and the
intervening country, was of endless fascination to BN with its
superabundance of natural and man-made beauty. *Valley
between Rimini and Urbino* is a soft-spoken composition.
Its baseboard is securely rectangular and orthogonal, its light

earth colour the colour of the pale board BN used for this
piece gently touched by white. One vertical break in that
surface and two breaks in angled lines lying across it
suggest unhurried motion. The grey forms that lie in front of
that surface, and in front of each other, seem to unfold: the
valley, perhaps, opening to the traveller. The inscribed circle,
for all its delicacy, anchors that form and leaves the others
hinged to it. A soft white shadow under the grey forms lifts
them off the pale ground, introducing space and suggesting
lightness. All is quiet and quite straightforward, and it takes
extra attention to notice the three different greys, the
variations in the earth colour, the fact that the break line we
read as vertical consists of four parts angled to each other,
and that the angled line above the grey group has the effect
of a curve.

The vertical array of forms in *Racciano*, interleaved by
one of a pair of grey forms that lie across their path, feels
like an easily crossed threshold, a shadowed mountain ridge,
possibly, between water and snow. The almost unbroken
edge rising along BN's usual sloping axis makes for speed;

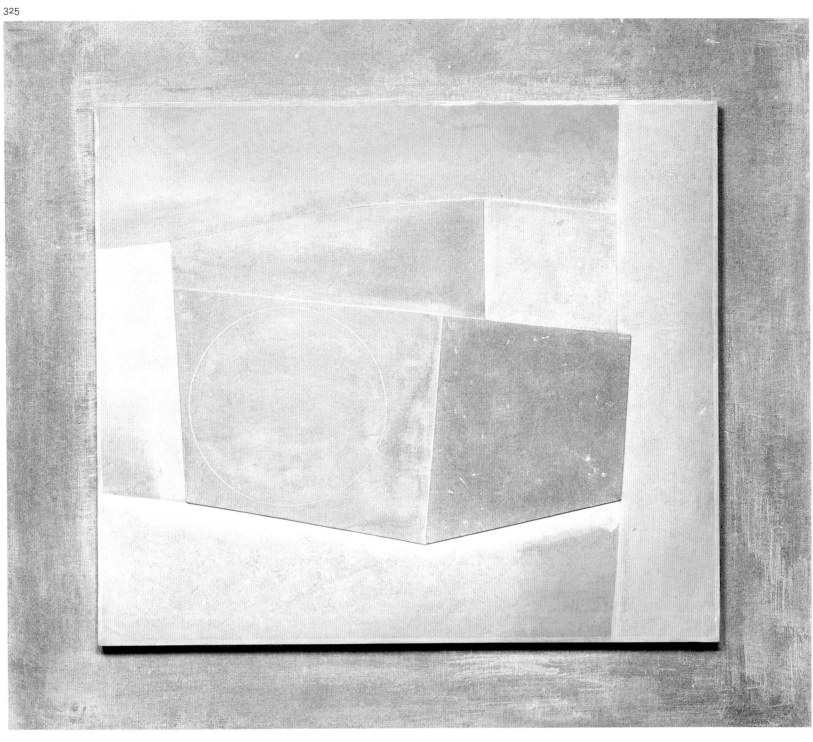

The 1960s

**326**
*1964, August
(Racciano).*
Oil on carved board,
138 × 79.5 cm
The British Council

the narrowing of the forms has a perspectival effect and makes for steady recession into the distance – more specific than BN's normal way of suggesting space between adjacent and overlapping forms. The horizontal grey forms are seen only on the left and thus scarcely slow down the motion; the extra width of the lower white form, extending beyond the vertical edge of the upper forms, makes the whole work secure and greatly adds to the drama of the piece. That a grey board, its edge more nearly vertical, is seen only on the left whereas on the right we see only the broken whitish brown of the baseboard, has the effect of lifting the white–blue–white sequence off the background; thus, quite irrationally, it proposes a view from above, a bird's-eye passage.

In 1965 BN returned to printmaking. How he and the Swiss artist/printmaker François Lafranca came to work together is worth retelling. Lafranca tells how, needing inks to print some small etchings he had himself recently prepared, he visited the nearest shop and was asked by the shopkeeper whether he knew of anyone who might be willing to print work for a local artist. He guessed it was likely to be one of the better-known artists living in the area, Arp, Bissier, BN, Hans Richter or Italo Valenti, and was tempted by the idea of collaborating with him, whoever it was. 'I bluffed', he wrote later, 'and claimed to be in a position to print such works.'[10] He was brought two plates prepared by BN, quickly bought some books on engraving and ordered a press. There was an interval during which he made hundreds of trial pulls. Then he brought the best ones to BN who was happy with them. The plates Lafranca had proofed were drypoints but BN in the end decided to do etchings, i.e. not inscribing the plate directly, as he had done in 1948 and the early 1950s, but drawing with a metal point through a ground put on the plate by the printmaker; the marks thus made are then bitten into the plate by acid, the length of exposure to the acid affecting the depth to which it eats into the metal and thus the amount of ink carried in it and the firmness of the mark printed from it. That decided, BN 'set to work with intensity'. In Lafranca's workshop he would mark the plates he wanted on the 2-metre sheets of copper and Lafranca

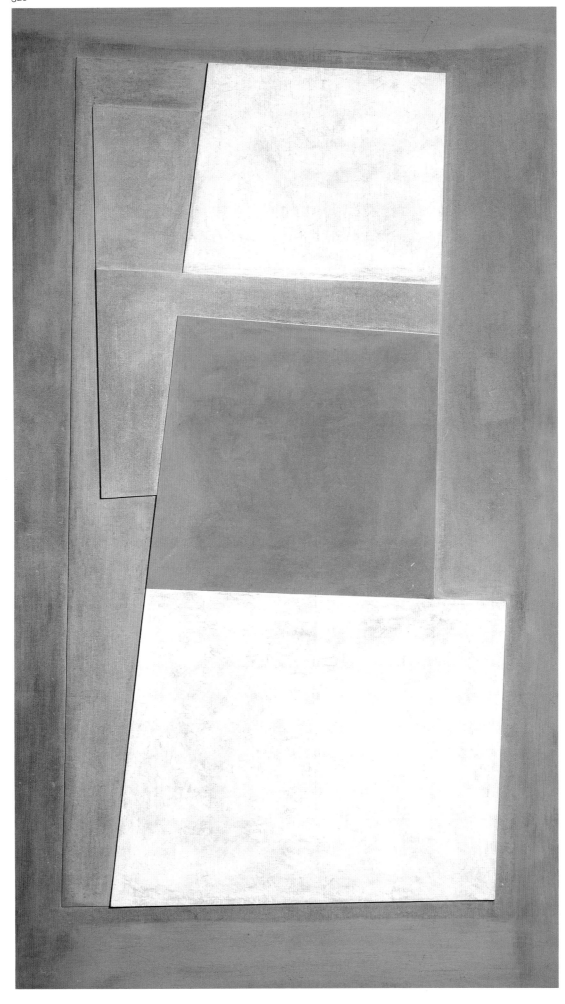

The 1960s

The 1960s

**327**
*1961 (still life
without red).*
Oil and pencil on canvas,
63.5 × 75.5 cm
Private collection

**328**
*1961, June (Alnwick).*
Oil and pencil on board,
80 × 81.3 cm
Private collection

The 1960s

**329**
*1961 (mug)*.
Oil and pencil on
board, 39.3 × 35.5 cm
Private collection

**330**
*1963, August (two
mugs, one blue)*.
Oil and pencil on
paper, 47 × 60.6 cm
Private collection

would cut them and coat them with asphalt varnish. BN wrote, on 8 October 1968: 'I think I am not an "etcher" as I understand the medium at all. … I suppose [my etchings] are really drawings on prepared copper (and I like very much the clear line and the resistancy of the material and the smooth run of the implement).'" This sounds as though he inscribed the surface of the coated plate the way in the early 1930s he inscribed lines into the paint-over-gesso surface of some of his paintings. Lafranca stresses that BN did not want the metal polished to perfection, only major scratches removed. He worked on the plates in his studio, and it is clear that he drew with the metal point with a firmness that took him into the metal (as for drypoint), not merely through the varnish.

The etching of the plates would be done in the workshop and then pulls made which BN would study at home, 'taking his time'. There was much experimenting with different inks, different exposures to acid, different papers. 'Unlike the other artists with whom I have worked, Ben Nicholson did not readily accord the "bon à tirer"', i.e. the indication that a particular proof would serve as model for an edition of pulls.

There were a lot of trial proofs to discard, sometimes whole runs. BN found he enjoyed using some of the rejected pulls, adding colour or other touches to them or turning them over to draw on the three-dimensional surface given by the impression of the plate. Thus a number of unique graphic works were created, the adjusted etchings which he called 'mixed media' and the relief drawings done on the backs. On the other hand he was punctilious about destroying the plates from which editions had been printed. BN had told Lafranca at the start that he did not expect to go on doing etchings for long. In fact they worked together from 1965 to 1968, for the best part of four years, before he called a halt. After that he did no more prints, of any sort.

We may wonder why BN felt the urge to turn to printmaking at this time and why it became so fruitful an experience for him. He was 70 years old in 1964 but it was clearly not a matter of a man feeling his age and seeking a less physically demanding way of working – something he could sit down to. He did not stop making reliefs; in fact, they got bigger rather than smaller, requiring intense physical

The 1960s

**331**
*1969 (Rievaulx no.1).*
Pencil and wash on
paper, 59.3 × 49 cm
Private collection

**332**
*1962, May (Urbino 3).*
Pencil and wash on
paper, 64.5 × 50 cm
Private collection

involvement. Lafranca says that, in those days, BN 'worked eleven hours a day and practically did not let himself be disturbed'. It may be, rather, that working on such a large scale, with large surfaces, BN felt the need for some compensatingly more intimate process, for chamber music amid the grand symphonies. The reliefs left much of his particular skill and talent unused, particularly his unique ability to launch a line and let it find its way to the right spot. In a letter to Maurice de Sausmarez, referring to an etching he had sent previously, he wrote:

I'm glad you liked the etching – it was one of the first two or three I made – since then I've made many others very different. The bite of the steel point into the metal is a terrific experience when all goes right and the necessity I am finding to reduce the idea to a series of lines is interesting. There is a point also where I can cut into the metal in a line as straight as any ruler but with this difference, that the ruler will always rule straight whereas my hand line may at any moment decide to develop a curve – (*it* may decide) and if it does so then other lines must relate and may even develop a bigger curve or even straighter line than either I or the ruler themselves could make ...

and he goes on to speak of the 'blackbird which flies in low over the terrace (especially in frosty weather when the berries must be pretty good food) and into the depths of the holly tree' to indicate the natural rightness and ease he could achieve with line.[12]

The subjects of the suites BN did with Lafranca were buildings and architectural fragments he had seen and drawn on his travels, and sometimes landscapes, intermixed with still lifes. The plates were listed in sequence as he produced them – not when they were printed or the date he often wrote on in signing them subsequently – and it is striking that not only types of subject but geography were thoroughly mixed up. Thus in 1966-7 *Siena* and *Tuscan pillars* were followed by *crystal* and *mugs and squares*, then two states of *San Gimignano*, two states of *small still life*, *St Ives* and *Pisa as intended*. The variety itself must have tempted and refreshed him. In his introduction to the catalogue of BN etchings shown in Locarno and Mannheim in 1983-4, Manfred Fath finds it worthy of note that BN's themes as etcher never include what Fath calls his 'geometrical reliefs'.[13]

There was indeed one earlier print related to his reliefs –
the woodcut *5 Circles* of 1934 [plate 103] – but that was an
exception and it is difficult to imagine him wanting to make
variations of his now much larger reliefs on the small scale
and in the medium of etching.

Landscape as such is rare among the etchings. What we
find instead is buildings plus landscape, near and far, just as
he had combined, and was still combining in these prints,
still-life groups and landscape. At times he used architectural
fragments as still life, for example in *1965, December
(Olympic fragment no.1)* [plate 336] where a single
meandering line near the top speaks convincingly of the
setting of the Doric capital found on the ground, seen very
close to and occupying the rest of the plate. At other times
he used architectural forms and objects as though they were
still lifes, placing them next to each other in pure line and
without any indication of a setting, as in *1967 (Turkish sundial
between two Turkish forms)*, or pressing man-made form and
nature's into dialogue, as in *1967 (column and tree)* [plates
348 and 340]. In other drawings and prints he captured and
developed his experience of interiors, a subject not found in
his paintings unless we consider *1930 (Christmas night)* an
interior, ignoring the view out of the window and the
important still life. It is as though, in places of a particular
character, he found he could take delight in enclosed spaces
– a surprising discovery in someone whose art, after its very
beginnings, always reached outwards into space and light.

Surprising for himself too, perhaps. There is no mistaking
the pleasure he took, and the fun he had, in drawing the
vaults and spaces he found in the basement of Palladio's
Villa Malcontenta. *1962, June (Palladio)* [plate 334] is the
result of many omissions – such as incongruent decorative
elements he decided not to see – and of clear identification
of those elements that pleased him and would make a good
drawing. He made little of the open door that could have led
our eyes into the distance, blocking the view with scribbled
foliage; it is the double action of the lines that is his subject,
as play or a kind of precise sport on the surface of the paper
and, perceptually, as an intelligent and intelligible structure
that informs us of the complex spatial forms of the building.

The 1960s

335

336

**335**
*1966 (bird's eye).*
Etching, 23.5 × 29 cm
Edition of 50

**336**
*1965, December
(Olympic fragment no.1).*
Etching, 18.2 × 21 cm
Edition of 50

**337**
*1966 (Siena).*
Etching and drypoint,
32.2 × 27 cm
Edition of 50

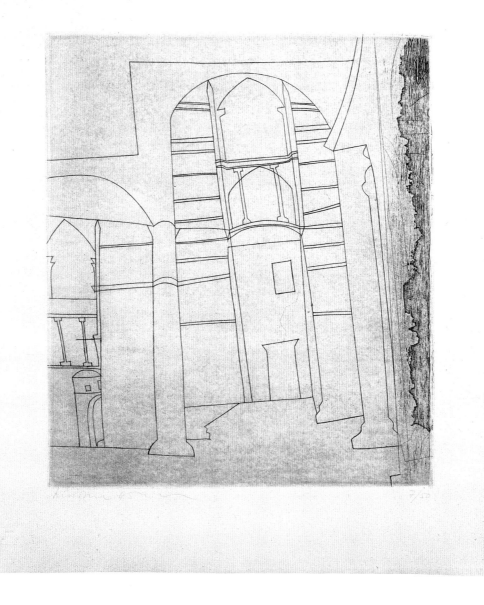

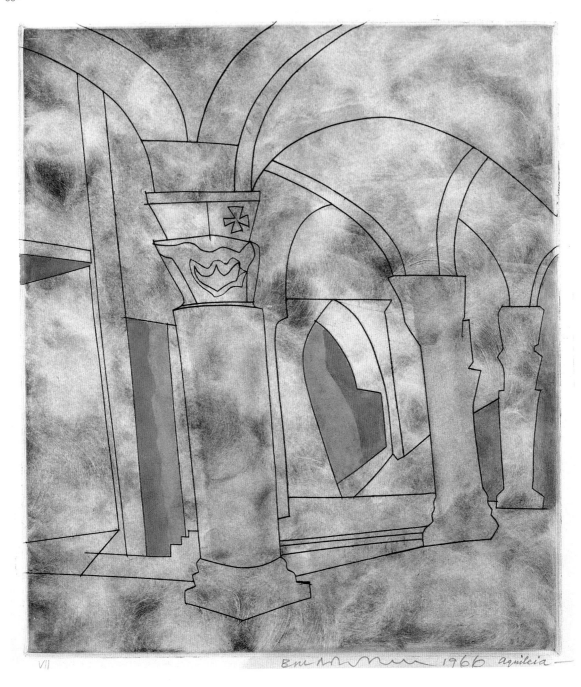

VII                                    Ben Nicholson 1966  aquileia

**338**
*1965 (Aquileia).*
Etching, 32.2 × 27.8 cm
Edition of 50
This example hand-
coloured by the artist

**339**
*1965, November
(Urbino 2).*
Drypoint and etching,
20 × 15 cm
No edition (?)

**340**
*1967 (column and tree).*
Etching, 29.8 × 20.6 cm
Edition of 50

**341**
*1967 (Torcello 1).*
Etching, 35 × 38.5 cm
Edition of 25

**342**
*1967 (Patmos monastery).*
Etching, 35 × 43.3 cm
Edition of 50

His delight is in the observing and in the highly selective, exact yet unconstrained making of lines. We repeat the process in reverse, tracing the lines with our eyes, enjoying their sweep and feeling empathetically the pleasure he took in this action, compounded of built-up experience and skill as well as the right instinct at the right moment; then we go on to read and enjoy the complex interior these lines have encoded. What is omitted is at least as important as what the drawing shows. Here and elsewhere BN knew exactly where to introduce a detail, in the architecture itself or by way of added data: in this case the lantern – complete with details of how it hangs from the vaulted ceiling by means of a rope entering left and going over a pulley – the stool and the balustrade outside the door. Such details give scale and make us even more aware of the naked bounding lines that make up so much of the rest; but they also humanize the image, entertaining us with their information and thus giving our minds something to attend to.

It is the same with the etchings. Cloisters are presented as interiors, without any suggestion of sky or other outer

spaces: see *1967 (Torcello 1)* or *1967 (Patmos monastery)* [plates 341 and 342]. Columns and arches fascinated BN, forms that repeat yet to his eye were never quite the same twice, because they truly are not identical or because his angle of view was not the same or there was some other form nearby that (as Cézanne had taught before Einstein) would affect our reception of both. Omit; don't explain. The result looks wholly spontaneous – the bird swoops over the terrace into the tree – yet this result is achieved by trial and error, with the errors becoming fewer as the artist's skill and cunning firmed up into self-reliance and self-knowledge. In 1969 BN wrote:

In some moods one cannot put a foot right and in others not a foot wrong. Those line drawings of mine are made with great ease and after years of experience I know the signs of when I can make them and when I can't! It's not the drawing that is difficult but finding and recognising the mood.[14]

Yet there was a lot of repeated drawing of the same motif, and a lot of discarding. In his finest, most mature drawings – they start in the 1920s – the feeling we get is that the line

The 1960s

The 1960s

**343**
*1965 (storm over Paros).*
Etching, 27.9 × 32.3 cm
Edition of 50

**344**
*1967 (St Ives
from Trezion).*
Etching, 17.5 × 29 cm
Edition of 50.
This example hand-
coloured by the artist

itself, a sentient force, has that very moment discovered the form it is to enact and its exact placing. And this sentient force is miraculously at one with its source, the artist. The line knows what BN wants; it has built up its own experience, it has rehearsed a generous repertoire of movements. In 1964, when I visited him in his house above Lago Maggiore, he showed me with pleasure, and then gave me, a large, high-quality photograph of a drawing. He obviously valued the photograph for its tonal richness, above all for the way in which, thanks to raking light, it shows the many imprinted lines left by previous drawings done on the same pad of fine paper. The pencil lines, of leaves in a mug, are echoed and countered by ghostly lines belonging to still lifes drawn before this one – mostly goblets – but they are all kin and mingle cheerfully, without conflict.

BN's prints, whether drypoints or etchings, are in many ways close in character to his drawings. Whether on paper or on the printing plate, he inscribes lines with a point, and these lines look final, the product of reflection as much as of looking, and are left unmodified by adjustments or additions.

Except for a rare special effect, he does not use his pencil to make scribbled patches of tone, and in printmaking he uses tone rarely as an element in his composition, though he will sometimes let tone develop on the plate in the etching process, as in *1965 (storm over Paros)* and *1967 (St Ives from Trezion)* [plates 343 and 344]. He enjoyed making some of these prints into what he called 'mixed media' works by adding small areas of colour to them. So evidently are these added that they feel like collage and their effect can be both attractive visually and disturbing conceptually since the colour works against the idiomatic coherence of the print.

One of the consequences of introducing tone into the print or adding colour is that it makes the white of the paper a positive factor in the work. So it is also with the shapes of these prints. The non-rectangular format of so many of them gives point to what Lafranca tells us about BN marking up the copper sheets for cutting; another artist would have ordered plates of a standard format and size. The effect of it is to emphasize that a print too is an image, like the post-Post-Impressionist kind of painting defined by Maurice Denis

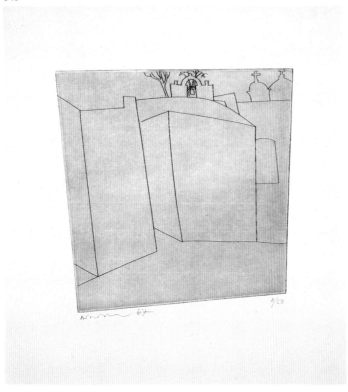

**345**
*1967 (Paros 2)*.
Etching, 26.2 × 26.2 cm
Edition of 50

in 1890 in his much-quoted statement, 'Remember that a picture – before being a war horse, a nude woman or some anecdote – is essentially a flat surface covered with colours arranged in a certain order.' The non-rectangular object resists our habit of reading it as a window frame through which we look into a picture space; it asserts the object made of paper, ink, lines, with added tone and colour in this case. Cubism had given Denis's words dramatic power through its success in confusing the picture space, just as it brought confusion but also a sense of novel objects in its treatment of still life and sometimes figures, fragmenting them and denaturing the fragments, and leaving us uncertain whether we are looking at solids or at dissolving planes. Collage added the message that the image, complex or simple, was something assembled on the paper and the canvas. BN's added tone and colour announce themselves as additions, his red particularly lying on the surface. Alfred Wallis's rough supports, the bits of carton or board he liked using for his pictures, made the same statement with the certainty of innocence. Part of the magic of BN's drawings

and prints lies in his ability to persuade us of both, the reality of the object he has made and the presence and the appeal of what he has pictured for us. This balanced duality, picture-object and image-power, is very rare but it would be misleading to claim uniqueness on BN's behalf. It is found, for instance, in Matisse's graphic work, almost exclusively devoted to heads and bodies. In BN's case we have images almost exclusively of buildings, places and still lifes, with or without elements of landscape. These are one broad category for him and in this, and in maintaining this balance in it, he is unique.

It has already been suggested that BN was able to use architectural or perhaps, better, carved forms in the same way as he used still life. I have spoken of his reliefs as developing from his experience, first of still life and then, in the 1960s, of landscape. For the present that distinction seems to hold: we find in his work two different sorts of scale and space, and when he brings them together, as in his still life plus landscape pictures – paintings, drawings and prints – it is for the sake of that contrast. At times he almost

**346**
*1967, August
(Aegean 2).*
Etching, 18.5 × 30.3 cm
Edition of 50

fuses the two. In *Torcello 1* the foreground objects, capital and well, recall the mugs and jugs often found in front of his landscapes. In *1967 (Paros 2)* [plate 345] the exceptionally bare lines of the buildings could easily belong to still-life objects: try covering that little skyline of chimneys, domes and trees and see what is left. The still lifes among these prints thus do not announce a wholly separate pursuit. Take the print of August 1967 called *Aegen* (which name may just have been a mistake) and also *Aegean 2* [plate 346]. It shows two glasses. A convoluted, extended squiggle suggests the outdoors – clouds or smoke if not exactly landscape; it is the placing of it across the top of the image that gives it what meaning it has, not its form. But the print also shows other forms. The glass on the right generates a curved line that springs from its fluting to swing across the surface, almost to the top. Another line swoops on a parallel path across much of the image; it seems to come from an almost rectangular outline the top of which is also the top of the glass on the left. Does that outline represent another object? In the middle we discover a jug, the source of yet

another curved line that loops back towards itself in the right half of the print; the jug seems to be on a larger scale, but then jugs are larger than glasses. The almost vertical line that is the left side of the jug is met at top and bottom by lines that may refer to a handle and go off the left edge of the print (all other lines stay within the plate, so that we feel the image is generated on to the plate from the left). If we focus on that almost vertical line and the lines going right and left from it we are suddenly back with the houses of *Paros*, just as the glasses themselves remind us of the columns, sundials, 'Turkish forms' and other objects we see in other prints of the period.

In drawings too we see a crossing of the slight barrier – small objects = still life, large = buildings; or: vertical lines = still life or buildings (man-made), horizontal lines = landscape and open space – that remains in what he persuades us is in the end one category for him. In the 1960s BN achieved unparalleled fluency in putting exact lines on paper. *1962, June (Palladio)* [plate 334] is an outstanding example of his drawing selectively in direct contact with the motif. His

347

**347**

*1965 (Tuscan church portico)*.
Etching, 25 × 19.3 cm
No edition (?)
This example
heightened in ink
by the artist

still-life drawings of the decade show him achieving a comparable facility combined with inventiveness. They are, in effect, impromptus on the theme of his real-life objects, performed with care but out of immediate invention. The musical analogy is supported by the impression that the large paintings I call polyphonic, of the early to middle 1950s – such as *1953, February (contrapuntal)* and *1953, August 11 (meridian)* – may have stimulated this particular exercise, as well as the large drawing on board, *1953, July (Cyclades)* [plates 253, 254 and 256]. In them he drew vases, goblets and other such things as though he was discovering them in taking his lines across the support, in straight lines and in great, swinging curves: they seem produced by the lines rather than envisaged and then executed. In drawings of the 1960s, on a smaller scale and thus perhaps with a feeling of greater intimacy, the process becomes even bolder. The lines move freely across the paper, meeting and diverging in what afterwards seems inevitable correctness, while somehow weaving a still life, sometimes with a landscape setting, as though by happy accident.

All this is indeed separate from BN's work on the large reliefs. Not the activity: there is no need to see inscribing lines as wholly different from cutting edges, or adding washes or printed tones as discrepant from carving into and texturing boards. The physical reach is different, and with that comes also some difference in the satisfactions to be found. The graphic work is best seen as a complementary pursuit, requiring a different kind of relationship between artist and object. In an essay on BN's drawings Maurice de Sausmarez makes a telling distinction between the drawings which are 'the result of an intensely felt reaction to a visual experience' (he refers to landscape drawings of 1959 and a nude of 1951) and those resulting from 'a sort of sustained constructive meditation, where the shapes, dimensions and intervals are like musical "inventions"' (referring to two still-life drawings).[15] This brings us close to the heart of things. In the former process the artist is working from the motif, his seeing and his other sensory/emotional experience of it. In the latter, he is inventing his motif out of his mental store of known forms and his knowledge of line as an extension of

**348**
*1967 (Turkish
sundial between
two Turkish forms).*
Etching, 25.3 × 35 cm
Edition of 50

his eye and hand. He is improvising at the keyboard of an instrument that is very nearly himself. This second process is, clearly, constructive, whereas the first is deconstructive or analytical. Yet in both we find an element of distillation. One line stands for a host of detail, for changes of colour or tone, for the difference between solid form and space. Many another artist shows how easy it is to let a practised process run away with itself, like the game of an over-excited child. We know that BN spent long periods getting to know the sights that became the motifs of his drawings of the first sort. No one has said how he made his constructive drawings; instinct suggests that he paused long before starting and then drew steadily, without haste, without much hesitation, letting one line suggest another. Added washes might well come long after, but often a ground wash was there first, before either kind of drawing, adding an impulse of its own. (Washes and other additions were almost always in oil paints, never watercolours. Occasionally he used chalks.)

An underlying similarity links the two sorts, and this

resides in BN's personal need to limit himself and leave the image breathing freely. He leaves out so much that we forget to notice how much he limits himself, both in what he selects to draw and in his selective way of drawing it. He entered a world in which drawings were admired for other qualities. When BN was still a toddler, about 1897, Professor Henry Tonks, the severe and high-minded teacher of drawing at the Slade, called one of his students the greatest draughtsman since Michelangelo. That student was Augustus John.[16] John's chief fame, over the decades that followed, was indeed that of Britain's draughtsman-genius. We would now say that he was much less than this, but certainly a good, sometimes delightful draughtsman who had benefited from Tonks's campaign to bring simplification and discipline into drawing after all the smudging and stippling enjoyed by the Victorians and often used to disguise graphic weaknesses. But even John's best drawings rely for their appeal on charming subjects – graceful women, bonny children – and a multitude of pencil or charcoal lines, hinting at a form more often than stating it and usually accompanied by much

hatching and other annotating. William Nicholson in 1899-1900 used a wealth of Victorian graphic tricks to produce a series of 23 drawings of characters from English fiction of the eighteenth and nineteenth centuries, aiming at a period flavour for each; sixteen of them were published in 1900 as a book of lithographic reproductions, *Characters of Romance*. These are drawings of a sort furthest removed from BN's; probably he knew them and abhorred them though he may have admired his father's verve in doing them at all. William's woodcuts, on the other hand, had depended very directly on a process of omission. William was also capable of a much simpler and more essentialist kind of drawing, as he demonstrated in the early or middle 1920s. His *Book of Blokes*, published in 1929, 'began as funny drawings for Nicholson's daughter Liza (known as Penny) by his second marriage. She used to sit on his bed in the mornings at Sutton Veny and watch him doing them.' He apparently went on doing them into the 1930s. They are pure line sketches, jokey things in which he caught very cleverly a number of types of faces and expressions and set them down in lines

which in themselves are jokes about how lines can be made to represent things, while the things represented come out as light caricatures. He kept a supply of the little books by him and gave them away to friends over several years.[17] Perhaps BN had one; he must certainly have seen them. Even so, his way of drawing was very different.

There is of course a basic punning process in all pictorial representation, from the most naturalistic to the abstracted. We agree in early childhood to accept images of many diverse sorts unhesitatingly as representing objects in the real world although the correspondence is ludicrously slight. We enter into a kind of complicity. No line, no patch of colour ever really looks like a war horse or a nude woman or the cloisters of a monastery on Patmos. Our reward is in part the pleasure we get in making leaps of recognition; mostly it comes from the paraphrase itself, the way it is managed, the echoes it strikes on our memory store of other images. In this sense BN inherited his father's verbal and visual wit on top of every artist's inheritance of the basic punning process; he did not have or use William's gift for caricature. By the end of

**351**
*1968 (jug, sexagonal).*
Pen and wash on
paper in relief,
50.9 × 45.4 cm
Bernard Jacobson
Gallery

the 1920s he had evolved a graphic language out of testing various possibilities, a punning system that was essentially his own and is unmistakable.

All BN's work signals awareness of this artistic dilemma, of having to be coherent yet also free, sensible and irrational. His work was not an investigation of it, yet he sometimes seems to be testing its limits. Take two drawings of 1968, *relief with half goblet* and *jug, sexagonal* [plates 349 and 351]. 'Sexagonal' is a verbal joke. (BN used to tell how he had named one drawing *cockatoo*, and another *cockathree*, and been told off by an art critic for not being serious.) But I am speaking here of oblique visual connections. The two 'half goblets' in *relief with half goblet* are just two exact lines, drawn simply with infinite know-how on the back of part of a copper-plate-embossed sheet. The indentation made by the plate now projects towards us and gives BN a relief surface. He draws part of one goblet as though the rest of it were hidden behind that projecting rectangle, implying that the rectangle has mass and that there is space behind it. On it we see somewhat more of a second goblet, a different

goblet but drawn just as barely, and this is cut off too, this time by the scissored edge of the paper. Were the drawing framed to that edge we could pretend to ourselves that the goblet continues behind and beyond it. But we see the edge and it speaks of paper and flatness and denies space and objects. Below the goblets is a delicate, wavy line which tells us more or less nothing but activates that part of the surface. A delicate oil wash adds tone and a hint of colour, but unevenly. A pale area below the rectangle suggests a table; a darker band between that and the rectangle lifts it and gives it a shadow. The left, very incomplete goblet and the wavy line hover without support. As experience – the experience we can guess at of making it, and the experience of looking at it – this drawing is almost wholly different from the other, *jug, sexagonal*. This is one of his improvised inventions, with lines from from various still-life objects coursing past and over each other with apparent freedom yet forming a fine, central, spiralling structure. The beak of the jug, where three lines meet with perfect aplomb, proves the artist's control, as do other, lesser conjunctions. Two little lines make a horizon

on the far edge of a table. Four sharp black accents both pin the structure down and keep it spiralling. A pale warm wash occupies much of the surface but is partnered by an even paler cool, greyish wash top and bottom. The wash continues on to the larger sheet on which the drawing is mounted.

Both drawings are still lifes and use much the same kind of objects. The lines in both are clean, clear and classical. If there is emotion it is not in the line itself but in what it does. It is not in the objects; they matter, being the artist's familiars, yet they are used as mere pretexts for limited but rich creative acts. The question of how like the drawings are to the things they refer us to simply does not arise; we are too involved in the performance to ask it. Here would seem to be the nub of the difference de Sausmarez discerned between the drawings rooted in a 'reaction to visual experience' and those he described as 'sustained constructive meditation' and likened to 'musical "inventions"'. There is an element of performance in the latter and, fast or slow, they recall the boy who was world diabolo champion and beat everyone at tennis; with the former we get a sense of BN responding

to a drama enacted for him by the buildings, landscapes, leaves or whatever, under particular conditions of light via particular spaces, witnessed and marvelled at by the child in the mature artist.

Manfred Fath, writing about BN's etchings, states that they are wholly distinct from the grander works of the same years, the large reliefs.[18] There has to be self-evident truth in that; no need to list the differences. Yet it invites, if not contradiction then contradistinctions. The large reliefs project. Each etching is a negative relief and BN's frequent use of odd shapes reminds us of that. When he adds colour he seems to be adding an element of positive relief, especially when it is a membrane of solid colour. In the 'simpler' etchings, such as *Paros 2*, we get the sense of lines as the edges of planes working with and against each other as in, say, *1966 (Zennor Quoit 2)* [plates 345 and 354]. When the reliefs and the prints refer us to standing stones, sundials or 'Turkish forms' they are presenting forms in essentially similar ways. But the new reliefs manifest a traveller's space-and-time whereas the prints and drawings present space as

it is for the stationary observer – not of course the distilled, objective space perspective systems can construct, but something more symbiotic, formed by the artist's feelings about the subject and the act of drawing.

It is striking, and typical of BN, that he should have bent the accepted rules of printmaking in producing many of his etchings, not only in the irregularity of his plates but also in his enjoyment and use of chance effects. Some plates he appears to have etched lightly to obtain a darker image, as in *1965 (storm over Paros)* and in *1967 (St Ives from Trezion)* [plates 343 and 344]. In some instances he added positive colour or soft oil washes; there his intention and process are not fundamentally different from his adjusting of the surfaces of his boards with colour and texture. I suggested above that the etchings are essentially complementary to the reliefs. There is the difference of size and of material, remembering BN's habit of not disguising wholly the character and colour of boards or of paper. And there is the difference of technique. The way he uses the etching tool is not very different from his use of pencils but of course he can make

lines of many different sorts. Cutting boards and cutting into boards are techniques of another order altogether, empowering the artist to do some things and prohibiting others. Here too BN's economical ways dominate, so that a board and its cut edges and perhaps a shape cut into it can feel quite similar to lines printed or drawn on to paper, the white or washed surface between them becoming a positive surface or a space just as the boards become positive and negative forms, objects and spaces. But size and material weight and presence bring with them another difference: the etchings are not only chamber music in comparison with the orchestral and sometimes symphonic compositions which are the reliefs, but also these are, in Aristotle's sense, tragic: complete in themselves and of a certain magnitude and weight, whereas the etchings are, in the same sense, comedies.

*1966 (Erymanthos)* [plate 353] is not one of the largest reliefs of this period but one of the most impressive. There is a greyish-brownish background, mid-toned and mottled, in front of which hovers an adjusted rectangle. It has straight

The 1960s

sides right and left, slanting slightly on BN's familiar off-vertical axis, and longer convex sides top and bottom. The upper and lower areas of this are coloured, not brightly but glowingly: turquoise above, Indian red below. Between these two bands, which suggest landscape, move three roughly rectangular forms, all with straight sides whose sharpness is underlined by the softness of the rest. They start and finish on the 'vertical' edges right and left, and seem to press across, left to right, the first two rising more sharply, the last falling back and diminishing that energy. A recessed circle in the left form is gently echoed by an inscribed circular line in the second; the first is low and feels heavy, the second high, floating upwards. Between the two is not a change of level but a deeply inscribed furrow. These cut lines, including the inner edge of the recessed circle, are picked out with cream paint to make them slightly luminous. The form on the right is featureless and smaller, and physically as well as perceptually set well back. There would still seem to be a large distance between it and the horizontal bands above and below, but in fact this is a hairsbreadth only; the forms

are firm and relatively bright although a vague light brown.

The backboard of *1966 (Zennor Quoit 2)* [plate 354] is one surface though unevenly painted, a negative field for the relief. That again has a main subject, the three (or three-and-a-bit) brown forms making a left-to-right sequence across this exceptionally extensive panorama. They grow in size and step forward, or seem to: the central form and its neighbour on the right are on the same plane; it is the placing of the latter plus an incised line that make us assume it projects further forward. The 'bit' form to the right is set well back and ambiguously belongs both to the main subject and to the background. Between the subject and the ground falls not a shadow but an area of light and cold, in fact two strips, above and below, all on one level. They add to the sense of progress and projection, and so does a change in brown, from darker to lighter, in part of the background. A rectangle of blue well to the right of centre adds further to the thrust while also controlling it; it is recessed yet seems at times to float in front of its brown field. *Zennor Quoit 2* is large but seems even larger, so powerful is its relatively simple

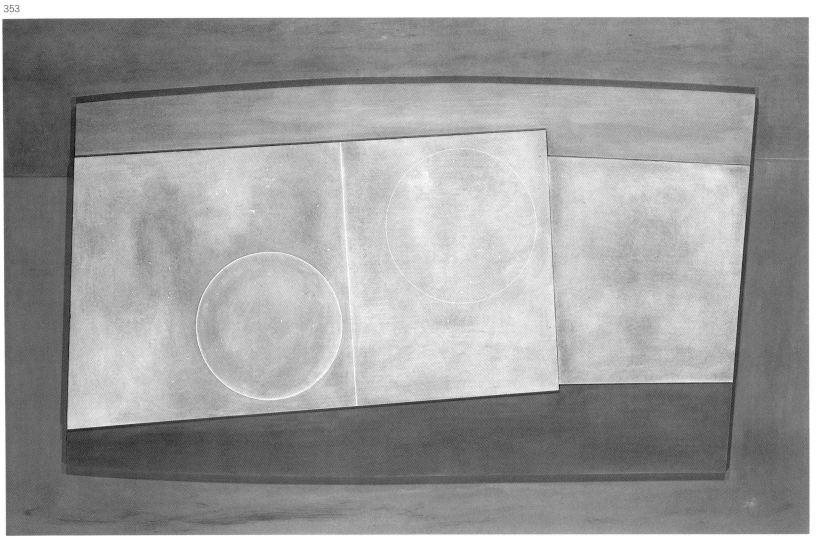

The 1960s

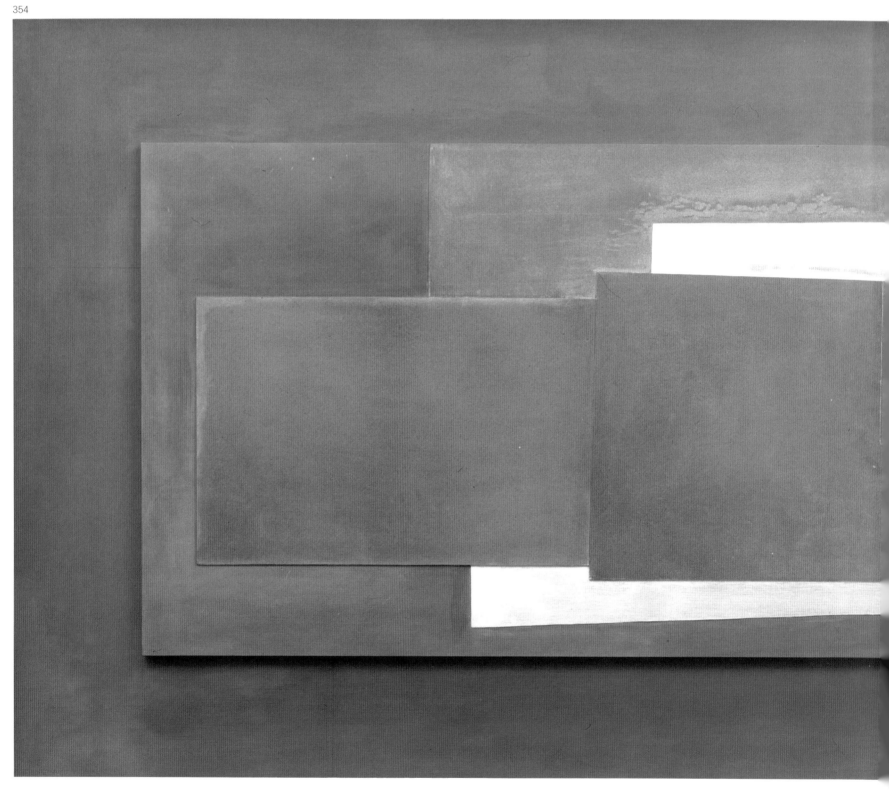

**354**
*1966 (Zennor Quoit 2).*
Oil on carved board,
118.1 × 264 cm
The Phillips Collection,
Washington

The 1960s

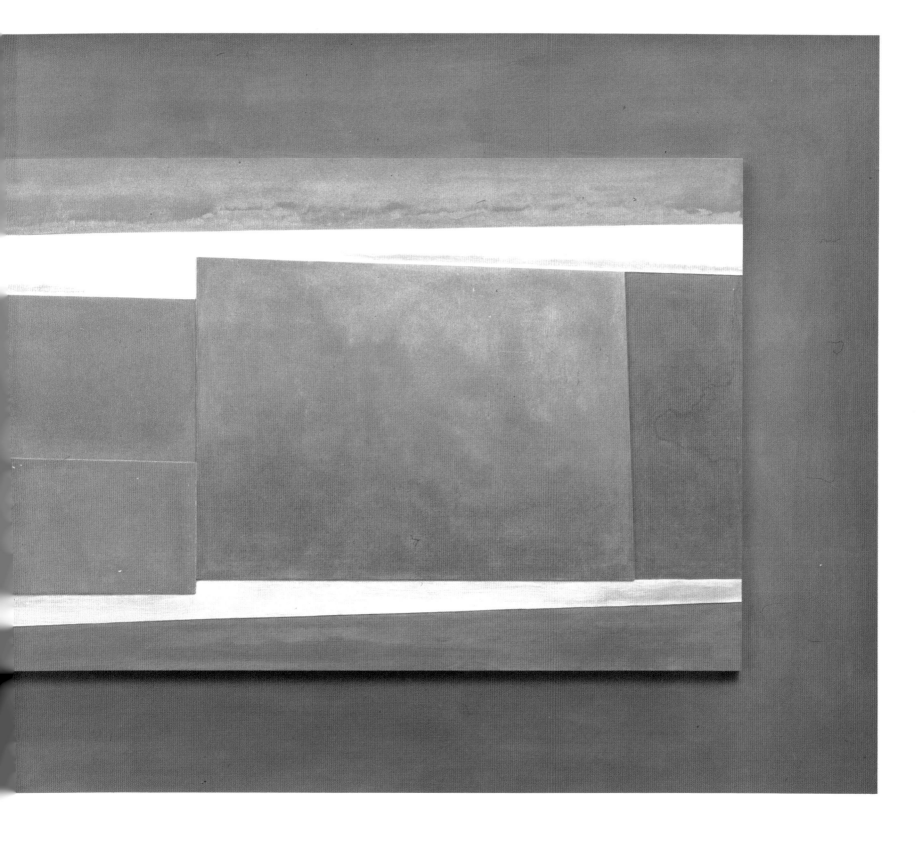

**355**
*1966 (Carnac,
red and brown).*
Oil on carved board,
101.5 × 206 cm
Private collection

and legible arrangement. Nothing in it is curved, and what mottling or other breaking of the surface we can find is very restrained, a slight variation in a surface rather than a disturbance of it.

The more remarkable, therefore, to find so richly worked a relief as *1966 (Carnac, red and brown)* [plate 355] done about the same time. 'Carnac' suggests the standing stones. Its action resides more in effects and implications of colours, stains and marks, than in the relief as such though that has its own complexities and warrants analysis. At first glance we seem to have one of BN's unfolding double forms; at second glance we know that there is not one vertical break between them but two, staggered, and these counteract the sense of unfolding. In the middle four colour areas meet, or nearly so: red and brown, as stated in the title, and also black and white. The black is mottled brown-black. The white is relatively solid where it approaches the other colours but is punished for it by an area of erosion right through to the board: one thinks of snow swept or blown away and revealing naked earth. A rectangle to the right, higher and

thus hovering in front of the rest rather like the nearly square form in *Argos*, has been firmly scraped and rubbed to reveal the grain of the board; the result looks like a stain in its flustered white-and-brown surface. The much larger L-shaped brown form on the left looks roughly abraded in its lower left area, with touches of white showing in the hollows, as though the snow had been blown from the rest; this effect was achieved by brushing creamy paint on to the board and rubbing most of it off in many places. Close to its geometrical centre is a dark mark that looks like and perhaps is a burn. Behind these forward planes is a background board that is a range of browns – purplish here, clearer brown there, with a hint of white like mould in one place – and, along the top, a very pale violet strip. The whole work is very powerful. The unusually dramatic treatment of its surfaces reflects BN's interest in the work of Alberto Burri, who had served as a medical officer in North Africa during 1940-3 and became an artist after the war; his work was shown in 1964 and 1965 by the Marlborough galleries in London and New York and was seen and praised internationally about that time. Burri's

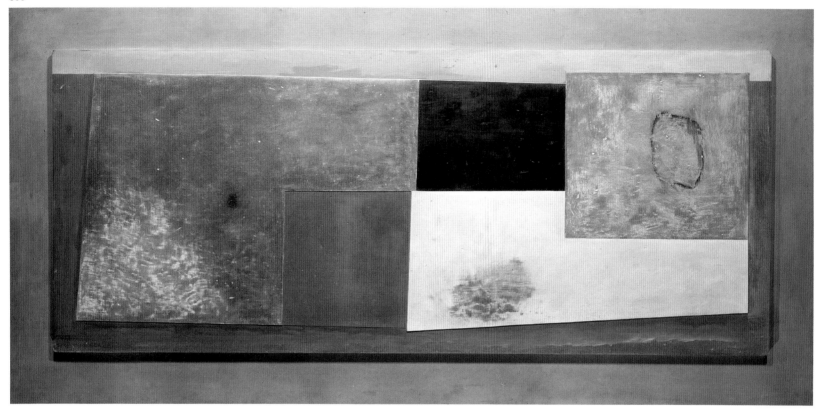

**356**
*1965 (Greek island).*
Oil on carved board,
97 × 192.5 cm
Private collection

The 1960s

357

**357**
*1966 (Ios)*.
Oil on carved board,
153.5 × 207.8 cm
Private collection

**358**
*1965 (Capraia)*.
Oil on carved board,
234 × 174 cm
Boymans-van
Beuningen Museum,
Rotterdam

reds and blacks, his torn sacking and shattered planes of iron, speak of acts of war: torn flesh and torn clothing, shelled tanks and shelters, blood and fire and the efforts with limited medical means to undo them. This is not BN's message. *Carnac, red and brown* is about man in nature; it speaks of earth and weather and light. The red is a deep terracotta, nature processed by man, and its clear form suggests mankind's action. The brown-black rectangle, again human work, is black rubbed back to brown, eroded rather than attacked. The tone is affirmative.

BN rarely spoke of the subject-matter of his work, perhaps because it was the activity of making art that mattered to him, not the visual impulses behind it nor the specific references he sometimes incorporated in it. These were for him matters of surface rather than core, and they were likely to get too much attention from the critics and the public. To confirm in words any current interest in some part of the visible world, or alternatively to label himself an abstract artist, would be to limit his future and to constrict possible readings of what he had already done. We, looking

at what has still to be a selection of his work (until we can know all his work in every medium in, at least, reproduction), must not label him and his work, remembering how in the 1930s he seemed to have committed himself to making nothing but white abstract reliefs when in fact he was also working on still lifes. None the less, in the 1960s he gave so much of his time to reliefs that were exceptionally economical as well as strong in the forms and planes in which he disposed his boards, and also in the colour, tones and textures he added to them, that it seems reasonable to see those years as a period of relatively austere and monumental reliefs. His subtitles of the time mostly refer to landscape. Frequently they refer to the standing stones with which humankind asserted itself in the face of nature; in these instances, as well as in many others, they indicate locations away from the Ticino and link with old memories as well as recent travel. The period includes some very delicate pieces, but from about 1963 to the end of the decade his work gave priority to the physical experience of nature, and to man-in-nature, in terms of stone. One is tempted to

The 1960s

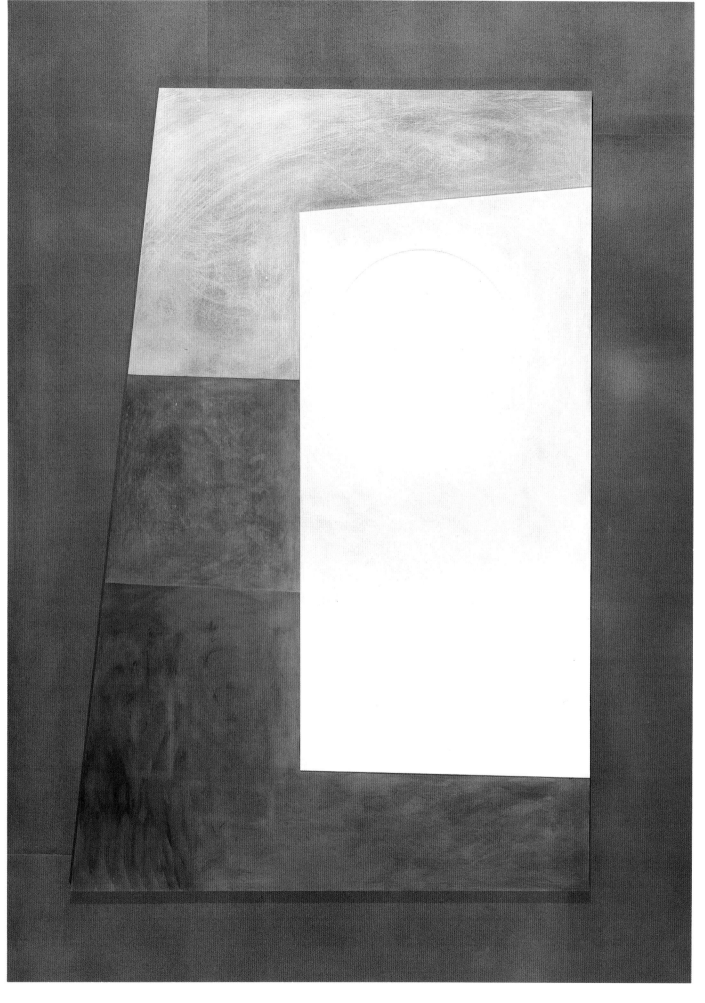

The 1960s

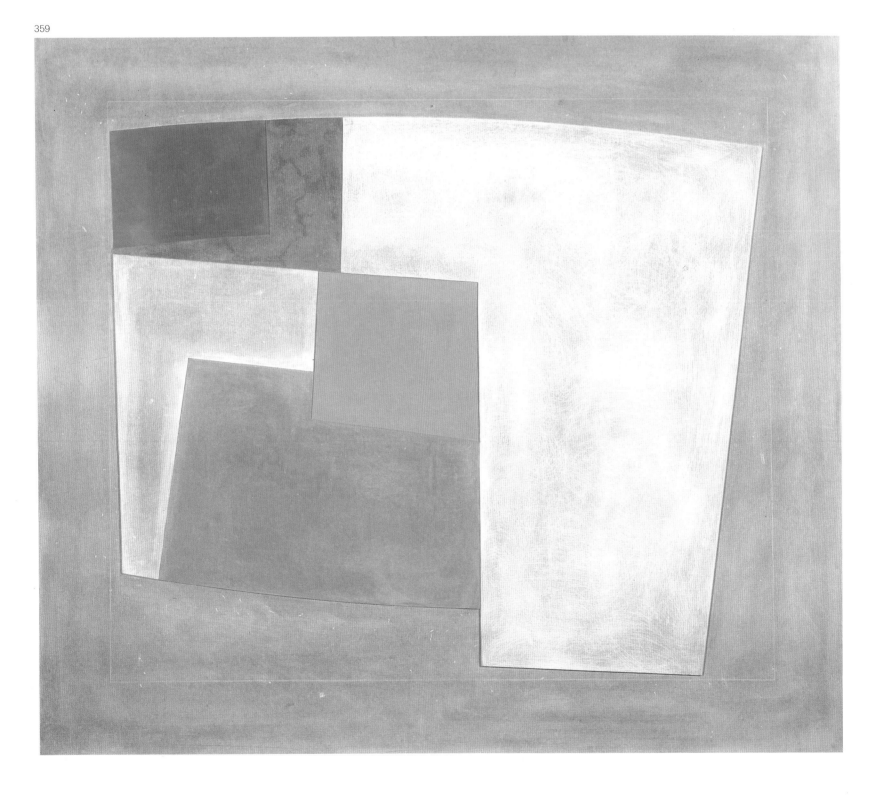

The 1960s

**359**
*1967 (Tuscan relief).*
Oil on carved board,
148 × 161 cm
Tate Gallery, London

**360**
*1968, January 1
(smooth pebble).*
Oil on carved board,
64 × 60 cm
Bernard Jacobson
Gallery

suggest that his reliefs of this time belong together as one group, like the white reliefs of the 1930s, but that is probably not how they seemed to him and the only benefit for us in doing so comes from distinguishing between examples within the group. The differences between *Zennor Quoit 2* or *Carnac, red and brown* are many, and there are further differences between these two and *1966 (greystone)* [plate 364]. The chief of these is disguised in reproduction: size. *Greystone* is much smaller than the others and, for all its firm design, is quite delicate in character with its fine shifts between whitish grey and greyish white. Yet the form is very strong, suggesting a standing stone, possibly the stone with a hole carved through, the Men-an-Tol in Cornwall. Barbara Hepworth had adopted the image of the holed stone in 1931 when she carved *Pierced Form*, a small work in alabaster.[19] A pencil line in *greystone* joins a change of tone and level across the top of the relief to suggest landscape space and setting.

In *1967 (Tuscan relief)* [plate 359] we again seem to see humanity and nature together. The strong blue form in the

middle can be water or sky but the almost black, almost rectangular form top left, settled against a marbled brown, suggests man's contribution. For the rest, air, space, light, and a sense of speed given principally by the sloping edge on the right and the shallow curve that is the top of the relief, pulling its several elements together. As in other examples, we find that the central blue form is recessed rather than projecting, in order to restrain its positive voice. Another closely toned work, like *greystone*, is among BN's 1968 productions: *silver relief* [plate 362]. There is more contrast here, though. The white-and-silvery forms are set against brown-grey-greenish tones on two levels. There is a clear movement from left to right, set off by the general horizontality of the elements, the direction suggested by some of the edges, the sharp corner bottom right and, most of all, the flat curve embracing the two innermost forms, one a broken white, the other a warm greyish white that seems to fly over the others. It is striking that the recessed circle in this form does not, in our reading, connect with the white form that we assume lies behind it. Were this an all-white relief we would ask ourselves whether

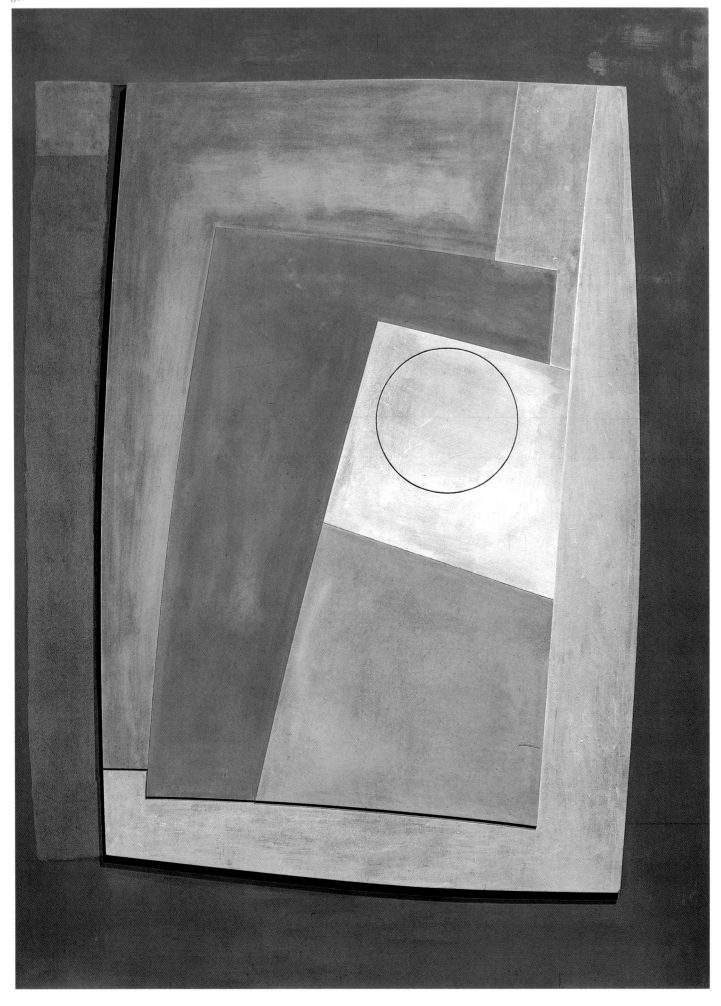

The 1960s

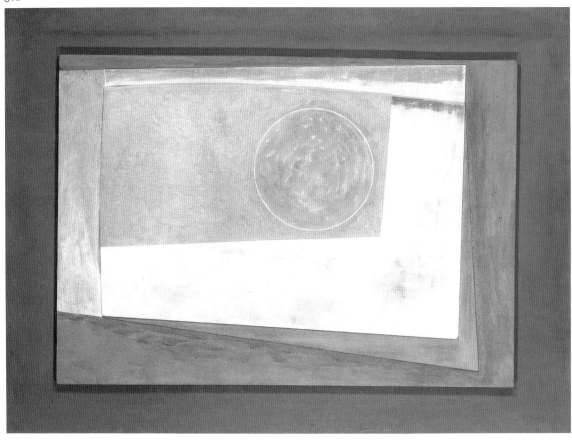

**361**
*1969 (Carnac no.1)*.
Oil and pencil on
carved board,
201.3 × 149.9 cm
Tate Gallery, London
(gift of the artist, 1970)

**362**
*1968 (silver relief)*.
Oil on carved board,
99 × 129.5 cm
Waddington Galleries

The 1960s

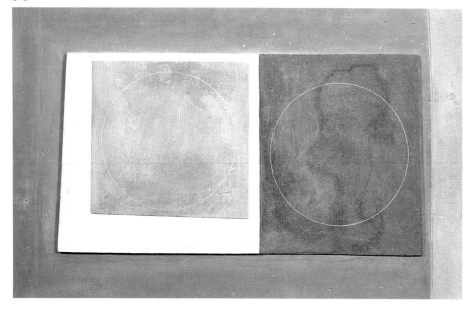

**363**
*1970 (Alfios 2).*
Oil on carved board,
32.5 × 56 cm
Private collection

**364**
*1966 (greystone).*
Oil and pencil on
carved board,
56.5 × 43.9 cm
Southampton City
Art Gallery

The 1960s

**365**
*1966 (Altamira 2)*.
Oil and pencil on
canvas, 100 × 146 cm
Collection of the Columbia
Broadcasting System, Inc.,
New York

the circle penetrated to, perhaps beyond, the white plane behind it. Here it is identified with the form into which it is cut, even though touches of white distinguish it a little. None of the surfaces in this work presents a firm, opaque appearance; everything appears evanescent and some of the planes look almost transparent. We seem to be looking away from Earth into another world – and soon this is to become the dominant theme of BN's work in reliefs.

Not long before, he was painting and drawing *1966 (Altamira 2)* [plate 365], a spacious, frieze-like work that seems to be a still life. Large and smaller forms, in most cases little more than outlines, present goblets and glasses of various sorts. Even the almost square patch of terracotta, left of centre, seems to want to turn into a useful object. Charcoal-black shadow forms in the right half have interesting positive shapes. Top right a patch of terracotta draws our attention to the perceptual but not material fact that most of the painting is on a plane in front of the full canvas and casts a shadow on it near the top. Another dark and interesting shape by the left edge of the painting

appears to be the hind leg of a quadruped and brings us back to the subtitle *Altamira*. Presumably all these forms came out of BN's memory in interaction with the work as it proceeded, and one wonders whether the hind leg too came into his mind or whether it was seen by him in a reproduction and pressed for inclusion, as another category of still life and perhaps a touch of humour. Though quite dramatic in the way its forms are staged, this has always seemed one of BN's blithest works, its orange-red and gentler hints of warm colour energetically partnered by a good quantity of cool hues. The BN of the 1960s is plainly a master, in command of enormous resources which he employs with continuing economy while also dazzling us with the wide range of experience he reconstructs for himself and communicates to us.

One of the most remarkable, as well as largest, of the reliefs of the late 1960s is *1968 (Delos 2)* [plate 367]. This is a vertical composition, strongly built and at the same time soft and mobile. Whitened forms occupy the lower two-thirds, dark forms and an area of blue the top third. This disposition

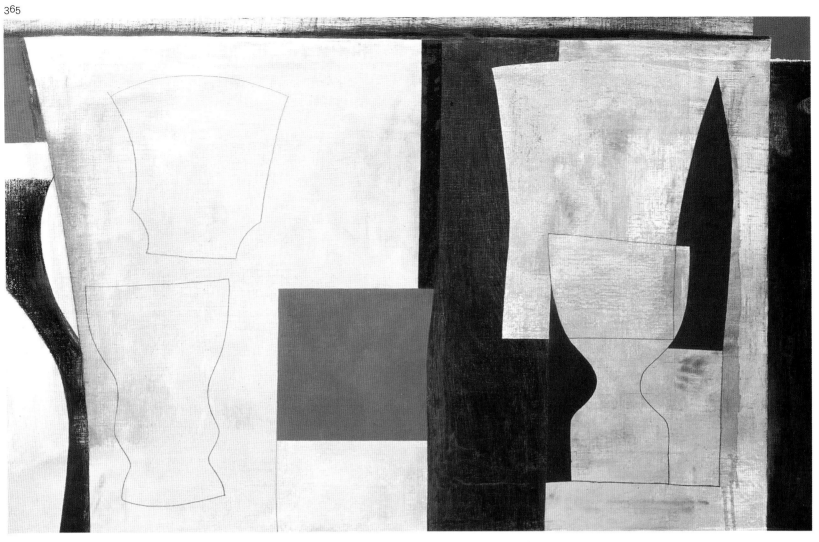

The 1960s

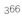

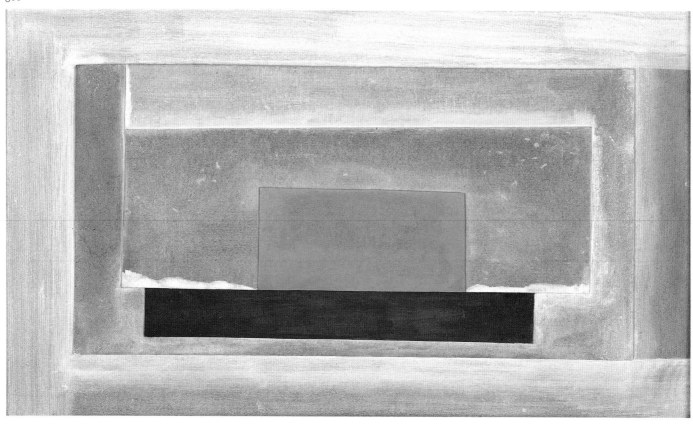

**366**
*1969 (Locmariaquer).*
Oil on carved board,
29.5 × 50.5 cm
Private collection

**367**
*1968 (Delos 2).*
Oil on carved board,
203 × 117 cm
Private collection

The 1960s

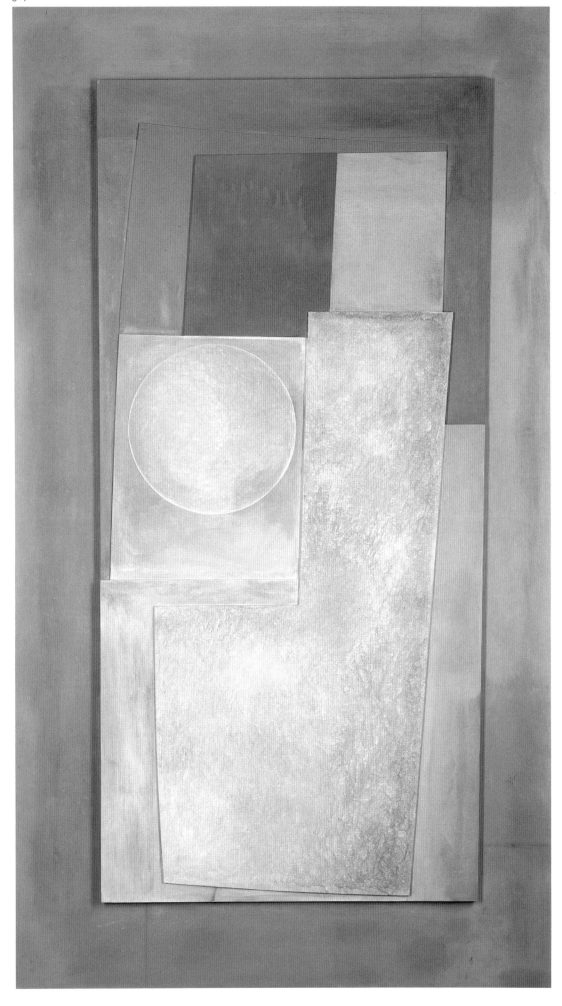

The 1960s

of tone makes for lightness and a sense of rising forms, and this is enhanced by the curved edge at the bottom of the most prominent of the relief elements, a broad L-shape that seems to rock slightly as though detaching itself from its base. A smaller horizontal relief, *1969 (Locmariaquer)* [plate 366], announces itself as more earthbound, consisting as it does of several emphatically horizontal rectangles. The subtitle refers us to the little port on the south coast of Brittany with its famous dolmen. The sea appears in the relief in the recessed area of broken blue, and also, to powerful effect, in the two soft areas of white either side of it that seem to foam like the ocean itself.

In 1969 *The Listener* published a poem by Geoffrey Grigson entitled 'A Painter of Our Day', written the previous year. The painter is not named but is certainly BN. The poem recalls a visit made by the poet in 1967 to BN at Brissago, their looking at work, and talking 'in the long room floating/Above the lake'. I quote the first, third and last of the poem's five stanzas:[20]

He teaches me what is: never nostalgia,
Yet never contempt for what has been composed.
With 'strangle the swan' I sympathise:
He would not paint a swan or a rose.
I would not write them. He says, don't disregard
The single swan drawing a glittering circumflex
Along your river avenue: look – *Allons*
*Voir si la rose?* – no, but into
Its packed centre. Recognising there much
Old reiterated wisdom of perceiving?
No, seeing what you see: what is.
...

This my old friend teaches me. I say, I see
This, that, in your abstract pictures, he says
Not quite no. I say, This blue space is that small
Window in your studio or is Atlantic Penwith
Blue, through a dolmen. Slightly he shrugs away.
I say, The title says. He says, I find the titles
Afterwards. Titles are difficult: suggest a title
For this picture here. Children need names,
I must reflect, and I am taught again to accept
What is;.also, that always each wonderful realm
He makes and the immense realm each other penetrate.

...

Last year you threw a ball, loving its line of
Sheer, rebounding curves, in light,
You spoke in the long room floating
Above the lake of Raphael, Giorgione, Tobey,
Braque, Cézanne, of blue, and of discovery, and
Of the power of lasting like Cézanne, in art,
To the extreme end: with age combining
Unimaginable Giorgione's youth I watched you,
Watched your pictures (in which stronger innocence
For the organised above all accidents survives),
Heard you, in your centre again, saddened
By leaving you and by your physical age,
And by the snow and sleet after your sunshine
Round the Alpine train.
                    Then days, days after
Were irradiated round me by your truth.

The award of the Order of Merit in 1968, the publication of the large and handsome John Russell book (with a short and light essay that BN is likely to have preferred to almost everything written about him) and the extensive Tate Gallery retrospective in 1969 involved visits to England and brought new and renewed contacts there. At the same time these events stimulated public interest in BN and his work, dimmed by his long absence. He was in London in June 1969, doing his best to evade the celebrations that others set up for the book and the exhibition, and he and Felicitas spent an evening with Winifred in London, presumably at her flat in Kathleen Raine's house in Paulton Square. In a letter that must have been written not long after, answering BN, she wrote: 'That is splendid that you think of coming to Hampstead.' He had lived there briefly in his childhood, close to the Heath, and again in the 1930s with Barbara Hepworth, and it seems that he felt drawn back there. It is striking also that St Ives features among his etchings of the 1960s. Cornwall must have seemed far away and long ago, yet *1967 (St Ives from Trezion)* [plate 344] is a vivid account of how the place looked from the house he had left in 1958. Perhaps it was time to return home, to a less commanding landscape than that of Lago Maggiore and to a social circle at once much wider and including many intimate friends. It would certainly be good to be speaking English again with people who could appreciate his deft turn of phrase and frequent humour. He had had family visitors in Brissago but those occasions were infrequent and not always easy.

Felicitas did not want to live in England. Her professional life as photographer, which BN had warmly encouraged, was important to her and called for maximum mobility, and she had other intellectual and spiritual interests which were better served in Central Europe. BN was getting on though his physical constitution was always remarkable, and looking after him had its difficult aspects even though, and perhaps because, he was a great artist. He had to give up driving and so was dependent on others if he was to get out of the dramatically but also awkwardly situated Brissago house. They sought advice from friends in England and investigated some London studios. In 1971 Sir Leslie and Lady Martin offered him accommodation and studio space in a part of their home at Great Shelford outside Cambridge, a converted seventeenth-century grain store and nineteenth-century mill. BN gladly accepted this offer from old friends and that year returned to his native country, thirteen years after leaving it.

*The Times* welcomed him back with an interview published on 3 August 1971 as part of 'The Times Diary' and with the special tone that section calls for. 'Ben Nicholson, OM, the foremost British abstract painter, is, I learn, living in England once more.' The Ticino is getting crowded and the mix of languages is 'very tiresome', BN is reported as saying; 'I can manage French and Italian, but I speak quite a lot of English.' It was good to be back where everyone else spoke English too. Dr Felicitas Vogler remaining in Switzerland, BN, wrote the diarist, 'does not rule out returning to the Ticino's kind climate for the winter (he suffers from asthma) but meanwhile he says: "I am enjoying myself immensely. My roots are in England and I wanted to return to them."'

In fact, Felicitas helped BN settle in Great Shelford and guided the hanging of his show of reliefs at Marlborough Fine Art in late September. On 1 October he wrote to me: 'I gather the show is well hung – Felicitas will have been v. good at this as she has a complete understanding of the work.' He went on to describe where he was living (which the diarist was evidently not allowed to tell the world):

5 miles from Cambridge – within your reach? – cul de sac so no noise of passing traffic, only depth of English countryside – 2 streams & huge chestnut trees – & swans with 5 nearly full grown cygnets –

Chapter 7

# The 1970s and early 1980s: Great Shelford and Hampstead

**370**
BN with his cat,
Tommy, in his studio
at Brissago, 1968.
Photo Felicitas Vogler

exquisite colour (not yet white –) & beautiful almost beyond belief –
in fact the whole affair here & my flat like something out of Hans
Andersen – enchanted and enchanting.[2]

Felicitas visited him there in 1972 and BN went to Brissago
for Christmas that year. He had brought a lot of unfinished
work from Switzerland and, as always, was eager to get
on with it. What he called 'the work' was always the most
important thing. An amicable parting from Felicitas was
turned into a divorce in 1977, mainly to determine questions
of property.

He was still very active and full of ideas. His friends
remarked that coming home had given him a new lease of
life. He resisted old age with his adroitness and an iron will to
go on working. He completed sizeable reliefs and could be
found moving several whole sheets of the heavy hardboard
he used for them without help. And he had not lost his
appetite for travel and seeing old and new places. In Angela
Verren Taunt, whom he met at the Martins' that December, he
found a youthful and intelligent companion willing and for
several years able to divide her time between him and her
family in Cambridge. Mother of three children whose lives
were by then largely independent of hers, and the wife of a
pure mathematician of Cambridge University additionally
occupied at the time as bursar of Jesus College, she
was attending painting classes and perhaps looking
unconsciously for a new focus of activity and interest. She
had long admired BN's work and was thrilled to meet him at
a party given by the Martins. He was undoubtedly taken with
her and delighted her by suggesting she might like to visit
his studio. She wondered whether the great man had really
meant it but in the end telephoned and went. Their friendship
was soon established and her husband, Dr Derek Taunt,
encouraged it. BN offered to help her with her venture into
serious painting on condition she stopped attending her
classes; he assumed that anything thus learnt would need
to be unlearnt if anything worthwhile was to be done. They
agreed easily on that. In return, for many years he benefited
from her companionship and multi-competent care.

Like his father, BN had a permanent need for female
company and approval. Angela was able to help him in many
ways, in the studio and out of it, at home and away. The
friendship continued even though in 1974, aged 80 now and
feeling a little uncomfortable in the academic sphere of
Cambridge, BN moved to London, to a house in Pilgrim's
Lane across the road from where he had lived as a boy. It
was found for him by his then dealers, Marlborough Fine Art.
Built in the 1950s for the sculptor Robert Adams, it was not
large but well planned and situated, and included two studios
that gave him more room than he had had in Shelford.
Angela spent part of the week with him in Hampstead
and used one of the studios for her work, until 1979 when
ill health forced her to end her visits.[3]

The 1970s and early 1980s

371
*1972 (Wharfedale
in rain)*.
Pencil on paper,
36 × 51 cm
Private collection

**371**
*1972 (Wharfedale
in rain)*.
Pencil on paper,
36 × 51 cm
Private collection

**372**
*1972 (Wharfedale)*.
Pencil and wash on
paper, 40.5 × 46.5 cm
Bernard Jacobson
Gallery

BN's international travels continued, with Angela as organizer, driver and companion and with many fine drawings in evidence. He had always had a special affection for the north of England landscape and a passion for the Greek mainland and islands as well as for central Italy; his enthusiasm for Siena Cathedral was such that he reckoned he had probably helped build it centuries before. In the interview he gave to John and Vera Russell in 1963 he had, perhaps playfully, spoken of his thoughts of possible previous lives: 'I have favourite places – Mycenae and Pisa, and Siena, for instance – and I feel that in a previous life I must have laid two or three of the stones in Siena Cathedral, and even perhaps one or two of those at Mycenae!'[4] The Yorkshire Dales feature repeatedly in his drawings, and four days were spent looking at, and drawing, Compton Wynyates [plate 375], a fine house in Warwickshire dating back in part to the thirteenth century. He was rediscovering his native land. In his new drawings of it there is a hint of the softness found in his landscape drawings of the 1920s, related to conditions of light and weather at least as much as to mood.

Tonal smudges on the fields and hills of *1972 (Wharfedale in rain)* [plate 371], and in other drawings of the time, join with sharper touches to produce a richer as well as a gentler image, more redolent of a particular moment and more inclusive in the perception they reveal. BN and Angela made thirteen drawing trips together, few of them shorter than three weeks. Their last foreign journey was in 1976, the last UK one in 1978.[5]

1973 brought a new subject into his drawing, not a new category but a new range of forms which BN made into his own unmistakable *dramatis personae*. The story of how he found them is characteristic. A plumber came to do some work in the autumn of 1973. BN noticed his tools, patinaed with age and use, strong and weighty shapes full of character. Six spanners, simple and adjustable, some of them double-ended, fascinated him especially. He offered to buy the man a new set in exchange for the old, and the offer was accepted. For about five months during 1973-4 BN worked with his new still-life objects again and again, producing forty drawings. The New York dealer André

373

374

**373**
*1973 (Lambousa Monastery 3).*
Pencil and wash on paper, 34.9 × 44.5 cm
Private collection

**374**
*1973 (Lambousa 1).*
Pencil and wash on paper, 40.6 × 50.3 cm
Private collection

**375**
*1973 (CW gateway).*
Pencil and wash on paper, 45.3 × 57.2 cm
Private collection

The 1970s and early 1980s

The 1970s and early 1980s

**376**
*1972 (Olympia).*
Pencil and wash on
paper, 30.7 × 52.5 cm
Private collection

**377**
*1972 (corner of
Olympia).*
Pencil and wash on
paper, 39.3 × 42 cm
Private collection

378

379

**378**
*1972 (Olympia –
fragment of Zeus
Temple).*
Pencil and wash on
paper, 38.1 × 55.2 cm
Private collection

**379**
*1972 (Olympia 2).*
Pencil and wash on
paper, 30.8 × 37.8 cm
Private collection

The 1970s and early 1980s

*1968 (scissors,
variation on
a theme no. 4).*
Pencil and wash
on paper in relief,
38 × 32 cm
Private collection

Emmerich showed them in his Zürich gallery in 1975, together
with twenty travel drawings.

BN's partly obsessional playing with a kit of forms is in
itself striking, but even more so is the variety of images they
suggested to him. (In 1968 he had drawn a sequence of
'scissors variations' [plate 380] on the theme of an old pair of
scissors, with wide curving blades and generously wrought
handles.) They were a new kind of still life, a new set of
friendly and patient objects, and he used them differently
from the other, more domestic objects – mugs, jugs, bottles,
goblets, etc. – he had inherited and collected.

One is tempted to see these new drawings as scenes
from a ballet sequence. Each spanner has its own character
in the performance. The adjustable spanners he took apart
so that the holes which made them adjustable became as
eloquent as the teeth with which they were meant to grip.
The rest is choreography. Remembering a visit to the sea
at Holkham in Norfolk, BN presented a little side-by-side
parade of spanners on a sheet of paper washed with pale
browns and with pale blue and two horizontal lines recalling

a seaside setting, and afterwards called it *spanners Holkham
sands 6* [plate 385]. *Spanners in relief* [plate 388] shows
a tighter grouping: four forms with some overlap and a
mandorla-like oval drawn round and over them, failing to
contain them though they seem at rest. The group, together
with a warm grey wash, is on the raised trapezoidal plane
made by the imprint of a copper plate. A second mandorla
line frames this plateau on the lower part of the paper. The
title is both well-justified and ambiguous: there is relief in
the paper and also in the way the spanners are represented
since two of them advertise their three-dimensionality and
one of them even seems to show hatching, not seen in BN's
work for decades but suggested here by the gripping teeth
ground into the tool.

So far the dance is fairly stately. In *spanners 3 and
holes 4* [plate 386] it becomes more expressive. There are
four forms, two of them belonging to one spanner. 'Holes 4'
is puzzling, as BN knew it would be, because we can see
only three and are left with various ways of accounting for
the fourth, including the strong curve that almost manages to

The 1970s and early 1980s

381
*1973 (spanners
Holkham 3).*
Pencil and wash on
paper in relief,
37.8 × 47.3 cm
Private collection

encircle the group. Most of the lines are firm, but the spanner on the left is drawn partly with a soft, in places erased line, sinking it into a complex web of previous lines, partly erased, partly screened by grey and pale orange washes. The figure in *spanners 6* [plate 382] must be a sequence number. Only three spanners appear in the drawing, placed over each other. The line makes them seem transparent, two of the spanners are double-ended, and there are many accompanying lines, curved and straight, as well as a rich cool and warm wash, so that altogether this is a complex image, not very easy to read.

Double-ended spanners can look like figures, especially if the ends are emphasized and the handle is shortened. The central spanner in *spanners in movement* [plate 387] has turned into a wholly curvilinear creature that seems to bounce among its dancing partners. In *spanners Carnac* [plate 384] we see one vertical form taking on the immobility of a standing stone; on its short torso, made more with tone than with line, is the crescent head of another spanner, inscribed like a sign. Those lunar hints

were not to be resisted long. In *spanners moonstruck* [plate 389] one spanner, set among curves on a curvilinear piece of paper, seems beset by crescents large and small and steadied by four black accents. Black has a steadying effect also on *spanners Holkham 3* [plate 381], putting a brake on the rotating tools seen against that seaside horizon. One little spanner not included in the group – or two parts of one spanner – looks like a child left out of an adult dance and looking right and left, turning this way and that, in puzzlement. Similar hints of spanners performing as a family are found elsewhere in the series. For instance, *spanners with blue* [plate 383], in which BN used the back of a print. On the raised rectangle in the centre a tall form inclines protectively to two smaller forms. Strong horizon lines left and right give them pictorial space. The lines repeat outside the raised area but higher up, and the effect of this is to suggest yet more space. A free-hand oval line frames the image like a mandorla, giving a sacred character to this drawing in what is generally a very lighthearted sequence.

The 1970s and early 1980s

382

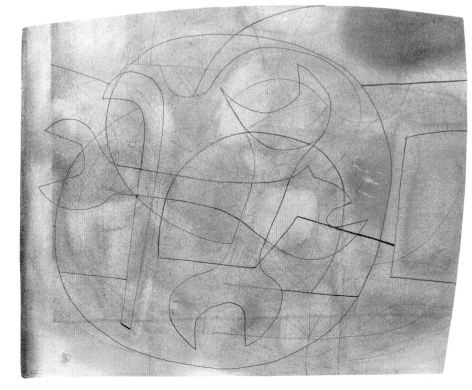

383

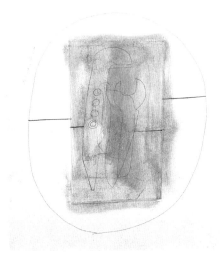

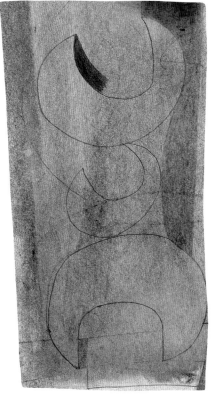

384

385

**382**

*1973 (spanners 6).*
Pencil and wash on
paper, 42.3 × 45.9 cm
Private collection

**383**

*1973 (spanners
with blue).*
Pencil and wash on
paper in relief,
37.8 × 32.1 cm
Private collection

**384**

*1973 (spanners
Carnac).*
Pencil and wash on
paper, 32.1 × 21.4 cm
Private collection

**385**

*1973 (spanners
Holkham sands 6).*
Pencil and wash on
paper, 53.9 × 68.3 cm
Private collection

The 1970s and early 1980s

386

387

388

389

**386**

*1973 (spanners 3 and holes 4).*
Pencil and wash on paper, 29.8 × 26.8 cm
Private collection

**387**

*1973 (spanners in movement).*
Pencil and wash on paper, 24.2 × 24.8 cm
Private collection

**388**

*1973 (spanners in relief).*
Pencil and wash on paper in relief, 49.5 × 46.2 cm
Private collection

**389**

*1974 (spanners moonstruck).*
Pencil and wash on paper, 31.3 cm × 44 cm
Private collection

The 1970s and early 1980s

*1971 (Obidos, Portugal 1).*
Oil on carved board,
78.7 × 103.5 cm
Waddington Galleries

Seeing the spanners endowed with such personality and life, one becomes aware of the altogether more respectful way BN had long used his domestic objects. Perhaps we would all respond differently to a set of tools and to a lived-with family of tableware, associated with comfort and conviviality. BN had obviously felt free to draw and paint them in many ways, teasing as well as honouring their silhouettes, taking deep pleasure in their decorative patterns, and playing fast and loose with the transparency of glass as against the transparency offered by line drawing. But though he made free with them in so many ways, they always retained their dignity whereas with the spanners he felt free to question their nature, allocating them in his art a different life and presence. Setting aside for a moment the skill and sensibilities that went into this, and focusing on the metamorphoses they underwent, we could say that he treated them like characters in a cartoon film, always recognizable but also ever-changing with the story and the music. The other still-life objects had always remained themselves, even when they were mingled together or interrupted by independent forms and colours. They retained their character as permanent emblems. But in his last works, as we shall see, they too were to undergo transformations and enter into dramas of a new sort.

In BN's late reliefs we find abundantly the curves he had long been practising in his graphic work and which began to play important roles in his reliefs of the 1960s. More noticeably than in the drawings and prints, though, the broad, sweeping curves he cut from his boards in the 1970s depend for their force on the straight lines and the angles they confront. The result is a sharper energy, and it is backed by increasingly vigorous brushwork, often in white or variations of white that could appear as firm marks or areas and equally as silvery mists dissolving the visual surface. *1971 (Obidos, Portugal 1)* [plate 390] is a key example. Its entire surface, basically a horizontal rectangle, is covered in misty white, unevenly so, with the board's colour showing through towards the right edge and on the baseboard. Reading the forms is not entirely easy though they are few and discrete. On the regular rectangle of the baseboard we find a curved

The 1970s and early 1980s

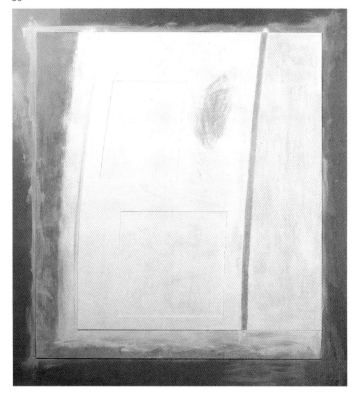

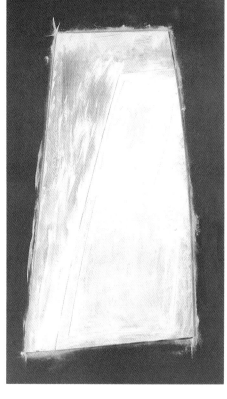

**391**
*1971 (Obidos,
Portugal 2).*
Oil on carved board,
158 × 142 cm
Private collection

**392**
*1971 (Obidos,
Portugal 3).*
Oil on carved board,
131.5 × 71 cm
Private collection

quadrilateral rising left to right, gently at first and then more emphatically. Its right edge coincides with the edge of the baseboard and is truncated by it, so that we imagine it continuing further. Its other three edges are curved. That even the left, starting, edge is curved makes us see this inner form as separated from the base and curved also in the third dimension. Depending on light conditions, it seems sometimes to float in front of, sometimes within, the larger geometrical field. There is a similar ambiguity about the third form, a much smaller, almost trapezoidal form equally dissolved with white. This form is negative in the sense that it is hollowed out of the second form. Only its lower edge is curved, running almost parallel with the long curve below it. Its other three sides are straight: two nearly vertical and the third sloping down firmly from left to right and thus opposing the pull of the curved quadrilateral. If we experience that as a curved plane moving in space, the smaller form seems to counter its movement with its firmer, sharper edges. Yet we can never quite decide where that small form is. In material fact its place is clear enough, but as part of this mobile and

melting composition it rejects any one allocation. One minute, as we focus on its lower edge, it partners the larger form in space and direction; the next, if we attend to its upper part, it takes a contrary position, moving to the right still but through the larger plane. These contradictory readings can give way to one in which the small form becomes a sanctum at the heart of the composition, a reserved area in which some significant phenomenon could occur at a favourable moment. The cosmic and perhaps spiritual character of this late relief is clear and is found also in other works of the 1970s. Most of the other reliefs shown then are more positively coloured though cool misty greys make frequent appearances, but among them were also *1971 (dolphin)* [plate 393] and *1971 (Obidos, Portugal 3)* [plate 392], equally distinguished by the prominent use of white.

The exceptionally tall rectangle which is the whole of *1971 (dolphin)* – a more extreme proportion even than that of the horizontal *1966 (Zennor Quoit 2)* [plate 354] – supports a curved quadrilateral whose longer sides are convex. The placing of that form, and its soft whiteness silhouetted

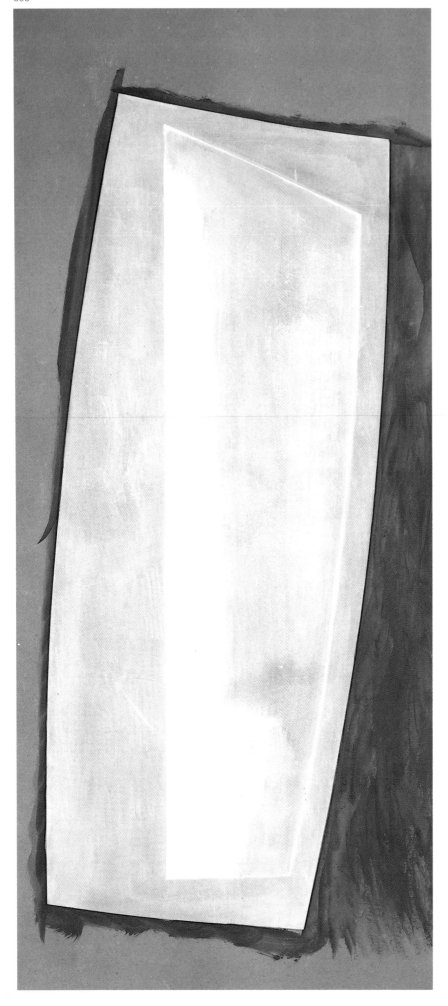

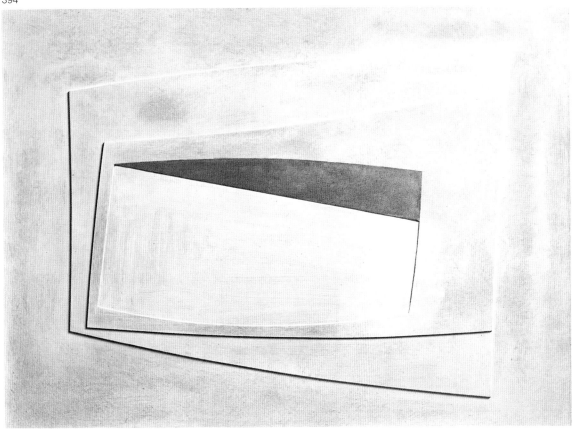

**393**
*1971 (dolphin)*.
Oil on carved board,
167 × 68 cm
Private collection

**394**
*1971 (silverpoint)*.
Oil on carved board,
68 × 92 cm
Private collection

against black paint thinly brushed on to the support, cause it to seem to rise slowly towards and beyond the top right corner of the work. The mottled black covers only part of the support – one wonders whether the work is quite finished – and seems to restrain movement over it. But the silhouetting of the swelling form is complete and makes a strong statement, so that we do not at once take account of the sharper form set within it, distinguished by a long straight edge parallel to the vertical sides of the support and emphasized by an area of relatively firm white paint. That, plus a halo of white along its other edges, separates this inner form from the outer one, and again we are not certain whether it hovers in front of or sinks into the other. This perceptual ambiguity is heightened by the fact of its being, again, a negative form, taken out of the main form. Its sharpness adds tension to an otherwise calm piece, and that is the product both of the acute top corner and of its long, curving right edge, confirming the right edge of the larger form.

*1971 (Obidos, Portugal 3)* [plate 392] is similar in its

silhouetting of a large form against a largely unpainted baseboard. The only added colour here is white. This has been brushed briskly over the large form and its burden of smaller forms, leaving surfaces of varying densities, none of them solid. The paint goes a little way on to the support all round the form, and seems to lift it from that base rather than anchor it. The bottom edge of this curved quadrilateral generates a narrower but almost equally tall form within it. Their right edges coincide too so that they seem locked together, the smaller, more densely white form, and its larger partner. Cut into the second form we find two smaller forms, different from each other and with one above the other. One is all curves and seems to hover free from constraints; the other echoes the curving left edge of its support with its own and comes close to echoing the bottom edge, thus again seeming to exist in confirmation of it. The first, large form has a straight left edge, rising sharply. Its convex right edge rises towards the left to moderate that thrust. The general effect is one of white forms together rising gently within the spatial envelope provided by the unpainted baseboard, while

The 1970s and early 1980s

**395**
*1975 (night blue and brown circle).*
Oil and pencil on carved board,
85 × 85 cm
Private collection

undergoing shifts and developments among themselves. The exploration of whiteness in these three works links them to the rich series of the 1930s, though now the white is used diaphanously, as an infinitely variable tuning of the surface. In a fourth relief, *1971 (Obidos, Portugal 2)* [plate 391], this variation is particularly marked. A negative margin of colour – a band of darkness between two relatively firm areas of white, but itself also tinted with white – makes a firm shadow to the right of a rising curved rectangle. On the face of that form is a soft patch where the white has been almost wholly rubbed away, reminding us of a similar erosion in *1966 (Carnac, red and brown)* [plate 355]. BN had visited Portugal with Felicitas in the 1960s.

This exploration of white as a major element in (as opposed to the entire character of) reliefs, limited in 1971 to the *Obidos* series, is seen more frequently in the reliefs that followed. The first three of the series were shown in BN's 1971-2 exhibition at Marlborough Fine Art. BN's 1976 exhibition at the Waddington Galleries was characterized by light tones, almost without exception. *1971 (silverpoint)* [plate 394], a small work shown on the cover of the catalogue, is almost all white, a thin, brushy white; a sharp triangle of brown board, only slightly touched with white, plays a pivotal role in an arrangement of curving rectangles set to rock on and against each other. There is less sense here than there was in the *Obidos* series of a transcendentalizing urge. The experiences recaptured are now earthly ones even when they are at their most poetic and even when they suggest an artist with an eye on the heavens. Some of BN's reliefs of the mid-1970s refer to the night sky and present visual phenomena at once very subtle and moving. The inscribed circle in *1974 (moonrise)* [plate 396] is identified by the title but is in any case a delicate phenomenon, a soft white line in a firmament shadowed with white. Apart from this white – which we tend to accept as part of the material in which the relief has been worked – the only added colour here is a soft band of greyish blue on the left. A deeper blue, but no firmer a colour note for all that, appears in *1975 (night blue and brown circle)* [plate 395] in the company of a whole range of whites, from the almost dense application that makes a small,

**396**
*1974 (moonrise)*.
Oil on carved board,
72 × 62 cm
Private collection

nearly rectangular form to the white that is left in the negative angles of the relief and along some of its edges. The circle itself has been drawn in pencil on to a gently rubbed hardboard surface. This relief incorporates many ideas BN had been exploring since his arrival in Switzerland and such works as *1960, February (ice – off – blue)* [plate 300], but it also represents his 1970s focus on celestial experience; this is true also of *moonrise*, yet *night blue and brown circle* is a more intimate and poetic work, almost a Chinese account of nature.

An incised circle is the only clear form in the much larger *1975 (one curve – one circle)* [plate 398]. BN wrote to tell me about it after I had seen it briefly in his Hampstead studio.

I had that curved panel you saw made in Brissago by a v good friend and a carpenter ... & took it out of the small outside store here because it took up so much room, & never dreamt it would take up more room in my small studio. But it was lovely to work on & v. interesting too, because the white curve was so beautiful that I cldn't possibly cut a relief into it – but Angela had bought me a kind of compass I'd never used or seen! before & the circle which the

painting needed (could not be pencilled & so removed if ever so faintly wrong) [sic] it had a *v. fine pointed* knife & if one was sensible surely one wld have tried it out in some way on another board – at least to get the feeling of the thing – but with the panel poised on the top of a narrow table & myself poised on top of the panel I couldn't willingly or even unwillingly get down & try it out (I suppose one was free from calculation) but incised it *there* and *then* and it came out just right ...[6]

The result was a horizontally concave painting – the last time he used this form. He divided its almost square surface into four horizontal bands, each of them with its own colour and textural treatment. It is difficult not to see a landscape in this grouping of bands. Indeed, it is possible to see this three-dimensional work as the last great example in a tradition of landscape painting that was born with Turner and found its second climax in Whistler from whom William Nicholson inherited it: landscape as transcription of visual experience in terms of broad perceptions, without local or anecdotal detail but giving the greatest possible attention to relationships of tone or light and implications of space. We know that BN

397

**397**
*1970 (invisible circle)*.
Oil on carved board,
53 × 48 cm
Private collection

admired some of his father's landscape paintings, and rightly so. We also know that BN, from his earliest known ventures into landscape, always simplified and generalized rigorously even though he was then led, by his desire to express lyrical feelings with primitivist directness, to add visual diversions in the form of trees, buildings, and occasional animals (never figures). The emptiness of *1923 (Dymchurch)* [plate 21] appears exceptional, inherent in the subject but underlined by BN's perpendicular view of beach and sea. Some of William's landscapes, including some of the best, can be called Impressionist. BN never, it seems, accepted the recording function of the Impressionists, always giving priority to the structuring of a composition, and it is quite possible that William's landscapes of the Whistlerian sort were in some measure encouraged by BN's example.

If *1975 (one curve – one circle)* is a landscape then it is a wintry one of snow and a heavy sky illuminated by sunlight deadened by mist. One hesitates to identify the large circle with the sun though the association comes up unbidden. At the same time that circle, cut into the board and exhibiting

the hole left by the pivoting point of the compasses, is very much a physical fact. The work is first of all a BN painting; nevertheless, its curvature and the line carved into it give it the presence of a relief even though it lacks the interacting of physical planes. The distinction may seem academic. It gains point from the fact that in his last years BN admitted to seeing his work on a hierarchical scale of importance in which reliefs came first, drawings second and paintings third, and I can attest to the pride with which he showed this work in his Hampstead studio the year he made it. It dominated the 1976 show.

In the late 1970s BN embarked on a new series of works. Three Waddington catalogues record the venture and its results exceptionally well, as made public in the last three one-man shows planned in his lifetime. One of the benefits of his move to London was that he could have easier contact with his dealer, more frequent but also less time-consuming. From 1975 on he was represented by the Waddington Galleries and in 1978 he had there an exhibition entitled *Recent Paintings on Paper*. That description can still give

404

The 1970s and early 1980s

**398**
*1975 (one curve –*
*one circle).*
Oil and pencil on
curved board,
110 × 121 cm
Private collection

one pause. Are they not drawings? None of them is large: they range in area from about 500 square centimetres to five times that. Oil washes had been used in many of his earlier drawings. Here, it is true, we can find more solid patches of paint – as also in some of his worked-on prints – though one wonders whether these are enough to make these drawings into paintings. He used here a new medium, and it is as characteristic of him that he does not name it as that he should leave us uncertain what to make of the category he puts the whole sequence of works in. The 62 paintings in the 1978 exhibition are listed at the back of the catalogue with their titles, dates and sizes but with no details as to medium, and they include eight recent landscape drawings of the usual sort. As the painter and writer Christopher Neve says in his introduction, 'Just as Nicholson refuses to be pinned down about such things as what media he is using or how he arrives at a particular arrangement, so he resists being cornered by his subject matter.'

The new medium was the Pentel pen, a fibre-tip pen made in Japan, the first and in some ways the best of what

has since become a flood of such things. BN was utterly at home in the world of pencils, from fine pencils made in several grades of hardness for artists' use to the strong, flat carpenters' pencils with their rich marks. He was clearly thrilled by the character of the new pens, at once soft and resistant, making a mark that is positively black though pressure and speed will to some extent vary its density. This black is much more positively a colour than the greyish black offered by pencils unless one works lines and patches over to get a deeper tone. BN had made many a shadow area in drawings and paintings by making what I have called bundles of lines. With these pens he found himself scrubbing the paper to make a black shape, rubbing with the tip in this direction and that, sometimes leaving a sense of transparency with the white of the paper glowing through between the marks, sometimes achieving a surprisingly solid black. That plus the use of solid areas of oils, as well as the forcefulness of many of these new works, does seem to justify their description as paintings.

He began the new works in March 1978. Another

characteristic of these and all pens of the sort is that they run out of ink – not suddenly, as ball-point pens often do, but gradually: the line becomes dryer and paler and the fibre-tip feels more resistant. BN's 84-years-old hand works with amazing sureness still but it is coping with a new situation and meets new challenges which also then stimulate his invention. In one of the earliest of works in what was to be a pursuit lasting him the rest of his days we see him using a pen that is showing its age. *1978, March 13 (sculptured forms 1)* [plate 399] shows a group of, probably, four objects: goblet, vase, jug and something squarish, a mug perhaps, its identifying handle hidden from us. They overlap and there is transparency as well as solidity. The jug, for instance, hides part of the mug (or whatever it is) but is transparent for the vase next to it. So the lines are given their by now familiar rights and powers and they make the objects mingle here and there so that we are not always certain which line belongs to what, as often before. That, one could say, is what this image is about. But there are washes on the paper – a very pale, dirty-looking wet smudge of grey right of centre and a horizontal wash of blue-grey making a band at the top. This turns the image into a landscape: a still life before a landscape, and to confirm that a horizon line runs to the left edge of the cut sheet from the group, though there is none on the right. Should that leave any doubt about the space in which these objects are seen, a very small block of Pentel black is wedged against the left edge of the group. It functions like a book-end, preventing any possible shift to the left, but it also asserts deep space with electrifying suddenness. We may even wonder what that black bit on the horizon might be part of, what might be hidden from us by the group of objects. What we know at once is that it is far away. In the introduction Neve quotes Giorgio de Chirico's phrase, 'the enigma of things generally considered

insignificant', and for a moment one wonders at his invoking there an artist honoured by the Surrealists as a founding father of their movement. But the words are apt. The vivid, almost vertiginous space created in the image, and the mysteriousness of the black thing or event on the horizon, touch one's insecurity.

Some of these new works can be called dramatic, while others have a playful, light-hearted presence. Landscape space is brought into many of them, and that has a relaxing effect in some, a dizzying effect in others. Some compositions without it confront us quite fiercely, as is the case in *1978, April 1 (small red, large black)* [plate 401]. The bulging black shape which is the first thing we notice in it is echoed by the bulging shape into which BN has cut the sheet of paper. Lines and smaller black shapes create some sense of space, of in front and behind, but everything is packed fairly tight, and the relatively solid brushed-on blue wash, as opposed to thinner areas elsewhere in the work, comes at the bottom and thus does not hint at sky and space. Also, there is the 'small red' of the subtitle. It is an L-shape and one feels it is being oppressed, devoured even, by the strong black form. The perceptual weight of the whole is amazing. *1978 (black shadows)* [plate 414] is quite different. It is bigger but feels smaller and more intimate. It is limited to Pentel black on white paper, and that black only in the upper half. It all looks quite innocent and straightforward, except that the still-life group and its accompanying shadows turn out to be in a state of crisis of a sort we have not seen in BN's art before. The shadows loom alarmingly; that and what looks like the edge of a structure of some kind on the right – a stage set perhaps – suggest dramatic action and lighting. The group seems to comprise a goblet, in part lost in the main shadow, a handled mug or cup and, on the left and least ambiguous, a tall cylindrical jug. Lines within it indicate

**399**
*1978, March 13 (sculptured forms 1)*.
Pen and wash on paper, 41 × 53.5 cm
Private collection

399

The 1970s and early 1980s

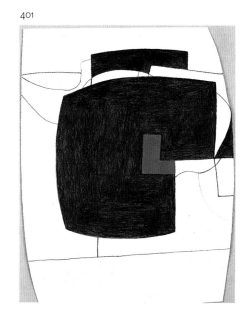

**400**
*1979, April 20
(vertical stripe).*
Pen and oil on board,
104.1 × 79.7 cm
Tate Gallery, London

**401**
*1978, April 1 (small
red, large black).*
Pen and oil on paper,
43 × 36.4 cm
Private collection

The 1970s and early 1980s

**402**
*1978, April
(several forms).*
Pen and oil on paper,
38.6 × 36.7 cm
Private collection

**403**
*1978, May (shadows
and lilac).*
Pen and oil on paper,
39.7 × 47 cm
Private collection

**404**
*1978, May (mauve
and blue).*
Pen and oil on paper,
26.2 × 42.6 cm
Private collection

402

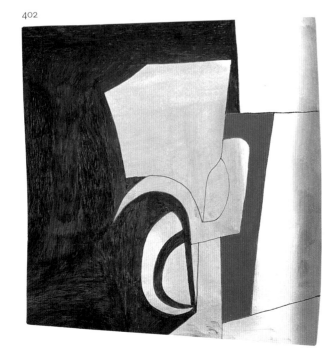

403

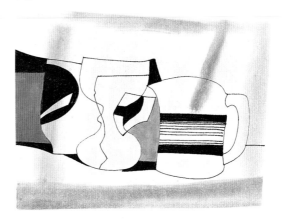

404

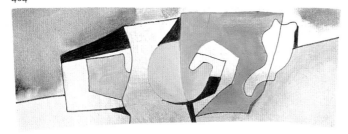

The 1970s and early 1980s

the level of liquid inside it. To our surprise it leans towards the other objects and towards us, and so we become aware how little BN's objects have done to us and to each other in earlier work. The action would seem less threatening but for those shadows and the blankness of the forestage.

Colour is very compelling in some of the others, blues and blue-greys, terracotta and Indian red, occasional green, bright red, suave pale mauve. And always black. *1978, April (several forms)* [plate 402] is a relatively flat, highly dramatic image in which terracotta forms and an Indian red shape contend with a black area that seems to be advancing from the left, pressing against and biting into the terracotta. There are hints of standing objects and of handles, but it is only our expectation of still life that makes us think of it here. The interaction between the black and the terracotta gives rise to new forms scarcely related to mugs and jugs. In the much calmer and friendlier *1978, May (shadows and lilac)* [plate 403] we find BN's and our old friends, goblets, cup, even a striped mug, fairly legibly paraded before us, and a little line making the far edge of a table top here, rather than a horizon. There is a particularly cheering detail where the handle of the jug meets its body and BN has omitted a connecting line: we see it in its absence the way we can read shapes that are not there in the Art Nouveau posters of the Beggarstaff Brothers. The same sophisticated game lightens some of the other works in the series. But most striking in this composition is the emergence of unexpected, unexplained shapes. No doubt they are engendered by the lines of the objects, but they take on a life of their own and are given forceful presence by the addition of black and lilac. Once they have surfaced they become part of BN's store, and so they can reappear elsewhere, without foreplay, as BN forms. In *1978, May (mauve and blue)* [plate 404] the centre of the composition is held by an interaction of curved forms

that include a handle but have no identities otherwise. The handle of the cup on the right has become a shell shape so curious that it seems accidental, yet it reappears in other works in the series. Here the upshot of these adventures is that the cup itself, though relatively large, is easily overlooked: what we would expect to be the main event is overtaken by local incident. The result is at the very least a quirkiness that does not feel entirely humorous, sometimes a disturbing sense of unreliability.

To put it another way, many of these images hold our attention where we would rather not have it, on awkward, odd, uneasy details when we would prefer a fine, ultimately classical display of trusted forms. Drawing attention to this may be to exaggerate its importance. Modest size, colour touches that are sometimes quite delicate, lines that are full of life in themselves – such factors make for an air of pleasure and entertainment. That is one's first response, and that is how the works struck me in the exhibition, but the less cheerful notes come through gradually. Going from one painting to another we notice the differences more and more, and these are mainly in the dark aspect. Looking at *mauve and blue* one is first beguiled by the slender horizontal format and the dominance of delicate tints: mauve in various densities and tending to blueness, a patch of muted light blue in the middle, and touches of grey above a horizon line to make a sky. As we look longer, that sky begins to close in, especially from the left, and the cluster of objects huddles together in some nervousness. Yet another image can be used for reassurance. *1978, May (one in one)* [plate 405] offers us a line drawing of three objects brought together in a heraldic way into a nearly symmetrical configuration in the middle of an almost rectangular, gently tinted piece of paper. We shall get into trouble if we try to disentangle mug and jug from bowl: their lines are clean and delicate and reassuring

**405**
*1978, May (one in one).*
Pen and oil on paper,
44.6 × 51.3 cm
Private collection

405

The 1970s and early 1980s

**406**
*1978 June (group in movement).*
Pen, oil and wash on paper, 49.2 × 54.6 cm
Private collection

so we must not object to their irrational fun at our expense. There is a black accent on the right, and the jug, on the left, is striped and given a band of muted red. There is also a smudge of blue-grey wash in that area. These things have the effect of holding down what would otherwise be a very ethereal image, but it is still relatively light and unchallenging.

Playfulness on the level of manipulation of media and marks, and a deeper kind of wit in bringing many meanings into these initially innocent compositions, an apparent effortlessness in producing ever more ideas and inventions and a hand that again and again demonstrates its continuing deftness – everything is still at this stage going with and for BN. There is still the basic miracle of finding such eloquence in things so ordinary. The Pentel pen, he convinces us, will let him do many things, firm lines, light and soaring lines, patches of variable blackness. Colour plays major roles compositionally and in producing meaning. In fact, BN had been through physical troubles shortly before embarking on these new works. His eyes had started watering, so much that they interrupted work entirely for a while. We witness in these works a new beginning after a break, and in time surgical treatment was to minimize the problem.

The 1980 exhibition included two reliefs, of 1971 and 1977, eight pencil drawings mostly of 1973-7 but with one each of 1959 and 1961, and 56 of the new sort of paintings on paper. Its catalogue does now give media details for each work and BN was at pains to distinguish between 'pen and wash', 'pen and oil' and 'pen, oil and wash'. The distinctions are not absolute and even 'on paper' calls for a warning since three of them are done on board. All of the paper works are loosely mounted on boards. Since the sheets of paper are in most instances far from rectangular and cut into a variety of shapes, including the swelling rectangles we know from the reliefs of 1971 and in one case a rough pentagon

406

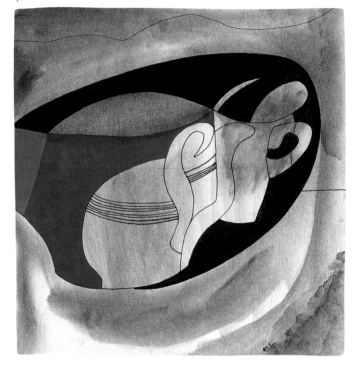

(*1979, February (Madeira)*): two straight sides and three curved concavely), how they are mounted contributes more than usually to their appearance, above all to their reception as objects. In the 1978 show many of the pieces were non-rectangular and mounted on brownish boards, most of them used as found. Now most of the mounts are tinted and rubbed and there is a whole range of textures and warm or cool tones. The range of sizes is more extreme, from *Madeira* with an area of about 620 square centimetres to *1979, April 20 (vertical stripe)* and *1979, April 22 (ivory)* [plates 400 and 415] which are of about 8300 square centimetres and on board. Most of them are towards the lower end of this range but there is no one typical size.

The subject is always still life. Perhaps one should say 'motifs being explored and exploited' rather than 'subject'. We still see bottles, goblets, cups and jugs, but we see even more lines and patches of Pentel black and of variously coloured oil paint as well as BN's familiar thin oil washes. If we ask ourselves what they are about, what the subject behind the motifs may be, we are led to the feeling that they are about everything, life and death, physical life and spiritual existence, present, past and future. In these last works his expression and its stylistic associations range more widely than ever before. Until now, almost without exception, he had made art as positive statements, about the pleasures of seeing, of recollection and of making; the religious experience with which he had associated art was an entirely expansive and confident one. Now, dramatic and sometimes aggressive images mingle with others full of his serenity and gaiety. The classical spirit which had always been his encounters an occasionally Baroque urge to make forms swell and zoom. The forms themselves, whether abstract or still-life forms, now appear militant in one instance, oppressed in another. The advancing blackness can seem

strong and good, but it can also strike one as a threat. Again, it is BN himself who shows us, with these late works, how he has accustomed us to expecting an unambiguously positive spirit from his works, and the sight of objects and scenes used in many ways but never as anything less than dignified or joyous. And we must guard, knowing his age when he did them and perhaps attributing to him anxieties that would be our own, against interpreting these works with anything like certainty. He ended a short letter to me in June 1980 – a 'quick note' written after a morning in town that left him 'rather weary', intended to thank me for the short introduction I had provided for the catalogue of his 1980 exhibition – with this scribbled postscript: 'oh, & the cover makes me laugh every time I see it –'. That is a reproduction of *1978, November (bird mug)*, which will be referred to below.

The earliest date given in any of the titles in the 1980 exhibition is June 1978, and *1978, June (group in movement)* [plate 406] is a powerful and surprising example. It is of a medium size for the series and combines black ink with Indian red on white paper. Little of the white remains visible. There is solid black as well as a blackish wash and a small area of slighter, lighter red on the left. The objects are bunched together, two or three of them. They are distorted in a new way, stretched sideways on a left-to-right rising path, and held in an elliptical shape which is made of the black and the two reds and appears to carry the objects in that direction. The darker red could belong to the first object. The dramatic black form, an unmitigated curve not seen in BN before, is not identified with anything though black areas in the cup on the right make it seem that the black is invading it. A short horizontal line emphasizes the feeling that the group is rising; one wavy line near the top provides a mountainous landscape background. The remaining areas of white and of brisk grey wash and dabs keep the group in

The 1970s and early 1980s

407

space, not resting on any surface, and also on the positive
side of gloomy. Yet the group disconcerts. We know those
glimpses of a striped mug or jug, those curving handles and
associate them with clear-cut forms and high spirits. Here,
distorted not unlike the anamorphic skull in Holbein's well-
known National Gallery painting *The French Ambassadors*,
they seem fleshly and under stress.

Again, the black can be so strong that it threatens the
objects. In *1978, August (black, brown, red and pink)* [plate
407] a jug and a cup perform quite positively in spite of a
spreading black background. In *1979, February (bottle in
hiding)* [plate 408] the black does seem to be taking over,
though in titling the work BN suggests a playful reading. The
distortion noticed in *group in movement* is even more marked
in *1979, January (in movement)* [plate 409], consisting almost
exclusively of curved lines and shapes picked out in black
applied over most of what had been areas of brown paint.
The result is a cluster of flickering forms, spreading upwards,
that only habit allows us to read as parts of still-life objects.
Other works restate BN's confidence in his world and remind
us again of his extraordinary sureness of touch. In *1979,
March (still life, Maggiore)* [plate 410] we see a group of
objects on a round table in front of a vast space made by an
almost horizontal bar of black on the right and the warm-and-
cool tinting of the paper. A curved patch of black-over-brown
is in the middle as part of the group; otherwise the objects
are in line only and that line assures us of BN's high spirits.
In fact, we sense an unusual solidity in those objects and
notice that those on the left, a mug and a stoppered jar or
decanter, are drawn almost entirely as though they were
solid, not given the transparency and the intimate
interdependence found in most of BN's linear images.
Soft dabs of black paint add another element of life
and visual interest; coarser versions of these touches in

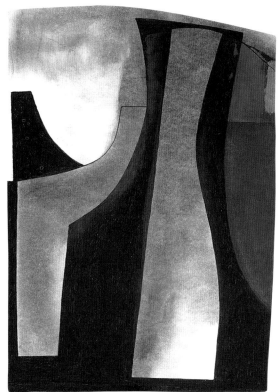

410

**408**
*1979, February
(bottle in hiding).*
Pen, oil and wash on
paper, 48.6 × 48.6 cm
Private collection

**409**
*1979, January
(in movement).*
Pen, oil and wash on
paper, 35.9 × 30.5 cm
Private collection

**410**
*1979, March
(still life, Maggiore).*
Pen and wash on
paper, 62.9 × 76.2 cm
Private collection

411

**411**
*1978, November
(bird mug).*
Pen, oil and wash on
paper, 42.9 × 35.6 cm
Private collection

**412**
*1979 (Maggiore).*
Pen, gouache and
wash on paper,
41 × 26 cm
Private collection

412

The 1970s and early 1980s

a much smaller drawing are named 'cat's paws' in its title.

The fleshiness spoken of already comes to the fore in two works that by contrast highlight the classicism of *still life, Maggiore*. *1978, November (bird mug)* and *1979 (Maggiore)* [plates 411 and 412] exhibit a kind of distortion that seems Baroque in comparison, with roundness and weight emphasized in the shapes and in the way they are reinforced by colour, mostly black. The first of these, chosen for the cover of the catalogue, is on a piece of paper cut at the top to echo the curvature of the jug which is its main object. A jug is the only object in *Maggiore*. It more than fills the slim, vertical form of the paper and its black handle swells towards us dramatically. Above, three lines present the lake and mountains. In other works all, or almost all, is flatness and slightness and light. Two of them are done on BN's three-dimensional paper – the back of a sheet that has been through a printing press – but no particularly dramatic use is made of that change of level. Another image, however, depends for its particular character on discontinuity where BN has taught us to expect and enjoy flow. This is *1978 (flamingo)* [plate 413] in which a mug with black bands meets a jug, and the upper part of their encounter is interrupted by an invisible barrier: lines and bands end and are deflected without explanation. The result is both pleasing as a mainly black-and-white image (plus some warm and cool washes on the right) and highly disconcerting.

It is striking that the two largest 'paintings on paper', done on board, are almost pure drawings, with only small patches of black – accents rather than invasions – and slight washes. The objects are drawn to appear opaque here, transparent there, quite without apparent logic, and the lines make known their need for extension and excursion beyond their descriptive duties. In the Tate Gallery's *1979, April 20 (vertical stripe)* [plate 400], they make shapes we do not even try to

413

**413**
*1978 (flamingo)*.
Pen and wash on
paper, 39.4 × 36.2 cm
Private collection

read as still life or table but accept as shapes, and some of these go off the edge of the board, turning the entire linear construction into something like a free network and stressing the flatness of the whole. In the Fitzwilliam Museum's *1979, April 22 (ivory)* [plate 415] a line to the left edge and a line to the bottom make it as clear as anything in BN that the motif is a still-life group on a table or at least hovering above one. A sharp-footed triangular decanter, seen with its corner towards us, almost persuades us that there is some sense of solidity and three dimensions in the work, and there is even a modest patch of black pretending to be a shadow to emphasize that, but it is denied by everything else – by mugs and a goblet floating mid-air, and also by the vividness given to what seems to be a negative form, a roughly triangular shape in the lower centre, framed by three little patches of black and highlit by the breaking off, above and below, of a soft, slight brushstroke of charcoal grey. Touches of grey and greenish yellow, dabs rather than washes, give texture and age to the surface. The group itself has the significant tendency of BN's still lifes to fan out and move upwards.

There are no fundamental changes from all this in the 1982 exhibition. Blue is used more than before, as thin washes and also as solider paint, and different blues can interact in the same work. There are occasional touches of bright red. Few of the works suggest gloom. *1981 (storm over Ascona)* [plate 416] is one, its relatively stable still life made insecure by a curving sheet of paper. Two curved lines, hinting at landscape, add to the uncertainty though strong patches of black in the group anchor it. A blue-grey wash sweeps across much of this and reappears in the sky where it is given an additional rough dash of charcoal grey to make the storm of the title. The whole is uneasy, though strong. In *1981 (Welsh landscape)* [plate 417] black is dominant. The negative, white form of an upside-down handle strikes

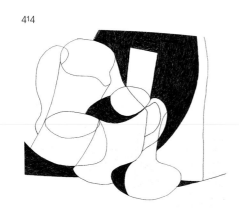

414

**414**
*1978 (black shadows)*.
Pen on paper,
56.2 × 43.8 cm
Private collection

The 1970s and early 1980s

415

**415**
*1979, April 22 (ivory).*
Pen and oil on board,
82.5 × 100.3 cm
Fitzwilliam Museum,
Cambridge

**416**
*1981 (storm*
*over Ascona).*
Pen and wash on
paper, 57.8 × 50.8 cm
Private collection

416

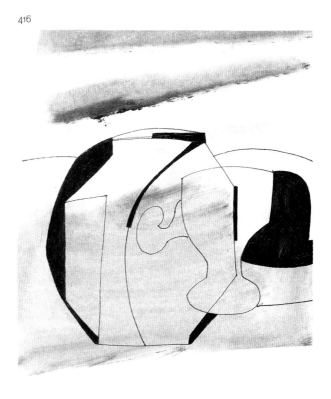

The 1970s and early 1980s

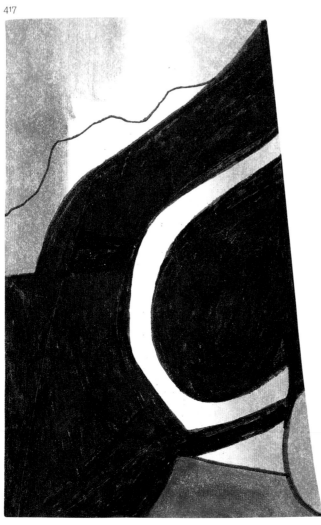

**417**
*1981 (Welsh landscape).*
Pen and wash on paper,
27.3 × 19.6 cm
Private collection

**418**
*1981 (interior cathedral).*
Pen and oil on board,
64.1 × 64.5 cm
Private collection

The 1970s and early 1980s

a brisk note, and there is light in the sky where a line meandering on a diagonal path hints at steep mountains. There is little else by way of still life, yet the whole small work, about the size of your hand, has all the fine BN dualism of near and far, small and large, familiar and strange.

Black is more dramatically dominant in *1981 (interior cathedral)* [plate 418]. There is a lot of black in the right half where curving bands of black interfere with still-life lines to leave negative shapes some of which remind one of Romanesque and Gothic arches. The left half is all black, with a hard edge, top to bottom, dividing the two. If we look again, 'all black' turns out to be an exaggeration: blue shows through much of it, and we can just make out lines of an eclipsed part of a still-life group, but the strangest discovery is a rectangle of solid charcoal grey in the top left corner. The black-on-black effect recalls Ad Reinhardt but there is no evidence that BN knew Reinhardt's work. He may have glimpsed it in a magazine. He would certainly have enjoyed knowing that learned, highly intelligent and deeply humorous man. An architectural note is struck also in *1981, September (several forms)* [plate 419]. Here lines and black patches present a still life in the foreground while other lines suggest a landscape setting. There is also an emphatic vertical line, left of centre and coming down from the top, that is read as the corner of a building. Not a cathedral; more likely a Greek house. A dash of cheerful blue top right speaks of sunshine.

Some of the paintings on paper could be called abstract, and some of them are untitled, though BN's use of 'untitled' can also go with a legible object or group. Their abstractness would seem to have been arrived at rather than set out to, by gradual development, one or two forms becoming dominant as free shapes rather than as references. In some instances it seems that BN's interest fastened on what was probably just one area of a larger drawing so that he isolated it with

419

**419**
*1981, September (several forms).*
Pen and wash on paper, 45 × 62.2 cm
Private collection

his scissors, discarding the information that gave those lines and forms referential meaning. For him the conventional barrier between abstract and figurative art had always been meaningless. In *1981 (mystery)* [plate 420] we see first shapes and washes in black, blue and darkened brown. The shape of that brown may have grown from a handle or the foot of a goblet: it is now an independent shape in earnest dialogue with the black plane backing or surrounding it. *1981 (untitled)* [plate 421] has been cut out of a larger sheet. We can see what fascinated BN in those echoing lines and forms, particularly the curving form in the centre which was once a handle and has become a new growth rising, apparently a solid thing, out of a perspectival black plane. In *1981, September (mountain side)* [plate 422] we can see the mountain side clearly enough – indeed we sense it before we read it – but what still-life objects there are have been largely consumed by a flow of blackness coming down that steep face, obliterating much of a mug and almost all of a goblet. This must not be taken to mean that BN's last works progressed towards a goal called 'abstract art'; rather that he was drawing and colouring with ever-increasing freedom and interest, finding, as he worked, new visual themes to respond to.

Some of the lines in these last works show a slight tremble in the hand; what is amazing is how many do not. It must also be said that though the hand may have shaken at times the mind did not. The pens themselves sometimes disobeyed, making an intermitting line; sometimes almost certainly the hand did not quite do what BN was envisaging. But if the line went dry he would make a whole drawing of drying lines. If there was an unwanted kink in a line, BN knew he could repeat it in parallel, as though he had meant it to be just like that – or perhaps to show that he wanted it and us to know it had its rights and that he could

**420**
*1981 (mystery)*.
Pen, oil and wash on paper, 34.9 × 26.9 cm
Private collection

**421**
*1981 (untitled)*.
Pen and wash on paper, 22.8 × 17.8 cm
Private collection

420

421

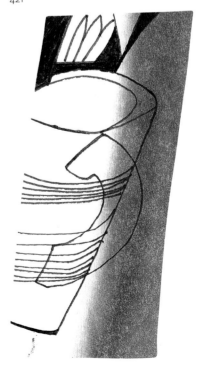

The 1970s and early 1980s

accommodate it. Thus such events could become part of the creative process and part of his mental store. No doubt some of the black patches were ways of dealing with a blemish, but then these patches become all-important contributions to the result. The old certainty, born in BN's mind in the early 1920s and never lost for one moment, that the freest and the best art comes from an open-minded working with the marks and effects which the work itself produces as it goes, here finds its apotheosis. There is no right or wrong if there is life in the result. There is no abstract or representational since in the end it is the process that we are witnessing; there is no need to claim special status for marks that make a mug as against marks that make a formal event. In *1981, April (untitled – brown and black)* [plate 423] we are left with nothing but a black shape and a terracotta one. Either of them could be part of an object. The shape of the black could be read as a broad, low glass, filled with the terracotta, light at the bottom, darker across the top. The combination seems hard and final by BN's standards of unceasing wonderment; it is also a very powerful image and were it large it would amaze and appal us.

In the 1982 catalogue Christopher Neve emphasizes BN's ease at making still life into landscape, landscape into still life, and points to a generally almost surreal air in the works taken together. They are memories, he says, often of particular places which the titles in some instances identify directly, *Ticino* and *Lago Maggiore* repeatedly, also *Ronco* and *Castagnola*. Neve aptly quotes a saying of one of BN's favourites, Braque: 'No object can be tied to any one sort of reality.' It is really what de Chirico said but said differently, and so we wonder for a moment whether Cubism and Surrealism are necessarily distinct camps, and whether BN's art, whatever its patent allegiances, does not function in Modernism as an art of reconciliation. One of the last works,

**422**
*1981, September (mountain side).*
Pen and wash on paper, 58.4 × 30.4 cm
Itawaya Department Store, Japan

**423**
*1981, April (untitled – brown and black).*
Pen, oil and wash on paper, 12.1 × 11.4 cm
Private collection

422

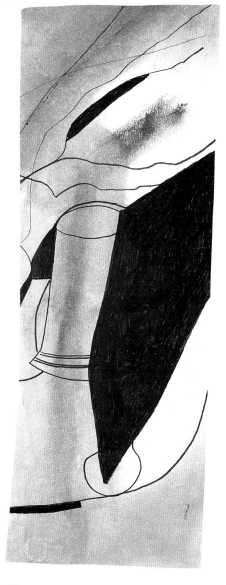

423

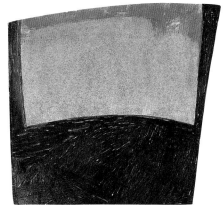

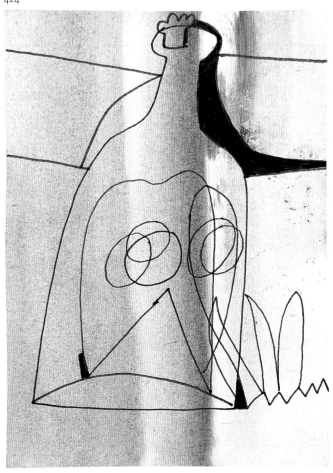

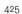

The 1970s and early 1980s

*1981 (bottle)* [plate 424], Neve says, 'has the surreal presence of a woman'. Three of the 1981 images have the subtitle *harlequinade*. This encourages me to write what might be taken to seem irreverent in the context, that together these last works on paper were a celebration, a party. To it came all sorts: the beautiful and charming, the brash, the witty and the grave, the old and the young. BN the artist was the best of hosts. Come as you are.

Is it only our knowing that the working will end that gives these images especial poignancy or is it signalled in them? *1981 (Castagnola)* [plate 425] takes us back sixty years to the time when, in partnership with Winifred Roberts/Nicholson/Dacre, he knew he was standing on his own feet. Again, this is almost all line. A vertical patch of black has taken over part of what may have been a jug. A very thin wash of bluish grey, across the top, speaks of sky. The lines present four objects – the others a straight-sided striped jug, a glass with sharp fluting and a very plain mug indeed, a diagrammatic thing consisting of a rough rectangle and curve for a handle flattened on to its side. This sits at bottom centre, where Seurat put a summary head, a clown's, in *The Circus* and Stanley Spencer put his own head in his *Self-Portrait with Patricia Preece* (1936) and Holbein put the anamorphic skull in *The French Ambassadors*. It looks like an emblematic motif, a sort of signature. A cursive rectangle, and in it what could be an opening, uncurling circle. The rectangle = matter, which mankind can form and make square, its quaternity referring us to the four stages of the seasons and of life. And a circle, at once dynamic and calm, but here opening, beginning to spiral and thus signalling also growth and evolution, a form of endless potency. Yet it is only a mug, or just a couple of lines.

BN died on 6 February 1982, at home. In a way, that too was like him. All the work was ready for the exhibition, *New Work*, at the Waddington Galleries. The catalogue was under way. The exhibition opened on 3 March without him. He had never much cared for these occasions.

In June 1982 the gardens of Sutton Place in Surrey were opened after their development by Britain's leading landscape architect, Sir Geoffrey Jellicoe. BN and Jellicoe had been friends since the 1960s, close friends after BN's return to London. Knowing BN's ambition to see a large-scale Nicholson relief set up in a good location, Jellicoe had investigated a number of possibilities of achieving this; all sorts of difficulties got in the way, practical and financial ones, not least BN's clear ideas of what would do. The wall at Dokumenta III had to be temporary and was built accordingly. The Sutton Place wall also was first to be built in concrete but in the end was constructed of Carrara marble.

The idea was to set up a greatly enlarged version of a white relief at the north-west end of the extended terrace between the house and its gardens. BN and Jellicoe had considered creating a new, rectangular pool to provide a reflection of the wall, a more generous version of the one at Dokumenta. But there was an Edwardian pool there already, of a strange shape, almost a long rectangle but with irregular straight-sided bays cut out of and into that rectangle. In the end BN opted for keeping it, and also the trim yew hedge that frames the site. The wall would stand at the far end of this semi-enclosed area, and at the far end of the long pool.

The relief chosen was that owned by the Albright-Knox Gallery in Buffalo, *c.1937-8 (white relief)* [plate 120]. That work, carved by BN out of the spare leaf of a Victorian mahogany table, measures 64 × 126 centimetres. It is a powerful piece, with a slightly projecting vertical rectangle presiding over a dialogue between two recessed circles, one large and relatively deep, the other small and shallower. It is evidence of BN's working by eye rather than by

**424**
*1981 (bottle)*.
Pen and wash on
board, 36.8 × 28.9 cm
Private collection

**425**
*1981 (Castagnola)*.
Pen and wash on
board, 57.2 × 59.7 cm
Private collection

**426**
The marble relief at
Sutton Place, Surrey.
White marble,
488 × 976 cm
Enlarged copy of
*c. 1937-8 (white relief)*
(plate 120)

**426**
The marble relief at
Sutton Place, Surrey.
White marble,
488 × 976 cm
Enlarged copy of
*c. 1937-8 (white relief)*
(plate 120)

**427**
BN in his studio at
Brissago, 1963. Photo
Felicitas Vogler

measurement that its proportions are so very nearly those of a double square. It was decided that the Sutton Place version would be exactly that, and raised slightly off the ground on a set-back black marble base. Its total measurements are given as 16 × 32 feet (approximately 488 × 976 centimetres) – about 60 times the size of the original. The greatest care went into an exact replication on this august scale, with BN watching over every detail. The wall had to be assembled out of several slabs of marble, so that one of the questions that exercised him most was where the joints should come since these would and should be visible. They should not, for example, impinge on the circles or draw any continuous lines across the relief. He was content with

the work as it progressed but never saw it finished.

The Sutton Place wall is a success [plate 426], strong and calm but with enough incident in it to hold one's attention. It dominates its site without pomp. As the light changes its presence changes too. On a bright day it is a very positive, confident image; on a grey day it retreats a little though its whiteness is still a blessing on the scene. Jellicoe subsequently hoped to place another large sculpture in the grounds, to stand by a new pool: a large bronze version of Henry Moore's *Divided Oval*. This is a horizontal form carved in white marble in 1967, nearly one metre across, in the collection of the then owner of Sutton Place. Moore was keen and helpful. A large bronze was cast in Hamburg and approved by him, but in the event it stayed there, acquired by the German government and set up on a not very satisfactory site. One wonders what BN would have thought of this pairing. The two pieces would have stood half a mile apart and not visible together. We noted in Chapter 4 BN's and Barbara Hepworth's reservations about Moore's *Madonna and Child*. This Moore is an abstract work, in organic forms that could be thought remotely anatomical. In a letter of 1971 BN referred to *Circle* and Surrealism and went on: 'Personally I have considerable trouble with anything "organic" (if that's the word – ) in abst. ptg or sculpt.' And he referred to 'very nearly a good Moore' the sculptor had given to the Tate Gallery in memory of Herbert Read – 'but at one point it looks as if the form is a truncated leg – to resolve this to the same point as the whole of the rest of the sculpture would be my burning problem.' The two works would have been very different, and the large bronze Moore would have lost some of the attractions of its white marble original, though it would have gained in monumentality. Jellicoe said to me that he thought of the Moore as representing the past, and the Nicholson the future.[7]

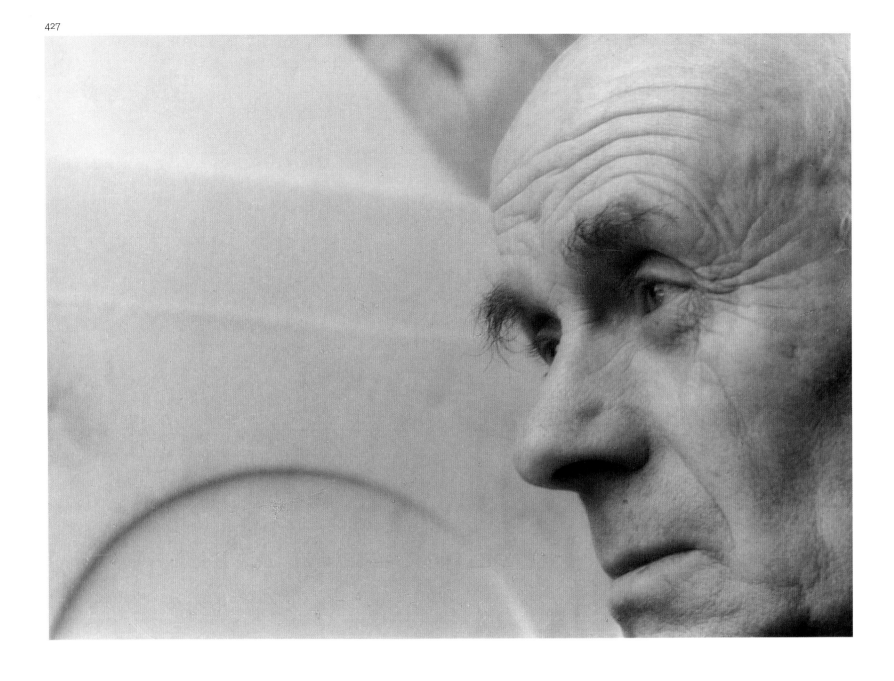

The 1970s and early 1980s

'Yes, it was an orange pomeranian, the less I think of it the more certain I am. And yet.' (Samuel Beckett, *Molloy*, 1947-8.) In surveying BN's work through more than six decades I have found myself drawing repeated attention to its ambiguities. In 1968 I used Beckett's words as a motto for a short text in the catalogue of BN's exhibition at the Beyeler Gallery in Basel. At this date I knew him only slightly, and was relieved when he later told me he liked the quotation. It still seems to me to say a great deal about the nature of BN's work that could only be said more laboriously in other words.

It would have been enough of an achievement had he proved himself a British representative of an international movement in modern art. That should have given him status in a country still hesitating to embrace Modernism. A clearer image and a tag would have made it easier both to praise him and to attack him. There is nothing like a brand image to establish an artist in the public's mind. Instead, his commitment was to remaining detached from almost all movements and to distance himself from the one movement of which he did appear to be the British protagonist.

The poetic, quasi-naïve idiom he developed in the 1920s owed little to Paul Nash, whom he admired and who might have been his first model, and nothing to the light Post-Impressionism of the Bloomsbury painters. It seems to have come out of Winifred Nicholson's instinctive search for an immediate response to the marvellousness of light and colour, growth and movement in nature. Their interaction was certainly mutual and he destroyed so much work at this stage that any conclusion about his early work must remain speculative. Yet I believe it was she who led the way into the fresh lyricism both used so well, aided and abetted by the crisp white winters they both enjoyed in the Ticino and the many stimuli their passing visits to Paris could afford. His work of the early 1920s shows a heavier primitivism and then also a classical figuration which do not appear in Winifred's work and which he soon abandoned. The essential point is that they had joined in rediscovering painting by starting from simple responses to the visible world and to the fresh and luminous things art's media made available to those willing to use them. They were stripping off the conventional subtleties and luxuriousness of Victorian and Edwardian painting, as well as the literary bias of much Victorian painting. Neither of them wanted association with any known style or model. In BN's case this decision had already been made in respect of his father.

He did, of course, venture into a Cubism-based form of abstraction in 1924. It appears and disappears suddenly in what we have of his work; there were other works which would have shown him moving towards it. Still lifes dated 1926 and thereabouts point to Cézanne and to Braque as major influences, not the Cubist but the post-Cubist Braque of the early 1920s. All this looks retrospectively like an excursion from Winifred's steadier and narrower pursuit; certainly BN was by nature the more experimental painter, and here he was using not only a more decidedly avant-garde idiom but also a distinct set of techniques. Yet it is about this time also that BN made his most innocent-looking paintings. Interaction with Christopher Wood may have eased his move into the full fluency of the landscapes of 1928 and after, but these are not basically like Wood's and they tend to be more firmly structured than Winifred's. That structural emphasis is patent in his still lifes of the same years. Here we now meet repeatedly the objects that will travel through his art like a troupe of players in repertory. From the first they are used as emblems: flat shapes, some of them with individual forms of ornamentation, to be arranged and manipulated in an infinity of ways without surrendering their identities. He never submits them to Cubist fragmentation

Chapter 8

# The Art of Ben Nicholson

nor to the Cubist game of contrasting volumetric presentation of an object or part of it with a flat image.

Braque was again an influence in BN's work of the early 1930s, when he began his life with Barbara Hepworth: both the free post-Cubist Braque of rich browns and blacks and domestic warmth, and the Cubist Picasso-and-Braque amalgam of collage and pretended collage. Picasso had taught BN the reality of a patch of colour as a patch of colour, and BN stressed that it was for him its Cubist, in effect abstract, setting that gave the vivid colour its power as idea. Winifred and Italian pre- and early Renaissance painting had taught him the reality of light as a force in painting to be invoked by means of luminous colours but also by white itself. For a short period BN was seduced by Braque's low and suave tones. Then, quite suddenly, he made his break into the white reliefs and he stayed with that curious sonority – at once a kind of silence and, especially in the British context, a clarion call – for several years.

It is at this point that BN finds himself identified with a particular kind of work and seen as the major British contributor to an international avant-garde movement. He may have felt he needed such an image at that point. His membership of Abstraction–Création meant something in Paris but not in London. Unit One was a brief and ill-defined gathering. He tried making the Seven and Five Society into a British Abstraction–Création but broke it in the process. *Circle* and what Gabo called Constructive art gave him a place and an apparent purpose in a London where movements and theories were now manoeuvring for prominence. It must have looked in 1937 as if he had turned against everything he had done before the middle 1930s: nothing now but the Constructive idiom which had some of its roots in Cubism but was more directly a creation of revolutionary Russia. BN's reliefs would have been recognized as *Kulturbolschewismus* in Germany just as they would have been condemned as bourgeois in contemporary Russia.

BN chose that moment to exhibit still lifes alongside his geometrical white reliefs and brightly coloured abstract paintings. He thus made visually a statement that held for the rest of his life. In words he had already asserted it: he was not to be seen as any one sort of artist, stylistically or in such matters of principle and art politics as whether or not to work in abstraction or figuration. His stated aim was to produce something that lives and gives pleasure by lifting us out of the mundane and the material on to a higher plane of awareness. I argued in chapter 3 that BN's abstract reliefs were basically transformed still lifes; that the pioneers of abstract art appropriated the most aspiring and honoured form of post-Renaissance art, the History painting; and that BN's ability to elevate the form of still-life painting to the dignity of History painting is an astonishing achievement, even if largely an unconscious one. He might well have pointed out that Cézanne led the way here, as in so much else: Cézanne's still lifes can have the gravity and significance of History paintings, though he still required his career to culminate in a series of large figure paintings. BN names Cézanne repeatedly in his statements as a key figure without quite saying why. Of History painting of course he says nothing; for him that would be art historians' business. Had he known of the genre hierarchy he would have inverted it instantly for himself, since History painting is traditionally allied to literary subject-matter. Yet it is also a fact that traditional History painting's aim was instruction + delight. This was also BN's purpose in making his reliefs and speaking of religious experience. He will have sensed the radical difference between what he was out to do and the task of History painting and what he called literary painting:

that these are art in the past tense whereas his art had to be about today and tomorrow, in subject, manner and spirit.

Christopher Neve, in his introduction to the 1982 Waddington catalogue, among many subtle observations, says that 'Nicholson's work is of the present day but has the aura of the past'.[1] He is speaking about the 'new work' of which the show consisted, but perhaps he meant it also as a general point. All art refers to the past in some way, except that which achieves a wholly impersonal naturalistic rendering of a visual motif and, in abstract art, that which is made by following a system (though the choice of motif and of system may harbour a reflection of the past). Experience and recollection play their part. Yet the making is of now, and BN's art resonates with making. Even his drawings: although we are obviously looking at something done on a particular day in a particular place, we are also looking at lines that are alive now. I do not mean just that they are lively but that they exist in this sense separately from the day they were set down and of course from the age of the motif. The skilful input of the artist's eye and hand, and the energy he transmits through what he does, live on in the present. The landscape experiences he incorporates in the later reliefs may be yesterday's or last year's or older than that, but the recollecting is in the present for him and the fashioning of the reliefs to carry the experience, that is the transforming of it into art terms, is something we watch happening.

Some of the late reliefs – though none of his drawings – refer to his visits to Carnac and other prehistoric sites and his admiration for physical presence and the mystery of standing stones and other such ancient works. Paul Nash discovered Avebury in 1933 and was deeply impressed by its stones. The paintings he made subsequently on the subject of these megaliths and their setting play living nature off against the ancientness of the stones and come close to suggesting that the stones are human vestiges in a post-apocalyptic world which mankind left long ago. BN's megaliths exist as today's potent objects in the reliefs as in the landscape, and one senses no self-consciousness vis-à-vis the distant past in his passion for them. 'You feel that they must travel right across Europe and Russia and on into infinity,' he said of them.[2] They are of today as much as is the campanile of Siena Cathedral and the storm over Paros. That is in the subject, but it is even more unambiguously in made works of art. Neve, in discussing the role of memory in BN's images of places he has visited, says rightly that the artist has no need to represent them directly: 'There is no call for landscape souvenirs like postcards.' My point is that, though memory serves as impulse and perhaps partial gauge of rightness (partial because the work itself makes its own demands), the result is not in any case a souvenir but a new growth. Unlike the Neo-Romanticists who attracted attention and patronage in the late 1930s and through the 1940s, BN never dealt in nostalgia.

Once he had given notice that his art was not to be placed in any available category, BN behaved with remarkable, visible freedom. Still lifes grow into monumental quasi-abstract paintings; landscape experiences are transformed into sometimes homely, sometimes epic abstract reliefs. Still life and landscape are brought together with varying degrees of abstraction and sometimes in contradictory idioms. The basis of all this work, however close to nature or far from it, is subjective experience. Yet it is not perceived as being subjective art. This is partly because we associate subjectivity with pain and protest – with, in brief, the broad tradition of Expressionism (even though some of that was no more than a display of high spirits). The area of subjective experience BN drew on was that of delight: 'a living thing

The Art of Ben Nicholson

428

as nice as a poodle with 2 shining black eyes'.[3]

This is as ambitious as it sounds modest: we cannot make poodles. We can make mugs and goblets, and they may please us greatly, and tables and window frames, and the landscape before us may or may not be wholly nature's work and we can put buildings in it and take ships across the water, but the ambition of this artist is to make an object as living and as good as a poodle out of all that and a force, 'an active force in our lives'. That is what in 1941 he called a Raphael. If BN's art spoke of hell-fire we would know at once we were in the presence of a preacher; his persistence alone would tell us that. But it is about life and so it can be thought lightweight, even frivolous … though the same persistence should protect him against the charge. BN's art speaks of gladness – a response at once poetic and physical to the visible world but also, all important, to what happens in the studio. At times the drama is more intense, and then the word gladness can sound too slight (though for Blake, as in *Glad Day*, gladness associates with monumentality). But the end product is always a positive statement. If very occasionally (for example in the mid-1950s) we sense that the drama he is staging is not necessarily a happy one, the work we confront has still been wrought with pleasure that we can participate in.

This focus is not unique to BN's art, but it is something not often spoken of for fear of belittling artists in the aftermath of Romanticism. We seem reluctant to accept that some of the finest and most adventurous modern artists have had pleasure as their means and purpose. Modern art's association has so habitually been with shock, destruction of the past, ugliness, avoidance of recognizable subjects, aggression against the subject (most obviously, the human image) when there is one, that it still feels improper to speak of pleasure. Brancusi said, 'It is pure joy that I am giving you,'

The Art of Ben Nicholson

and he meant just that. Matisse spoke of his art as providing rest and peace, 'an appeasing influence'. Mondrian slowly fashioned a form of art that would exclude all destructive desires and celebrate humanity's creative potential. I don't think the word joy occurs in BN's statements yet he does speak out plainly about pleasure, about art as a sane and living thing which can become part of our living, and he speaks with a warmth that at times goes beyond polite English usage. In the same text of 1941 he spoke of abstract art as an 'interplay of forces' and said this related it to 'Arsenal *v*. Tottenham Hotspur quite as much as to the stars in their courses'. In 1961 he spoke of the parallel 'between the movement in a Raphael painting and the classical style arrived at in the 1920s by the French lawn-tennis player René Lacoste; in each a continuous flowing movement unfolds so that no single movement is isolated'.[4] He was of course nudging at his readers' conventional scale of cultural values, but he was also taking account of the fact that they would respond to mention of football teams and tennis stars better than to talk of abstract forms. So he appeals to experiences of physical dynamics at the highest professional levels. These have to be, for almost all of us, vicarious experiences but then art too is vicarious experience: he is asking us to give the same sort of positive attention to his work, the same sort of empathetic engagement, as we give to sport. Through empathy we can join the artist in making a line soar across a canvas or in taking a colour to its required presence in a given context. But we have to approach the object he has put before us on the level of enjoyment, not as a problem but as a live encounter.

To differentiate the point a little further. Arp's work is full of pleasure and fun. It makes jokes. BN's art has jokes in it sometimes. He was attracted to Arp's work at the start of the 1930s though as a model it was probably more important to Hepworth. But the humour in BN's art is closer to wit than to jokes, a deeper action that is both visual and mental and touches every aspect of a work and radiates from it. Making sophisticated use of childlike idioms is one form of this, a dangerous one of course. BN's primitivism was never a pretence. To attain it he had to unlearn many things inherited from his father, from art training and 'Vermeer'. He formed a BN style of primitivism, and Alfred Wallis's utterly truthful, necessary sort was welcome confirmation. BN would never have claimed that you could explain modern art in terms of 'childish drawing' plus 'the beauty and refinement' of the artist, as Wood did.[5] He demanded from himself a much wider base and a much deeper understanding. He said in 1963 that, rather than deny being influenced, as some did, 'I'd rather say that *every* alive painter (and sculptor) that I've ever seen influenced me (I hope). … I feel a strong link with, say, Chinese, Greek, Spanish, French and Italian art, and of course with primitive art of many kinds. I also feel that we have a period in painting today which is immensely alive,' and he went on to offer some names, American and European, and to point to Cézanne's and Chinese painting's 'eternal quality'.[6]

Much of this 'eternal quality' is in BN's work, most obviously so in his reliefs; the phrase comes close to defining what he was after. Suppose he had gone on making Constructive art, the white reliefs and occasional brightly coloured geometrical paintings. That work speaks of the 1930s yet, like Mondrian's and selected pieces by a few other moderns – Brancusi, Matisse, Picasso, Klee – it is also timeless. In standing above time it stands also above style. Had he gone on doing that, he would no doubt have found many things worth doing within those confines, and the world would be a better place for having more of it. His image and the shape of his career would have been like Mondrian's,

The Art of Ben Nicholson

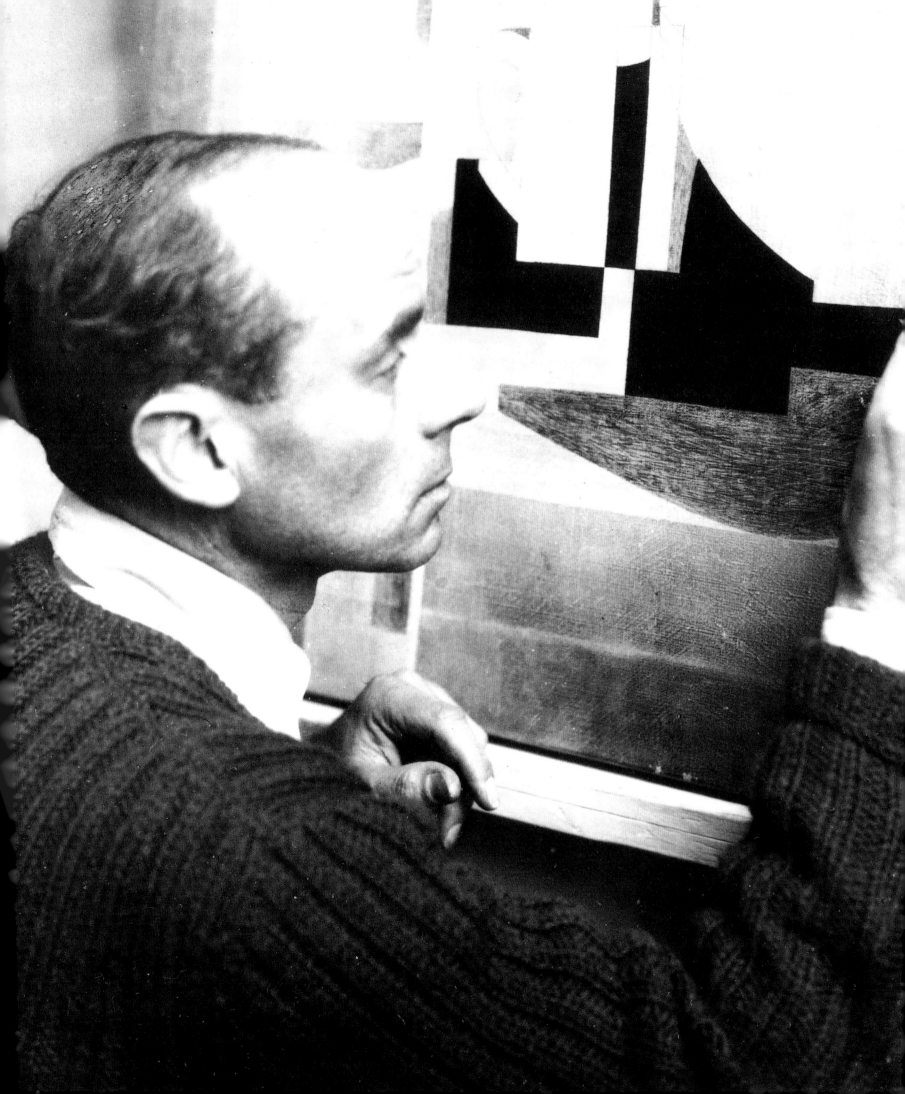

430

providing him with a nameable place in modern art. Yet moving on was not merely negative, a form of restlessness. To remain in one place was not his experience of life nor his understanding of art, and in this too an energy operates that comes close to wit. Above all the ambiguity that is always at the heart of his work, destabilizing even the most apparently solidly founded of his works, is a form of wit. It is precisely in the white reliefs, with their beguiling simplicity and solemnity, that we find it operating most subtly and persuasively.

Mondrian did not comment in detail on other artists' work but made it clear he thought well of BN's. I know of no BN comments on individual Mondrians beyond warm approval. I suspect Mondrian would have respected BN's white reliefs and colour paintings but would have found them a little too loose and unresolved to satisfy him: the elements are not in the end tied down. Conversely, one would expect BN to find Mondrian's mature paintings, generally speaking, too resolved, too nailed down with layer upon layer of paint, though he would have been more sensitive than anyone to the tensions set up in them. He admired them greatly but selectively. The ones he liked best he valued above almost anything else in modern art. He wrote to me more than once about a Mondrian he had seen in a London collection, one from the mid-1930s: it 'looked as good a ptg as I've seen anywhere at any time & with an extraordinary *power*. ... I like power in *this* form & here it justifies itself.'[7]

An important negative principle BN and Mondrian shared is their lack of system. In 1919 Mondrian used a grid as the basis for a succession of outstandingly beautiful canvases; he abandoned the method, perhaps because it tamed the tensions he wanted to set up with his painted structures. Similarly, BN, contrary to many a commentator at the time, did not use mathematics or any other extraneous resource as a basis for his reliefs. Both artists worked by eye and

hand, and even when BN turned to compasses and rulers the decisions behind them were intuitive and the aids did not preclude free-hand work.

We recall BN's enchantment at the sight and spirit of Mondrian's studio in 1934, when he was still finding the work puzzling. Mondrian will have set some of his pictures up on his easel for his visitor to study, but what BN absorbed was the white environment plus the colour rectangles pinned to the walls of the studio, turning the whole place into a Neo-Plasticist interior. The arrangements were free: the edges of the rectangles were all vertical and horizontal but there was no grid or other linear system tying them together. Their relationship was as irrational as were the relationships in the white reliefs BN was exhibiting in London that March. He went again, but his understanding of the paintings came only gradually:

His studio in Paris contained a special feeling – this I spotted (as anyone wld surely) while the ptgs were so new to me that I suppose I regarded them as merely contributing to this [here a BN line swoops up to circle the words 'a special feeling']. A year later I visited him again & then began to understand the ptgs (this in mid-1930s) & a year later went again to his studio & understood more. Now I understand them very decidedly.[8]

It is because these two artists, the Dutchman and the Briton, stand head and shoulders above the others in 1930s abstract art that this kind of speculation is warranted. The world would have come to know this of BN had he gone on holding that position, reinforcing it with more work and related statements, and we might even have come to admit the transcendental thought embodied in his work as we have had to do, slowly and reluctantly, in the case of Mondrian, Malevich, Kandinsky and others. The war approached, BN moved into Cornwall. Most of all it was his own need of freedom that made him reach out for new ideas. He was

a youthful 40 when he embarked on the white reliefs (Mondrian was 49 when he painted his first Neo-Plasticist compositions); even when he was in his eighties he followed his instinct into new kinds of work.

So BN abandoned his key position. He never had another one because he was never again willing to pursue one nameable idiom for long enough. Not that he was changing his mind radically, or jettisoning anything substantial from his past. John Russell put it very well when he wrote that 'What is special about BN is, in fact, the continuous overlapping of his ideas.'[9] His ideas are not eternal laws but discoveries and tools, to be reused, combined, fused, shuffled, adapted, above all added to. That too involves a kind of wit. It can also signal restlessness – 'Ben loved moving, making new environments', Winifred wrote in her reminiscences, and she joined to that the recognition that though he destroyed so much of his work in the 1920s 'he never once said, "O dear I can't paint, I can't reach what I want, I shall never be a painter". He never said it, not so much as a murmur of it, because he never thought it.'[10] The corollary of that is that he never said to himself, 'This is it: I now have reached what I wanted to reach; from now on nothing but further demonstrations of the same thing.' After about five years he moved on from the white reliefs, having already shown that they had not occupied him exclusively.

Since BN had no one goal we cannot present his career as the path towards it. This makes finding one central development difficult, let alone describing it. Anything said firmly creates doubt. Take his debt to Cubism. Summerson, guided by him, says that in the period after his return from California, BN 'slowly discovered Cézanne' and was 'attracted to Wyndham Lewis and Vorticism'. Then: 'The real revelation, however, came when he began to visit Paris and to see the work of the Cubists', that is when he saw that Picasso with

**431**
Works by BN, Barbara Hepworth and Mondrian on display at the 1936 *Abstract and Concrete* exhibition (see p. 112)

431

its area of an amazing green colour. That this was a Cubist painting appears incidental to BN's response, which was to a colour in an abstract setting. In his statements BN repeatedly stressed the importance of Cubism, in reaction perhaps to the Bloomsbury artists' reluctance to accept the revolution it wrought. To BN it was a liberating movement. It liberated painting from the need to give coherent accounts of the world, it liberated the virtual space of a picture from the duty of offering convincing accommodation to a subject, it liberated the image from delivering a clear subject, it liberated colour from identifying what is represented. It shed duties imposed by Renaissance humanism. In his first known statement, in 1932, BN likened the refusal to accept Cubism's intervention to ignoring Einstein in order to cling to Galileo. The beauty of art, as opposed to scientific development, is that it does not trump, let alone destroy, the past; BN implies that this is also true of scientific thought, and speaks of the new ideas as 'unfolding the past'.[11] He was convinced that positive thought lives on and is available to us as an undying resource – another reason for not limiting one's activity.

Barr's book of 1936, *Cubism and Abstract Art*, long provided the best guide to modern art's international development and interactions. In it BN appears as part of a 'younger generation' of abstract artists and as representing the 'geometric' as against the biomorphic (e.g. Moore, Hélion) faction in it. But all this, Constructivism included, stems from Cubism in his mental map of Modernism. Nutshell accounts of BN have tended to emphasize his involvement with Cubism – see, for example, Russell's statement that until 1933 'the more evidently radical Nicholsons had been variants of cubism, with Braque and Picasso as the godfathers at the font'.[12] It might well have been so: BN was moved by an area of colour in a Picasso in the early 1920s, he was certainly close to some aspects of Braque when he painted *1926*

*(still life with fruit – version 2)* [plate 26], and he was even closer to Braque in the low-toned paintings of the early 1930s. There were good reasons why he might have attached himself to the Cubism of Picasso and Braque. Vorticism, the short-lived but memorable English movement that was rooted in both Cubism and aspects of Futurism, had attracted him as a way of escaping from the basic convention ruling art in England then, that it had to be polite, sophisticated and rich. Cubism must have seemed a more powerful, less parochial alternative. It lived on in 1920s Paris, but mainly in academic versions that turned it into an orderly, classical way of organizing forms on a surface, cancelling most of the freedoms it had offered. Analytical and Synthetic Cubism, created by Braque and Picasso before the first world war, could be found too, not the latest thing but full of interest and charged with the vitality and wit that BN valued. If he made a conscious affiliation it was with Synthetic Cubism, introduced in 1912: Analytical Cubism was too concerned with disrupting systems of representation and too limited in its use of colour, whereas Synthetic Cubism was an art of construction, demonstrating the artist's right to build with whatever he liked in the way of form, space, colour, pattern, representation or abstraction, with paint and collage and pencil or charcoal drawing in the same picture.

BN himself said, 'my route was obviously via early Cubism to Mondrian.' It had to be 'early Cubism'. 'Those pre-world war 1 Cubist ptgs *still* move me enormously,' he wrote in 1968, '... and I mean Braque & Picasso (Gris had no influence on my work – I can admire the best but they don't move me – they are too conscious). ... [postscript:] I think world war one knocked true development of Cubism on the head (& indeed everything else).'[13] We see the results in those two fine paintings of 1924, saved by BN from the routine of destruction and reworking: *first abstract painting – Chelsea*

The Art of Ben Nicholson

432

Sat aft

dear   me to leave you letter
some of still life
of the photos are VERY

NICE

would like enlargements of these
five
please

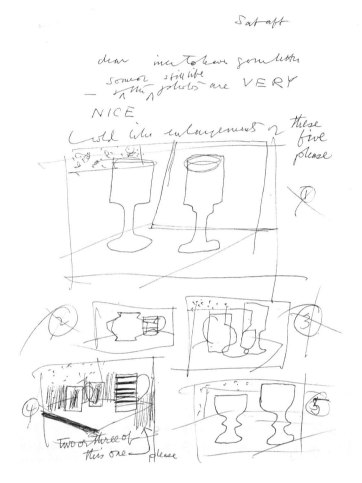

two or three of
this one — please

evident the tele
camera is just the
chap for still life

perhaps you can take a
funny one for the Mettmess
book

?

Take care of yourself in
Zürich ( Charles is (supposed)
to be coming on Tues. — I have
many important things to discuss
with him so don't dis-courage
him - - -)  what a beautiful p.c.
& those deer in snow - - aren't
you a deer (deer?)?

endent the house tisdale — with love
in the first arrund — please remember
I think I could get some super photos
& architecture with that camera
I've found the tripod

The Art of Ben Nicholson

435

and *trout* [plates 19 and 20]. Yet it is oddly difficult to trace these two back to a particular source. They do not look like any Picasso or Braque. They come closer to what Apollinaire dubbed Orphic Cubism when it appeared in an *ad hoc* group show in October 1912: the work principally of Robert Delaunay, and also of Picabia, Léger and Kupka at that time. Here colour and flat, all-over design were dominant in compositions that were mostly without centres (as Picasso's and Braque's still were), and they tended to a weightlessness, an anti-gravity vision in which the bottom of the canvas was something to arise from rather than sit on, which Kandinsky shared with the Orphists and BN demonstrated in his 1924 paintings and in many subsequent ones. One wonders whether he had seen anything of Klee's abstract colour compositions, but that is unlikely. It would have made very good historical sense if, like Klee and Kandinsky and other Blaue Reiter painters, BN had had contact with Delaunay – indeed if Ben and Winifred Nicholson had become part of the Robert and Sonia Delaunay circle, but there is no evidence of that either. It seems he fashioned those remarkable paintings out of many intimations.

Thus the moment we try to identify BN's 1924 Cubism we have to admit its distance from any known model, and the same applies to his work of the early 1930s. What is Cubist about *1932 (Au Chat Botté)* [plate 81] is first of all the lettering, introduced by Braque twenty-one years earlier and by now a familiar device, and then also the way a discrete drawn form, the little guitar, is included in what is mainly a work of paint on canvas. Nothing else in it needed Cubism as a model. The white reliefs have no clear source but embody so wide a range of impulses that one almost forgets BN's positive act in producing them. From a bit of gesso falling off the support as he cut lines into it to the fully fledged white

reliefs was a short step in time but a vast one in concept, and I offer this moment as illustrating a specifically BN gift, close to the heart of all his art and being: of seizing the right hint at the right time and seizing it recklessly. 'The road of excess', says Blake, 'leads to the palace of wisdom.' BN had no time for Blake's Gothic visions but he liked the voice.[14] While enjoying the beauty and athletic perfection of BN's work, or perhaps accusing it of being constrained by English habits of moderation, we should also be capable of admitting his headlong adventures into areas that anyone would have thought extreme before the event. When BN writes that 'In my work I don't want to achieve a dramatic arresting experience exciting as that can be, but something more enduring – the kind of thing one finds say in the finest Chinese vases or in the Cézanne apple paintings,' we may choose to focus on the perfection of the vase and on what is now agreed to be the deep beauty of the apple paintings, but we can also think of the painstaking development leading to that perfection and of Cézanne's struggles with his passions and his urge to give them unbridled expression to arrive at paintings in which apples touch, don't touch and nearly touch, placed precariously on an unhorizontal surface. There is a difference between second-hand perfection, got through imitation, and working towards a particular rightness. Later in the same letter BN wrote, 'I am not interested in the kind of life which sparkles and attracts or staggers for the moment but that which increases with time.'[15]

The only worthwhile definition of BN's work must somehow combine his taste for what looks like effortless perfection with his hunger for freedom. I have emphasized what seems to me the essentially libertarian nature of the original Cubism. Mondrian too won freedom for his art by excluding all sorts of things and then doing whatever he wanted with what remained; he would probably have agreed

with BN's reiterated demand for an element of surprise in a work of art. In this same sense a primitive like Wallis is entirely free within his limits; what makes him a primitive is that he did not choose these consciously. Next to all the other thrilling and useful encounters BN spoke of we must not forget his response to a Miró: 'The first *free* painting that I saw and it made a deep impression. … One can only accept what one is ready for and this I was ready for.'[16] That was in 1932 or 1933, on the eve of the white reliefs.

To place BN's work more specifically in the history of art we need to look at particular aspects of it and try to relate them to the vast body of art he inherited:

*Space.* There is perspectival space in BN's earliest still lifes and landscapes. It has gone from the still lifes by 1924; in the landscapes a sense of deep space remains, inevitably perhaps, because of the forms of the land, the diminishing scale of things, the ending in a horizon and sky. The abstracts of 1924 show him making deft use of the space suggested by apparent overlaps and by changes of tone that read as shadows, but there are paintings of the later 1920s that are heraldic in effect and lack almost any hint of pictorial space. From now on he was free to introduce space effects of all sorts, and then also to go into relief with its actual space and its component of implied spaces. BN moved to this position with unique resolution. No one else attempted it. Spaceless painting had been tried briefly by Bloomsbury painters and soon abandoned, and it had featured briefly in Vorticism. BN needed the freedom to use space where and as he liked. It was now not a given element in his art but one of his tools. His dual exploitation of real space and what people call illusionary space, in the 1930s and later, is unique.

*Composition.* The kind of composition made conventional by the Renaissance is centred and anchored. The main representation is in or near the centre; the sides if used positively function like wings in the theatre, forming a setting for the representation, and it is all set firmly on the ground. Everything contributes to a special, elevated sense of reality. Diagrammatically one could sketch this as a pyramid set in the middle of a rectangle, but closer to the bottom edge than to the top. By 1900 this convention had been challenged. Landscape painting could exist without a central emphasis, even when, as in the classical landscape art of the seventeenth century, it included Biblical and other literary subjects. At times space itself becomes the central event: the pyramid lowers itself to point to the distant horizon. With Impressionism landscape painting approaches flatness and compositions that can be composition-less, an all-over surface akin to a tapestry's representing a section of landscape without self-evident motif or motivation. It was the Impressionist generation, too, that took anti-compositional ideas from the photograph, imitating its chance imagery of marginalized and oddly cut-off figures. Japanese printmakers provided alternative models for much the same thing. The Post-Impressionist generation, most obviously Gauguin, made conscious use of pre-Renaissance and also non-European conventions, as in his use of frieze-like rows. Cézanne, on the other hand, honoured Renaissance conventions in much of his otherwise revolutionary art. And so did Braque's and Picasso's Cubism. There the pyramid is paramount; it is Matisse who explores the centreless, dispersed composition. By the 1920s the European avant-garde has many possibilities open to it but, thanks to Cézanne and Cubism, the centralized composition is still prevalent. This is particularly noticeable in still lifes; landscape painting is free to present itself as a panorama.

BN's still lifes and landscapes of the 1920s show these tendencies too: both *1923 (Dymchurch)* and *1928 (Porthmeor Beach, St Ives)* [plates 21 and 47] are centreless

compositions, whereas almost all the still lifes of the decade are firmly centred even when they are painted most softly. Yet some of the landscapes are composed like still lifes: *1928 (Walton Wood Cottage, no.1)* [plate 50] is one example, the view through a window, *1929 (Feock)* [plate 60], is another. In the early 1930s BN's use of line inscribed into a more or less flat ground, as in *1932 (painting)* [plate 69], diminishes the sense of a centre. It goes entirely with the first reliefs. The white relief series plays a typical double game. No relief is centred in itself, though sometimes one feels there are two centres. At the same time the reliefs are mounted so as to be centred objects.

The combination of still-life foreground and landscape background, frequent from the mid-1940s on, enables BN to explore dualities of several sorts, including the spatial and the compositional: flat or flattish still life against receding landscape and centrally clustered still life against expansive landscape. Sometimes this duality is quite extreme: see *1947, November 11 (Mousehole)* [plate 214]. Sometimes it is minimized, as in *1940 (St Ives, version 2)* [plate 161], where the distant scene is treated in much the same graphic way as the still life and takes on a toy character that recalls the drawings and paintings BN did for his children. The vertical polyphonic still-life paintings of the 1950s show the still-life components rising towards the top of the composition on or near the central axis: the pyramid has yielded to something more like a vertical band, with the representational emphasis above the horizontal centre of the picture. The reliefs that dominate BN's activity from the late 1950s on (he probably painted his last canvas in 1961) are at first centred in much the same way as the white reliefs of the 1930s but the larger ones tend to panoramic expansion from 1960 on. The large vertical reliefs of the end of the 1960s and early 1970s pull upwards like the polyphonic still lifes with much the same

433

The Art of Ben Nicholson

sense of weightlessness. The small reliefs are generally closer to centred still lifes, but in 1975 BN finished his last large relief, the concave *1975 (one curve – one circle)* [plate 398], and this is even more panoramic and centreless than *1923 (Dymchurch)*. In all this BN was first aligning himself with the most advanced and least conventional devices of his time and then using them with exceptional, one might say ahistorical, freedom.

*Colour* eludes useful analysis and exact discussion, but must be brought into this overview. BN's challenge to himself to make positive use of colour where his father had made such fine use of tone is clear quite early on, still within his father's range in *1919 (blue bowl in shadow)* and wholly outside it already in *1922 (Casaguba)* [plates 8 and 13]. In the abstract studies of 1924 his colour achieves an exceptional range in a context of freedom; it does not have to inform us about particular objects and BN puts strong colours next to delicate ones, primaries and near-primaries next to subtle mixtures, and colour contrasts next to finely gradated tonal shifts. The still lifes of that year also make very free use of colours, mostly without tonal adjustments. Again, one feels that from that time on he was free to do many things, even bring all colours together in the emphatic white of the white reliefs. They were not all the same white: he experimented with different pigments and admixtures. Some of the whites are more matt than others. And they have not all aged equally well, creating problems for the restorer.

Particularly bright colours, including primaries, appear in some of BN's paintings of the early 1930s, with Miró and Calder as possible instigators, and then in the abstract paintings of 1937-8. Here they suggest the De Stijl and Bauhaus call for primaries, but they are accompanied by luminous and exquisitely judged colour areas for which there

434

is no precedent in international abstraction. They are fine colours in themselves and their effect in the compositions is partly tonal, especially where they serve as a background margin to a centred rectangular composition. This combination, found again in much of his later work, most obviously in the polyphonic still lifes, is uniquely BN's and it shows his mastery of colour. But how can we define what mastery of colour means? One requirement is command of a wide range though the range need not itself be all that obvious. Mondrian used black and white and primaries – but we find that he reworks and rebalances the primaries from painting to painting, and the white too, and a great deal of his effort went into giving each element the exact visual density it called for. In this sense BN is a fine colourist when he makes his white reliefs, but he is a great colourist in his ability to do unexpected things with familiar colours and to introduce unexpected colours into familiar settings. That ability to surprise himself and us with colour is the second requirement. The third is economy. I do not mean parsimoniousness but the full employment of every colour brought into a work so that nothing is wasted. And similarly the full, positive use of tone. BN's ability to use bright fresh colours amid the suavest, most diaphanous veils that are more tone than colour, or amid visual and physical textures that operate like tone, is unique.

*Light* in art is created by colour and tone and cannot really be considered separately. But it is so much BN's concern that it must be mentioned here. Winifred Nicholson's life and art centred on light. The winters in the Ticino were light above all else. BN and Winifred admired Matisse's ability to make light out of colour combinations. That green patch in a Picasso, mentioned by both as so compelling an experience, must have struck them first as light. Early in 1934 Winifred wrote to BN from Paris, replying to his excited letter about flying from Le Bourget to Croydon: 'It is for us to liberate light … *A nous la libération de la lumière* – That and some other things even more important.'[17] BN was just beginning on his white reliefs. They liberate light, as does much of his subsequent work, and – I believe – embody other things even more important. By contrast, William Nicholson's work, in which light can perform marvellously, arises out of and resolves itself into darkness. Some of the reliefs BN made in the early and mid-1960s are outstanding for the quality of their light – works such as *1962, March (Argos)*, *1963 (violet de Mars)*, *1964, June (valley between Rimini and Urbino)* and *1966 (Zennor Quoit 2)* [plates 307, 319, 325 and 354]. Sometimes one's pleasure comes from the work's luminosity even though no part of it is particularly bright, but rather a matter of finely controlled contrasts of colours and tones in the right, unpredictable quantities. At other times the colours invoke light directly. The artist is composer and conductor of his work, bringing each element in his orchestration to the right pitch and presence to achieve its particular resonance. BN said many times that he judged the liveliness of a painting by the quality of its light.

*Subject-matter.* Winifred Nicholson recalled vividly one aspect of BN's way of working. She writes of him 'up in his studio all long happy hours', then bringing a canvas down at supper time and putting it up on the wall in the corner to see how it would affect the place if one did not actually look at it, and then leaping up as supper arrived and carrying it back up to the studio 'to have another go at it – "Coming back tomorrow," he laughed.' Of the picture she said it had been 'in the morning a still life, midday another subject, and now on the same canvas a faraway landscape of hills and mists, spaces leading to the ends of the earth'.[18] Still life, landscape, occasional animals and flowers flourish in the paintings, and echoes of some of these things in the works called abstract.

435

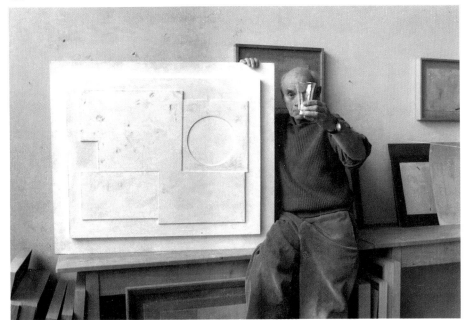

Buildings and landscapes appear particularly in the graphic work, some of them again and again. In all of this reigns BN's honest pleasure. Figures, portraits even, among the earliest works and again at the start of the 1930s; a few figure drawings later. Why not more figures? Not, surely, that they were difficult: BN's drawn figures, on paper and in paintings, are delicious and done with verve. He wrote in 1968: 'As to the human (female!) figure, I always mean to continue drawing this as it seems to me completely fascinating, & I hope there's still time − − −'.[19] Why does his art generally exclude the human image? The fact may relate to an essential solitude one senses in the man though he certainly loved women. In art terms it may relate to something equally difficult to be certain of, that he wanted to be free to manipulate the objects and scenes that are the visual stuff of his art, and that doing this with figures would have been to distort them and perhaps demean them, with painful results. The Picasso-ish Neo-classicism of the lovers in *1933 (St Rémy, Provence)* [plate 71] is distortion of a painless sort, recognizable, humorous, negative only in the sense that it evades visual truth and emotional expression; it is like a cheerful moment from a ballet. That would not be enough for an artist wanting to make major use of the human image.

Behind subject-matter lies *content*, and it can be quite different. A Picasso painting of a woman can be about happy love, despairing love, fear, death, a man's helpless perplexity before the awfulness and the marvels of sex. BN's art is about being alive and conscious of living, of breathing, moving, sensing. In some of his still lifes one senses the Cézanne content of human relationships enacted by apples, but without Cézanne's fear ('*Ne me touchez pas*', to a well-meaning acquaintance greeting him in the street). BN the artist is BN the sportsman, performing to his best ability out of innate talent, acquired skills and a sense of vital energies:

BN the animal, BN the bird flying low over the terrace. In 1962 he wrote for David Baxandall's little book on him a statement which says it in characteristic fashion. He refers to a cat that visited his St Ives house most days:

When we opened the door he would saunter in as though he owned the place, wander round, give our ginger cat a friendly push and brush past us with his whiskers as we sat at a table to a particularly highly polished spot in the middle of the floor and there he would perform a couple of extremely off-hand pirouettes followed by a single perfected pirouette, the circle of which was completed by his looking exactly under the kitchen dresser for an imaginary mouse. He made this pirouette on several occasions on this spot but I never saw him make it in any other place in the house and it is this kind of reaction to a set of circumstances which will have produced the first creative sculpture and painting.[20]

In his letters to me he twice quoted a sentence from Kierkegaard: 'as a bird gathers wisps of straw more joyful over each scrap than over all the rest of the world', adding the first time: 'it is *this* I'd like to get into my drawing or relief.'[21]

So BN's art may be said to be about well-being. That does not imply he was blind to other things in life; he did not think them apt matter for art, especially not for his own art. He had mixed feelings about Klee's work, finding some of it (as Klee did also) too intellectual and some of it excellent; but 'there is a strong belief in *death* in much of his work. It is a belief in life that I look for.'[22] He must have had something of the same feeling about the work of his friend, Paul Nash. The well-being BN worked with is not a simple, mindless thing. It ranges from domestic ease and the deep pleasure he took in landscapes and places, enhanced by the excitement of hard looking and drawing, to recalling intense joys and thrills provided by experiences of light, mountains, air and water, and many other things. The quality and weight of the experience is then mitigated, amplified at times,

possibly more channelled at others, by the process of recollecting and making, so that the content of the finished work partakes of both and it is both that we can draw on when we attend to the work.

It is because BN had a clear, broad sense of what his art was about that he could move with apparent arbitrariness between subjects. Hence Winifred's account of his cheerful move from subject to subject on the same day on the same canvas. Hence also his dazzling comment, in 1957, that 'My "still life" paintings are closely identified with landscape, more closely than are my landscapes which relate perhaps more to "still life".'[23] Five years earlier Patrick Heron had considered the role of landscape in BN's work:

The connection is there, and it is a strong one; but it is oblique. I mean that it is in his more abstract still lifes, rather than in his overt, and utterly representational, landscapes, that the connection is manifest. … On the other hand, the still-life paintings are impregnated with qualities of light, texture and colour which convey one at once to St Ives. The over-clean 'washedness' of the cool colours and the smooth neat textures are qualities very precisely related to that rain-washed Atlantic-blown town.[24]

Heron was considering a particular group of recent works and his general admiration for BN ('an artist of great distinction and originality') was qualified by limitations and bad habits he noted in them, for example, setting a 'nursery model of landscape' up behind a still-life group. But his observation is correct: whereas in the 1920s one senses still-life forms and qualities being built into BN's representation of landscape, the still lifes of the early 1950s bring us visual characteristics that belong to the landscape experience of a particular place. *1952, March 14* [plate 246] is a convincing example. We recall that BN worked in a studio that shut off all views of St Ives and the Atlantic.

In the same review Heron states that BN 'was never a

The Art of Ben Nicholson

436

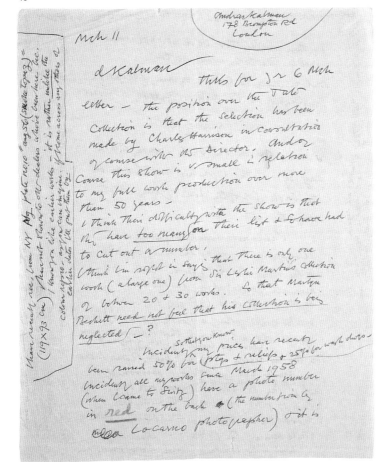

Cubist; not even before 1933 [when he began his reliefs], up to which point his main influence had been Braque.' That is as accurate as saying that he was a kind of Cubist and that, as he said himself, his 'route was obviously via early Cubism to Mondrian'. Either statement excludes whole swathes of what he absorbed and used. Cubism mattered, but we have to remember BN's childlike primitivism and his passion for early Italian painting. He was never just a Cubist because he never worked in any of the several Cubist idioms available. Heron sees significance in the fact that BN never put his still-life objects through the dislocations Cubism, in his view, demands. For a long period, according to Heron, BN's work was Constructivist. I would say that he was never a 'Constructive artist' in the sense in which *Circle* represented the international movement in the spirit of Gabo – as artistic Constructivism that shunned the Soviet impetus to seek materially useful roles in a suffering economy – because his art never had the logic, the universality, the impersonality that Constructive art offered to the world. His apparently Constructive art remains mysterious. Constructivism in the original sense was never within his sights.

The ambiguity of BN's art leads commentators to grasp at this or that stylistic set in order to contain him, whether for praise or blame. The American critic Clement Greenberg, a fine judge where his eyes precede assessment, wrote about BN's first New York exhibition in 1949. He considered him a good minor artist, but described him as one who had worked 'until recent years, with ruled and horizontally based rectangles and exactly plotted circles', subjecting himself 'to a discipline whose penalty for error is so severe that the artist can leave absolutely nothing to chance'. Even when BN used rulers and compasses, there is nothing exact about his work; everything is chance, the intuition of a moment, the countermanding of anything that might smack of calculation.

Greenberg sensed quality, and both charged BN with 'prettiness ... the besetting sin of English pictorial art' and claimed for him that he was the 'first English artist to have put it to a truly virtuous use ... by imprisoning his native aptitude for the pretty in a canon of abstract forms that derives largely from Mondrian and ... is even narrower'. This raises many issues already touched on in this book, but discussion of one of them may aptly serve to end it.

Writing about BN for his 1968 show in Basel, echoing debates in the British press of that time, I opened my piece (after the Beckett quotation) like this: 'In Britain we inevitably see Ben Nicholson as the man who went into Europe and proved that nothing need be lost by the venture'; I went on to point to some of his Continental interests and allegiances and argued that he did not abandon Englishness for their sake. His English roots are so firm, I said, that nothing he met abroad could threaten them. This still seems to me more or less true but also, though suitable for a short text, too simple.

BN's own response was modest. 'It was quite natural', he wrote, 'to feel that good ptg *wherever you met it* was something worthwhile encountering', and he stressed how little artists in Britain tended then to know about art in Paris, let alone anywhere else.[25] Very few artists of BN's generation engaged with art on the Continent. If they went it was often on the strength and under the near-compulsion of the Prix de Rome (set up when study of ancient and Renaissance art in Rome was seen as the only secure base for significant painting and sculpture) or some other traditional scholarship; few continued to develop their understanding of European art let alone make personal contact with leading Continental artists. The Nicholson family crossed the Channel as a family, to Dieppe principally, then a well-established resort for English artists. In addition, young Benjamin was sent abroad for his health and to study languages. He was used to

thinking in international terms before he knew he would be a painter. Moreover, he was not English but English and Scots with a shot of French blood injected by the Scottish side. So it is not difficult to show him to have been unEnglish from the start, certainly unfettered by Englishness.

There was also in him an ambition to know everything, that is to know enough about everything to know what he would not need. His travels were almost exclusively European, and one is tempted to say that this went for his artistic attachments too. Certainly he did not use the opportunity success brought him, from the 1950s on, to spend time in India and Japan, say, or the United States. But he was alert to the beauty and power of much non-European art, the primitive and the most sophisticated. He did not care for museums but that did not entirely stop him from using them. A name he mentions, from early on, is that of Mu-Chi, the thirteenth-century Ch'an Buddhist monk and painter who worked in China but may have been Japanese, and whose work shows unequalled fluency and economy, often in representing the simplest of still lifes. BN had a little French paperback about Chinese painting, and in it was the Mu-Chi he admired so much, a painting in ink on paper, *Six Persimmons*, in the Daitokuji Temple in Kyoto. 'Of all painters Giorgione and Mu-Chi are for me the most poetic.'[26] He welcomed Action Painting; he liked Tobey and admired his art selectively. One wonders where friendship and artistic affinity might have led him in New York or Los Angeles. As he wrote in another letter of 1968, picking up the same point, 'one just follows one's nose but the escape from London provincialism I suppose needed some driving force and *conviction*.'[27]

The same letter continues: 'But all one's roots are in London & Cumberland & Cornwall & with those English skies which are not high up & blue but come in & out of one's windows.' He had recently been to England with Felicitas, in Wiltshire and Bath as well as London. The pull he felt then brought him home three years later, in 1971. Soon after he commented on my introduction in the catalogue of his Marlborough exhibition, *New Reliefs*. I had hesitantly invoked the word 'English' after quoting his much earlier sentence about works of art being different experiences 'just as walking in a field or over a mountain are different experiences.'[28] That seemed to me a non-Continental way of writing about art. He picked up the word 'English': 'I wld like to feel that my work, as you say, is v. English (but not isolated English)! just as Braque is v. French, and Picasso & Tapies Spanish.' In his next letter he scribbled this afterthought into the margin: 'Also Cumberland was particularly English experience – converted mile castle on Roman wall – I suppose ten early years of this.' Five years earlier he had written from the mountain-ringed Lago Maggiore, with its often brilliant skies, thinking of a recent visit to England: 'central London was chaos … but Yorkshire dales one of the finest landscapes I've ever seen – the form emphasized by the stone walls and the general ferocity.' This was scribbled in the margin, but he found space to add an anecdote. 'I made a dwg [drawing] in Rievaulx & a tall spinster with tight white curls all over her head came up to me & said "Do you feel drawn to this?" I thought I knew all the questions but certainly felt drawn to this one.'[29] The more one focuses on this verbal short circuit, the more implications spark off from it. One is: as he drew the abbey did the abbey draw him? Who/what made the drawing? BN watched words as he watched things. He liked them to spring surprises. It may be that there is something English about his enjoyment of this accidental pun and its resonance.

He knew England was his home. Having returned, in 1971, he relished the beauty of where he lived at Great Shelford.

**437**
Felicitas Vogler in front
of the Kassel
Dokumenta wall, 1964.
Photo BN

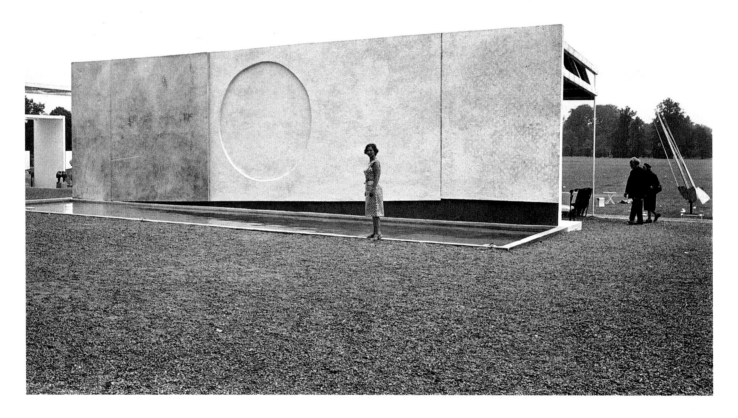

But then we recall his deep attachment to the Ticino too, and to Tuscany. That, we can say, is the response of someone with assured roots, and where Tuscany is concerned, falling in love with that part of Italy is an English habit. To answer the question of his Englishness further demands a definition no one has yet been able to give though definitions have been essayed from time to time. There have also been opinions, mostly negative in the way they are offered though one can turn them round. One of the by-products of American Abstract Expressionism has been the accusation that English art lacks tenacity and vehemence and is debilitated by understatement. The obverse of this is that

Abstract Expressionism should be seen as American and tough. In fact some Abstract Expressionism has been delicate rather than tough and what was tough turned out also to be repetitive and thus ultimately bland. English art includes Hogarth and Turner. Continental critics have noted that English art is not very physical, both in the sense that it does not parade sensuality and that it uses media delicately rather than with abandon. The first seems to go with Protestantism and Puritanism, and these may be seen as English achievements. England's passion for classicism, patent in the eighteenth century but marked before and after, could have established but did not establish classical modes of painting and sculpture. Full-blooded History painting, based on classical prototypes, scarcely gained a foothold. English art has no Rubens or Renoir. The second implies a delicacy in the face of matter, but it goes deeper: English artists use the materials of art to execute an idea rather than work symbiotically with these materials and thus risk, or achieve, the visual and emotional energy that goes with strong physical presence. No Rembrandt, no Van Gogh, let alone a Jackson Pollock or de Kooning. (It is taken for granted that immigrants are part of American art yet are not to be counted in English art while other components can be separated off as Irish, Scots or Welsh.) We have Turner again, especially the later work, moving between utter delicacy and amazing physicality, and also the later work of Constable. But there is some truth in these claims and they parallel distinctions we make between classical art and romantic which in Europe is often a distinction also between northern and southern.

John Russell writes of BN's reliefs that they are 'peculiarly European in their lack of bluster, and peculiarly English in their refusal (as it were) to write down the constitution.'[30] I am not sure that a lack of bluster is a European characteristic though perhaps it is a French one, at any rate in the upper levels of the arts in France – in other words a classical characteristic. But the point about refusing to write down the constitution (how English that 'as it were' sounds) is apt. Why pin down, in hopes of permanence, matters that need to grow, change, develop – especially in a language that does not lend itself to grand generalizations intended to guide behaviour?

BN's reluctance to be seen as an artist of one type or movement is his version of this. He sets limits to his art, conscious and unconscious, and one feels they remain even though he stretches them as the decades pass, but he never says what he intends except in broad, analogical terms. There is a moderation in his art that arises out of his relationship to his materials: he is not going to violate them, any more than the good sportsman violates bat, racket or ball. There is an associated moderation that goes with a preference for clarity. We approach a BN work knowing we will not be shouted at or confused. And we are not shouted at but we are often confused if we stay beyond the first encounter. Wit again, but also an urge to say that nothing is that simple, that seeing and understanding are actions rather than termini, and that there is a dimension that can take us beyond the plain facts of the work if we are willing to go. He uses simplicity in order to attain a complexity that lasts and attracts where others are content with a momentary assault.

His drawings are among the finest in English art, often accused of lacking draughtsmen of real quality. They are, indeed, the finest of their kind, and no draughtsman is expected to perform in a wide range of that apparently infinite medium. It was probably not a conscious choice of BN's to have attached himself to the tradition of neo-classical drawing with which England, through the work of Flaxman, taught the world. Flaxman used his pure line

447

method as a way of approaching the character of relief carving, and was himself a great carver of reliefs. It is, at the very least, a significant accident that BN too becomes a maker of reliefs. Flaxman's art served narrative; he designed his actors and set them on an almost totally blank stage. BN shuns narrative and uses pure line to enact visual motifs in terms of what he likes about them, selecting from the wealth of data before him. In his paintings and reliefs the same selection process operates, but here it draws on his accumulation of visual and working experiences, and his emotional life too, especially that part of it which involves excitements and joy. It is the duality pervading his art that is all-important: a limited range of content delivered through a wide range of styles and methods; a limited range of subject-matter but this capable of carrying a wide range of references as well as content and in his art put through many permutations and combinations; colour and texture given importance as purveyors of light, yet line as a major component throughout and purveying movement, rhythm, time as well as structure.

How essentially English is all this? It is very English if we use the term broadly, non-prejudicially. There is much in English art that BN rejected from the start, and often it was the kind of thing that would have brought success quite quickly. His appetite for light, colour, space and all these good things as matter for art, had to be expressed austerely while finding rich reserves within that austerity. That seems English, more English than the charming and dreamy art he shunned, and it combines northern with Mediterranean priorities in a wholly English way. He answered a loose question about Abstract Expressionism as follows:

I find all 'expressionism', whether abstract or not, entirely beside the point, but I think the real gist of your question is whether the romantic and classic approach are both valid? I should have said that they are,

438

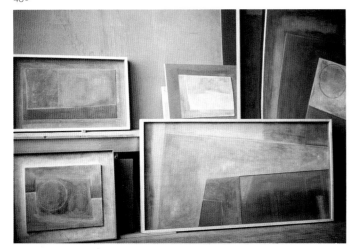

The Art of Ben Nicholson

439

Mch 20

dear Norbert

Thks for your letter
16 Mch

Leslie W. was here & I gathered
that he had also just sent you
an albright Knox Cat. so you were
peppered with these ↑. Leslie
saw the Hirschorn washington
show & thg/t it v well presented.
He went over by Concorde for 4 hrs
& this ———— was 6 hrs late
returng to England ————

I need time also to know which
are OK – I keep them propped
up where I can see them while
workg on another & without knowing
that I see them

I don't know Michael Compton but
I gather he's v. much in the running for
the next director ∨ the Tate —
I was interested to see some of my
reliefs work had been buried
under the Tate bu so long that I'd
forgotten them & was relieved that
they seemed alright – here then tell
this new bunch of work they ∧ tell
me is alright & not kind of
repetition of the
former bunch.

I know your Brighton & Sussex a bit
as my parents had a house at
Rotting Dean I used to play
real ~ tennis at Brighton but
didn't know a University there
perhaps there wasn't then, about
185 years ago —
ever
Bn

I am this on
april 10
& I suppose
9/10 ths of my
work I make
now is a
much to be
sought after
swan - song ?

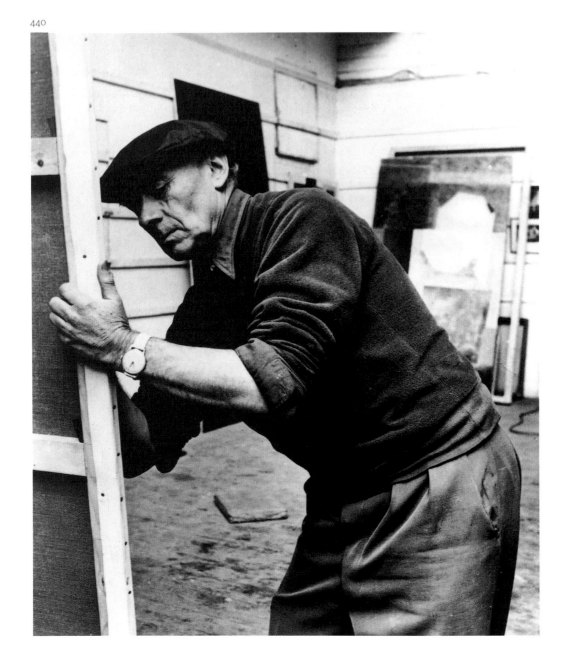

but that the best work contains an element of both. I should be very sorry indeed if my work contained no element of the romantic, as it would be rather like preventing the moon from getting up behind the mountains.[31]

His work always contains both and this was clearly natural to him. It made him both English and avid for stimuli of other origins and character. Much of the vigour of his art comes from this openness.

I have already suggested that there is also a secret element, a hidden message. BN's focus on the visible world – whether still life, landscape, their combination or abstract compositions concordant with them – was in part a means of reaching beyond it, to the world of the spirit. In the 1930s, publicly associated with artists and designers insisting on the worldly value of what they did as contributors to the present and timely guidance to a cleaner, more harmonious future, he curtly dissociated himself from both functionalism and utopianism. 'Painting and religious experience are the same thing.' He used the statement twice, almost word for word, in 1934 and 1937, the first time after quoting Professor Eddington on 'something like religious experience' as the path to understanding the material universe. I cannot find that any of his contemporaries reacted to his words. I suspect they were embarrassed by them.

BN did not go on repeating them, just as he did not go on making white reliefs. His colleagues' embarrassment seems essentially English. Religious experience is a private matter, almost a bad habit, not to be paraded even in church. Yet the English tradition is as full of priests and prophets, from George Herbert, Donne and Bunyan to Blake, Ruskin, Holman Hunt, D. H. Lawrence and T. S. Eliot, as it is of insistent positivists of the order of Samuel Johnson, prime oracle of what we call common sense.

The 1930s decade was more secular than most, with political business of such urgency that the arts could not altogether stand aside. That meant ignoring the spiritual dimension of what was on offer in order to enrol everything on the political right or left. So in the 1930s BN made an issue of the spiritual direction of his work, aware of its absence in most of the work and almost all the cultural debate around him. In the 1920s he did not. It became a need and a conviction during his life and work with Winifred. After the 1930s international war and then international art promotion may have seemed to leave no room for claims of spiritual functions in art though these would not have jarred on the public around Abstract Expressionism as much as the modish Existentialism that passed for a philosophical stance in Europe.

Yet the impulse persisted. If BN had no time for the black side of Expressionism, if he had no thought of competing with Francis Bacon or any other poet of pains and plagues, however brilliant, this was not merely a shying away from those areas of experience, nor merely equally reasonable insistence on experiences on the positive side of life. It was a matter of conviction. Pain and ugliness exist. Death, whatever that may be, will come. But the art that goes with being alive cannot, for him, speak of death. That would be using light and colours, planes and lines, and all those marvellous components that he worked with, against their true nature. It would equally be denying his acute pleasure in the visual worlds of nature and of art. When he was struggling and poor, and equally when he was well known and well off, BN put his life's work on that side of the terrestrial balance. Creation is always a positive act. That its bearing should be positive too, whatever others were thinking and doing, was common sense to him.

# Notes

## Abbreviations

**Summerson 1948:**
John Summerson, *Ben Nicholson*, The Penguin Modern Painters series edited by Sir Kenneth Clark, Penguin Books, West Drayton 1948.
Sir John Summerson, the eminent architectural historian, was BN's brother-in-law by his marriage to Barbara Hepworth's sister Elizabeth.

**LH I 1948:**
*Ben Nicholson, paintings, reliefs, drawings*, with an introduction by Herbert Read, Lund Humphries, London 1948, reprinted 1955 as volume 1.
Primarily a book of plates, it was 'supervised and laid out by the artist'. Photographs of work done during, approximately, 1934-9 were taken by Barbara Hepworth.

**LH II 1956:**
*Ben Nicholson, work since 1947*, volume 2, with an introduction by Herbert Read, Lund Humphries, London 1956.
This includes a bibliography, mainly of reviews and articles, going back to 1926.

**Harrison 1969:**
Charles Harrison, notes on BN's development and commentary on selected works in the exhibition catalogue, *Ben Nicholson*, Tate Gallery, London 1969.

**Hepworth 1978:**
*Barbara Hepworth – a Pictorial Autobiography* (first published 1970), extended edition Moonraker Press, Bradford-on-Avon 1978.
A chronological account of the artist's life and thought in her own words and in photographs of her work, family and friends, exhibitions and selected reviews.

***Studio* special 1969:**
*Ben Nicholson*, a *Studio International* special edited by Maurice de Sausmarez, 1969.
A collection of illustrations of BN's work and an anthology of texts including all his published statements until that date, as well as a few BN letters, reminiscences of him provided by fellow artists and others, including Stokes, Gabo, Moore and the editor, himself a painter and academic.

**Lewison 1983:**
Jeremy Lewison, essay 'Ben Nicholson and his Critics' and commentary in the exhibition catalogue, *Ben Nicholson, the Years of Experiment 1919-1939*, Kettle's Yard Gallery, Cambridge 1983.

**Tate 1985:**
Exhibition catalogue *St Ives 1939-64, Twenty Five Years of Painting, Sculpture and Pottery*, Tate Gallery, London 1985.
A highly informative publication, notably the Chronology and the Biographical Notes by David Brown.

**Andrew Nicholson 1987:**
Andrew Nicholson (ed.), *Unknown Colour: Paintings, Letters, Writings by Winifred Nicholson*, Faber and Faber, London 1987.
An illustrated book of plates of Winifred Nicholson's painting, its text material includes also an introduction by Sir Norman Reid, essays by Christopher Neve and Kathleen Raine, and letters from Mondrian to Winifred (1935-40) and letters exchanged by BN and Winifred (1932?-75).

**Lafranca 1983-4:**
François Lafranca, *Ben Nicholson Etchings*, Ateliers Lafranca, Locarno 1983.
Catalogue of an exhibition of 127 BN etchings printed by Lafranca during 1965-8, shown 1983 at the Ateliers Lafranca in Locarno and 1984 at the Kunsthalle in Mannheim, with essays by Manfred Fath and François Lafranca in German and English (the English version of the Fath text much condensed).

**Lewison 1991:**
Jeremy Lewison, *Ben Nicholson*, Phaidon Press, London 1991.

**Lewison 1992:**
Introduction to exhibition catalogue *Ben Nicholson*, Fondation Pierre Gianadda, Martigny 1992.

**Russell 1969:**
John Russell, *Ben Nicholson*, Thames and Hudson, London 1969.
Many fine plates of BN's work to that date, chosen and arranged by him, introduced by an exceptionally lively essay.

## Notes to Chapter 1: Benjamin and the Nicholsons

**1** Information on William Nicholson and his family is taken primarily from John Rothenstein, *Modern English Painters*, vol. 1: *Sickert to Grant* (first published 1952), Eyre & Spottiswoode, London 1962, pp. 152-62; Lilian Browse, *William Nicholson*, Rupert Hart-Davis, London 1965; Alan Bowness, introduction to exhibition catalogue, *Sir William Nicholson*, Marlborough Fine Art, London 1967; Duncan Robinson, introduction and commentary to exhibition catalogue, *William Nicholson*, Arts Council of Great Britain, London 1980; Marguerite Steen, *William Nicholson*, Collins, London 1943; Colin Campbell, *William Nicholson, The Graphic Work*, Barrie & Jenkins, London 1992.

**2** Andrew Nicholson 1987, pp. 43-4.

**3** Lewison 1991, p. 7, citing the artist's letter of 6 May 1944 to John Summerson.

**4** Geoffrey Grigson, *Recollections, Mainly of Writers and Artists*, Chatto & Windus, London 1984, pp. 188-9.

**5** I am indebted to Sophie Bowness for a copy of the Nicholson/Roberts wedding certificate.

**6** Steen, *op. cit.*, pp. 132-3 and 109.

**7** See 'Ben Nicholson, The Life and Opinions of an English "Modern", in conversation with Vera and John Russell', *Sunday Times*, 28 April 1963, reprinted in *Studio* special 1969, pp. 50-2.

**8** Lilian Browse, *op. cit.*, p. 13, presumably guided by William Nicholson's comments, refers to Mabel in severe terms. She was 'as talented as she was lazy'; James Pryde and she 'belonged to those envied yet handicapped people whose charm and personality are so great that they never have to exert themselves'.

**9** 'Ben Nicholson, The Life and Opinions …': see note 7 above.

**10** It is striking that Summerson, in Summerson 1948, avoids saying anything about a possible relationship between BN's work and his father's though BN's letter to him might have invited it. BN's letter is cited in Lewison 1983, p. 10. Winifred's words about William's art were first written in 1967 and are reprinted in Andrew Nicholson 1987, pp. 77-9.

**11** BN letter to NL [Norbert Lynton], postmarked 8 June 1979.

## Notes to Chapter 2: The 1920s

**1** BN refers to Winifred by the name she sometimes used professionally, Winifred Dacre, in a list of eleven names of individuals who admired Alfred Wallis's work soon after BN and 'Kit Wood' came upon it in August 1928: see his essay 'Alfred Wallis', published

in *Horizon* in January 1943, amended for the catalogue of an Alfred Wallis exhibition at the Tate Gallery in London in 1968, and reprinted in *Studio* special 1969, pp. 37-8. She was born Roberts; Dacre was her mother's maiden name, and she used it in connection with her abstract paintings, neither she nor BN wanting commentators to bracket their work too closely. 'Roberts' could at that time have been thought to associate her with William Roberts, the former Vorticist. It should be said that BN rarely mentioned family and friends unless his statements were openly autobiographical.

**2** Andrew Nicholson 1987, p. 6.

**3** Information and quotations from Andrew Nicholson 1987, especially pp. 6 and 30-6.

**4** See Summerson 1948, plate 2, and LH I 1948, plate 1. Both plates are black-and-white. In the latter, the caption includes the information 'collection William Nicholson' while the list of plates states: 'striped jug, 1911: oil on canvas (first painting), c.20" x 24"' (LH I 1948, p. 7). Harrison 1969 says the painting is 'now destroyed', and that it is 'usually dated 1911 … but perhaps painted a few years later'. Lewison 1983 thinks 'the bold composition and handling of paint, as far as we can tell from photographs, betray a greater facility than the two still lifes mentioned above [*blue bowl in shadow* and *the red necklace*]'. He adds that 'it is unlikely that Nicholson would have exhibited at Patterson's Gallery in 1923 [a joint show of BN and Winifred] a work painted during his student days at the Slade' (Lewison 1983, p. 10). If the sequence is *the red necklace*, *blue bowl in a shadow*, *striped jug*, then the development could be summarized as from 'Vermeer', towards William Nicholson, and then rejection of William Nicholson's optical and painterly priorities in favour of austerity and plain speaking in a pre- or early Renaissance manner.

**5** See Lewison 1983, p. 52, where the catalogue entry presents the painting as 'A profile in brown, c.1919'.

**6** *Pink house in the snow* and BN's photograph are juxtaposed in Lewison 1983, p. 8. It is worth noting that BN wanted to include a group of these house paintings in his 1969 Tate exhibition, see Harrison 1969, p. 65.

**7** Cited by Kathleen Raine in Andrew Nicholson 1987, p. 201.

**8** In 1978 BN sent me from London a colour postcard he particularly liked, of Ambrogio Lorenzetti's small painting in the Pinacoteca of Siena, known as *Castle on the Shores of a Lake*. Ambrogio Lorenzetti was active in Siena during 1319-48. The postcard represents one of two small panel paintings by him, both in the Pinacoteca, tentatively ascribed to the mid-1320s (see Erika Langmuir, *Pan Art Dictionary*, vol. 1, Pan Books, London 1989, pp. 200-1: 'the earliest surviving pure landscape paintings in Italian art'). The panel shows the castle partly obscured by a white mountain rising in the foreground and, on the lake in front of the castle, a relatively large, crisply painted boat. BN's words on the back of card end with 'I wish I could paint like overleaf'. He spoke to me about that time of his continuing admiration for the work of Piero della Francesca, seen in Italy and in the National Gallery, London.

**9** Quotation from BN's letter to John Summerson: see Summerson 1948, p. 7, where it is said to be dated 3 January 1944; see also Jeremy Lewison's more exact transcription, in Lewison 1991, p. 10, where it is dated 3 January 1948. The implication is that BN supplied Summerson with information for his important essay in the first book on BN's art.

**10** See Summerson 1948, p. 7.

**11** Andrew Nicholson 1987, p. 39.

**12** Information from Dr Felicitas Vogler, in conversation with me on 18 April 1992.

**13** For *Bertha; no. 2* see Lewison 1991, p. 9, text, and p. 10, black-and-white illustration. *Coal Fell*, in a British private collection, has not been published.

**14** See Harrison 1969, p. 10.

**15** Lewison 1992, p. 33 and Lewison 1983, p. 56, quoting a letter of 11 February 1983.

**16** Harrison 1969, p. 12.

**17** Lewison 1983, pp. 56 and 14.

**18** In titling BN's works of this period I am using the dates given in the recent literature, principally by Lewison, thus making cross-referencing possible. But there is reason to doubt the firmness of many of these dates, few of which can be backed by proof.

**19** Andrew Nicholson 1987, pp. 40-1.

**20** This picture is dated 'c.1926' in Lewison 1991, plate 19. It was first published as 'c.1927' in LH I 1948 (plate 26) and is firmly ascribed to 1927 by Steven Nash in the exhibition catalogue, *Ben Nicholson: Fifty Years of his Art*, Albright-Knox Art Gallery, Buffalo 1978. It may well be that BN provided a date from memory when LH I 1948 was in preparation.

**21** See Lewison 1983, p. 57.

**22** Version 1 is illustrated in LH I 1948, plate 12. The date ascribed to one or both of these has some insecure support from documents of the time: Lewison 1983, p. 58, says one or both may have been exhibited in two 1927 exhibitions.

**23** Information regarding Winifred's motherhood and accident, and the words quoted are from Andrew Nicholson 1987, pp.

50-2 and 170. See also Lewison 1983, p. 59.

**24** Jake Nicholson, in an essay in the catalogue of the exhibition *A Painters' Place – Banks Head, Cumberland, 1924-31*, Abbot Hall Art Gallery, Kendal 1991, p. 11.

**25** Harrison 1969, p. 62, has outline information on the Seven and Five Society.

**26** See the exhibition catalogue *Christopher Wood*, Arts Council, London 1979.

**27** Jake Nicholson, in conversation, 4 December 1992.

**28** Andrew Nicholson 1987, p. 20.

**29** *Ibid.*, p. 141.

### Notes to Chapter 3: The 1930s

**1** BN's visit to the Hepworth and Skeaping show: Lewison 1992, p. 35, Hepworth 1978, p. 17 and John Skeaping, *Drawn from Life – an Autobiography*, Collins, London 1977, p. 95.

**2** Hepworth 1978, p. 17.

**3** *Ibid.*, p. 9.

**4** Skeaping, *op.cit.*, pp. 46 and 71.

**5** See Sophie Bowness, 'Ben Nicholson and Georges Braque: Dieppe and Varengeville in the 1930s', in the catalogue of the *The Dieppe Connection* exhibition, Herbert Press and The Royal Pavilion, Art Gallery and Museums, Brighton 1992, pp. 44-52; BN's words and Bowness's comment are on p. 46.

**6** For the fuller version of BN's account of his visit to Mondrian as set down for Summerson, see *Studio* special 1969, p. 57. It is remarkable to find that Summerson not only shortened it further but actually altered the text slightly, not just turning each ampersand into 'and' but also moderating BN's tone: thus 'very like' in the last sentence becomes 'not unlike'. See Summerson 1948, p. 12. Hepworth on Mondrian is quoted in Herbert Read (intro.), *Barbara Hepworth, Carvings and Drawings*, Lund Humphries, London 1952. Letters from Mondrian to Winifred Nicholson are printed in Andrew Nicholson 1987, pp. 111-14. One from New York, shortly after Mondrian's arrival there in October 1940, includes: 'You see it was good you brought me from Paris to London after Nicholson's good help' (p. 114).

**7** Herbert Read (ed.), *Unit 1*, Cassell, London 1934. I presume that the difference between the name of the group and the book's title as given on the cover and title-page and as used elsewhere stems from a design decision. Herbert Read's introduction was mainly about the value of associations formed by modern artists to make their work better-known and to make a point about it, indeed, as Read put it, in this instance 'to form a point in the forward thrust of modernism in architecture, painting and sculpture, and to harden this point in the fires

of criticism and controversy' (p. 12).

**8** See King, *Interior Landscapes, a Life of Paul Nash*, Weidenfeld & Nicolson, London 1987, p. 158.

**9** The letter is quoted in full in Read's introduction, *Unit 1*, pp. 10-11.

**10** *Unit 1*, p. 89 (reprinted in *Studio* special 1969, p. 32) and *Unit 1*, pp. 19-20. Words from Moore's statement, *ibid.*, p. 29.

**11** Hepworth's words are cited in Tom Cross, *Painting the Warmth of the Sun: St Ives Artists 1939-1975*, Alison Hodge with Lutterworth Press, Penzance and Guildford 1984, p. 48.

**12** Winifred Nicholson's words are from her foreword to the catalogue of her exhibition at the Crane Kalman Gallery in 1975, *An Unknown Aspect of Winifred Nicholson*, reprinted in Andrew Nicholson 1987, p. 105.

**13** See also Sophie Bowness's account of this and related paintings in her essay 'Ben Nicholson and Georges Braque: Dieppe and Varengeville in the 1930s' (see note 5 above), pp. 44-52.

**14** BN's original text was published in *Horizon*, vol. 4, October 1941, pp. 272-6. BN revised it slightly and added to it in 1948 when it was reprinted in LH I, pp. 23-7. This is discussed in chapter 4.

**15** Lewison 1991, p. 15.

**16** Andrew Nicholson 1987, p. 142.

**17** Jeremy Lewison, 'The Early Prints of Ben Nicholson', *Print Quarterly*, vol. 2, June 1985, p. 110.

**18** Kasimir Malewitsch, *Die gegenstandslose Welt*, Albert Langen, Munich 1927 (edited and designed by Moholy-Nagy). An English edition appeared only much later: Kasimir Malevich, *The Non-Objective World*, Theobald, Chicago 1959.

**19** Marguerite Steen speaks of Chaucer's House and this white-painted panelling in *William Nicholson*, Collins, London 1943, pp. 76-7 and 93; when the Nicholsons let the house to a stranger for a year, and he altered the interior, all the family, she says, were stunned by the changes. BN on his father's black-and-white floor, in Rottingdean: see *Studio* special 1969, p. 53.

**20** BN letter to NL, 29 April 1966.

**21** For a biographical outline for Kit Nicholson see the exhibition catalogue *The Nicholsons: a Story of Four People and their Designs*, York City Art Gallery 1988. The exhibition sampled the work of BN and of Nancy, Kit and E.Q. Nicholson (Elsie Myers). The catalogue includes illustrations and texts by various hands including Jake Nicholson and Margaret Gardiner about BN's activities and views. In the architecture section of *Circle* a page is given to

Christopher Nicholson's plans for a house being built at Henley and a photograph of it under construction.

**22** Herbert Read, *Art Now*, Faber and Faber, London, first edition 1933, revised edition with additional illustrations (including a BN white relief of 1935) 1936, reprinted 1938; the words cited are on p. 102. BN's letter to Winifred is quoted by kind permission of Jake Nicholson.

**23** See Kenneth Clark, 'The Future of Painting', *The Listener*, 2 October 1935; Herbert Read, *ibid.*, 9 October 1935; Geoffrey Edgar's letter, *ibid.*, 23 October 1935; Read's reply, *ibid.*, 30 October 1935.

**24** See Hugh Gordon Porteus, 'Mr Ben Nicholson', in *New English Weekly*, vol. vii, no. 21, 3 October 1935, p. 414; David Gascoyne, 'Art' in *ibid.*, vol. v, no. 3, 3 May 1934, p. 66; Geoffrey Grigson, 'Comment on England', in *Axis*, no. 1, January 1935, p. 10; J.M. Richards's review in *ibid.*, no. 4, November 1935, p. 21. The review subsequently turns to the last, abstract, Seven and Five Society show.

**25** Herbert Read: 1933 in *Art Now*; 1934 in *Art and Industry*; and in his introduction to *Unit 1*, p. 16. Paul Nash, quoted by Read in *Unit 1*, p. 10.

**26** Summerson 1948, p. 12.

**27** J. L. Martin, Ben Nicholson, N. Gabo (eds.), *Circle, International Survey of Constructive Art*, Faber and Faber, London 1937. The file at Faber and Faber shows that Herbert Read approached Richard de la Mare with a proposal for the book. An edition of 1,500 copies was published in July 1937; a year later 756 copies had been sold in the UK and 250 to the United States. Some copies were lost in the bombing of London. Leslie Martin submitted the material for the book, including a lay-out. His wife, Sadie, served as secretary for the editors but it seems that Hepworth saw to much of the day-to-day negotiating with the publishers over type, blocks and other details. The Martins were then living in Hull and it is clear that Hepworth was in large measure transmitting Leslie Martin's advice. Winifred Nicholson organized contributions from Paris, including photographs; where necessary she took these herself, though quite inexperienced in photography. Read's essay is on pp. 61-6; the words quoted are on p. 66. Gabo's *Circle* essay occupies pp. 1-10; the words quoted are on p. 7. The anonymous editorial, none of which reads like BN, emphasizes in its first words the 'new cultural unity' it asserts is 'slowly emerging' in the world, and ends by identifying the book's purpose: 'we hope to make clear a common basis and to demonstrate, not only the relationship of one work to the other but of

this form of art to the whole social order': pp. iii and iv.

**28** BN in a letter of 6 September 1946 to Read, in King, *op. cit.* (see note 8 above), p. 232.

**29** Cited by David Lewis in his essay on the reliefs in *Studio* special 1969, p. 60. BN's letter to Read, 25 September 1946, in King, *op. cit.* (see note 8 above), p. 232.

**30** In 1980 BN spoke to me at some length about Hepworth's importance and qualities as a sculptor, showing me illustrations of her work in a copy of Hammacher's 'World of Art Library' book on her (Thames and Hudson, London 1968), which she had given and inscribed to him. He marked some sentences and illustrations of sculptures he particularly admired and subsequently sent me the book, adding a new inscription. *Monumental Stele* was not among the works he picked out. He emphasized his admiration for such works as *Corinthos*, 1954-5, one of Hepworth's generous, curvilinear carvings in African mahogany, its external surface like a chestnut, the hollowed interior spaces painted white ('this enormous and most impressive', BN wrote against the illustration), and he drew my attention to her *Pierced Form*, 1931, with which, as Hammacher confirms on p. 42, Hepworth, possibly responding to the ancient standing stone of Cornwall, pierced by a hole and known as Men-al-Tol, pioneered a device usually credited to Henry Moore who first used it in 1932.

**31** Lewison 1991, p. 17.

**32** *Circle*, p. 75; reprinted in *Studio* special 1969, p. 32.

**33** H.S. Ede, Jim to his friends, had been an assistant at the Tate Gallery and had met BN and Winifred about 1924. He bought work from BN and others and in 1957 was given the use of 'four tiny condemned slum dwellings' at Kettle's Yard in Cambridge. He converted these into a home for his collection and himself and wife, open to visitors in term time, and this became part of the University in 1966 as an art gallery.

**34** Interview, 'The Aims of the Modern Artist', in *Studio*, December 1932, p. 333; reprinted in *Studio* special 1969, p. 30.

**35** BN's statement in *Unit 1* (see note 7 above), p. 89.

**36** This information was provided unbidden in an interview with Adrian Heath conducted by me on three days in August 1992 (this part of the conversation took place on 12 August). Tapes of the interview are held by the National Life Story Collection at the British Library National Sound Archive in London. See chapter 5 for a brief account of the context for the conversation between BN

and Heath referred to.

**37** My account of the genres is based on the summary in Erica Langmuir, *The Pan Art Dictionary*, vol. 1, Pan Books, London 1989, pp. 135-6.

**38** In correspondence with BN in 1979, I said I had read somewhere that he had spoken of the white reliefs as distantly representing still lifes. In his reply BN denied this firmly: 'PLEASE I have *never ever said* – – – – "circle = plate rectangle = book" it shows a singular misunderstanding of those reliefs.' I cannot now find my source — it exists — and was naturally glad to have Adrian Heath's unsolicited confirmation that BN did at times admit to this relationship (see note 36 above). The contradiction is best understood as arising from BN's awareness of context and his suspicion of art historians and critics. In the early 1950s his statement reflected the fact that he was working abstractly on a basis of still life and in a way that included recognizable still-life elements. In the 1970s he was working on abstract reliefs as well as small still-life compositions on paper and perhaps wanted it understood that the reliefs were abstract. On these, see chapter 7.

In an essay in the catalogue of the 1993 BN exhibition at Mendrisio (which appeared after this book was written), Peter Khoroche quotes (n. 8) a letter from BN to Geoffrey Jellicoe of 24 May 1964 (Tate Gallery Archives): 'I have, I think, little intellect — but not at all a bad INSTINCT. So that for example the circles which occur in my work originated with a plate on a table & not at all with any idea of "infinity".' This provides further confirmation of BN's ambivalence on this point.

**39** See Jake Nicholson's essay 'Ben Nicholson's Fabrics' in *The Nicholsons* (see note 21 above), pp. 35-9.

**40** I am indebted to Sophie Bowness for copies of the relevant Divorce and Marriage Certificates.

### Notes to Chapter 4: The 1940s

**1** See Tate 1985 for information about artists and their friends working in and visiting St Ives in that period.

**2** See Hepworth 1978. The quotations are from pp. 45, 31 and 42. I am also indebted to Ann Stokes Angus for information about this phase.

**3** Letter of 17 August 1940 to Read at Broom House; see King, *op.cit.* (chapter 3, note 8), p. 187.

**4** See Sophie Bowness, 'Mondrian in London: Letters to Ben Nicholson and Barbara Hepworth', *Burlington Magazine*, vol. cxxxii, no. 1052, November 1990, pp. 782-5.

**5** Gabo's words are taken from Tate 1985, p. 101.

**6** See Tate 1985, p. 100 for Margaret Mellis's text, and additional information there on p. 102.

**7** At the time of writing, *1940-2 (two forms)* is touring Japan in a BN exhibition. I am indebted to its organizers, Art Life Ltd of Tokyo, for taking photographs of the picture's back at my request and for the Southampton City Art Gallery's permission to have them taken.

**8** See Harrison 1969, p. 40.

**9** See LH I, plate 147, also Summerson 1948, plate 30.

**10** Information principally from Tate 1985, pp. 100-9.

**11** Moholy-Nagy in *Circle*: the article 'Light Painting' is on pp. 245-7; his paintings are plates 16-18 in the early section of painting illustrations, but also one on p. 236 where it is associated with Maillart's concrete bridges and Aalto's plywood chairs; his photogram is p. 248, immediately after the article.

**12** *Ben Nicholson, paintings reliefs drawings* was published in 1948 by Lund Humphries (a Bradford firm) in London, and consists primarily of illustrations in black and white, plus a few in good colour, altogether 204. There is also an introduction (with additional illustrations) by Read, a bibliography and a biographical summary, and BN's 'Notes on "Abstract" Art', a revised version of a text published first in *Horizon* in October 1941 and again by the New York Gallery, Art of this Century, in 1942. The book was reprinted in 1955 when it became volume 1; its biography and bibliography were much enlarged, especially the latter. A comparable volume had been published by Lund Humphries in 1944 as a survey of Henry Moore's work up to that time, the first of what was to grow into a series of five volumes. A second BN volume was published by Lund Humphries in 1956. It should be emphasized that such adventurous publishing of living artists' work was very rare in Britain. The impulse came from Eric Gregory, director of Lund Humphries, who also established the Gregory Fellowships at Leeds University for a painter and sculptor and, all too briefly, for a composer — at that time unparalleled in Britain. He also became a friend of BN and bought work from him as well as from other living artists.

**13** John Summerson, *Ben Nicholson*, Penguin Books, West Drayton 1948. Clark had bought some of BN's earlier works but had lost faith in the artist over the white reliefs, and it took some pressure from Read before he would agree to a volume on BN in the series. (A volume on William Nicholson, by Robert Nichols, was published in the same year.) Summerson's exceptionally lucid introduction is accompanied by sixteen black and white and sixteen colour plates representing paintings and reliefs and just one drawing, the nude *girl in mirror* of 1932 now also known as *1932 (nude, The Mall)*. Almost all the plates in Summerson appear in LH I, but some of the titles are enlarged with subtitles, e.g. *painted relief 1945* becomes *painted relief (Arabian desert) 1945* and *(Chinese)* is added to *still life 1945*. This suggests that at least the titles, perhaps the selection as a whole, for the bigger book were finalized last.

**14** Hepworth and BN wrote to Read in December 1946; their letters are cited more fully in King, *op. cit.* (see chapter 3, note 8), p. 233. Hepworth too accused Moore of making a compromise ('for the first time in his life') and she agreed with BN that Sutherland, a Roman Catholic, had acted honestly as well as bravely. It is interesting to find BN, impatient with institutionalized religion, responding so positively to Sutherland's work as 'the outcome of his R.C. conviction & an idea worked out on a considerable scale & with great courage' although its idiom, a fusion of Sutherland with Grünewald and Francis Bacon, could not have been to his taste.

**15** Tate 1985, p. 125.

**16** Tate 1985, p. 106. This studio, used by BN until 1958, was then allocated to Patrick Heron. The place of broadcast and recorded music in the history of modern art awaits investigation.

**17** David Lewis, 'Ben Nicholson's *Feb. 18-54 (azure)*', *Carnegie Magazine*, May 1978, p. 10.

**18** This painting gained BN the first prize for painting in the Carnegie International — the '39th International Exhibition' — in 1952.

### Notes to Chapter 5: The 1950s

**1** The interview, published in the *Sunday Times* on 23 April 1963, was conducted by Vera and John Russell, who visited BN (who, they reported in their introductory paragraphs, 'never gives interviews') in Brissago. Illustrated by a photograph of BN drawing near Lake Garda, a drawing of Rievaulx Abbey and the Tate Gallery's painting *1943-5 (St Ives)*, the interview plus a Nassau-Bahamas Tourist Board advertisement filled a page and gave unusual prominence to a living British artist. See *Studio* special 1969, pp. 50-2. *1943-5 (St Ives)* was bought by the Tate Trustees in 1945 together with *1945 (still life)* [plate 193], these, together with *1933 (Guitar)* which was presented by the Contemporary Art Society

in 1940, remained the Tate's only BNs until 1955, when *1935 (white relief)* [plate 115] was bought with the help of the CAS, together with *1937, June (painting)* [plate 141] and a more recent painting *1953, February 28 (vertical seconds)* [plate 252].

**2** J.L. Martin, 'A World inside a Frame', *The Listener*, 27 January 1949, p. 148. The article is in part a review of the Penguin and the Lund Humphries books of 1948. It is aptly illustrated with a painting strong in its abstract as well as representational character: *1944 (still life and Cornish landscape)* [plate 174], discussed in chapter 4.

**3** See my Adrian Heath interview, 12 August 1992, previously referred to in chapter 3, note 36.

**4** This is part of the paragraph BN added in 1948 to his 1941 essay 'Notes on "Abstract" Art' for the first volume of his Lund Humphries monograph. BN's use of inverted commas leaves one uncertain how directly he associated the relationships to which he refers with music. He does not use inverted commas in referring to 'architectural construction'. That he enjoyed music, swing and jazz mostly, is certain. One wonders how close he felt to it as creative expression. Among contemporary composers he knew and valued Priaulx Rainier, who had come to England from South Africa in 1920 at the age of seventeen and in the 1940s and 1950s was professor of composition at the Royal Academy of Music in London but had a home also in St Ives. In 1953 BN wrote a letter to the *St Ives Times* complaining that a BBC broadcast had ignored her role in organizing a St Ives 1951 festival: 'Without … her creative contribution, there would have been no festival at all.' See Tate 1985, p. 108.

**5** BN, 'Defending Modern Artists', *Daily Mail*, 7 August 1951, reprinted in *Studio* special 1969, p. 39. The title is presumably editorial.

**6** BN's notes in the catalogue for his 1955 Tate Gallery retrospective, reprinted in *Studio* special 1969, p. 40.

**7** BN to me, during one of my visits to his house in Hampstead in 1980. He showed me illustrations of these works, using his copy of A.M. Hammacher's Hepworth monograph in the World of Art Library series, published by Thames and Hudson, London 1968. She had given it to him: it is inscribed 'for Ben, with love & every good wish Barbara'. BN marked these and other works with a red cross, also added a comment here and there and underlined some sentences, added to the flyleaf the words 'to Norbert from Ben 1980', in blue with a red line, under my name, going off on a little excursion of its own, and sent me the book. Some of his best paintings of

the time entered her collection, including some of the polyphonic series.

**8** *Cyclades*, on loan to Kettle's Yard, University of Cambridge, was exhibited upside down for some years. No one remarked on this since it looked convincing. Some of the still-life objects in it are indeed reversible, and the angled line was seen as a terminal feature on the right. BN is known to have hung works in different ways on different occasions, and to have taken some pride in their adaptability. Even where he made his preference clear, in signing the work on the back (which indicated which way up it should be) or even showing where its top is by word and arrow, it need not always be assumed that showing it some other way has to be ruled out.

**9** Seeing *nightshade* translated into French (in the Martigny exhibition catalogue, 1992) as *teinte nocturne* makes one stop to consider what BN's meaning was. 'Nocturnal hue' may have been one of his meanings but it was surely not the only one. A nightshade sounds like the opposite to a lightshade: the latter controls light so as to direct it or to moderate it to the benefit of our eyes, so a nightshade may be something that protects us against too total a darkness. But nightshade is also the name of a plant of the genus *Solanum* that bears black or red berries that are both attractive and poisonous, generally referred to as 'deadly nightshade'. BN knew and enjoyed words and will have enjoyed the ambiguity of his subtitle.

**10** See *Studio* special, 1969, p. 40.

**Notes to Chapter 6: The 1960s**

**1** See 'Mr Ben Nicholson Answers some Questions about his Work and Views', *The Times*, 12 November 1959, reprinted in *Studio* special 1969, p. 46.

**2** Andrew Nicholson 1987, p. 172.

**3** Lewison 1991, p. 23, and 1992, p. 43; quotation from BN: Russell 1969, p. 35.

**4** Other ballet designs are illustrated in LH I 1948, plates 61-2.

**5** *1962, July (Mycenae stone)*: Lewison 1991, plate 130.

**6** Vogler in *Studio* special 1969, p. 21.

**7** Jake Nicholson in conversation with the author, 4 December 1992.

**8** BN, 'Notes on "Abstract" Art': see *Studio* special 1969, p.33.

**9** See BN's words quoted from a letter of 11 February 1967 to Maurice de Sausmarez published in *Studio* special 1969, p. 59. The same thought, expressed in much the same words, was passed on to me by individuals close to BN: it seems he was fond of it.

**10** See the catalogue of the BN etchings

exhibition shown in the Ateliers Lafranca, Locarno, in 1983 and in Kunsthalle, Mannheim, in 1984.

**11** From BN's letter of 8 October 1968 (to Maurice de Sausmarez?) published in *Studio* special 1969, p. 59.

**12** Lafranca: quotation from the 1983-4 catalogue (see note 10). In fact 11 hours may be an exaggeration; BN regularly worked 5-7 hours in the studio, although of course time spent outside the studio on reading, thinking, looking or whatever could well be thought by him to be part of his work. Letter to Maurice de Sausmarez, 8 February 1967: published in *Studio* special 1968, p. 58.

**13** Manfred Fath in the Locarno/Mannheim catalogue, p. 18: see note 10 above.

**14** From BN's letter of 23 February 1969 to Geoffrey Jellicoe published in *Studio* special 1969, p. 59.

**15** Maurice de Sausmarez in *ibid.*, p. 66.

**16** Tonks on John: see Michael Holroyd, *Augustus John* (first published 1974), Penguin Books, Harmondsworth 1987, p. 85.

**17** See Colin Campbell, *William Nicholson, the Graphic Work*, Barrie & Jenkins, London 1992, four reproductions of *Characters of Romance* on pp. 98-9; for *The Book of Blokes* see *ibid.*, pp. 145 and 231. The words quoted are Lilian Browse's, p. 231.

**18** In the etchings catalogue, see note 10 above.

**19** BN drew my attention to this work, which was destroyed in the war, stressing its date and implying her priority with what has often been presented as an innovation of Henry Moore's.

**20** See *The Listener*, 6 March 1969, 'A Painter of Our Day by Geoffrey Grigson'; a slightly modified version is printed in Grigson's *Collected Poems 1963-1980*, Allison & Busby, London 1982, pp. 40-2.

**Notes to Chapter 7: The 1970s and Early 1980s**

**1** Andrew Nicholson 1987, p. 188.

**2** BN letter to NL, 1 October 1971.

**3** As a result of this work — she would say thanks to BN's encouragement — Angela (as Angela Verren, her maiden and professional name) had solo exhibitions in London in 1978 (at the Crane Kalman Gallery where BN himself had shown in 1974) and in 1984 (at Gallery 10) and contributed to a number of mixed exhibitions.

**4** See chapter 1, note 7; *Studio* special, p. 51.

**5** These and several other details given in this chapter were provided by Angela Verren Taunt in conversation on 21 December 1992 and in subsequent correspondence.

**6** BN letter to NL, 8 March 1976.

**7** BN letter to NL, 2 August 1971. Information

about the wall and about the planned Moore installation was given me by Sir Geoffrey Jellicoe in conversation on 12 February 1993.

**Notes to Chapter 8:**
**The Art of Ben Nicholson**

**1** Christopher Neve in the catalogue of BN's *New Work* exhibition, Waddington Galleries, London 1982 (no pagination).

**2** Russell 1969, p. 40.

**3** See *Studio* special 1969, p. 31.

**4** *Ibid.* – quotation of 1941 p. 33, of 1961 p. 48.

**5** Christopher Wood's letter of 1922, quoted more fully in chapter 2, p. 38.

**6** 1963 quotation: *Studio* special 1969, p. 51.

**7** BN letter to NL, 24 April 1968.

**8** BN letter to NL, 22 April 1968.

**9** Russell 1969, pp. 7-8

**10** Andrew Nicholson 1987, p. 40.

**11** 1932 quotation: *Studio* special 1969, p. 30.

**12** Russell 1969, p. 24.

**13** BN letters to NL, 22 April 1968 and 24 June 1967.

**14** BN letter to NL, 5 June 1979: 'Those longhaired Gods sitting on a cloud drive me crackers – how cld the same man write Tiger Tiger?'

**15** BN letter to Lilian Somerville, 25-6 March 1954; see *Studio* special 1969, pp. 57-8.

**16** BN letter to John Summerson, 13 May 1944, cited by Summerson 1948, p. 12, and at slightly greater length in Lewison 1991, p. 15.

**17** Andrew Nicholson 1987, p. 144.

**18** *Ibid.*, p. 50.

**19** BN letter to NL, 24 April 1968.

**20** BN statement in David Baxandall, *Ben Nicholson*, Methuen, London 1962, reprinted in *Studio* special 1969, p. 49. Also BN letters to NL, 22 April 1968 and 1 June 1979.

**21** BN letter to NL, 22 April 1968.

**22** BN letter to NL, 17 December 1965.

**23** In catalogue of the *Statements* exhibition, Institute of Contemporary Arts, London 1957; see *Studio* special 1969, p. 40.

**24** Patrick Heron's review of BN's show at the Lefevre Gallery, in *New Statesman*, 17 May 1952, p. 584.

**25** BN letter to NL, 24 April 1968.

**26** Geoffrey Grigson, *Recollections*, Chatto & Windus, London 1984, p. 188.

**27** BN letter to NL, 11 August 1968.

**28** The second paragraph of 'Quotations' in *Circle*, 1937: see *Studio* special 1969, p. 32.

**29** BN letters to NL of 'prob. Aug. 2', 1971 and 1 October 1971.

**30** Russell 1969, p. 41.

**31** Interview in *The Times*, 12 November 1959; see *Studio* special 1969, p. 46.

# Select Bibliography

## Articles and Statements by Ben Nicholson

'The Aim of the Modern Artist', *Studio*, vol. 104, December 1932.

Untitled statement in Read, Herbert (ed.), *Unit 1: The Modern Movement in English Architecture, Painting and Sculpture*, Cassell, London 1934.

'Quotations' in Martin, J.L., Nicholson, Ben and Gabo, N. (eds.), *Circle: International Survey of Constructive Art*, Faber and Faber, London 1937.

'Notes on Abstract Art', *Horizon*, vol. 4, no. 22, October 1941.

'Notes on Abstract Art' in Guggenheim, Peggy (ed.), *Art of this Century*, Art of this Century, New York 1942.

Berlin, Sven and Nicholson, Ben, 'Alfred Wallis', *Horizon*, vol. 7, no. 37, January 1943.

'Defending Modern Artists', *Daily Mail*, 7 August 1951.

Untitled statements in *Ben Nicholson: A Retrospective Exhibition*, exhibition catalogue, Tate Gallery, London 1955.

Untitled statements in *Statements: A Review of British Abstract Art in 1956*, Institute of Contemporary Arts, London 1956.

'Architecture and the Artist', *The Architects Journal*, 16 January 1958.

'Mr. Ben Nicholson Answers some Questions about his Work and Views', *The Times*, 12 November 1959.

'More or Less about Abstract Art: A Reply to Victor Pasmore', *London Magazine*, vol. 1, no. 4, July 1961.

Untitled statement in Baxandall, David, *Ben Nicholson*, Methuen, London 1962.

Interview with Vera and John Russell, 'The Life and Opinions of an English "Modern"', *Sunday Times*, 23 April 1963.

'Mondrian in London', *Studio International*, vol. 172, December 1966.

Untitled Statements in *Ben Nicholson*, exhibition catalogue, Galerie Beyeler, Basel 1968.

'Tribute to Herbert Read', *Studio International*, vol. 177, January 1969.

Extracts from letters in Sausmarez, Maurice de (ed.), *Ben Nicholson*, a *Studio International* special number, London 1969.

## Books and Articles

Abadie, Daniel, 'Ben Nicholson ou l'éloge de la modestie', *Hommage à Ben Nicholson (1894-1982)*, exhibition catalogue, Galerie Marwan Hoss, Paris 1990.

Alley, Ronald, *Ben Nicholson*, Express Books, London 1962.

Anon., *Art in Britain 1930-40 Centred around Axis, Circle, Unit One*, exhibition catalogue, Marlborough Fine Art, London 1965.

Baxandall, David, *Ben Nicholson*, Methuen, London 1962.

Cross, Tom, *Painting the Warmth of the Sun, St Ives Artists 1939-1975*, Alison Hodge, Penzance, and Lutterworth Press, Guildford 1984.

Grigson, Geoffrey, 'Revolutionary Simpletons', *New Statesman*, 16 December 1962.

Grigson, Geoffrey, 'Ben Nicholson', *New Statesman*, 10 May 1963.

Grigson, Geoffrey, *Recollections*, Chatto & Windus, London 1984: chapter 34, 'Ben Nicholson', pp.188-95.

Harrison, Charles, 'Abstract Painting in Britain in the Early 1930s', *Studio International*, vol. 173, April 1967.

Harrison, Charles, *Ben Nicholson*, exhibition catalogue, Tate Gallery, London 1969.

Harrison, Charles, *English Art and Modernism 1900-1939*, Allen Lane, London and Indiana University Press, Indiana 1981.

Heron, Patrick, 'Ben Nicholson', *New Statesman*, 17 May 1952.

Heron, Patrick, *The Changing Forms of Art*, Routledge and Kegan Paul, London 1955.

Hodin, J.P., *Ben Nicholson – The Meaning of his Art*, Alec Tiranti, London 1957.

Jellicoe, Geoffrey A., 'Recent Developments in the Work of Ben Nicholson', *Art International*, Summer 1967.

Lewis, David, 'Ben Nicholson, Another View', *Studio*, May 1952.

Lewison, Jeremy (ed.), *Circle: Constructive Art in Britain 1934-40*, exhibition catalogue, Kettle's Yard Gallery, Cambridge 1982.

Lewison, Jeremy, *Ben Nicholson: The Years of Experiment 1919-39*, exhibition catalogue, Kettle's Yard Gallery, Cambridge 1983.

Lewison, Jeremy, 'The Early Prints of Ben Nicholson', *Print Quarterly*, vol. 2, June 1985.

Lewison, Jeremy, *Ben Nicholson*, exhibition catalogue, Fundación Juan March, Madrid and Fundação Calouste Gulbenkian, Lisbon 1987.

Lewison, Jeremy, *Ben Nicholson*, Phaidon, London 1991.

Lewison, Jeremy, *Ben Nicholson*, exhibition catalogue, Fondation Pierre Giannadda, Martigny 1992.

Lewison, Jeremy, *Ben Nicholson*, exhibition catalogue, Tate Gallery, London 1993.

Lynton, Norbert, 'A Unique Venture', *Studio International*, vol. 173, no. 890, June 1967.

Lynton, Norbert, *Ben Nicholson*, exhibition catalogue, Galerie Beyeler, Basel 1968.

Lynton, Norbert, *Ben Nicholson – New Reliefs*, exhibition catalogue, Marlborough Fine Art, London and Zürich 1971, Rome 1972.

Lynton, Norbert, *Ben Nicholson*, exhibition catalogue, Waddington Galleries, London 1976.

Lynton, Norbert, *Ben Nicholson – Recent Works*, exhibition catalogue, Waddington Galleries, London 1980.

Martin, J.L., 'A World inside a Frame', *The Listener*, 17 January 1948.

Martin, J.L., Nicholson, Ben and Gabo, N. (eds.), *Circle, International Survey of Constructive Art*, Faber and Faber, London 1937.

Martin, J.L., 'Architecture and the Painter, with Special Reference to the Work of Ben Nicholson', *Focus*, no. 3, Spring 1939.

Moore, Helena (ed.), *The Nicholsons: A Story of Four People and their Designs*, exhibition catalogue, York City Art Gallery 1988.

Nash, Paul, 'Ben Nicholson's Carved Reliefs', *Architectural Review*, vol. 78, October 1935.

Nash, Steven A., *Ben Nicholson: Fifty Years of his Art*, exhibition catalogue, Albright-Knox Art Gallery, Buffalo 1978.

Neve, Christopher, *Ben Nicholson – Recent Paintings on Paper*, exhibition catalogue, Waddington Galleries, London 1978.

Neve, Christopher, *Ben Nicholson – New Work*, exhibition catalogue, Waddington Galleries, London 1982.

Neve, Christopher, *Unquiet Landscape*, Faber and Faber, London 1990: 'Ben Nicholson', pp.125-38.

Nicholson, Andrew (ed.), *Unknown Colour. Paintings, Letters, Writings by Winifred Nicholson*, Faber and Faber, London 1987.

Piper, Myfanwy, 'Back in the Thirties', *Art and Literature*, no. 7, Winter 1965.

Ramsden, E.H., 'Ben Nicholson: Constructivist', *Studio*, December 1945.

Read, Herbert (ed.), *Unit 1: The Modern Movement in English Architecture, Painting and Sculpture*, Cassel & Co., London 1934.

Read, Herbert, 'Ben Nicholson's Recent Work', *Axis*, no. 2, April 1935.

Read, Herbert, 'Ben Nicholson and the Future of Painting', *The Listener*, 9 October 1935.

Read, Herbert (ed.), *Ben Nicholson: paintings, reliefs, drawings*, Lund Humphries, London 1948: reprinted in 1955 as vol. 1.

Read, Herbert (ed.), *Ben Nicholson: work since 1947*, vol. 2, Lund Humphries, London 1956.

Read, Herbert, 'A Nest of Gentle Artists', *Apollo*, vol. 76, September 1962.

Robertson, Bryan, 'Grace and Favour', *The Spectator*, 23 June 1967.

Russell, John, *Ben Nicholson: Drawings, Paintings and Reliefs 1911-68*, Thames and Hudson, London 1969.

Sausmarez, Maurice de (ed.), *Ben Nicholson*, a *Studio International* special number, London 1969.

Soldini, Simone (ed.), *Ben Nicholson: opere dal 1921 al 1981*, Museo d'arte, Mendrisio 1983.

Stokes, Adrian, 'Ben Nicholson's Paintings', *The Spectator*, 20 October 1933.

Stokes, Adrian, 'Ben Nicholson at the Lefevre Gallery', *The Spectator*, 19 March 1937.

Summerson, John, 'Abstract Painters', *The Listener*, 16 March 1939.

Summerson, John, *Ben Nicholson*, Penguin Books, West Drayton 1948.

Tschichold, Jan, 'On Ben Nicholson's Reliefs', *Axis*, no. 2, April 1935.

# Exhibitions

## A: One-man Exhibitions

**1922**
Adelphi Gallery, London (?)
**1924**
Adelphi Gallery, London
**1930**
Lefevre Gallery, London
**1932**
Lefevre Gallery, London
**1935**
Lefevre Gallery, London
**1937**
Lefevre Gallery, London
**1939**
Lefevre Gallery, London
**1944**
Leeds City Art Gallery,
Temple Newsam House
**1945**
Lefevre Gallery, London
**1947**
Lefevre Gallery, London
**1948**
Lefevre Gallery, London
**1949**
Durlacher Gallery, New York
Framestop Gallery, Boston
**1950**
Lefevre Gallery, London
**1951**
Durlacher Gallery, New York
Phillips Gallery, Washington DC
Swetzoff Gallery, Boston
**1952**
Durlacher Gallery, New York
Lefevre Gallery, London
**1952-3**
Detroit Institute of Arts, and tour to Dallas
Museum of Art and Walker Art Center,
Minneapolis
**1954**
Galerie Apollo, Brussels
Lefevre Gallery, London
**1954-5**
Biennale, Venice (BN awarded Ulisse Prize),
and tour to Stedelijk Museum, Amsterdam,
Musée d'Art Moderne, Paris, Palais des
Beaux-Arts, Brussels and Kunsthalle, Zürich
**1955**
Durlacher Gallery, New York
Gimpel Fils, London
Samlaren Gallery, Stockholm
Tate Gallery, London
**1956**
Durlacher Gallery, New York
Galerie de France, Paris
**1957**
Gimpel Fils, London

**1957-8**
Fourth Bienal, Museum of Modern Art, São
Paulo, and tour to Museum of Modern Art,
Rio de Janiero, and National Museum of Fine
Arts, Buenos Aires
**1959**
British Council, London
Galerie Lienhard, Zürich
Galerie Schmela, Düsseldorf
Gimpel Fils, London
Kestner-Gesellschaft, Hanover, and tour to
Stadtische Kunsthalle, Mannheim,
Kunstverein, Hamburg and Museum
Folkwang, Essen
Laing Art Gallery, Newcastle
**1960**
Galerie Lienhard, Zürich
Galleria Lorenzelli, Milan
Gimpel Fils, London
**1961**
André Emmerich Gallery, New York
Kunsthalle, Berne
**1962**
Galerie Lienhard, Zürich
Galerie der Spiegel, Cologne
**1963**
Gimpel Fils, London
Kunstmuseum, Sankt Gallen
Marlborough New London Gallery, London,
and tour to Marlborough Galleria d'Arte,
Rome, and Marlborough-Gerson Gallery,
New York
**1964**
Crane Kalman Gallery, London
Dallas Museum of Fine Arts
Richard Gray Gallery, Chicago
**1965**
André Emmerich Gallery and
Marlborough-Gerson Gallery, New York
**1966**
Gimpel and Hanover Gallery, Zürich
**1967**
Galleria d'Arte "La Bussola", Turin, and tour to
Galleria Antonelli, Milan
Marlborough Galleria d'Arte, Rome
Kestner-Gesellschaft, Hanover, and tour to
Munich, Berlin and Aarau
Marlborough New London Gallery, London
**1968**
Crane Kalman Gallery, London
Galerie Beyeler, Basel
Marlborough Fine Art, London
**1969**
Tate Gallery, London
Tokyo Gallery, Tokyo
Waddington Graphics, London
**1970**
Marlborough Fine Art, London
**1971-2**
Marlborough Fine Art, London, and tour to
Zürich and Rome

**1973**
Galerie Beyeler, Basel
Galleria Castelnuovo, Ascona
Gimpel Fils, London
**1974**
André Emmerich Gallery, New York
Crane Kalman Gallery, London
Fischer Fine Art, London
Galleria Narciso, Turin
**1974-5**
Galerie Georges Moos, Geneva, and tour to
Forni Galleria d'Arte, Bologna, and La Nuova
Pesa Galleria d'Arte, Rome
**1975**
Galerie André Emmerich, Zürich, and tour
to André Emmerich Gallery, New York
Victoria and Albert Museum, London
**1976**
Agenzia d'Arte Moderna, Rome
Arts Club of Chicago
Galeria Ynguanzo, Madrid
Waddington Galleries, London
**1977**
Kasahara Gallery, Osaka
**1977-8**
Victoria and Albert Museum/British Council
touring exhibition to Les Sables d'Olonne,
Montbéliard, Rouen, Calais, Bordeaux,
Nantes, Chartres and Strasbourg
**1978**
Waddington and Tooth Galleries, London
**1978-9**
Albright-Knox Art Gallery, Buffalo, and tour to
Hirshhorn Museum and Sculpture Garden,
Washington DC, and The Brooklyn Museum,
New York
**1979**
Theo Waddington, Toronto
**1980**
Waddington Galleries, London
**1982**
Art Centre, Tokyo
Galerie Beyeler, Basel
Waddington Galleries, London
**1983**
Ateliers Lafranca, Locarno, and tour to
Kunsthalle, Mannheim
Kettle's Yard, Cambridge, and tour to
Bradford, Canterbury and Plymouth
Micart, Tokyo
Waddington Graphics, London
**1984**
Galerie Artek, Helsinki
**1985**
Gallery Kashahara, Osaka
Maclaurin Art Gallery, Ayr, and tour to Pier
Arts Centre, Stromness, Kirkcaldy Museum
and Art Gallery, Artspace, Aberdeen

**1987**
Fundación Juan March, Madrid, and tour to
Fundação Calouste Gulbenkian, Lisbon
Rex Irwin Gallery, Sydney
**1989**
Josef Albers Museum, Bottrop
**1990**
Galerie Marwan Hoss, Paris
Ganz & Co., Cambridge
**1992-3**
Fondation Pierre Gianadda, Martigny
Odakyu Museum, Tokyo, and tour to
Shizuoka Prefectural Museum of Art, The
Hakon Open-Air Museum, Kintetsu Museum
of Art and Gunma Museum of Modern Art
**1993**
Museo d'Arte, Mendrisio
**1993-4**
Tate Gallery, London, and tour to Musée d'Art
Moderne, St Étienne

**B: Selected Group Exhibitions**
**1923**
Patterson Gallery, London
(with Winifred Nicholson)
**1924, 1926-9, 1931-5**
Seven and Five Society, London
**1927**
Beaux-Arts Gallery, London
(with Wood and Staite-Murray)
**1928**
Lefevre Gallery, London (with Winifred
Nicholson and Staite-Murray)
**1930**
Galerie Georges Bernheim, Paris
(with Winifred Nicholson and Wood)
**1931**
Abby & Co, London (*Watercolours and
Drawings*)
Arthur Tooth & Sons, London (*Recent
Developments in British Painting*)
Bloomsbury Gallery, London
(with Hepworth and Staite-Murray)
Lefevre Gallery, London (*Young British
Artists*)
**1932**
Arthur Tooth & Sons, London (with
Hepworth)
**1933**
Arundell, Clarke Gallery, New York (*A
Comprehensive Selection of Modern English
and European Paintings*)
Lefevre Gallery, London (with Hepworth)
Lefevre Gallery, London (*Flower Paintings by
Contemporary British Artists*)
Mayor Gallery, London (*Art Now*)
Zwemmer Gallery, London (*Artists of Today*)
**1933-5**
Abstraction-Création permanent exhibition,
Paris

**1934**
Biennale, Venice
Mayor Gallery, London, and tour to Walker
Art Gallery, Liverpool, Platt Hall, Rusholme
and City Art Gallery and Museum, Hanley
(*Unit One*)
**1935**
Artists' International Association, London
(*Artists against Fascism and War*)
Everyman Cinema, London (*Abstract Art*)
Experimental Theater, London (*Abstract
Painters*)
Kunstmuseum, Lucerne (*Thèse, Antithèse,
Synthèse*)
Mayor Gallery, London (*25 Years of British
Painting: 1910-35*)
Musées Royaux des Beaux-Arts, Brussels
(*Exposition Internationale d'Art Moderne*)
**1936**
Artists' International Association, London
(fund-raising exhibition for the International
Brigade)
Duncan Miller, London (*Abstract Art in
Contemporary Settings*)
Lefevre Gallery, London, and tour to Oxford,
Cambridge, Liverpool (*Abstract and
Concrete*) (with Arp, Calder, Gabo,
Giacometti, Hélion, Hepworth, Kandinsky,
Mondrian and others)
Museum of Modern Art, New York
(*Cubism and Abstract Art*)
Stedelijk Museum, Amsterdam
(*Twee Eeuwen Engelse Kunst*)
**1937**
Artists' International Association, London
(*Abstract Section*)
London Gallery, London (*Exhibition on the
Theme of Musical Instruments*)
London Gallery, London (*Constructive Art*)
**1938**
New Burlington Galleries, London (*New
Architecture: An Exhibition of the Elements
of Modern Architecture organized by MARS*)
Stedelijk Museum, Amsterdam
(*Tentoonstelling Abstrakte Kunst*)
**1939**
Guggenheim Jeune, London (*Abstract and
Concrete Arts*)
Leicester Galleries, London (*Modern British
Artists*)
London Gallery, London (*Living Art in
England*)
New York World's Fair, British Pavilion, and
tour to San Francisco, National Gallery of
Canada, Ottawa, Art Gallery of Toronto, Art
Association of Montreal, Museum of Fine
Arts, Boston and Arts Club of Chicago
(*Exhibition of Contemporary British Art
organized by the British Council*)
Whitechapel Art Gallery, London
(*Art for the People*)

**1940**
Lefevre Gallery, London (*Art of Today*)
Lefevre Gallery, London (*Modern English
Painting*)
Museum of Living Art, New York
**1942**
Toledo Museum of Art, Toledo, OH
(*Contemporary British Art*)
**1944**
St Ives Society of Artists
**1945**
Lefevre Gallery, London (with Cluysenaar)
St Ives Society of Artists
**1946**
Institute of Modern Art, Boston (*An
Exhibition of the Work of Modern British
Artists*)
Lefevre Gallery, London (with Sutherland)
Musée d'Art Moderne, Paris (UNESCO,
*International Exhibition of Modern Art*)
**1948**
Galerie René Drouin, Paris (*Exposition de la
jeune peinture en Grande Bretagne*)
Museum of Modern Art, New York
(*Masters of British Painting 1850-1950*)
**1949**
Musée des Beaux-Arts de la Ville de Paris,
Paris (*Salon des Réalités Nouvelles*)
Penwith Society of Arts, Cornwall
Stedelijk Museum, Amsterdam, and tour to
Amsterdam, Dusseldorf, Hamburg and
Luxembourg (*Twaalf Britse Schilders*)
**1950**
Knoedler Galleries, New York (*British Art:
The Last 50 Years, 1900-1950*)
Pennsylvania Academy of the Fine Arts,
Philadelphia (*Contemporary British Painting
1925-1950*)
**1951**
British Council, London (*Festival of Britain*)
**1952**
Carnegie Institute, Pittsburgh (*39th
International Exhibition*) (BN wins First Prize)
**1953**
Studio of Adrian Heath, London, third Fitzroy
Street exhibition (with Pasmore, Hilton,
Kenneth and Mary Martin, Paolozzi and
others)
XXVII Biennale Internazionale d'Arte di
Venezia, British Pavilion (with Bacon and
Freud)
**1955**
Third International Exhibition, Tokyo
(BN wins Governor of Tokyo's Award)
**1956**
Arthur Tooth & Sons Ltd, London (*Critic's
Choice*)
E. and A. Silberman Galleries, New York (*An
Exhibition of Contemporary British Art*)
Museum of Modern Art, New York, and tour
to St Louis and San Francisco (*Masters of
British Painting, 1850-1950*)

Villa Ciani, Lugano (*Mostra Internazionale di Bianco e Nero*) (BN awarded Grand Prix)

**1957**

Institute of Contemporary Arts, London (*Statements*)

Walker Art Center, Minneapolis (*Contemporary British Art*)

**1958**

Contemporary Art Museum, Houston (*Collage International: From Picasso to the Present*)

**1962**

San Francisco Museum of Art, San Francisco, and tour to Dallas and Santa Barbara (*British Art Today*)

The National Museum of Wales, Cardiff (*British Art and the Modern Movement: 1930-40*)

**1963**

Crane Kalman Gallery, London (*The Englishness of English Painting*)

Galerie Beyeler, Basel (with Arp, Bissier and Tobey)

National Gallery of Canada, Ottawa (*Contemporary British Painting*)

**1964**

Albright-Knox Art Gallery, Buffalo (*Contemporary British Painting and Sculpture from the Collection of the Albright-Knox Art Gallery and Special Loans*)

Kunsthalle, Düsseldorf (*Britische Malerei Der Gegenwart*)

Marlborough-Gerson Gallery, New York (*Mondrian, De Stijl and Their Impact*)

Museum Fridericianum, Kassel (*Dokumenta III*)

**1965**

Marlborough Fine Art, London (*Art in Britain 1930-40 Centred around Axis, Circle, Unit One*)

Marlborough-Gerson Gallery, New York (*The English Eye*)

**1966**

Crane Kalman Gallery, London (with Wood and Wallis)

**1967-8**

Crane Kalman Gallery, London (*Modern British Paintings*)

**1969**

Crane Kalman Gallery, London (*Some Explorers*)

Crane Kalman Gallery, London (*Modern British Painting*)

Marlborough Fine Art, London (*A Selection of 20th Century British Art*)

**1970**

National Gallery of Art, Washington DC (*British Painting and Sculpture, 1960-1970*)

**1970-1**

Hayward Gallery, London, and tour to Laing Art Gallery, Newcastle upon Tyne, Kettle's Yard, Cambridge, National Museum of Wales, Cardiff and Abbot Hall Art Gallery, Kendal (*The Helen Sutherland Collection*)

**1972**

Albright-Knox Art Gallery, Buffalo (*English Painting and Sculpture in the Albright-Knox Art Gallery, 1942-1972*)

Annely Juda Fine Art, London, and tour to Basel and Milan (*The Non-Objective World 1939-1955*)

Dallas Museum of Fine Arts, Dallas (*Geometric Abstraction 1926-1942*)

**1973**

Annely Juda Fine Art, London, and tour to Austin (*The Non-Objective World 1914-1955*)

Crane Kalman Gallery, London (*British Paintings*)

Palais des Beaux-Arts, Brussels (*Henry Moore to Gilbert & George. Modern British Art from the Tate Gallery*)

**1974**

Camden Arts Centre, London (*Hampstead in the Thirties, a Committed Decade*)

Redfern Gallery, London (with Dubuffet and Tapies)

**1975**

Schweizer Mustermesse, Basel (*British Exhibition Art 6'75*)

Smith College Museum of Art, Northampton, MA (*One Hundred*)

South African National Gallery, Capetown (*Modern Graphic Art from the Collections of Friends of the South African National Gallery*)

**1977**

Kunsthaus, Zürich (*Aspecte Konstruktiven Kunst*)

Tate Gallery, London (*Art in One Year: 1935*)

**1978**

Musée d'Art Moderne de la Ville de Paris, Paris, and tour to Westfälisches Landesmuseum für Kunst und Kulturgeschichte, Münster (*Abstraction Création, 1931-1936*)

**1981**

Marlborough Fine Art, London (*Drawings and Watercolours by 13 British Artists*)

**1982**

British Council, PR China (*British Drawings and Watercolours*)

Kettle's Yard, Cambridge (*Circle: Constructive Art in Britain, 1934-40*)

**1983**

Browse and Darby, London (with William Nicholson)

Crane Kalman Gallery, London (*The Nicholsons*)

**1983-4**

Galerie Maeght, Paris (with Riopelle)

**1984**

Artcurial, Paris (*English Contrasts*)

William Weston Gallery, London (with Moore and Sutherland)

**1985**

Redfern Gallery, London (*Real and Abstract*)

Tate Gallery, London (*St Ives, 1939-64 Twenty-five Years of Painting, Sculpture and Pottery*)

**1985-6**

Crane Kalman Gallery, London (*A Selection of Modern British Paintings and Sculpture*)

**1986**

Galerie Academia, Salzburg (with Bissier)

Tate Gallery, London (*Forty Years of Modern Art, 1945-1985*)

**1987**

Pier Arts Centre, Stromness, and tour to Aberdeen Art Gallery and Museums, Smith Art Gallery and Museum, Stirling, Kettle's Yard, Cambridge

Redfern Gallery, London (*Landscape and Figure*)

Royal Academy of Arts, London (*British Art in the Twentieth Century*)

**1988-9**

York City Art Gallery, and tour to Bath, Salford, Aberdeen, Newport, Wakefield and Kendal (*The Nicholsons: the Story of Four People and their Designs*)

**1989**

Hyogo Prefectural Museum of Modern Art, and tour to Museum of Modern Art, Kamakura, and Setagaya Art Museum (*St Ives*)

**1990**

Gimpel Fils, London (with Hepworth)

IVAM Centre Julio González, Valencia (*Paris 1930: Arte Abstracte—Arte Concreto: Cercle et Carré*)

**1991-2**

Hayward Gallery, London, and tour to Maclaurin Art Gallery, Ayr, Bristol City Museum and Art Gallery, Walker Art Gallery, Liverpool (*The Contemporary Art Society. Eighty Years of Collecting*)

**1991**

Abbot Hall Art Gallery, Kendal (*A Painters' Place: Banks Head, Cumberland, 1924-31*)

**1992**

Brighton Museum and Art Gallery (*Rendez-vous à Dieppe. The Town and its Artists from Turner to Braque*)

Piccadilly Gallery, London (*British Drawings and Watercolours, 1936-1958*)

**1993**

Bernard Jacobson Gallery, London

# Index of Works by Date

Within the chronological sequence, more precise dates are placed before less precise ones. Where there is more than one date in a title, the first date determines the place in the sequence. Where both dates and subtitles are identical, the works are distinguished by their dimensions and placed in sequence according to plate numbers. Works by artists other than Ben Nicholson are listed in the General Index.

Index of Works by Date

Index of Works by Subtitle

General Index

General Index

General Index